Embodied Meanings

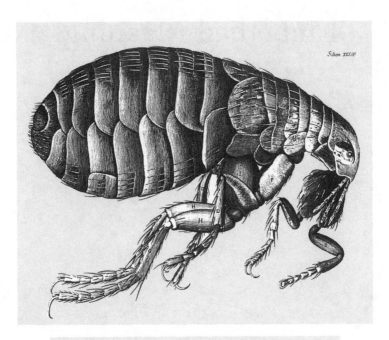

Schem XXXIV

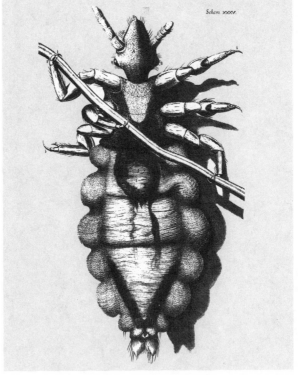

Schem XXXV.

EMBODIED MEANINGS,

Critical Essays &

Aesthetic Meditations

Arthur C. Danto

The Noonday Press

Farrar, Straus and Giroux

New York

Library of Congress Cataloging-in-Publication Data
Danto, Arthur Coleman.
Embodied meanings : critical essays and aesthetic meditations /
Arthur C. Danto. — 1st ed.
p. cm.
Includes index.
1. Art, Modern—20th century. 2. Art—Philosophy. I. Title.
N6490.D236 1994 701—dc20 93-44961 CIP

The frontispiece consists of plates XXXIV ("Flea") and XXXV
("Louse") reproduced from Robert Hooke, Micrographia; or, Some
Physiological Descriptions of Minute Bodies Made by Magnifying
Glasses (London: John Martyn and James Allestry, 1665).
Photographs are by courtesy of the Dana Biomedical Library,
Dartmouth College. These two remarkable images embody the idea
of "embodied meaning" and are discussed in "Aesthetics and Art
Criticism," where they make vivid the connection between aesthesis
and cognition.

$14 - FNW 1/30/97 (SW)

Contents

AESTHETIC MEDITATIONS

Preface

WHEN HE HAD BECOME one of the world's most celebrated painters, the artist Mark Rothko came to feel that painting alone no longer fulfilled his artistic aspirations. According to his biographer, James E. B. Breslin, Rothko confided to a friendly critic that "he had lost his zest for easel paintings, finding them inadequate and episodic." His ambition, a curiously precocious one for the early 1960s, was to create *environments* through arrangements of paintings very much like those upon which his great renown was based—large abstract canvases in which one or two luminous rectangles floated in a space of their own. But the ambition implied that he wanted the works to relate to those who experienced them in some relationship more complex than exclusively as objects of visual delectation, and in this one respect Rothko, whose artistic beliefs and attitudes were typical of his age, was ahead of his time. Rothko's world was one in which painting defined what it was to be a visual artist, with sculpture coming in a distant second. There was an unwritten ranking—comparable perhaps to that which prevailed in the era of academies, when historical painting was esteemed above all other genres—which placed abstract painting at the apex of esteem in Rothko's world. Because such paintings existed to be visually appreciated, it was assumed without question that the audience was composed of *viewers*, who engaged *visually* with painting in rooms specifically devoted to the activity of gazing—the space of the gallery or the museum. It was this scheme and ranking that Rothko began to find unsatisfying, and it is a tribute to his prophetic powers —powers he would have been altogether pleased to acknowledge— that his discontents came to define a later era—our own—where easel

painting has come under suspicion and artists strive to encompass their audiences in a relationship more intimate than vision alone permits. The happening, the performance, the installation, the site-specific work—the environment!—have competed with painting as the bearer of artistic experience. And indeed, artistic experience has itself been more widely conceived than the concept of aesthetic experience, understood in terms of visual pleasure, could have accepted. Rothko aimed at something closer to transformation rather than visual satisfaction, and in this he is closer in spirit to the artists of our own postmodern era than he is to his cohorts in the Abstract Expressionist movement of the fifties.

It is worth dwelling for a moment on the masterpiece through which Rothko best achieved these transcendent ends, namely the chapel in Houston, Texas, made possible by the visionary patron Dominique de Menil. He had learned that an ensemble even of internally related paintings does not instantaneously constitute an environment when he lined the walls of a privileged dining space at Harvard University. The primary function of such spaces is, well, *dining*—and that means that the paintings on the wall are instantaneously reduced to background decorations for whatever takes place at the table: paintings in the dining room are like music played during dinner, there to provide agreeable background for the drama of the meal. Rothko's Harvard paintings in fact made very disagreeable decorations, and were perceived as gloomy, forbiddingly dark expanses, scarcely suitable visual accompaniments to academic gossip or departmental discussions, and they clearly could not transform diners into something more commensurate with their intentions. Rothko was given a room at the Tate, in which he installed a suite of paintings originally commissioned for a luxurious restaurant in New York, but then wisely withdrawn by the artist. But a gallery is exactly the kind of viewing space assumed as normal in Rothko's world, penetrated primarily by those in quest of visual experience. They would be surrounded by paintings which did not constitute an environment, just because no transformation from viewer to something else could be expected; and while the paintings in the gallery were not the decorations they would have been in the dining room, they remained objects of an aesthetic gaze rather than the means of spiritual transformation. Beyond question, there are visitors to the Rothko Chapel who come as aesthetic pilgrims, and whose primary experience within the space his paintings define is visual. But as an environment those paintings imply a different kind of experience

and a range of different meanings, all of which click into place when the transformation takes place as intended, and visitors are transformed onto another plane as celebrants and as metaphorical participants in some larger spiritual transaction. That after all is what the concept of the chapel implies, and it is the kind of change Rothko sought.

The transformation of ordinary persons onto another plane is one of the great effects of art Nietzsche talks of in *The Birth of Tragedy*— not coincidentally, one of Rothko's favorite texts—and if Nietzsche is right, it was the effect to which art aspired at the very dawn of Greek tragedy. Such transformations were not, of course, real: Nietzsche treats them as forms of intoxication, and in truth something like a mass intoxication is portrayed by Euripides in *The Bacchae*, with people so frenzied by the powers of the god Dionysus that what they do while under it survives its passing, as happens, or can happen, sadly enough, to those who act under the influence of intoxicants. The transformations achieved by Rothko's environment may also have real effects— one might enter a visitor and emerge an altered person—but the effect can also be sufficiently transient as to bear analogies with what the contemporary thinker Kendall Walton calls "make-believe." But for the period in which the relationship between individual and work endures, and independently of whether it is internalized in any further sense, the "viewer" embodies the meaning the work confers. In Nietzsche's ancient Greece, a mere shepherd becomes a satyr; in Rothko's Houston, an ordinary tourist becomes a celebrant, caught up in some spiritual atmosphere it would not be an easy matter to define more specifically. It is perhaps less important to endeavor to define it than to observe how little connection there is between that experience and the canonical experience of aesthetic gazing which was widely assumed to be *the* appropriate artistic stance in the world Rothko saw beyond. But this expanded notion of artistic experience is explainable only so far as we treat even paintings as something more than things to be looked at and to be understood in strictly visual terms. Like the viewers they transform, paintings themselves are embodied meanings. Rothko's canvases are literally so much paint and canvas, as the person who sits in front of them is literally, say, a female human being from Minnesota. In a more recent environment, created by Robert Irwin, what is literally so much scrim and so many fluorescent lamps becomes luminescence embodied, and because of the metaphorical associations of luminosity, some more exalted meaning gets embodied in the installation. To see it merely as scrim and fluorescent light is not to see

it as art. To see it as art is to undergo a transformation corresponding to the transformation the materials of the work undergo: "viewer" and work are together lifted to the same plane.

It is evident I am uncomfortable with the term "viewer," but the absence of a less constraining term with which to designate us when we engage actively with works of art is evidence of the way we have also come to think of painting and sculpture as "visual arts." We are defined as gazers—to use a term given an almost political inflection by feminist theorists—and they are what is gazed at, admitting, of course, that on this base gazing can be instructed by formalist training so that one can appreciate the object in terms of structural features we can also learn to look for. Instructed gazing is the experience conveyed by docents and art history teachers throughout the world. It is something I infer Rothko felt trapped in, given the urgency with which he sought to break out, into something less formalistic, and indeed less visual. It is easy to understand how Clement Greenberg, who typifies what I must designate *visualism*, should have decreed that Rothko "lost his stuff" after 1955. He did not lose his stuff so much as enter what at the time was unexplored artistic territory, where the older critical criteria had to be left behind. And we are living in an art world to which they apply less and less. What used to be the visual arts today address what used to be their viewers as embodiments of meanings achieved as a result of interaction with works themselves understood as embodied meanings. It is in this spirit that the critical and the meditative essays which compose this book were conceived.

I owe my readership a clearer account of the concept of embodied meaning than is appropriate in the preface to a work where it is more or less taken for granted. The tentative beginnings of a proper philosophical account may be found in my 1981 text, *The Transfiguration of the Commonplace*, but I feel that inasmuch as the years since its appearance have been so intensely taken up with thinking and writing about "the visual arts," I am more than due for a thorough philosophical reworking of the ideas that have emerged, and especially have emerged through my practice as art critic and through my study of Hegel's philosophy of art. Hegel writes: "The work of art, as a sensuous object, is not merely for *sensuous* apprehension; its standing is of such a kind that, though sensuous, it is essentially at the same time for *spiritual* apprehension; the spirit is meant to be affected by it and to find some satisfaction in it," and while this terminology is hardly of our own times, we have abandoned the ideas it expresses to our great disadvantage.

I have imprudently pre-empted what ought to have been the title of such a work, *Embodied Meanings*, primarily because it condenses so perfectly what I take my task as a critic to be. The task is twofold: to identify what the work means and then to show how that meaning is embodied in the work. Thus I am not in the least interested in formal features of the work unless these connect with the meaning, and do so in such a way that they in fact are that meaning's embodiment in the work. Further than this I would not care to go here, but I will say at least this: meanings more or less come from the world in which the artist lives, including the art world which constitutes his or her closest institutional environment. They are, one might say, historically indexed, in that they must belong to the world the artists find themselves in, and are part of that historical moment. Inventing meanings is not something I would expect artists for the most part to do, least of all if they have the slightest ambition to communicate. The originality of the artist comes from inventing modes of embodying meanings she or he may share with communities of very large circumference. It sometimes takes historical scholarship to discover what the meanings were that found their way into an artist's work, for those meanings faded with changes in history and no longer defined a community which shared them. But until those meanings are recaptured, modes of their embodiment remain opaque, and the works in question are alien to us, as are many opaque artifacts we know to be meaningful but whose meaning we cannot grasp. A lot of the art being made today is alien to us in this way, as much as if it belonged to a remote culture. At the very least, it seems to me, a critic must make plain—or as plain as the work allows—what meaning it has and what meaning the reader who experiences it as intended is supposed to have, and hence what mutual transformation of person and object constitutes the successful artistic experience. *After* that, one can make critical judgments.

THE TWO KINDS OF TEXTS of which this book is composed—critical essays and what I somewhat uncomfortably designate aesthetic meditations—each bring together the two disciplines I practice: philosophy and art criticism, but from different directions, so to speak. The art critical pieces were occasioned by specific exhibitions or by specific works, but they aspire to something more than the status of reviews: each is, I hope, driven by some philosophical thought the work elicited, though they are too caught up in the concreteness of the art to be treated as exercises in applied philosophy. The meditations mean, for

the most part, to offer philosophical clarifications of issues raised by contemporary art and the world in which it is practiced, but for just that reason each of them is tightly enough tethered to the reality that there is no danger of them sailing off into pure abstraction. In two of these essays—the first and the last—I talk about art criticism and philosophy together. "Philosophy and the Criticism of Art," which serves as an introduction to the book, was delivered as a lecture at the New York Public Library, in a series organized by David Cronin, who asked a number of critics to speak about their practice. This explains the somewhat personal character of the piece. "Aesthetics and Art Criticism" was the valedictory essay in an issue of the *Journal of Aesthetics and Art Criticism*, edited by Professor Lydia Goehr of Wesleyan University, which marked the fiftieth anniversary of that periodical. It is perhaps the most purely philosophical piece in the collection.

As for the remaining "meditations," "Art After the End of Art" was published in *Artforum*, April 1993, after having been presented as an evening lecture at the School of Visual Arts in New York, at the invitation of Jeanne Siegal. But the paper has a somewhat longer history than that: I presented an early and far rougher version of it at an immense conference on contemporary aesthetics (Der Aktualität des Ästhetischen) under the auspices of the Stiftung Niedersachsen in Hannover, Germany, in June 1992; and, in November of that same year, to a rowdy audience at the Rottersamse Künststickting in Rotterdam. "Quality and Inequality" was written especially for a symposium on the subject of quality at the invitation of the great art historian James Ackerman, then in residence at Cranbrook Academy in Michigan, and greatly revised for presentation at the museum of Mount Holyoke College at the invitation of Kristin A. Mortimer; and, later still, further revised for a meeting in Santa Fe, New Mexico, of the National Society for Education in the Ceramic Arts. "Museum and Merengue" was presented as the keynote address for a conference called "Crossing Cultures," at the invitation of the inventive and energetic curator, Mary Jane Jacobs, at the Fundación Caixia in Barcelona, Spain, in June 1993, and presented in a somewhat variant form at the World Congress of INSEA, held in Montreal, Quebec, at the invitation of David Pariser and Judy Freeman. "Beauty and Morality" was delivered in January 1992, at a conference called "Whatever Happened to Beauty?" held at the University of Texas in Austin, Texas, the inspiration of Richard Schiff. I am deeply obliged to all the organizers of these stimulating events for their imagination, generosity, enterprise, and intelligence.

It was altogether wonderful to be able to think in public on such provocative and difficult matters.

Except where otherwise noted, the critical essays first appeared in *The Nation*, which I have considered my chief venue as a writer on art since October 1984, when I began publishing as that magazine's regular art critic. I know that all *The Nation* pieces here benefited from the interventions of my great editor, Art Winslow, an intuitive and exemplary reader, as well as an intuitive and exemplary person. I would like to take this opportunity to thank the tireless corps of fact checkers at the magazine, who let me get away with nothing and have in consequence spared me the costs to which my somewhat casual spelling and somewhat eccentric scholarship might otherwise have exposed me. How dependent upon them I am comes vividly to my attention in the letters column of such publications as the *Times Literary Supplement*, for which I occasionally write, when some astonished reader comments on my bizarre beliefs about, say, the Thirty Years' War. The *TLS* takes it for granted that its writers know the relevant facts. The fact checkers at *The Nation* know better.

It is in this same spirit of acknowledging my limitations that I thank the copy editor at Farrar, Straus and Giroux who saved me, manuscript by manuscript page, from referential disaster. My greatest thanks here are due, however, to Phyllida Burlingame, who took the manuscript through to its final stage before striking off in a new direction for her life. I wish her the fulfillment her courageous act merits.

No set of acknowledgments could be complete without enthusiastic mention of my agents, Georges and Anne Borchardt, and their gifted associate, Alexandra Harding, a young woman of wisdom, grace, and clarity; and a solver of intractable problems. Like Phyllida, however, and virtually within the same week, Alexandra announced her resolution to seek fulfillment in endeavors other than publishing, and I felt bereft of two angels. I am especially grateful to Wendy Schachar Finn, who never fails to wring the last franc and pfennig from foreign publishers not famous for munificence.

This will be the third of my books to be published by Farrar, Straus and Giroux, and I am glad to have the continued confidence of Jonathan Galassi. I am no less grateful for the inspired graphic intelligence of Cynthia Krupat's design. Finally, I am gratified that the jacket of this text is again illuminated by one of Russell Connor's brilliant art historical inventions. Wit in the visual arts is in exceedingly short supply, but *humor* is virtually unheard of. It gives me the keenest

pleasure to think that the fronts of my books now constitute a permanent installation of Russell's sly, wry, dry contributions to the *musée imaginaire*.

Life in the art world is filled with adventure and astonishments, and I am beyond expression happy to have been able to share it with my high-spirited and affectionate sidekick and wife, the artist Barbara Westman. There is no such thing as drabness or dreariness when she comes along, and I hope the cocktail effervescence of her company is somehow communicated in the livelier passages and pages of this work.

New York City A.C.D.

Embodied Meanings

Introduction
Philosophy and the Criticism of Art: A Personal Narrative

MOST ART CRITICS have, as a general rule, two relationships to art, and it seems pretty inevitable that the way he or she conceives of criticism must be colored by the other relationship. A standard case is where the critic is also an artist, as some of our best critics have been—Fairfield Porter, who was one of my predecessors at *The Nation*, being one. Porter saw art from the perspective of the studio and hence was best as a critic on artists whose work was close enough to his own so that a kind of understanding from within of the artist's problems and the success or failure of his solutions defined his style as a critic. The sculptor Donald Judd was a very successful critic, but, like Robert Smithson, I think he was best and truly most illuminating when dealing with art of the kind he understood best, which was art that had some affinity to his own. In the 1970s, a great many critics were art historians, and criticism in their cases by and large consisted of the sorts of formal analyses they had learned to give of the works they talked about in class or wrote about in monographs and articles. Or they found it valuable to look for signs in a given body of work of the influence of other artists, which meant that they were much concerned with resemblances: criticism in their cases bore the structure of the two-projector art history lecture, where the audience was asked to note similarities. And, since they had, as art historians, seen a good many more works of art than most, their critical essays tended to be dense with allusions and references and comparisons. Before the historians set the canonical critical style, poets did. John Ashbery, David Shapiro, Kenneth Koch, James Schuyler, Frank O'Hara, and, later, Peter Schjeldahl were New York School poets who hung out with painters, and their relationship

to art was like their relationship to lovers, or the city, or landscapes, or whatever it was that moved them to write poetry: so their criticism characteristically took the form of sensitive personal responses, valuable because their sensibility was as authoritative before paintings as before the world itself. They were in constant intellectual interchange with painter friends—*en troc*, as the valuable French expression introduced by the historian Michael Baxandall has it. This kind of mediated relationship to art—where the critic is a poet who relates to art through his friends the painters—is traditional: one thinks of Apollinaire, or Paul Eluard, Tristan Tzara, and others. Finally, the critic of art will often be an intellectual whose interest in art is defined through some sort of theory the art is made to exemplify or illustrate. Clement Greenberg would be a good example of this, with Harold Rosenberg, our other major critic of recent times, being more a poet. What marks a critic who is also an intellectual is that his or her criticism subserves some agenda—some theory of what painting must be, of where art is heading, of what happens to art under specified social circumstances. A great many critics who were followers of Greenberg carried forward his various agendas. Some critics, of course, have more than one extracritical relationship to art: Barbara Rose is an intellectual and an art historian, as are Rosalind Krauss and Donald Kuspit.

My own case is somewhat unique, in that as well as critic I am a philosopher of art, which is very different, as I see it, from being an intellectual, just because philosophy itself is a discipline in which the philosophy of art has, as its counterparts, the philosophy of science or the philosophy of mind or the philosophy of this and that, and because there are professional criteria in philosophy, whereas there are none that I know of in being an intellectual. I am, of course, not the only philosopher who writes criticism professionally—my close friend and constant correspondent, David Carrier, is another. As with the other modes of double relationships to art, there is bound to be some penetration of my critical style by my philosophical practice, but it is neither easy nor obvious to say what this relationship is. This seems as good an occasion as any to work it out, but my own case strikes me as sufficiently different from any other that the best way to do this is probably autobiographical. So I will begin by saying what kind of philosopher I am and what kind I am not.

I am not, to begin with, that kind of philosopher of art who has made this his specialty, and who teaches courses in and writes articles on the subject as a specialist would. I have never been greatly interested

in what other philosophers have said or written about art in the past, from Plato and Aristotle to Kant and John Dewey, though I have come to a great admiration for Hegel's philosophical writings on art. My main reason for this uninterest is that I have always had a great interest in painting, and for a long time intended to be a painter—for a long time, in fact, had a sort of moderately successful career as a painter and especially as a printmaker—and from my experience I knew that almost nothing philosophers had ever said had much to do with art as I knew art. I stumbled into philosophy, as a matter of fact, because I had some time left on the GI Bill, and I had the strange idea that philosophy, of all the disciplines I considered, would give me the most time to paint. I wanted to be in New York, and when Columbia admitted me as a Ph.D. candidate in philosophy, the situation seemed ideal: the checks came in, the woman I lived with made up the rest, I did not find the course work especially taxing, and so I did a lot of painting. What I had not counted on was that I would both fall in love with philosophy and have a certain talent for it—more talent in fact than I had for painting. So I found myself writing and publishing philosophical articles, and gaining a sort of reputation as a promising young philosopher, and in truth I got so interested in philosophy that it began to seem as though I were making art more a duty to an ideal than what I most wanted to do. I vividly recall one night working on a woodcut when the thought crossed my mind: I would rather be writing philosophy than doing this. I immediately responded to this internal directive by saying: Well, if that's the feeling, you had better stop. And so I did stop, cold turkey, dismantling my studio and never again making a mark on paper other than what were words. This was early in the sixties, and philosophical thought was running very strong in me, and I was fascinated by what was coming out. Moreover, it turned out to be a remarkably fortunate thing for me, inasmuch as the sort of art through which I defined myself, Abstract Expressionism, was about to end, without a second generation to speak of and certainly without a third. I would have been beached by the shifts in history, and spent my life in bitterness, like those sad students of Hans Hofmann who would end up teaching courses at Pratt, insisting on certain ways of painting which had no longer anything to do with what the students were interested in: Robert Mapplethorpe, the photographer, recalled such figures teaching at Pratt when he was a student there. I would have had no place in the art world of the sixties and seventies, although, ironically, it was in the mid-sixties that, for the first time, I found

something philosophically interesting in art—but interesting in a way in which, again, none of the great philosophers of the past could help me or anyone understand. They were profoundly irrelevant.

In the years in which I was finding myself as a philosopher, the great movement was Analytical Philosophy, the view that in general the way into philosophical questions is through the analysis of language. For a time, I was profoundly interested in symbolic logic, but I discovered that I was not truly creative in it. I could get results, but at great effort, and the results were not central. But I loved the strategies of philosophical analysis, and in what for me was a very beautiful period, intellectually at least, when I was writing my first book, *Analytical Philosophy of History*, I loved the way one could apply pressure to a problem until it yielded up its little kernel of confusion. I used to think of the way a starfish opens an oyster, applying its powerful muscles to the shell until the latter yields to pressure and the starfish then gobbles up the tender morsel within. But I also felt myself to be part of an international movement, and was convinced that the masters—Russell, Wittgenstein, Carnap, Moore, Frege—had shown the way to do philosophy, and that all philosophical questions would, perhaps in my lifetime, be dissolved. There is nothing more gratifying than to feel oneself part of the swell of history, a feeling which, in my case, was true so far as philosophy was concerned, and perhaps which *had* been true so far as art was concerned but which stopped being true in art. Needless to say, it stopped being true in philosophy as analysis petered out in technicalities—but that is another story.

My revelatory moment in art came when I went to see the exhibition of Andy Warhol's *Brillo Box* at what was then the Stable Gallery on East Seventy-fourth Street in Manhattan. It excited me immensely, though, of course, as an artist I would have been absolutely unable to work that way. What especially moved me at the time was the sense that here at last was a philosophical question raised from within the art world, the question, namely, of why Warhol's *Brillo Box* was art, as I unquestionably accepted it to be, and why something that looked just like it—namely, the carton in which Brillo comes in the supermarket—is not a work of art at all. The show demonstrated a number of things, not least of all that the eye is incapable of determining the answer to this question and indeed that the Good Eye of artist and critic alike no longer was of great use in arbitrating the deep questions of art. It also demonstrated that the resemblances so dear to the art historian were of no great value either—what could look more like

Brillo Box than a Brillo carton from the supermarket? Imagine a pair of slides, one of each. What could the viewer make of that? What could he or she learn? Only that the eye is of no value whatever in distinguishing art from non-art. It occurred to me that one needed, at the very least, some sort of theory in order to do that; and that in fact the art world must be an atmosphere saturated in theory if a work like *Brillo Box* was to be possible. I defined an art world as an atmosphere of theory and of historical beliefs, relative to which things get constituted artworks. Luckily, I was invited to talk on the philosophy of art at the American Philosophical Association meetings that year—it was 1964—though I am afraid nobody much understood what I was trying to say. I published an essay in *The Journal of Philosophy* that year, and that paper provided the basis for what came to be known as the Institutional Theory of Art. I was astonished some years later when people told me that I was the father of that theory, which shows how little attention I was paying, even then, to the philosophy of art.

I was occupied instead with other sectors of philosophy, and after *Analytical Philosophy of History* came out in 1965, I published two books, *Analytical Philosophy of Knowledge* and *Analytical Philosophy of Action*. The former was something of a flop, but the material on action more or less made my name in philosophy, for it was quite original and promised to illuminate a whole range of issues on the topic of freedom and on the relationship of mind to body. Sometime in that period I conceived of myself as writing a system of analytical philosophy in several volumes, just like a nineteenth-century philosopher, and I more or less knew that one of them would be on art. Systematic philosophers have always had something to say on art, and I was sure that I would have something to say as well, when the time came to write it. When that time came, however, I did not want to call it my "Analytical Philosophy of Art." For one thing, it did not feel like analytical philosophy anymore, though the book is filled with the sorts of analyses and clarifications that are the mark of that style of philosophy, including the development of the sorts of questions the Warhol show raised for me. I had the inspiration to call it *The Transfiguration of the Commonplace*, a title I took from Muriel Spark. It was the title of a book the heroine of *The Prime of Miss Jean Brodie* wrote and I thought I would just take it over. Mrs. Spark and I corresponded for a while about what the fictional book would have been like, and what the real book (mine) was going to be like. She was very supportive, as people say these days. It is a wonderful title, and I am sure that if I

were honest with myself, the fact that I used it instead of some abstract title meant that I was going through an internal change. I wanted, for one thing, to reach people outside of philosophy, which shows that I no longer felt myself just a part of the world movement of analytical philosophy. I wanted to affect the minds of people who were thinking about art as it was being made in those years—the late sixties and seventies (the book was not published until 1981). I suppose I wanted to become famous in a way which went beyond just having a reputation among philosophers as a good philosopher. I do think it safe to say that if I have written anything that will be read after my death, *The Transfiguration of the Commonplace* is the most likely candidate. But my aim was not so much that of being remembered after my life is over as that of changing my life through changing the lives of others. And to some degree the book did have that consequence. It at least led to a change in my own life. It led to my becoming a critic.

Here is how that happened. Among the people who admired the book was Ben Sonnenberg, the editor of *Grand Street*. Ben trusted his judgment, which made his magazine eccentric and finally great, and he asked me if I would review a book of Ernst Gombrich for it. I wrote a really hateful review—I am ashamed of it, in fact. I was resentful of Gombrich for a number of things and found reasons to write negatively in a way I have never done since. But Ben printed it, and over the next some years I published frequently in *Grand Street*, and felt myself to be part of a world—namely, the world of those writers Ben gathered from here and there for his magazine, people like Christopher Hitchens and Norman Rush and Richard Howard. Once I wrote Ben a letter about the British PR firm Saatchi and Saatchi, who were interested in art, and who I had begun to feel were rigging the market in an unhealthy way, promoting artists far beyond what their actual gifts entitled them to. It was the beginning of the overheated art world of the eighties, and I felt it was being manipulated from the outside: I no longer felt that it was being driven by the sorts of internal forces I had always thought drove the history of art. It was an act of economic will disguising itself as a historical inevitability, and I was very angry about it. Ben sent the letter to Elizabeth Pochoda at *Vanity Fair*, saying that this was something that ought to be looked into. Betsy later told me how much she enjoyed the letter, which she wished she could just print as it was, but she then returned to *The Nation*, from which she had taken a year's leave, to edit the back of the book. *The Nation* needed an art critic just then, as Lawrence Alloway, who had been its critic

for about fifteen years, had fallen terribly ill. Betsy was unable to find anyone she especially liked, and when Ben said I knew a lot about art, she phoned to ask if I would like to write on art for *The Nation*—her exact words. She said we had friends in common (which turned out to be Ben) and she had read things by me (which turned out to be the letter I had written Ben). Betsy, like Ben, has powerful intuitions, which is what makes them both great editors and willing to try writers others would not think of. For me, the call really was a call in the German sense of *Beruf*. I was "called" to be an art critic. It was like the sky opening and a hand reaching down and lifting me onto a path I would never have found myself. It was a powerful intervention, and one for which I shall be eternally grateful. All the more marvelous to me that it came out of the blue.

This call came in the fall of 1984, and I find it curious in retrospect that this was a moment in which I was reflecting on my life in a certain way. I felt it was somehow complete, that as a philosopher I had done what I was to do. My books were translated and discussed, I held a named chair at a great university, I had been chairman of my department for some years, and had just been made president of the American Philosophical Association. I thought that I would write some more philosophy but by and large this was it. And I thought it would not greatly matter if I did write the philosophy I had in mind, either to the world of philosophy or to my own reputation. For I thought that philosophy had become extremely quiescent after the years of energy I had known, that what happened in philosophy no longer made a lot of difference, and that philosophy itself did not make a lot of difference. It was a moment of contentment but also of hunger, for I felt that while my life was complete, there was more I would like to have done, though I had no idea what. A natural thing which suggests itself to men in that frame of mind is a love affair, but in truth I had entered into an extremely fulfilling marriage, with Barbara Westman, and infidelity had no appeal to me. I had no thought of becoming an art critic, and in truth I would not have known how to go about becoming one. I am certain that had I walked into the offices of *The Nation* and introduced myself, saying that I had written what was regarded as an important book about art and would like now to be their art critic, I would have been shown the door. I was overqualified, an academic, and too old: it would just have been impossible. And here came this unimagined phone call, which was like a door into another world opening up, with glimpses of whole new landscapes through it, like something in *Alice*

in Wonderland. It was one of those communications that change one's life. I say that my life would have been complete had it never happened, and I would never have missed it save in the most abstract way. A friend of my daughter described his feeling about his marriage this way: he was content but not happy. The life of a critic has brought me that which I would not have known I wanted until I had it.

The first assignment I took on was an exhibition at the Whitney called "BLAM!," which addressed New York art from 1957 to 1965, which were the Warhol years, more or less. I was prepared for this, for I had lived through those years and responded to them philosophically. My essay brought to bear the full weight of that response, and that gave it a flavor art writing does not typically have. But while it made a considerable impression, it raised a problem of what I was next to do: I could not write about Pop Art for the rest of my critical career! The next major show was the stupendous "Van Gogh in Arles" at the Metropolitan Museum of Art. The thought crossed my mind that Van Gogh cut off his ear within weeks of Nietzsche's going mad in a piazza in Turin, and it seemed an odd coincidence that the most advanced philosopher and the most advanced painter in Europe should have broken down at almost the same time, roughly around the New Year of 1889. And I began to think of them together. I had written a book about Nietzsche, as a matter of fact, and knew his philosophy very well. I thought of his style and Van Gogh's and wondered if the parallels could be explained in any way as due to their similar situations in life. The next show, as I remember it, was of Leon Golub's paintings of torturers and mercenaries at the New Museum of Contemporary Art, which raised moral questions of an interesting sort. After that I was the regular critic, and wrote about things as they came up, providing I felt I had something to say. *The Nation* is not a "journal of record," like *The New York Times*, and I was never obliged to write about something for the sake of the record. Nor, happily, was it an art magazine. The audience, rather, took the kind of interest in art that intellectuals generally do, and visited museums when they traveled, but they were not deeply informed about the art scene. I wrote only about the sorts of shows intelligent readers would be interested in, and in a way that would justify that interest, connecting the art to the kinds of human concerns—political, moral, psychological, historical, philosophical—readers of that sort will have in mind when they look at or think about art. I did not write as a painter, or an art historian, or an intellectual. Nor, strictly, did I write as a philosopher. And that requires some comment.

Just in the way my life worked out, I have a degree of philosophical literacy most writers for magazines will not as a rule possess. Knowing about Nietzsche is a case in point. I once brought in Heidegger in an essay on Eric Fischl. Writing about Alex Katz's cutouts, I described an example in contemporary epistemology I thought would be illuminating. In situating a controversy about Richard Serra's *Delta*, which had become controversial in St. Louis, I wrote about the Institutional Theory of Art. These were not brought in as ornaments, but as useful pieces of thought—as Carlin Romano put it in a review of my work, they were not boasts but a natural gait. But these enter the prose in the way in which some historical insight might, or some stray bit of science I happen to know, or just an illuminating anecdote. They are incidental to the way I write. They are part of the extra-artistic knowledge I happen to have, but every critic carries some parallel piece of knowledge, which she or he will bring in when it seems valuable to do so.

Anyway, bringing in philosophical information is not "writing as a philosopher." But then I don't write as a philosopher at all when I write criticism, and here is why. *The Transfiguration of the Commonplace* really is a philosophical work, and it advances a certain theory. It attempts to state a few conditions necessary for something to be a work of art. Anything which is a work of art has to satisfy those conditions, if the theory is any good. If it is any good, everything will fit it, which means that it cannot discriminate among artworks, it cannot say "So much the worse for them," if they fail to fit it. If something is art and fails to fit, the theory has to be adjusted. So if it is good philosophy, it fits modern and medieval, Eastern and Western, abstract and representational, painting and sculpture, installation and performance. It has to fit everything because it means to articulate the very concept of art. So in particular it engenders no critical agenda. A lot of critics say about things that cannot easily be thought of as anything but art, that they are not art. That is the mark of their having an agenda. I have none. This means that, as a critic, I can like anything, so far as my philosophy is concerned. Someone—a dealer, in fact—once showed me the photograph of a work the artist claimed was based on *The Transfiguration*. I was flattered, of course, but were that artist to have said that he or she had been deeply moved by the book and that the work exemplified its philosophy to perfection, I would say that the artist understood the book not at all: *every* work of art has to exemplify it to perfection or it is bad or incomplete as philosophy. Everything in the art world fits as well as everything else. This leaves me marvelously

free as a critic. There is almost no connection between my philosophy and my critical practice. I can have no ax to grind except with other philosophers or critics of my philosophy.

On the other hand, there is a connection which a bit underwrites this rather cheerful pluralism, a view, if you like, of the history of art, or of art's historical present, which not everyone will accept. This brings me back to Warhol. About *Brillo Box*, I felt, as I said before, that for the first time there was something philosophically instructive about art. I thought in particular that Warhol (though not Warhol alone) had brought from within art the question of its true philosophical nature —namely, how something can be a work of art while something else which resembles it as much as *Brillo Box* resembles a carton of Brillo, is not art. That is like asking how two experiences can be exactly alike while one is dreamt and the other real. Nothing internal to the pair will account for the difference. One has to go outside the plane in which these pairs occur and construct the differences systematically. One needs a theory of the real, against which to talk about dream, in the one case, or art, in the other. And it struck me at some point with the force of a revelation that this problem could not have been raised as a philosophical problem within art at any earlier moment in the history of art: it was as though there were some internal historical development in the course of which art came to a kind of philosophical self-awareness of its own identity. In a curious and somewhat perverse way, I thought, art has turned into philosophy. Nothing artists can now do can carry that process any further. From now on the task is up to philosophers, who know how to think in the required way. And this frees artists to do something other than investigate the philosophical nature of their endeavor. A whole history is finished.

This is the theory of the end of art, which many people have heard of and wondered about, and which many find hateful. What it means, however, is very clear, however contestable. It means that the history of art in the West has been the history of achieving self-consciousness of the nature of art—of achieving, if you like, a philosophical understanding of what art is. In this history, painting especially took the lead, and dealt progressively with the problems as they presented themselves on the shoulders of prior solutions. I thought that from the late 1880s especially, painters undertook to define their enterprise in new ways, which meant that they made new kinds of paintings. This was widened in the early years of this century in the investigations by such figures as Duchamp—especially by Duchamp. And it culminated in the advanced art of the 1960s and 1970s. A great narrative ended in 1964

in the work of Warhol in particular. So my experience at the Stable Gallery in April 1964 not merely opened up a way to do the philosophy of art: it opened up, as I later recognized, a way of doing the philosophy of the history of art. I began to see the history of Western art as having a remarkable internal structure in which a narrative of dawning self-consciousness unfolded over time. It was a very Hegelian vision, and I am a bit astonished to have come upon it: it goes against my entire training as a philosopher to speculate so wildly. But there it is.

I do not so much propose to define the theory here as to spell out briefly what its implications are for the practice of criticism. The first thing, certainly, is that I do not praise artists or works of art for making historical breakthroughs, as I deny that there is historical room for those. For a long time, Modernism was believed to have a certain history, which consisted in the pursuit of the essence of art and the attendant jettisoning of whatever was accidental. This was Greenberg's thesis, and it was a very powerful one: it implied an end of art as well—namely, when the essence of art should be discovered. After that there would, speaking crudely, be only the interminable productions of flat surfaces. For me, the essence of art must be shared by everything that is an artwork, so there is nothing that exhibits this essence more than anything else, nor is it important that it should do so. In a way, what makes artworks interesting is the *accidents*, what changes from artist to artist and period to period. The essence, philosophically construed, is so abstract and attenuated that it is difficult to see what the essence in its Platonic purity would be. But there is no special virtue in attempting to achieve it. So I can cherish works of art that have a lot of what Greenbergian analysis disdained: the decorative, the literary, the political. Aesthetic delectation, which Hilton Kramer has made so central as to be exclusive in his appreciation of art, is only one of the virtues artworks can have. I have what I think is a strong argument that accidentalizes the aesthetic. It's all right if it is there, but it is all right if it is not. I can like a lot of things Kramer despises.

So the analysis of the structure of art history reinforces the pluralism which the very distinction between philosophy and criticism of art makes salient. It is still possible to criticize—but not on the grounds of failing to fit an agenda, of which I have none, or of failing to exhibit aesthetic qualities, which is only one of the virtues, and then only important in its place. People have, for example, criticized Mapplethorpe's photographs for being "too beautiful"—but my approach would be to see what their beauty has to do with their content, and what difference it would make if they were not beautiful but squalid.

Kramer will criticize art for being political, saying that politics has nothing to do with art. But that is like criticizing art for being religious. It could not have the aesthetic qualities it does have, when it has them, if it did not have the religious content and intention. I felt that many of the works in the recent "Dislocations" show at MoMA were failures, not because they were political, but because of the way they embodied their political message.

Michael Baxandall, a historian I totally admire, identified what he calls "inferential art criticism." That consists, first, in seeing works of art as requiring explanations, and then inferring to the best explanation of why they have the form they do have. The explanations are historical and causal. And that is what I think I spontaneously tried to do. I looked at a show until I began to see it, problematically, as something that had to be understood. To understand is to explain, and I look always for explanations. Recently I wrote a piece on a late-sixteenth-century work by Hendrik Goltzius. It was a pen drawing on canvas, where the pen line was disguised as an engraved line. The most interesting question for me became: what explains that choice? In the end it seemed to me the association Goltzius wanted to evoke with that immense ink drawing was that it could not be corrected, could not be, that is, erased or painted over or brushed out. It had to be perceived as a work of astonishing dexterity and an almost miraculous virtuosity. The regularity of parallel engraved lines, their hatching and thickening, conduced to this effect. That opens up a lot about Goltzius, his patron, his age, and the shape of art criticism in the court of Rudolf II of Prague. But it also helps make accessible this work which is so alien to our temperament.

Let me say in conclusion that I get a lot more out of art, now that I am writing about it, than I ever did before. I think what is true of me must be true of everyone, that until one tries to write about it, the work of art remains a sort of aesthetic blur. Once, in the years when I was an artist, I evolved what I called a technique of analytical sightseeing, which meant drawing the sites I visited, seeing how they held together. Drawing a baroque church is far more elucidative than simply staring at it. The same is true about writing. I think in a way everyone might benefit from becoming a critic in his or her own right. After seeing the work, write about it. You cannot be satisfied for very long in simply putting down what you felt. You have to go further. Most people, of course, will not have the time for that. My critical writing attempts to do what they cannot or will not do for themselves.

[*14*

CRITICAL
ESSAYS

Braque, Picasso, and Early Cubism

BRAQUE'S NAME SOUNDS like a fusion of *brique* and *bloque*, so if there is the deep connection between name and nature entailed by *Nomen est Omen*, his artistic destiny lay with right-angled polyhedra. As a matter of history, he was clearly the first to paint if not cubes then cubelike forms, and was hence the first Cubist to the degree that his implicit theory of painting ideologizes angular solids as exemplified by the cube. The standing anecdote is that the term came from Matisse, who made up the third member of a jury that rejected all Braque's entries for the Salon d'Automne of 1908.

But the paintings evidently made sufficient impressions that Matisse told the critic Louis Vauxcelles that "Braque has just sent a painting made of small cubes." When, not long after, Braque exhibited at the Kahnweiler Gallery, Vauxcelles wrote that the artist "reduces all, sites, figures, and houses, to geometrical schema, to cubes." "Cubism" had become art-world jargon in Paris by the following year, though the cube itself is not especially privileged as a geometrical form in most of the early works.

Such priorities notwithstanding, the exhibition on current view at the Museum of Modern Art in New York City carries the title "Picasso and Braque: Pioneering Cubism." Since the order of names is not alphabetical, the implication is that Picasso was the chief pioneer. In truth, as the organizer of this remarkable exhibition, William Rubin, has himself written, "Braque had already evolved significantly in the direction of Cubism *before* he met Picasso." Even more strongly: "The *earliest* form of Cubism was less a 'joint creation' of Picasso and Braque than an invention of Braque alone."

I would go further. The two artists whose convergence is magnificently documented in this exhibition came from such different directions that almost all the innovative moves had to come from Braque, with Picasso making adjustments to what in his case was a *manner* rather than a style, since the premises of Cubism were alien to his original impulses as an artist. The implication of this is that, where there are resemblances between the two artists, they are more or less outward, and disguise altogether different artistic agendas. In any case, if Cubism, in name and artistic substance, emerged only in 1908, then the legendary wonderwork *Les Demoiselles d'Avignon* clearly cannot be the "first Cubist work," since it was done early in the summer of 1907. It was not even proto-Cubist. But because it was retrospectively seen as Cubist, it became a docent's commonplace to describe it in terms of geometry, a chill exercise in curves and planes and angles—"a purely formal figure composition," as Alfred Barr described it in an influential book. "Can we be looking at the same canvas?" Leo Steinberg wrote in the first essay I know of that sees the work as "a tidal wave of female aggression" and a complex image of acute eroticism in which women beckon, hoot, squat suggestively, and lift their skirts. *Demoiselle* is one of the synonyms for prostitute, and the Avignon was a Barcelona whorehouse. The crossed readings of the stunning work, which opens the show, could not more vividly illustrate the philosophical point that we typically see what we are told to see in art; unless something as powerful as Steinberg's sense for the erotic drives the mists away from the received interpretation and allows us to see that a work believed to illustrate one artistic vision in fact illustrates its opposite.

Once we acknowledge the powerful sexuality of *Les Demoiselles*, we have to acknowledge the deep primitivism of Picasso's work in the period just before and leading up to his Cubism, however much (and irrelevantly) the latter may at times look like Braque's. Braque's was *l'esprit de géométrie*, to use Pascal's famous expression. Picasso's was *l'esprit de finesse*. One was driven by a sense of order, reduction, and simplification, for which geometry is a natural metaphor. The other was guided by intuitive and visceral feelings of an almost uncontainable intensity. That their work came to look alike for a certain period must have been due to the mutual perception that each possessed, to the point of genius, what the other lacked, and that a truly whole artist—Braquasso, say—would be magnificent through possessing both Pascalian spirits at once.

If *Les Demoiselles* is not the first Cubist picture, then in truth I am not certain which picture of Picasso's *is* his first Cubist picture. Braque's seems reasonably clearly to have been his *Houses at l'Estaque*, since this is almost certainly the work that prompted Matisse's fateful characterization. But for a very long time into the Cubist era, Picasso seems to have been working out the ideas of *Les Demoiselles*. We know that this painting was inspired by certain primitive Iberian images that greatly aroused Picasso's interest, and that in the period just before the great summary painting he had been much impressed by Gauguin and was an avid reader of American comic strips (he adored *The Katzenjammer Kids*). The females in *Les Demoiselles* lie at the intersection of the primitive, the flat, and the violent. There is one further and momentous influence: Picasso visited the Ethnographic Museum of the Palais de Trocadéro and was obviously enough shaken by Negro and Oceanic art to modify two of the demoiselles' faces into fierce and masklike apparitions with, one feels, ritual strips of paint or symbolic scarifications. One gets the sense in the paintings that come afterward that Picasso is painting in an Africanistic mode—even the still lifes have heavy outlines and irregular shapes, as if given form under conditions too primitive for the potter's wheel. Finally, if we go further back in time, Picasso had passed through the Blue Period, in which his figures embodied themes of the widest human meaning conveyed by postures of sentimental desperation. Sex, sorrow, and sentimentality, combined with an acute romantic obsession with primitive forms and feelings, were what drove him as artist and pictorial thinker, responding to things "felt rather than seen," as Pascal phrased the sensibility of the intuitive spirit.

Braque's origins as a Cubist could not be more remote. Where Picasso was gripped by medieval Iberian carving, by masks, and by comic strips, Braque was dazzled by Cézanne, whose paintings he seems first to have experienced in the Salon d'Automne of 1906. Cézanne, it must be appreciated, was still very obscure and underrecognized. His famous remarks about seeing nature as so many cubes, spheres, and cones was written in a late letter to Emile Bernard, who did not publish his memoirs of Cézanne until the 1920s. But Braque must have intuited the geometricity, and in *Houses at l'Estaque* and other paintings of the time he was constituting Cézanne as his predecessor, producing representations that, in Vauxcelles's words, have undergone "a terrible simplification." He appropriated Cézanne's perspective, in which, essentially, distance from the viewer was coded as

distance from the bottom edge of the canvas, so that further meant higher. He appropriated Cézanne's brushstrokes as well, but coarsened them to the point that a superficial resemblance became available between them and Picasso's stripes of "war paint," despite the absolutely different conceptual provenance. He used but muted Cézanne's colors: tans, grays, grayed yellow, grayish pink, the blue of heavy skies, a green that looks like the dye soaked out of socks. Occasionally, Cézanne is given a Fauve overlay, with bright colors and a certain curvy rhythm, which is almost a signature cadence in Braque's works of his High Cubist phase. And he seems to have done only landscapes and still lifes. No sex, no sorrow, no sentiment, no violence, no fascination with dark urgencies and savage decoration.

Braque said he and Picasso were like mountain climbers, roped together. Picasso said, *"Braque, c'était ma femme."* Where Braque pictured them as solitary climbers of glacial heights, distant from one another but connected by curved lines, Picasso saw them as two fleshes thrashing in ecstasy and then separated by an emotional rather than a geometrical space. For a time, Braque was a geometrist who believed in being intuitive and even wild, while Picasso had the penetrating vision of the primitive but believed, again for a time, in being geometrical, even accepting the idea that his work involved the fourth dimension as a kind of fancy compliment. And during this period they looked a lot alike, as if by dint of a kind of artistic transvestism. But the meaning and feeling of outwardly similar works are radically different, as the context furnished by this marvelous exhibition enables us to see—*requires* us to see.

Braque was working with planes. Picasso was playing with powers. Picasso called Braque "Wilbourg," after Wilbur Wright, primarily because he saw his compatriot as compiling planes into flying machines (literally "aeroplanes"), not because they were brothers in Cubism. Braque never called Picasso "Orville." Braque strove to *be* Cézanne, removing himself to l'Estaque, in the bay of Marseille, where Cézanne found refuge with his mistress, Hortense Fiquet, away from his father's disapproving eye. There Cézanne painted the blocky houses of Provence. Braque painted those very houses, amid plane trees and cypresses, piling them up hillsides. He even wore the sort of round hat in which Cézanne portrayed himself. It was as if he were summoning the spirit of Cézanne to possess his hand and eye. Picasso too was engaged in summoning spirits: Who, looking at the figurines and idols, the shields and fetishes, the terrifying masks and frightening weapons,

would not want the power that came with these? Who would want just to be a painter of pictures when there was another ideal of the artist as the capturer of powers? Picasso's images were not constructs out of planes. They were embodiments of great forces that may have expressed themselves in hewn limbs and carved flat features, in material shaped to act, as in ax blades or the bows of ships, where power finds the forms it needs to be effective. The paintings after *Les Demoiselles* go on being harsh containers of fierce powers, rough idols, uncouth effigies to the civilized eye. In his *Friendship* of 1908, Picasso appropriated the forms of masks and war paint, which only in the retrospective vision of Cubism as a stabilized artistic language looks or even could look geometrical.

Braque, who had met Picasso and seen *Les Demoiselles* by 1908, painted his *Large Nude* that year, using harsh black outlines and willed distortions to depict in curves and angles something that outwardly resembles Picasso's primitivist effigies, but only as a kind of artistic cross-dressing. He did not really try it again, so alien was it to his original impulses. Compare *Large Nude* with Picasso's *The Dryad* of the same year, with its dished face and carved nose, its arms like war clubs, its wedged belly like a blunt instrument. Its power comes from within itself, whereas Braque is simply painting a surface with savage cosmetics. The first really Cubist nude that I was able to identify is Picasso's drawing *Standing Nude from Back*, in which the body is faceted into triangular planes as if shaped by a diamond cutter. But Picasso too was into cross-dressing artistically by then, and painted some houses and trees that could have been done by Braque, save that the trees look like spear points instead of abstract cones. That the two artists should have exchanged clothing, as it were, in the *Large Nude* and in Picasso's Braque-like landscapes, strikes me as a kind of ritual of marriage, like the mingling of blood. There is one work that could almost be a collaboration, Picasso's *Woman with a Book* of 1909, where the subject, all lumps and columns, sits like a pile of rocks, musing about whatever she may have read in the book held loosely in one hand while she leans upon the other. In the upper left corner is a woods as Braque would have painted it. It is as if the two sets of impulses lie here side by side. But true Cubism is a hybrid, the offspring of an intercourse between planes and powers, a kind of Minotaur, half Apollonian and half Dionysian, like the theorems of Euclid beaten out on a war drum.

Because he was the artist of planes, Braque was the more inno-

vative in several ways that came to be standard in Cubism. Because he had to translate objects into their planar surfaces, he inevitably depicted the world in terms of flatnesses, and so found his natural subjects in pages, shadows, walls, and the faces of guitars. His *Musical Instruments* of 1908 is a small lexicon of Cubist images. Picasso, whose habitat was three-dimensional, saw mandolins as swollen curvatures with holes. Braque pulls everything toward the surface; Picasso presses everything back in space. By 1910, Braque had introduced writing in the form of musical staves and notes. The musical notations in *Musical Instruments* were simply gray swipes, like Picasso's striated masks. But once real notation is made, a philosophical line has been crossed: To represent notes as notes really look is really to write notes; one might as well paste in a sheet of music. One feels the collage an inevitability at this point. I find it surprising that Picasso, a student of comic strips, where image and text occupy the same panel, had to follow Braque's lead in bringing words in among his images.

Braque's basic image was the cluster of houses, ascending the slope at l'Estaque; his direction is upward. Picasso's basic image is the idol squat on the ground; his direction is down. Braque's elements, in the Aristotelian scheme, are fire and air. Picasso's are water and earth. As Braque became the artist of overlapped planes, his solution to the problem of perspective drove his forms up toward the top edge of the canvas—and since the forms come forward and drive upward, soon his work becomes one with the surfaces on which he pastes and writes things. Both artists did a *Woman with Mandolin* in 1910, and though they look immensely alike, Braque's belongs to a series of ascending compositions, whereas Picasso's is tacitly a three-dimensional arrangement of forms brought to the surface against their will. But in autumn of that year, Picasso did a portrait of the collector William Uhde that Braque could not have touched. Look especially at the winged collar, exactly what Picasso needed, a three-dimensional object created by a fold into something nearly flat. Uhde's suit is transformed into folded stuff—pockets, lapels, handkerchief. Even the face seems tailored (which may be a deep piece of characterization), all pleats and cuffs, with a mouth like a buttonhole. It was an elegant piece of origami. Just as the collage fulfilled Braque's approach to painting, the folded paper sculpture fulfilled Picasso, each using the third dimension in a radically different way.

Picasso had to paint his way out of the planes as from a maze: he was the Minotaur, Braque the artificer Daedalus. By 1913 the idol had

returned. Picasso took the planes apart and built someone as awesome as the demoiselles, or more so. *Woman in an Armchair* is a terrifying assemblage, with breasts like goat udders pegged to her front and the scalloped hem of her undergarment looking like an instrument of martyrdom. Picasso is once more back in a world of primordial religious energy, Cubism merely a costume he had put on and then taken off. Braque, wounded in the war, never really stopped being a Cubist when he returned to painting.

This is one of the great exhibitions. It must be seen at least twice. See it first naïvely and immediately, as if you did not know painting's future, and watch Cubism emerge like a destiny unfurling. The installation provides an astonishing moment when one issues out of the last gallery back into one of the first, as if having executed a loop in time. To emerge from what Cubism turned into—wild edifices of interlocked forms—and encounter its youth—the suddenly rather dowdy *Houses at l'Estaque* or *Musical Instruments* or Picasso's voodoo dolls— is to have a breathtaking revelation of how big a distance has been traveled. The second time see it from the perspective of this revealed future, having now read through the superlative catalogue, especially the documentary chronology by Judith Cousins. Note especially the ingenious pairings of parallel Braques and Picassos by whoever designed the book. And murmur thanks to William Rubin, without whom this would not have happened, leaving the history of modern art in the darkness of misperceptions.

—*The Nation*, November 6, 1989

Helen Frankenthaler

IN HER MARVELOUS MEMOIRS of life with Picasso, Françoise Gilot preserves a priceless anecdote about the treachery of inadvertently legible forms in art. It comes from the time when Braque and Picasso were co-inventing Cubism, and with it, they hoped, an entirely new canon of pictorial representation. Braque was at work on an oval still life with characteristic Cubist content—a package of tobacco, a pipe, and similar banal objects of common life. Picasso claimed he saw a squirrel in the painting. "Yes, I know, it's a paranoiac vision," he said.

"But it so happens that I *see* a squirrel. That canvas is made to be a painting, not an optical illusion. Since people need to see something in it, you want them to see a package of tobacco, a pipe, and the other things you're putting in. But for God's sake get rid of that squirrel." Braque stepped back a few feet and looked carefully and sure enough, he too saw the squirrel, because that kind of paranoiac vision is extremely communicable.

Picasso went on to laugh at the way Braque fought the squirrel for eight or ten days, but the creature kept coming back, "because once it was in our minds it was almost impossible to get it out."

Pictorial representation is possible only because of the human eye's propensity to see forms in what is in effect only a marked surface. This is continuous with our disposition to see faces in clouds or snakes in glowing embers. Leonardo, in a celebrated passage of his notebooks, advises the painter with a flagging imagination to stare at an irregularly surfaced wall, stained and pitted and spotted, which will sooner or later resolve into strange profiles and landscapes swept by armies. Richard

Wollheim, in his searching philosophical analysis of pictorial representation, *Painting as an Art*, gives central prominence to what he designates as "seeing-in," which, we all understand, the painter knows enough about to be able to control, modulating the surfaces of his or her work so that the eye will see in it only what the artist intends to be seen. But, as Picasso's malicious recollection underscores, there are limits to this control, and "seeing-in" can become, in his word, paranoiac.

Drawings and paintings are often filled with undeclared and unintended forms; in a recent troubling study, *Interpreting Cézanne*, Sidney Geist finds so many of what he calls "cryptomorphs" that it is finally difficult not to suppose some secondary communication, especially when, as he demonstrates, there are so many punning connections between morph and cryptomorph. One of my children, when small, was convinced there was a penguin in Picasso's etching *The Frugal Repast*, which in fact shows two emaciated figures from the Blue Period, a heel of bread, and half a bottle of wine—there certainly would be no pictorial room for a penguin as the third partaker of their reduced collation. Even if Braque's squirrel was cryptomorphic, he would have had to kill it once he became conscious that it was there. So would Picasso have had to kill the penguin, and Cézanne have had to rid his drawing of Pissarro of the cryptomorphically present penis Geist identifies.

Picasso's discovery of the unwelcome squirrel was not without that touch of wicked satisfaction so typical of his personality: he and Braque were collaborators, to be sure, but they were also competitors, and it must have given him a certain mean pleasure to watch Braque's struggles to eradicate the rodent and restore the vision it corrupted. But there were other and more serious artistic considerations. Cubism is an essentially representationalist art. Abstraction, to be sure, had not yet been explicitly invented, but its possibility was in the air (though neither artist was ever tempted by it when it became an available option). But Cubism requires a certain stability in its objects, simply because so much is happening within the pictorial space, with subjects fragmented into facets and planes, that the eye, always in danger of getting lost, requires a set of stable visual cues to know what the work is about, and hence to be able to appreciate just what modification the Cubist has induced. So the objects need to be recognizable and prototypical.

I suppose an earlier Dutch painter would have been able to in-

sinuate a squirrel among the tankards, pipes, loaves, and tobacco jars of his virtuoso representations, the way a cat will be found painted among the oysters. For all one knows there might be a pungent Dutch proverb linking the squirrel to the objects of such a still life. But the space within which those objects are displayed would be like the picture's surface, transparent and in effect invisible in the ordinary transactions of artistic perception—something we "see through" to put alongside Wollheim's "seeing-in," making use of another collusive capacity painters have counted on in the history of illusion. But it would immediately make a Cubist work ambiguous if the eye were to find a squirrel in its novel spaces; it would suggest that the pipe and tobacco package might themselves be paranoiac visions. Rationalizing space and form as he did, Braque had to dominate his painting absolutely. He had to battle such incursions or his work would have been destabilized, like a painting of a rabbit that keeps slipping into the undesired shape of a duck.

With the work of Helen Frankenthaler, on the other hand, the inadvertent visitation of real forms only underscores an essential abstraction. Their appearance does not jar with other appearances, or harmonize with them, and she can either keep her squirrels as visually piquant notes or decide to get rid of them because of dissonances they may set up with the system of dots and splashes to which she has attempted to give formal coherence as a matter of abstract composition. Her work, inherently improvisational, a matter of making a start somewhere and then seeing what happens through the sustained act of painting, of seeing what latent structure asserts itself through the surface dispositions, has, at its best, something of the quality of inspired jazz. The difference is that the jazz artist begins with a known structure, which Frankenthaler only discovers when the painting has achieved itself through her mediations.

In the disassembling of chords into their components and rearranging them in conformity with the defining principles of harmony, it may suddenly happen in jazz that some notes fit themselves into an utterly familiar melody—an air, something one can sing and has sung, like "Mary Had a Little Lamb" or "O Tannenbaum." The jazz player may seize upon this found melodic object for a moment, repeat it, vary it, play it with mock feeling as if it were meant—and then the foolishly familiar melody dissolves away into more abstract progressions, never to return, though it is these phrases we often wait for when we listen to records, and which give us a curious delight. Something of the same

sort can happen accidentally when one paints fast and fluidly, depositing shapes of no known or recognizable or meaningful form, nothing from the pictorial lexicon of everyday life: Suddenly, unforeseen, a blunt star or snow shovel appears, or a cursive M. Or the space between forms, like the sea between continents, takes on the shape of a human profile, a familiar peninsula like Italy or a squirrel with a bushy tail. And then, after the fact, like a jazz player, a painter can decide to mean the shape, treat it as a gift and begin to structure something around it until, once again, abstract and compositional impulses take over and it gets abandoned as such in the further progress of the work.

Something like this happened in Frankenthaler's *Swan Lake I* of 1961, for example, in which a mere white space switched itself into a swan. I do not know if Frankenthaler could have painted the bird with as much conviction as a matter of representational intention. "I started with blue, and a rather arbitrary beginning," she recalls. (I quote from the catalogue of E. A. Carmean, Jr., that accompanies the retrospective of her work appearing at the Museum of Modern Art in New York City.) "At some point I recognized the birdlike shape—I was ready for it—and I developed it from there."

It is quite hard to see how the notion of development is to be taken in this work. We can see several swans, though whether they would be there even to paranoiac vision without the one unmistakable swan is difficult to say. The painting contains an inner square, the geometry of which contrasts deliciously with the fitful irregularity with which its sides are broken and blobbed. Within the square are some white forms which the eye can see as swans if the mind wishes. Does the square then mark the boundaries of a lake? Is the lettucy green swath about a third of the way up from the bottom of the square and equidistant from its two sides meant as water weed? Is it botanical at all? And what about the black form at the left that has quit the square and has the shape a dried swan might make if hung in the window of a food shop in Chinatown? Or are the rhythms and harmonies just rhythms and harmonies, form answering to form as form, color to color as color, so that the painting's development has nothing to do with any kind of semiological concatenation of pictomorphs and is to be understood as design, and nonreferentially? Or both?

A Whitney Darrow, Jr., cartoon of some years back shows a pair of his characteristically dim and dumpy suburban women in a gallery of abstract paintings. One of them says, "Oh, look! I think I see a little bunny." She is probably exercising paranoiac vision. It is inconceivable

that an abstract painter would expend all the energy required, brush and puddle and fling that much pigment over so considerable an area, and in the end seize upon a little bunny rabbit like a lifesaver and throw that onto the turbulent surface to keep viewers from drowning in it. The spoofed painter must have fought like Braque to stifle the alien rabbit. (What a wonderful animated cartoon this would make!) But I have the sense that Frankenthaler accepted pictomorphs. I am not sure she courted them, but they were made welcome if they dropped in, unless they were too uncouth. For they gave her opportunities for unforeseen developments that may in any other sense be quite abstract, creating rather than capturing a feeling, which in the case at hand might be the feeling poetically connoted by *Swan Lake I*. Nevertheless, you are not supposed to count the swans, ask how deep the lake is or whether the black shape is a black swan or what. It may be "or what."

But the critical literature on Frankenthaler is devoted to the kind of interpretation that Susan Sontag was famously against: efforts to work from some clear pictomorph out to morphs of less and less clear identity until a coherent reading can be given of the whole, to which the original pictomorph must be the key. Consider *Eden* of 1956. It has three pale green verticals and some salmon-pink curves, a few of which collect into a pictomorph if one is desperate to find meaning, and indeed the pictomorph of an apple if the title is construed as a hermeneutical hint. Then the green verticals must be trees and, if this is Eden, one of them has to be the tree of Knowledge and another the tree of Immortality. So then the raised red hand has to be the hand of God saying STOP! And at once the painting is reduced from a fusion of pale and fluid forms (a bit on the messy side), to a biblical cartoon of Genesis, which we pore over for further clues. Where are Adam and Eve? The serpent? The angel with the sword? Since so much is accounted for, the rest must have an identity we have not yet found. I can hear one of Darrow's Thursday-afternoon aesthetes cry out that she thinks she sees a daisy.

But what are we to do with the numeral 100 twice inscribed? It is a mystery only against the background of such identifications. Frankenthaler says, a shade disingenuously, that she only meant to contrast straight and curved lines, and "a single straight vertical line followed by the two circles becomes 100." But 100 is a leximorph: only someone afflicted with aphasia (or a computer programmed in shape recognition) could see it as a straight line followed by two circles, for the same reason that anyone not so afflicted (or programmed) will see the hand-

like shape as a hand. There is a point at which seeing and reading are cognate activities, which is why there are hieroglyphic scripts. It is difficult for the artist to plead innocent and accuse of paranoia those who see 1 followed by 0 and then 0 as 100. What she can accuse the critics of is pressing past these obvious and inescapable recognitions to give a sustained reading of the painting as a text, as if abstraction in the end were only a tease and a puzzle, the solution to which is a realistic landscape or something of the sort.

The Frankenthaler retrospective opens, appropriately enough, with the famous *Mountains and Sea* of 1952, a painting too beautiful, to use an old-fashioned word, to regard merely as a historical moment in the march forward of the modernists, and too compelling, as beauty always is, to see only as a work that influenced some important artists to begin staining canvas. It is beyond question big with a future that would have been invisible when it was made, and so for us big with a past, momentous in the style wars of thirty-something years ago. But it is worth the effort to try to see it as it must have been seen before the later history happened, as a cool composition of slender loops passing in and out of diaphanous washes of color—pale greens and blues and pinks—distantly Cubist but feminized, without the harsh angles, aggressive edges, and dangerous vertices. It is like a dance of seven veils. As a matter of biography, *Mountains and Sea* was inspired by a trip to Nova Scotia, but it could as easily be seen as a still life rather than a landscape or not read referentially at all. The picture in the catalogue looks as if it could be a reproduction of an aquarelle. The great achievement, here as in the work that followed it for nearly a quarter-century, consists of Frankenthaler's adaptation of the fluidity and transparency of washes over drawn lines, and the luminosity of thin glazes without the fat opacities of oil paint, to the scale of the large canvas, then the format of the Abstract Expressionists. But it would be a wonderful painting even if it had had none of its subsequent influence, and there are passages in it I cannot see too frequently. The string of drips in the upper right corner, for example, allow an archipelago of vibrant dots to form, the brush having discharged its delicate load and then, perhaps, descended to make the streak of pale blue in which the archipelago reappears, faintly, as a dot and then another paler dot. That is as beautiful as painting gets.

As a visual narrative of Frankenthaler's artistic life unfolds through work after work of the same order of beauty as *Mountains and Sea* but more confident, less diffident, and increasingly tasteful, one realizes

that their collective aesthetic is more that of drawing than of painting in oils, even as that has been revolutionized and redefined through the Abstract Expressionist approach to paint. Part of the beauty has to do with the fact that the canvases are treated much as paper is treated in drawing, where the uniform neutral color of the paper, behind and within forms, gives a unity to the work and often a brilliance to the hues it sets off. Frankenthaler's forms, moreover, stay on the surface by visibly soaking into it: often they are shadowed by an aureole of tinted turpentine, because of different chemicals being absorbed at different rates, as in paper chromotography. And that continually reminds us that this is canvas, inhibiting any propensity on our part to treat the space illusionistically. Even when the forms remind us of Gorky or Miró or Motherwell, those artists characteristically deploy such forms in illusionistic space, however shallow. But Frankenthaler's forms remain, as if they were writing, on the surface. The edges of illusionistic space are never included in the space they define: there is no more room for the edges of the canvas in a depiction of the Resurrection or the Adoration than for a squirrel in a Cubist still life of tobacco and pipe. But the edges *can* be part of a surface, and Frankenthaler, as if to demonstrate this, occasionally claims the edges for her forms. Even when the surface is completely flooded with color, so that none of its native whiteness or buff shows through as raw canvas, one remains conscious of it through the transparent pools and washes.

All this changes, radically and for the worse, in the work of the late 1970s. Before that, the canvas itself was a medium, as paper is in drawing: Degas exploited the greens and blues of the treated papers he drew on, but their color was never part of the color of the images he evoked on their surfaces. The color of a surface used as a medium is an enormous given for an artist, something to work with that has not had to be worked for. Wittgenstein, in his eccentric "Remarks on Colour," raises the question of why there cannot be a transparent white. The white of white paper in a drawing is invisible as far as the images on it are concerned; one does not count it in as part of the image, as with the greens and blues of Degas's papers. It is like air. But after 1976 Frankenthaler begins to use white opaquely, as paint, and her surfaces, in losing transparency, visibly deaden. One sees her wrestling with Wittgenstein's problem, trying to thin her whites down, as if to get them to become transparent. But chemistry works against her: the thinned white becomes ugly and the particles of pigment do not emulsify.

But then, in the later works, everything is altered. Since the paint is used opaquely, the canvas no longer breathes through it. It is scraped rather than floated on. The forms have lost their fluid, dilating vitality. Space becomes illusionistic, and the edges are no longer available for her forms. It is as if Frankenthaler has turned her back on everything that had made her Frankenthaler, perhaps because it had begun to seem to her too easy or not serious enough. I cannot imagine these newer works being taken seriously had they been made by someone other than her. One of them is called, appropriately, *Grey Fireworks* (1982). But a gray flash is like a transparent white—no flash at all. I do not know why her painting took this turn, but it was not a happy one. Through much of her life as an artist Frankenthaler was blessed, being at one with her gifts and at one with her times. In these later works she is instead driven by will.

—*The Nation*, August 21/28, 1989

Ming and Qing
Paintings

LITERARY THEORISTS not long ago were understandably excited by the theory of intertextuality. This was the view, rudely put, that literary utterances never refer to the world—"daffodils" never to daffodils, for example—but only to other literary utterances which it may require considerable erudition and ingenuity to track down. So literature, as literature, was about literature. Yeats would certainly have had to exclude himself from those whose lines were merely "rhymed out in love's despair / To flatter beauty's ignorant ear." But it would surely have depressed him, as it must depress us, to learn that "Sailing to Byzantium" is about the footnotes in the definitive annotated version of "Sailing to Byzantium," where all the transtextual references are identified. Intertextuality itself was a corollary of a particularly heady claim by Jacques Derrida, *Il n'y a pas de hors-texte*—that outside the text there is nothing but more text. Because it is a variant of philosophical idealism, Derrida's thesis is difficult and perhaps impossible to refute, and this invulnerability, together with the exclusive franchise intertextuality gave the literati to interpret texts, must explain the theory's immense appeal to them. For if a line means what it refers to, it must be meaningless to the mere common reader who happens to be intertextually illiterate, and only the literati hold the key to understanding texts heretofore believed to tell us something deep about such things as life, death, nature, and the human heart.

As a theory of artistic content, however, intertextuality seems to me to fit Chinese painting to perfection. It takes very little study to discover that the marvelous images one admires, of mountainsides or stands of pine or figures in skiffs sliding languorously past spare vil-

lages, would have been perceived by connoisseurs as conscriptions from other works known to the artist, who painted them with the intention that they be recognized as such by those who understood painting as an art. Dong Qichang's handscroll of 1635, *Clearing After Snow on Mountain Passes*, might have been occasioned by actual experience, the artist having viewed the mountain passes at a hushed moment when the snow ceased, and sky and hills, fore- and background were a single color, looking like a drawing on whitish paper. But according to its inscription it is based on a work of the same title by the tenth-century master Guan Tong which was then in Dong's collection. (I cite this fact from the indispensable notes by Howard Rogers in the catalogue that accompanies the exhibit "Masterworks of Ming and Qing Painting from the Forbidden City" at the Metropolitan Museum of Art in New York City.) So there would be little scholarly incentive to seek, on the basis of geological evidence, the site where Dong painted those bleached and angular rocks, the black pines and frozen streams and soft meadows, which a Chinese aesthete might unroll in leisurely contemplation of imaginary snowscapes but real other paintings. Landscape itself has no great interest save as transcribed—"In terms of the refined subtleties of brush and ink," Dong wrote, "the landscape is absolutely inferior to painting"—and the interest of transcription lies in the comparisons it makes available with other transcriptions of the same motif. There really appears in traditional Chinese art very little by way of *hors-texte*. It is as though, entering the work of art, one entered an alternative world whose substance was paper, silk, and ink, created alongside the real world, an aesthetic refuge from uncertainties and terrors, and disasters personal, political, or physical. This meant that intertextuality yielded an almost metaphorical reflex into a space of peace and beauty, an escape into pictorial texts as a form of reclusion.

Consider now one of the earliest works in the show, again a handscroll, titled *Autumn Thoughts on Xiao and Xiang*, a serial collaboration between Chen Shuqi and Wang Fu, the latter completing it after Chen's death. "Xiao and Xiang" refers to the confluence of those two rivers as they flow, united, into Lake Dongting in Hunan Province. So there really is a geographical *hors-texte* here. But *Eight Views of Xiao Xiang* had become a standard format for landscape painters, as standardized in its own way as the Ten Ox-Herding pictures of Zen or the Fourteen Stations of the Cross. It is fascinating to learn that *Autumn Thoughts* is a tacit criticism of the genre, which consists of eight discrete views of the celebrated sight. The literatus who commissioned this

work wanted a painting that fused the eight views into a single continuous image, so that, in unrolling the scroll, the experience would correspond to an idealized experience of flowing toward Lake Dongting. It is very affecting that at the point Wang Fu began his part of the work, he appropriated the style of his predecessor, as if in tribute; but by the time he finished, at the scroll's left edge, he was painting in his own more famous manner. It is as if the painting were the confluence of two distinct artistic temperaments for which the confluence of the two great rivers is a metaphor. But the thought I am even more anxious to express is that the octaval views of Xiao and Xiang, even if allowed, as in the present scroll, to meld into one another so that there may in fact remain only six, imply a form that stands to the various paintings of this theme as a score stands to the class of its performances. So the Chinese painter would be judged as we judge performers of known pieces or of known roles—as an interpreter rather than composer or author, whose interpretation may be compared in terms of virtuosity and with respect to the way the spirit of the motif is transmitted. There would be room for dazzling skill and for eccentricity, but not for a certain kind of originality or innovation. Everyone who understood and collected paintings could himself paint, up to some creditable level, simply as a natural extension of calligraphy, which everyone commanded as a matter of course. The artists who were admired stood out only in degree, like great performers on the pianoforte in a society in which it was expected that everyone could play through the classical repertory with a convincing degree of proficiency. It was an art world in which differences in talent were as clear as differences in personal style (talent really *meant* personal style), and in which creativity as we understand it in the West would have been impugned as largely vulgar. My late great friend the calligrapher Chiang Yee took a kind of irrelevant pride in having introduced the panda as a new subject for Chinese art. But this may merely have been evidence of having spent too much time in the West, where novelty of that sort might count for something.

The Ming and Qing dynasties, end to end, covered something under six centuries, from 1368 until 1911, but all the truths of Chinese painting were in place before that protracted period began. Sherman Lee, a world authority on the subject, writes, "Painted images and calligraphic writing in ink on silk were already more than 1,700 years old, and the materials, formats, and techniques of painting had developed in flexibility and complexity to a point where further subtlety

was both unimaginable and superfluous." Now, in 1368, Andrea Orcagna, the leading painter of his age, died, leaving an art world still very much defined by Gothic criteria, and the immense conquest of visual appearances, in which Western painting consists, had barely begun. Giotto was recently dead; Sassetta, the master of the Sienese altarpiece, was yet unborn; perspective remained undiscovered—and might never have been discovered if the Sienese paradigm prevailed. The last Qing painting in this show was done in 1889, the year of Van Gogh's crack-up and of Gauguin's exhibition at the Café Volpini. The Qing Dynasty ended the year before abstract art was invented, when Cubism was almost an old story. Imagine, then, an exhibition which begins with Giotto and ends with Gauguin, showing all or most of the intervening masters. Only from the most Olympian of viewpoints could it be said that everything was already in place at the beginning, further development of which was "unimaginable and superfluous." Western painting was nothing *except* further development of strategies started by Giotto and resisted by Orcagna and later by Sassetta, but went from achievement to achievement until the entire program came to an end with Gauguin and Modernism: a progressive unfolding of peak after peak of stunning innovation. Between *Autumn Thoughts on Xiao and Xiang*, of circa 1412, and Ren Yi's *Su Wu Herding Sheep*, of 1889, there are differences of style, of course; but Roger Fry would not be wrong, only parochial, in speaking of "that strange atrophy of the creative spirit which has affected Chinese art during the last few centuries," or in remarking with dismay on "the excessive reverence for the tradition . . . so strong that at this day [1926] artists in Pekin execute watercolours which repeat almost unaltered the forms of certain Sung paintings."

The works in the Met's show seem—certainly to a viewer who is intertextually illiterate—oddly contemporaneous. The changes, such as they are, are not internal or progressive changes. This is not meant in any sense as a criticism of one of the great traditions of world art (one in which those who participated were exquisitely conscious of the history to which their work belonged). It is, rather, meant as a characterization of the shape of the history in which the Chinese artist located himself, one so different from the shape of our own that we are certain to be wrong, or vulgar, when we apply to it critical categories appropriate to the West. Not everyone is as obsessed as I am with the "shapes" of the history of art, but one gets the sense that the first of the artists shown here would have been immediately comfortable aes-

thetically in the company of the last, and this is something the exhi-
bition, when seen as more than a collection of individual works, makes
especially vivid.

How different the Eastern and Western historical structures are
can be gathered from the case of Wan Shang Lin, an exceedingly
minor Qing painter not in the same class, as he would no doubt have
admitted, with the masters displayed here. I acquainted myself with
his work a season or so back with a painting from the Robert Ellsworth
Collection which shows a monk wandering through a diffidently de-
picted landscape of rocks and stripped trees. It is, intertextually enough,
not really about an itinerant passing through a deserted landscape but
about a painting of that subject done by the master Ni Zan (1301–74).
Wan Shang Lin's thin appropriation was done in 1800, after thinking
for ten years about two other paintings of this subject, one of which
may have been by Ni Zan. In the whole vast period between the two
artists there was a continuous tradition of imitating Ni Zan. Wan was
very much a *petit maître*. He had few illusions about his gifts—"I feel
embarrassed by the quality of my work," he inscribed on the Ellsworth
painting—but it was no part of his embarrassment that he copied a
known work, or that he did little else as an artist beyond paint in the
style of Ni Zan. It would in fact have been possible for someone to do
this and be a very great artist. (There is a striking work from 1734 by
Fan Shishu, *Autumn Grove*, in which even a barbarian like me can
see the memory of Ni Zan.) Nothing remotely like these options would
have been available to a Western painter, who inevitably must see
himself situated in a history it is his fulfillment to drive forward and
revolutionize. Chinese art was past-oriented, like Chinese culture itself,
which grounded its values, flexibly and nonfundamentalistically, to be
sure, on the classics of the Confucian canon. But Western painting,
like Western science, saw the unremitting transcendence of the past
as the imperative to follow. One or two oddballs aside, the Chinese
painter carried so vital a sense of the past that, once more, it would
have been considered vulgar and presumptuous to attempt to more
than merely prove oneself not unworthy of the masters everyone in
that art world knew as well as they knew the *Analects* and *The Great
Learning*.

Still, it must at times have been a heavy burden. Much in the way
that a Confucian gentleman, taken up with ritual and ministerial ob-
ligations and laced into a rigid social garment of roles and duties, had
inevitably to fantasize the untrammeled natural life promised by the

poetry of Taoism—illustrated here in painting after painting of tiny figures crossing fragile bridges to solitary huts by plunging waters— the Chinese painter must have yearned to escape the tyrannies of intertextuality. Freda Murck, one of the curators of the show, drew to my attention a wonderful painting of 1671 by Yuanji, *Plucking Chrysanthemums*. Yuanji quite properly asked himself how the first painters worked, when there were no models to follow—the Confucian philosophers seem never to have asked how the Sage Kings knew how to act—and sought in this work to paint as if there were as yet no styles. "In remote antiquity," he wrote, "there was no style because the original substance had not been differentiated. . . . On what basis were styles established? They were established on the basis of the first stroke. . . . So I established the style of the first stroke . . . creating a style from what lacked style." *Plucking Chrysanthemums* is a "first stroke" painting, done as if the whole art of painting was invented with it. According to the Met's catalogue, "virtually nothing in the painting, from the brushstroke to the architecture, was based on earlier styles." Think of how much Yuanji had to have known in order *not* to use it. Moreover, nothing could be more exemplary of his own tradition than the vertical format of the hanging scroll, the motif of pine trees and crumpled mountains or the cheerful lone soul gathering flowers, which became emblems of the reclusive life. The strokes have a crazy, almost Art Deco rhythm, while the trees and foreground plants are urgent blots and blobs. Yet Yuanji's ambition, to reinvent his own tradition, has been a standing obligation in the West, and one of the issues facing artists collectively today is whether this is any longer a possibility. Can Western artists learn to live within their possibilities the way Chinese artists took it as given that they must do?

Occasionally, the two traditions have touched. Chinese gardens became something of a rage in the West in the eighteenth century, and were cherished for the wild irregularity that contrasted with the ordered geometry of garden architecture in Europe. In 1715 the Jesuit artist Giuseppe Castiglione presented himself to the Emperor of China. Among his undertakings were frescoes for missionary churches, including studies of architecture done in scientific perspective. Chinese response to these is worth citing, in view of the fashionable thesis that perspective is a symbolic form rather than an optical truth. Castiglione's work should have looked hilariously wrong if perspective is merely a cultural convention, but in fact a Chinese critic wrote, "The ancients lacked perspective method, and when it is used so skillfully as here,

one regrets that the ancients had not seen it." Nevertheless, they had not, and the Chinese, now knowing what true perspective was, still did not use it. Perhaps they would have had to change motifs completely in order to exploit it, there being, after all, no room for linear perspective in the wildly imagined landscapes they favored. And there is an instructive painting by Castiglione, done in the Chinese manner and executed under his adopted name of Lang Shining. It is of the prince and his mentor, and Lang uses Chinese perspective in his depiction of a table with a book on it, almost as if it were a convention like the shadowless light that bathes his figures. Still, the persona of Castiglione, not that of Lang Shining, is responsible for the bamboos, which have a botanical accuracy at odds with the Chinese treatment; and even without shadows his figures stand solidly on the ground as no Chinese painter could have made them do.

Western ideas became a flood in the nineteenth century, and the struggle to assimilate the new strategies of representation opened a window into the Chinese artistic soul. One of the masterpieces in the show is a huge self-portrait by Ren Xiong, very likely done in the last year of his brief life: he died at thirty-seven, in 1857. What is remarkable is the difference in style between his garments, as he paints them, and his face and bare chest, which he shows coming out of his lowered robe. He is looking out at the viewer, and there can be little doubt that he aimed, here, at precise resemblance and anatomical accuracy, both alien to the Chinese tradition. His garments, Chinese, are painted in the Chinese manner, the rest of him in the Western manner. It is as if he wanted to show something new emerging from something old, depicting himself emerging from his tradition, so that the scroll is an allegory for himself and for the Chinese artists like himself, no longer at one with their tradition.

It is something of a blessing to be intertextually a bit illiterate, going through this show, and to look at these paintings with Beauty's ignorant eye. This is a show of wonders, of amazing invention and astonishing touches. No one can forget the wind-furled garments in *Standing Alone on a Lofty Ridge*, drawn by Gao Qipei with his *fingernail*! I was struck by the strange talonlike nails on so many of the figures shown, and applauded the thought Gao must have had, in a flash of imagination, that the fingernail would make a great pen! Sheer ignorance on my part: painting with the fingers goes back to Tang times. I'll wager that everyone's favorite painting is Gai Qi's idyllic *Plucking Lotus Blossoms*, which shows what the Beatles called a "clean

old man" floating downriver in a world of lotus blossoms, with a somewhat apprehensive and considerably younger courtesan, a wine jar, and what looks like a lute. (Agreed, it is his dream of bliss, not hers.)

Finally, one must pay tribute to the diplomatic and curatorial energies that brought these works out of the Forbidden City. They have been traveling in the United States since January, and it is hardly likely that it would have happened had it not begun before the events of June in China. But even if the June massacre had never taken place, and feelings between the two nations remained cordial and travel open and easy, one would certainly have found it difficult to see many of these works in the Palace Museum itself, where they are rarely on view, and then only for restricted periods.

—*The Nation*, October 23, 1989

Mario Merz

SOME EXPRESSION less passive and more fierce than the customary "shown" or "displayed" or "exhibited" must characterize the relationship between the works of Mario Merz and the Guggenheim Museum, which the artist currently occupies in its entirety. Merz has seized the ordinarily unaccommodating galleries, *occupied* them therefore in a sense more possessive and dominating than we are used to: he occupies them as students occupy a building or an army occupies high ground, defining the shape of the battle. It is as if he had transformed the museum over into part of its own contents, in an act of stunning appropriation. One of Merz's signature forms, for instance, is that of the igloo, a hollow hemispheric form connoting shelter. On the very floor of the museum he has constructed an igloo within an igloo, while igloos of various descriptions crowd the ramps. Merz thus makes the circular domed space of the building feel like an igloo in its own right, housing the igloos within it and hence participating in the spirit of the show rather than standing aloof outside it as mere space. Or again, Merz uses as one of his signature motifs a spiral form that appears and reappears so variously throughout the show that the very curlicue space of the Guggenheim's core, though a helix and not a true spiral, seems to have become assimilated to the visual language of its conqueror.

The Guggenheim is a paradigm of the autocratic architectural will—chilly, self-celebratory, indifferent to the wants and needs of its users. "While I have no doubt that your building will be a great monument to yourself," the Countess Hilla Rebay wrote to Frank Lloyd Wright at one stage of the building, "I cannot visualize how much (or

how little) it will do for the paintings." But "for" was the wrong prep-
osition: the question ought to have been what the building would do
to the paintings. The answer is that it digests them in its intestinal
coils, reducing them to patches and swatches. So there is something
exhilarating in seeing the old Cyclops bested and nearly domesticated
by *arte povera* ("poor art"). Bravo, Mario!

Arte povera is a term introduced by Germano Celant, organizer of
this exhibition and recently designated curator of contemporary art at
the Guggenheim. Its chief referent is the material content of the art
in question, consisting of substances regarded as "worthless" for pur-
poses of art, like dirt, or nondescript waste materials too firmly mar-
ginalized by critical sensibilities to become transformed into means for
the expressive ends of high art: broken glass, old newspapers, burlap,
scraps of industrial plywood, fragments of concrete, hunks and chunks
of this and that. Coming from the underclass of the bashed and
broken—the despised and rejected discards of things once whole and
usable—the matter in question was felt to make a statement against
artworks as luxurious, collectible, commodified accoutrements of the
high life to accompany fast cars and beach houses, snappy suits from
Milanese tailors, shiny and designy chairs of chrome and polished
leather. In thus siding with the subproletarian substances cast off by
the industrial world, the makers of *arte povera* were held to have taken
a posture that resembled one taken by Minimalism here at home.
Minimalism's effort was in part to leach from works of art all internal
meaning, beauty, or significant form—often by using much the same
order of matter favored in *arte povera*—in order to emphasize the social
character of art and the participatory character of aesthetic experience.
The American minimalists thus displayed wall-like units of Masonite
or plywood, or fashioned boxes through desultory carpentry painted
over in the blandest, most neutral of colors. Needless to say, the Italians
went a good bit further, much as the Red Brigades crossed lines that
had been respected by the Weather Underground. In truth, the char-
acteristic exemplar of *arte povera* is visually exciting and bewitchingly
tasteful, as if inspired chefs were to make marvelous dishes only by
opening cans: Mario Merz's dapper igloos made of tiny pillows of putty-
colored stuff, laced with suave blue neon, have all the high style of
Italian design. There is, moreover, the inevitable paradox that items
of *arte povera* quickly have become sought after by stylish collectors
and curators à la mode, and fetch a pretty lira in the art exchanges.
So the movement began as a kind of anti-art revolution, the equivalent

of having everyone dress down in Chairman Mao caps and jackets, but ended up by making things that impress us as dazzling redemptions of what one would have supposed were aesthetically intractable substances. In this, Merz stands close to the artist one feels he was destined through his name to resemble, Kurt Schwitters, whose *Merzbilder* and *Merzbauen* collages and assemblages aestheticize materials so utterly outcast as to verge on untouchability.

Part of the *arte povera* concept is sustained throughout the Guggenheim's installation, and in particular by the igloos. There is an odd feeling that the space had been occupied by nomads who displayed the most extraordinary ingenuity in setting up their camp, compiling shelters out of materials they might have found in Dumpsters, turning to use what the rest of us would have stigmatized as trash if we so much as noticed it. And then they moved on, discarding their shelters the way snakes leave their skins behind. The Eskimo igloo is a marvelous example of how an adverse environment can be rearranged to protect human beings who would otherwise be terribly exposed to it. It vividly illustrates the dialectical cunning of which Hegel makes so much, wherein natural forces act to achieve their opposites. It is by the keystone pressing down that the arch stands up, using gravity to overcome gravity. It is by baking bricks that fire contributes to the existence of structures proofed against flame, or the sun causes trees to grow that shelter us from the sun. The bitter cold preserves the ice that protects the Eskimo from the bitter cold. The connotations of the igloo are benign; the igloo symbolizes wresting out of nature the warmth and shelter that human beings require, in our fragility, to endure in nature. Merz uses shards of broken glass for some of his igloos, and the transformation effected by clamping them to bent tubing is at once political and aesthetic. It is political because what had been rendered useless for building becomes the very stuff of building. It is aesthetic because the eyesore of shattered glass becomes a glistening dome. His igloos are tributes to human resourcefulness because of their unlikeliness. They resemble in this the improbable and ephemeral shelters one sees cobbled out of cardboard and plastic—and anything else at hand—by the homeless at the edges of streets in our cities. They imply, as do the igloos of the Eskimos, a way of coping at the edge of extremity. And in some uncanny way, Merz's igloos project a message of survival and hope.

It is this aura of optimism, as much as the triumph over the tyranny of the Guggenheim's space, that accounts for the rush of good feeling

the Merz show arouses. The igloos have skins of slabs of slate, of daubed canvas, of bean bags, and of wattles, bundled twigs, lumps of clay, even, in one case, of flat loaves of Armenian bread. The imagined shelter makers live with a philosophy that the world consists of useful bits. Everything can be appropriated to human need: leaves, sticks, stones, and shells form an exploitable complex of things ready to hand. It is a world in which we can get by, however reduced the materials. Merz's message is, without preachiness, one of solace and uplift.

There is more. The world is not merely composed of things that may be shaped and assembled into structures: it brings forth things that nourish. Interspersed among the igloos are what feel like offerings placed on altars—fruits and vegetables, piled and placed in artful arrays on spiral tables. The table itself is a potent symbol of sitting down together and participating in the inevitable ritualization of the meal, but a spiral table carries a further metaphorical meaning in that the shape is associated with growth in Merz's symbolic vocabulary, and hence such a table expresses that what is placed upon it is the product of growth. In the large alcove on the lowest coil of the Guggenheim ramp—the one that can be viewed from the coil above—Merz has placed a particularly large spiral table with green apples arranged in an arithmetic progression that is repeated throughout his work—namely, that of the Fibonacci series: one apple, then one apple again, then two apples, then three, then five, then eight apples. (In the Fibonacci series, each number is the sum of its two predecessors.) Fibonacci numbers are everywhere in the atmosphere Merz has created, painted and drawn or formed out of shaped neon tubing. Wherever they appear in the art world at large, they advertise the message: Mario Merz was here. And they are the hit of the show: I saw two guards explaining to visitors how the series runs. And the visitors walked away smiling, having mastered one arcane symbol of modern art.

The Fibonacci series was discovered in the thirteenth century by the mathematician monk Leonardo of Pisa, who published it in a book important for a number of things, including the popularization of the now-familiar Hindu-Arabic numerals. It offers an algorithm for solving perplexing problems such as how many pairs of rabbits, stemming from an original pair, will exist at the end of a year if each pair produces a pair a month and every pair becomes productive after the second month (and there are no deaths). The Fibonacci numbers are related to the logarithmic spiral that my friend the mathematician Ralph Raimi says, with tongue spiraling into cheek, is "the one used by God in building

the spiral nautilus and sunflower seeds." The logarithmic spiral is found exemplified from the snail shell to the tails of lizards and the trunks of elephants; you can get a good sense of its proportional increments if you think of it as a coiled cone. So the standing cone can be thought of as a kind of linear or unwound logarithmic spiral, and it is thus not surprising that the cone, like the snail's spiral or the lizard (bearing Fibonacci numbers on its back), figures largely in Merz's iconography. It connotes growth, for him, and he uses it as a symbol of hope. Raimi told me an interesting fact about the series, which I am sure Merz would have used had he known it. The ratios between the numbers and their predecessors in the series converge to the ratio "one plus the square root of five, divided by two," which is the famous Golden Section of antiquity, admired as expressing the ideal aesthetic proportion for the rectangle. The internal connection between the mathematical, the organic, and the aesthetic is irresistible to a certain kind of mind.

That kind of mind is especially addressed in a once-popular book, singularly influential upon aesthetic and spiritualist readers, but less so evidently upon scientific ones—namely, D'Arcy Thompson's *On Growth and Form*, which discusses the spiral in some depth. It has been suggested to me that Frank Lloyd Wright was inspired by the book, but since Thompson is careful to distinguish the helix from the spiral, and since it is the former that Wright uses, I am not convinced by the hypothesis. What is true is that Wright was obsessed by spiral-like structures: he designed an observatory in which a spiral makes some marginal metaphorical sense; a shoe store and an automobile showroom, where it may have made some functional sense; and then the museum, where it makes sense neither functionally nor metaphorically (though it might have made both had it housed Japanese scrolls, where the coiling ramp might suggest the act of unrolling). The outside of the Guggenheim, which resembles a sort of upside-down spiral, like a squat cyclone, makes no architectural sense at all. In any case, there are enough felt congruities between helixes and spirals for Merz's tables and the museum that houses them to yield the rather rare sense of harmony possible with Wright's stubborn space. And one feels, in effect, some sort of harmony, cosmic and moral, in a show that fuses so much together into a symbolic whole: humans as dwellers and growers, igloos and tables as primordial forms of art, vegetables and fruits and even animals whose shapes or markings conform to the Fibonacci series, and then the Fibonacci numbers themselves. Then

finally there are various slogans, political and sentimental, that Merz encountered, for example, as graffiti on walls in Paris in the *événements* of 1968, executed here in a stylish neon script, attached to or even penetrating surfaces, with a feeling somewhat like the texts in the panels of comic strips. It is a show almost transradiated by sentiment and warmth, as if kitsch and the avant-garde were not quite so polar and opposed as Clement Greenberg made them out to be in his land-mark essay "Avant-Garde and Kitsch."

Merz has difficulty integrating an impertinent motorcycle, to which the artist has attached horns as incongruously as he has attached the motorcycle itself to one of the upper coils of the gallery, where it sticks out like a mechanistic gargoyle above the distant floor. In a superb review of this show the critic Roberta Smith suggested that by placing it where he has, Merz has in effect converted the ribbon of concrete that is the guardrail of the gallery into a sort of loop-the-loop. I think this too ingenious. You cannot at once have a tabernacle and a joyride, and the harvest feeling of the show, the sense of plenitude and grat-itude, the harmonies of humans, numbers, animals, and shapes is at odds with a machine a shade too expensive in any case quite to fit *arte povera* criteria. Perhaps it was put there to inhibit the sentimentality the artist sensed as an aesthetic danger. No matter what, it is a bad idea where the Fibonacci numbers are a good idea. They are a good idea even when their symbolism is darkened somewhat by D'Arcy Thompson's observation that "it is in the hard parts of organisms, and not the soft, fleshy, actively growing parts, that this spiral is commonly and characteristically found: not in the fresh mobile tissue, whose form is constrained merely by the active forces of the moment; but in things like shell and tusk, and horn and claw, visibly composed of parts suc-cessively and permanently laid down. . . . The logarithmic spiral is characteristic, not of the living tissues, but the dead." (I don't quite see how to square this with trunks and tails.)

Still, it is the feeling that counts. The show could not be more seasonally appropriate, and for those who care to co-meditate the thoughts conveyed by Succoth or Thanksgiving in a secular enclave, quite apart from the usual style wars of the moment, this is a wonderful show to experience.

—*The Nation*, November 20, 1989

Velázquez

ANECDOTES HAVE their own truth, deeper, often, than the bare historical truth that would be theirs if the events they pretend to record in fact took place. It is a matter of historical truth that Velázquez painted the great portrait of his slave and assistant, Juan de Pareja, during his second sojourn in Italy. Pareja was a Moor of an "odd color" according to an early biography of Velázquez, who was his master in two senses of the term. The anecdote is this: Before exhibiting the painting, Velázquez had Pareja himself carry it around to some influential Roman acquaintances. "They stood staring at the painted canvas, and then at the original, with admiration and amazement, not knowing which they should address and which would answer them." Perhaps it was because Pareja was a slave that Velázquez selected him as a subject, for it provided the singularly theatrical opportunity of having Pareja show up at someone's palazzo bearing his own likeness. The anecdotal truth is this: Velázquez meant to *dazzle*—not just show what he was capable of, but do so in a way calculated to amaze. He was a master of conceptual drama.

The Roman acquaintances murmured, of course, the obligatory compliment that one would have believed the painted head could talk—something people said about painters at the very dawn of illusionism. For Velázquez it was not the right compliment. He was not bent on illusion and in fact had some sense of his limitations in bringing illusions off. What he meant to show was what he could do with paint; it was essential to the shock that it be perceived as paint and not misperceived as flesh. Consider the wide lace collar Pareja is shown wearing, a form of luxurious ornamentation then forbidden by the sumptuary laws of Spain. The critical question is: Why did Velázquez

paint his slave in this expensive accessory? The answer once more is: to dazzle. Viewers were meant to be astounded that anyone could generate out of visible flecks and dabs of white paint a lavish confection of lace. At no point was illusion a possibility. Nobody, looking at Pareja's mop of hair, would think it real hair. Everyone would see it as smudges of paint of indeterminate color that, without giving up their identity as paint, miraculously became the wiry coiffure of an exotic man. Or again, out of strokes that defy analysis, the artist achieved a velvet sleeve.

Velázquez was, after all, seeking commissions. Specialists say that it was immediately after the Pareja episode that he did the magnificent portrait of Innocent X, one of Velázquez's many masterpieces, which the Metropolitan Museum of Art (owner of the portrait of Juan de Pareja since 1971) was unable to secure for its nonetheless spectacular exhibition of this transcendent genius. In the papal portrait, once again, without paint ever concealing itself as paint, are the white touches that shimmer as lace, as the shirred white garment the Pope wears under the cape of heavy crimson silk the painter has summoned out of sweeps and swags of pigment. And beyond even that is the fierce and crafty face of the throned Pontiff, Innocent by name but hardly by nature, peering out from the corners of his eyes at a difficult and treacherous world he is shifty enough to master.

The anecdote, if my reading of it holds, yields an explanatory hypothesis for a good many Velázquez paintings. Think, for particular example, of the astonishing *Old Woman Cooking Eggs*, done in 1618, when Velázquez was nineteen. It is one of the so-called *bodegón* works, domestic scenes in which it often seems as if the human beings are of secondary importance to the pots and pans and ladles arrayed on rough tables or suspended from kitchen walls. There are two *bodegones* in the show, the other being the even more compelling *Waterseller of Seville*. Each of them is an exercise in virtuosity in which the artist has chosen objects in order to display his ability to overcome the difficulties of painting them. One question scholars raise is for whom the paintings were done, but my sense is that they were advertisements by an artist possessed of tremendous gifts and in search of commissions. So they were executed in the same spirit as the portrait of Juan de Pareja or the measurably less successful baroque paintings I shall discuss below, evidently done on speculation, since they were sold to the King of Spain: to display Velázquez's mastery of the Italian technologies of illusion.

Old Woman Cooking Eggs shows a variety of substances, selected

in part to demonstrate the artist's ability to paint them convincingly: copper, brass, pottery both glazed and unglazed, straw, pewter, linen, the skin of onion and melon, the human eye, wood, eggshell, string, and glass. The ceramic casserole is tipped up so we can admire the artistry of painted egg whites in varying stages of opacity. There are fewer substances in *Waterseller*, but in compensation there is the stunning virtuosity exhibited in the discoloration of the immense jug, due to misfiring in the kiln, and the way the clay looks when water trickles down its sides.

Both paintings are redeemed from mere boasting in the medium of paint by an extraordinary sense of mystery, as if the works had deep intelligence to communicate in the notation of humble utensils. Thus the objects in *Old Woman Cooking Eggs* have an almost otherworldly luminescence—the light source comes from in front of the picture plane, highlighting the objects without illuminating the room, which is in the darkest of shadows behind the two figures. Each of these, the old woman and the boy, seems caught up in some meditation, and almost arrested in mid-action. The boy holds a heavy, trussed melon with one hand and a glass cruet, perhaps of oil or of wine (each of them a ritual fluid), with the other. The woman and the boy are connected by their obliviousness of one another. The woman holds a spoon poised over the pan in one hand and an uncracked egg in the other, as the whites thicken beneath. It is as if the kitchen were a scene of otherworldly intervention or mystic visitation. In *Waterseller* the old man and the boy have hold of the base and stem of the water glass, respectively, but otherwise have no contact. Why is the glass in fact an ornamental goblet of intricate workmanship? And why does it contain a fig? The fig-bearing goblet is overdetermined; it enables Velázquez to dazzle and puzzle us at once. I am not sure this or any of his puzzles are meant to be solved so much as merely felt. The paintings seem to me to have as part of their content the mysteries they transmit. And I think as well that the intermixture of mystery and mastery, each uncanny in its own but connected way, defines Velázquez's project throughout his career, down to *Las Meninas*, which to this day defeats learned interpreters. Cunning man: it is as if he assured his immortality by frustrating an understanding that seemed at once urgent and inaccessible.

Let us now examine the baroque tableaux Velázquez executed on his first and, one might say, apprentice expedition to Italy, where he went to learn from masters who had nothing to teach him the next

time he visited. These are striking partly because of their discontinuity with his overall style, due to their artificial theatricality and their organization of space. Velázquez has deployed gesticulating figures in a stagelike setting in relatively clear interior illumination, hence without the odd shadows that contribute to the portentousness of the *bodegones*. These are *Joseph's Bloody Coat Brought to Jacob*, in which the wicked brothers, appropriately scolded by a wise spaniel, pretend grief before their shattered father; and *The Forge of Vulcan*, in which a radiant Apollo informs Vulcan that his wife, Venus, is making out with Mars. In these efforts Velázquez is trying to be an Italian master, and it is instructive to see how clumsily he handles perspective, especially in the Joseph painting, where he utilized the kind of checkerboard tiles standardly employed to facilitate an illusion of orderly spatial recession. The stunned Jacob is shown rising from his seat on a carpeted dais, but Velázquez somehow cannot get the carpet to lie flat on the floor, or the walking stick to lean convincingly against the platform. Each painting is filled with stunning detail, such as the brilliant pitcher on the mantelpiece in Vulcan's workshop, which even so does not get transfigured in the way the objects in the *bodegones* do, emerging from the dark like angelic presences. I am insufficiently a scholar to say with certainty that Velázquez never attempted Italianate spaces again, but my sense is that he recognized that certain effects made possible by perspective lay outside his repertory of bewitchments. This is worth mentioning on two counts. First, reconstructions of alleged perspective in *Las Meninas* have, since Foucault, played a considerable role in the various "solutions" to the painting, when it is doubtful Velázquez could use perspective with the required precision. But second, we can appreciate how he deepened his work by finding a way around this curious ineptitude.

Compare the two remarkably similar portraits of his patron, Philip IV, owned by the Metropolitan and the Prado. They must have been done, judging from the King's features, at very nearly the same time. I conjecture that the Metropolitan portrait is earlier because Velázquez had not yet discovered the solution that was to enhance the mysteriousness I consider an intended effect of his work. Each portrait shows the King standing next to a chest, on which he has placed his authoritative and emblematic hat. In the Metropolitan version there is a horizontal line to mark where floor meets wall, implying the space of a room. This line has in effect been erased in the Prado version, where the tonalities of wall and floor are indistinguishable, so that the King

is now placed in an undifferentiated space, spiritual rather than geo-metrical, almost fluid, with shadows floating like the ink emitted by cuttlefish. Velázquez, as far as I know, invented this kind of space, and used it to great effect in his standing portraits, most stunningly in his study of the jester Pablo of Valladolid (not in this show). The jester is poised in undifferentiated space, alone with his shadow, which gives the space an intensity ordinarily dissipated in the royal portraits, where the subject co-occupies the space with some appropriate symbol of power—at the very least a table on which to place a hat or a chair on which to rest a possessing hand. A jester has no such authority, which is what gives him his power: Pablo almost wears his empty space like a visible soul and becomes in consequence monumental. Manet thought *Pablo de Valladolid* perhaps "the most astonishing piece of painting ever done." The undifferentiated space in which shadows float became natural for Manet and Degas to use—though for neither of them was mathematical perspective either a problem or a solution—and it found its way into portrait photography as a common device for lending presence to the face and features of the subject.

There is another anecdote concerning Juan de Pareja. Because Pareja was a slave, Velázquez—"for the honor of art"—refused to allow him to have anything to do with drawing or painting as such, restricting him to the grinding of pigment or the priming of canvas, as if a drawing by a slave would be a perversion of art. (I recall an episode in *Elvira Madigan* in which the starving performer seeks to sell a portrait of herself by Toulouse-Lautrec, only to be told that drawings by dwarves are worth very little.) In any case, Juan de Pareja learned to draw and paint, and the anecdote has him placing one of his own paintings where the King ordinarily would have expected to see the new work of Ve-lázquez. If the King were to admire the work, believing it to be by Velázquez, he would, in consistency, be acknowledging parity between slave and master. The mathematician Alan Turing proposed exactly such a test in connection with machines: if the only plausible expla-nation of a given output is that it is due to intelligence when coming from a human, then consistency would require ascribing intelligence to a machine whose output is identical. The King in effect endorsed the Turing test by saying to Juan, "Be advised that any man that has this skill cannot be a slave."

It must be appreciated that with the discovery of the New World there was a raging question in Spain whether, as a Christian nation, it could rightly enslave the Indians encountered there. One strategy

was to revive the Aristotelian argument that there exist natural slaves, and while indeed it may be unchristian to enslave a human being, natural slaves are not human, but merely tools. The issue was debated at the faculties of Salamanca and Valladolid, and against this background the King's emancipating remark takes on a certain profundity. If there are natural slaves there are natural masters. The ability to paint like Velázquez marks a metaphysical superiority. It sometimes is said that painters were mere artisans in the social hierarchies of Spain, but the anecdote suggests that this cannot have been altogether true in the royal household. There was a profound bond between monarch and painter. The immense privileges the King secured for Velázquez stand as evidence of this, given the obstacles even the King had to deal with to do so, and I think this recognition of his natural nobility had to mean a great deal to this artist. So in painting he was doing more than displaying unmatchable gifts. He was claiming high position in the stratified universe of divine rulers and natural slaves. So it perhaps really did become less important to him to make paintings when acknowledgment of his true position came through such recognitions and rewards. To us this seems the wrong order of values; but that only measures the distance between his world and ours.

There is a great difficulty in finding our way into a world in which dwarves and fools and jesters have a dignity and meaning we cannot altogether fathom, or in which a queen's handkerchief is almost as interesting as she is. And who knows how to read the marvelous dogs? There is a portrait, not shown in this exhibition, of Prince Felipe Próspero, the hope of his country, who died before reaching age four, despite the arsenal of amulets draped around his pinafore. Felipe's hand is resting on the back of a velvet chair as a sign of status and power. In an earlier portrait of Doña Antonia de Ipeñarrieta, that lady also has the privilege of resting her hand on a chair, showing that she has the right to be seated while others stand. (For a discussion of the meaning of chairs, see my "The Seat of the Soul," in *397 Chairs*.) On Felipe's chair lolls an adorable dog, its tail hanging insouciantly over the edge, its witty, dark eyes engaging us in some complicit way. Given the heavy meaning of the chair in the rigid semiotics of courtly etiquette in Spain, something is being conveyed beyond the fact that spoiled dogs could climb onto furniture in which courtiers would not dare sit. Some metaphysical joke? Or the suggestion that dogs hold some rank in nature higher than slaves or even certain courtiers? All I know is

that a dog in a chair is not innocent naturalism. One has the sense, in fact, that everything means something awesome, which intensifies the pleasure one takes in this tremendous painter we know we will never fully understand.

—*The Nation*, December 11, 1989

Women and Mainstream Art

IT IS A TRIBUTE to the curatorial intelligence of Randy Rosen and Catherine Brawer that their exciting exhibition, "Making Their Mark: Women Artists Move into the Mainstream, 1970–85," which has been given a suitably celebratory installation at the Pennsylvania Academy of the Fine Arts in Philadelphia, should raise as many questions about the concept of the mainstream, and especially the historical structure of the mainstream in the period under survey, as it does about the artistic relevance of the fact that the eighty-seven artists are all female. At least half those artists would turn up as a matter of course in an exhibition titled "The American Mainstream, 1970–85," where the issue of gender had no bearing on the principle of selection; there is certainly no comparable period in twentieth- (or any) century art in which as many women would be among its outstanding creative exemplars. I would go even further. Were I asked to select the most innovative artists to represent this particular period through having come of artistic age in it, most of them would probably be women: I can think of few men in those years whose achievement matches that of Cindy Sherman or Jennifer Bartlett, to name but two, and none who come close to Eva Hesse (though 1970 was the year of her sad early death). Nothing like this would be true of the 1960s, a decade of deep conceptual exploration in which women played a relatively minor role, nor would it have been true of the 1950s, despite the flourishing in that decade of Helen Frankenthaler, Lee Krasner, Grace Hartigan, and—even today a vastly underappreciated painter—Joan Mitchell. So the question is whether this particular period, and hence this particular mainstream, was made to order for women, even if the work in question

might not have any especially feminine—or feminist—content. Of course, a great deal of the work here has both, as might be expected, given the sharp political demands that women were making on institutions of high culture in which they had to that point generally played a secondary and subservient role. But one can beat the gates down and gain admittance to the precincts of privilege without assuring that significance be attached to one's work, and my question reasserts itself: was there something in the times, in the objective structure of the art world, that made this female ascendancy possible and even necessary? And this brings with it the question of what kind of mainstream it was.

The 1970s are a difficult period to bring into art-historical focus, though this could be due in part to the assumption that the decade is the basic historical unit in periodizing art, with each thought to have a style of its own. In these terms the 1970s did not materialize as the kind of decade the 1950s and 1960s were. The other part of the difficulty is that it was widely anticipated that the 1970s *would* become that sort of decade, and the fact that it did not may be the most important fact about it. The 1950s and 1960s were times of extraordinary artistic revolution, and it had begun to seem as though the great sequence of revolutions—Fauvism, Cubism, Abstractionism, Futurism, Constructivism, Dada, and Surrealism, to name the high points—was not only to define the structure of art history in the twentieth century but that it was being carried forward in America rather than in Europe. One of the marks of the American artistic revolutions was their extreme philosophical character, in that each corresponded to a different philosophical theory of what art is. Indeed, we can reconstruct this history as moving forward on two levels—the level of artworks and the level of theories of art, with the former supposed to exemplify the latter. And during this development a number of boundary lines were erased, or even exploded, which had been thought essential to the definition of art, as the almost alchemical pursuit for the pure essence of art moved forward through the 1960s. It was taken for granted that this would continue on into the next decade, when in fact what happened was that *nothing* along those lines occurred at all. In an interview he gave a few years ago, Roy Lichtenstein said in genuine puzzlement, "The seventies seem a kind of nonentity. I don't know what to think of the seventies; I don't know what happened."

There is little doubt that the commitment to artistic purism continued in the 1970s through a kind of inertial force. In an interview with Calvin Tomkins, Jennifer Bartlett said, "I imagine there were very

few people doing abstract work who were acceptable to Brice Marden, and very few people doing sculpture who were acceptable to Richard Serra." Of herself, Bartlett said, "I didn't really have a point of view like that. I liked a lot of different work." But "not having a point of view like that" came to be, by the end of the decade, the point of view to have. The New York art world, for perhaps a quarter-century, was defined by intolerance, by the zealotry with which it was insisted that outside a narrowly defined canon, nothing was really painting, or really sculpture, or really even *art* (this dogmatic spirit survives today primarily in the writing of Hilton Kramer). But by the end of the 1970s, the uneasy term "pluralism" began to be used, tentatively and gingerly, to define the direction of art, understood now as perhaps not having any longer the kind of historical direction that had to that point been believed necessary. It was not that "anything goes" but it was no longer urgent—no longer possible—to go by adhering to a prescribed line. Miriam Schapiro, whose aggressively feminist work is one of the touchstones of "Making Their Mark" and who came up as an artist through the harsh exclusionary imperatives of postwar art history, found a certain liberation from the very idea of this in feminism: "Feminism taught me not to worry about what I was 'allowed' or 'not allowed' to do as a serious artist." But much the same moral revelation was being made all across the art world, if not through feminism then through the discovery that not only had the old dogmas died but the very idea of dogma was itself dead. The German painter Hermann Albert recalls a moment in 1972 when he was gazing with friends at a dramatic sunset in Tuscany. Someone said, "It's a pity you can't paint that anymore these days." Albert writes, "That had been a key word I'd heard ever since I started trying to be a painter. And I said to him, . . . 'Why can't you? You can do everything.' . . . Why should anyone tell me I can't paint a sunset?"

There is a more external and material consideration to place alongside the end of aesthetic ideology. Nobody especially expected to make a living selling art in the 1970s. New York City real estate was not to begin its terrifying climb until late in the decade, and it was still possible to find fairly inexpensive studio space and to support oneself doing nondescript labor while making art one did not expect more than a few people would find of interest. Cindy Sherman worked as a receptionist, and her art was made for a small company of performers and conceptual artists who were her world. Others taught, or did carpentry, or were housepainters, and, like Sherman, made art for the small circle

of initiates who understood how the work was to be appreciated. The kind of international market that was to become a reality in the 1980s did not exist in the 1970s, nor did the phenomenon of the "hot artist" or the star system. The interesting question is: why didn't everybody just paint sunsets, which is, after all, a pretty satisfying thing to do? The answer is that most of the young artists who came up in the 1970s were graduates of a very few advanced art schools. The number of artists coming out of Yale alone is simply astonishing: Serra, Nancy Graves, Bartlett, Chuck Close, Eva Hesse, Robert Mangold, Sylvia Plimack Mangold, Brice Marden, Janet Fish, Lois Lane, Judy Pfaff, and Howardena Pindell are only some of them. These artists inherited from the 1960s the ambition and the imperative to drive the boundaries of art back, to find the *next thing*. And perhaps there was as well an intense competitive drive, like scientists seeking to drive back the boundaries of knowledge, whatever the material rewards for doing so. All this notwithstanding, no single global breakthrough was achieved. Rather, there were a number of individual breakthroughs. There was, in effect, no mainstream as such at all, simply confluences of individual tributaries with no mainstream to flow into. In retrospect, it seems to me that the 1970s were a Golden Age in which artists could pursue individual visions in a permissive cultural atmosphere under livable economic conditions.

All these factors were objective and structural features of the art world, subject to its own laws, and this would have been true had no women been on the scene, or if there had been women but in the traditional proportions of, say, one woman artist per every forty men. Pluralism permitted diversity (while making it possible for artists to infuse their work with political content if they so chose), and economics supported experiment. In these respects, there is a continuity between the profile of work in "Making Their Mark" and what any adequate survey of the art of the 1970s would show. There is, on the other hand, a greater degree of diversity among women artists and at the same time an almost invariably insistent feminist edge to women's art. My sense is that these two facts are sufficiently connected so that a speculation is in order as to what this connection is, which requires a few remarks on feminism as such.

There are two forms that feminism took in the art world of that (and indeed of the present) time. One was a demand for justice and equality, the kind of demand that could in effect be met through affirmative action: including more women in galleries, in important ex-

hibitions, in the distribution of grants, in the hiring of faculties and curatorial staff, and in promotions within these. These matters are quantitative and can be monitored and measured. The other form is conceptual and, in a loose sense, deconstructionist. Feminists undertook to examine every component in the institutionalized conceptual scheme of art, asking of each if it might not be an insidious form of male oppression. Think of each of these forms in connection with art history. The demand for justice and equality entailed the search for neglected women artists of the past, resurrecting vanished and almost invisible reputations, giving these neglected female creators prominence in exhibitions. The deconstructionist demand entailed rethinking the very premises of art history as understood in terms of geniuses, masterpieces, the imposition of styles, the domination of space, and the definition of genres, with the entire concept of the fine arts construed as exclusionary and invidious and the structure of the art museum as embodying a scheme highly detrimental to women. Occasionally, the two forms collide. There are those who, as feminists, applaud the number of women entering the mainstream. And there are those who, as deconstructionists, deplore the very concept of mainstream as a form of male domination, alien to an entirely different female nature which has not found its institutional form as yet. From the deconstructionist viewpoint, nothing in art is sexually innocent or, in consequence, politically innocent.

Not even, for example, the easel picture—"the traditional male-heroic genre of the easel painting," to use Thomas McEvilley's phrase—escaped critique. For it conjures up an image of a male presence dominating the canvas as his penile brush violates its white passiveness. And certain ways of modifying matter that would not commonly occur to males, like sewing or stitching, might suggest themselves as alternatives. Women became resourceful seekers of traditional forms of female expressiveness, using their bodies or making patterns or cultivating ornamentation, or raising to a higher power practices like cosmetic modification or dressing dolls or fabricating quilts or making dresses or plaiting hair or tying ribbons. Anything *but* the traditional and hence the male-dominating forms. There are, of course, some easel paintings in "Making Their Mark," but they are in a surprising minority. So there is a feminist answer to why one, if a woman, cannot paint a sunset, which is that women must find their own way in art. And "Making Their Mark" is an encyclopedia of some of the ways found: reassembling furniture, building little houses, forming

horses out of mud and sticks, even, in one case, making a gown. And then there are the performances: women in the 1970s made performance art their own and used it to challenge and attack features of a world they found oppressive. The feminist content generates the wild profusion of untraditional or even countertraditional forms that is the first thing to strike the eye in this exhibition. So one has to qualify the claim that the period seemed made to order for women artists. Had there been only that form of feminism that insists on equality, it might have remained a man's art world despite women entering it in larger and larger numbers. What made it the art world it was, I think, was feminism as transformed by poststructuralist philosophy, with its possibilities of ultraradical critique. And from this perspective women did not so much enter the mainstream as redefine it, and the *men* who entered it were more deeply feminist than they could have known.

It is possible for work, then, to be feminist without having an obviously feminist content, though much of the work in this show is clearly and even militantly both. Miriam Schapiro is the paradigm figure. Her *Wonderland* of 1983 makes art out of traditionally feminine items—frilled aprons, doilies, a sampler, the kinds of things that might wind up for sale at church socials, products of the needle and the embroidery hoop—arrayed on a quilt. Presenting itself as high art, it calls into question the distinction between high art and the art women unassumingly contrive without thinking of themselves as artists. In just this spirit, Schapiro exhibits a dollhouse she and Sherry Brody made "to challenge," according to the always helpful catalogue notation by Judith Stein, "the limits of what 'art' could be." Her immense *Barcelona Fan* of 1979 monumentalizes a feminine accessory, and does so by combining pieces of fabric in what she terms a "femmage." Nancy Spero's *Artaud Codex* scatters script and sparse images angrily across a scroll that slows down the viewer who intends to read the language Spero has appropriated, much as Sherrie Levine appropriated the Walker Evans photograph of a woman sharecropper, which Levine rephotographed to uncanny effect and conceptual perplexity. Sylvia Sleigh uses the easel format but as a way of subverting its masculine intentions by depicting, in one painting, a group of women artists grouped the way men artists were shown to be in some well-known nineteenth-century works, and, in another, a harem of naked art critics, all men, their penises displayed, one of whom, with his arm coquettishly crooked over his head like an odalisque, is her husband (and my predecessor as art critic for *The Nation*), Lawrence Alloway. Hannah

Wilke had herself photographed nude, her skin covered with tiny vulvas (made, one reads, of chewing gum), looking (and intending to look) like the victim of some terrifying skin disease or the gashed and wounded Jesus of Grünewald's savage altarpiece.

This is not, for the most part, work that is easy or even important to appreciate aesthetically. Or rather, the demand that art be judged strictly by aesthetic criteria is itself not a politically innocent demand. In its own way, especially today, it is as political as the explicitly political art it condemns in the name of aesthetic purity. And often the willed impurity of feminist art is a rebuke to aestheticism as being, in the end, a form of repression. On the other hand, this is art that will mean different things to those of us on different sides of the gender line, and this difference is internal to the meaning and force of such works. It is work that would have failed had I, as a male, not felt myself under assault.

Some of the work, and indeed some of the best work, might not have existed had the artist not been a woman—simply because it's unlikely that anyone but a woman would have had the idea of making it in the first place. Somehow the possibilities available to women to alter their appearance through makeup, costume, and wigs enter into Cindy Sherman's project. What is remarkable is that she has achieved something that transcends the differences between the sexes and touches us all in our inmost humanity. I cannot imagine anyone but a woman achieving what Eva Hesse has, just because the fun and fondness toward her often hopeless works seems archetypically feminine and forgiving. But she invented a new language of sculpture, and her followers come from either side of the sexual divide. My favorite work in the show was by a California painter I had never heard of, Joan Brown, and it is called *New Year's Eve #2* (1973). It shows a skeleton in tux and top hat, cakewalking—or is it a tango?—across a large canvas with a spirited woman in a red gown, the skyline of San Francisco in the background and the two of them kicking up their heels in celebration. It may be a painting of reconciliation, it may have no symbolism beyond what meets the eye, but either way it is a wonderful painting and I wish I could see it often.

—*The Nation*, December 25, 1989

Jenny Holzer

JENNY HOLZER is to be the official U.S. representative in the 1990 Venice Biennale, and it is difficult to think of a more appropriate artistic emissary, for hers is in every sense state-of-the-art art and a symbolic condensation of our national culture—up-to-the-minute in technology, populist in format, moralistic in tone. The technology is electronic; the format that of the Broadway moving band of flashing lights in LED notation; the tone is admonitory, disapproving, chastising, practical, complacent, and ominous, as if Cotton Mather had expressed the sentiments of the Puritan ethic in adman phrases and in the razzle and blaze of Las Vegas's electric signboards. Holzer is currently to be seen in two stupendous installations in New York City, at the Solomon R. Guggenheim Museum and the Dia Art Foundation. Should anyone have doubts that art in its postmodernist phase is capable of holding a mirror up with the reflective accuracy demanded by Hamlet as a ruse for entrapping conscience, a visit to both these exhibitions should dissolve them. At both sites the viewer is enveloped in an atmosphere Barnumesque in visual extravagance, revivalist in moral urgency, Wagnerian in aesthetic ambition, and transformative in spiritual intent.

Holzer has traversed an immense distance in the dozen years since she first stuck leaflets, bearing what she termed "Truisms," on bus stops and telephone booths, compilations of dour platitudes ("A man can't know what it's like to be a mother"; "Ambivalence can ruin your life") and sour adages ("An elite is inevitable"; "Abuse of power comes as no surprise"). They looked like the dubious accumulated wisdom of a self-taught evangelist who had appropriated the no-budget advertising strategy of the Off-Off-Off-Broadway production, the block

party, the clothing drive, the moving sale, and the offers to rent you a van, groom your dog, build your bookcases, paint, plaster, or clean your house, acupuncture your body, and read your future, which compose the ephemeral paper excrescence of urban surfaces. The casual pedestrian, just checking it all out, would find himself or herself set straight, told what's what, when all that was expected was a useful telephone number. Her work had the astringent shock of an unmodulated voice interrupting the commercials with irrelevant one-line sermons: "Any surplus is immoral"; "Being sure of yourself means you're a fool."

At the same time, there is a startling continuity between the Holzers of 1977 and 1989, at least at the Guggenheim, where the Truisms are in lights, so the content is the same even if the embodiment is more spectacular, with spectators sitting on polished benches, taking notes, as the same redundant apothegms and injunctions coil luminiferously overhead. The Dia installation—"Laments"—is somewhat different, having the quality of a mute masque in which the characters are represented by what they would have spoken if they were present, and so by written speech each laments her or his condition when alive (they are all, in effect, communicating from beyond the tomb). I find both exhibitions extraordinary and extraordinarily powerful, and though I am uncertain whether the bitter voices at the Dia or the platitudes at the Guggenheim have made me a better person, they have transformed me into a qualified enthusiast for this odd artist.

Since the most salient feature of Holzer's work to date is the fact that it is composed of words—printed, carved, or electronic (both moving and still), critics who have sought to place her in some tradition in the visual arts trace her antecedents to the Cubists, as if they had been the first to incorporate letters into pictorial space or to breach the boundary between images and words. This gives insufficient credit to Holzer's originality and too much credit to the Cubists. Words and images have occupied the same spaces at least since Grecian urns, and in fact there are two powerful traditions I know of in which words and images combine to deliver information to the viewer. The most obvious is that in which the object depicted has words as part of its surface, as with pages or banners or tablets or documents, when these occur as part of the reality depicted. Thus Botticelli shows the Virgin with a book, from which she is teaching the Christ child to read, or, in another painting, in which she herself writes with an ornamental hand. Or he shows St. Augustine's cell with numbers on the clockface

and the open text of Euclid's *Elements* on a shelf above his head. We can read the time, identify the theorems, admire the Virgin's elegant cursive, read the very text the child reads ("The Song of the Virgin"). The Cubists belong to this tradition, and the fact that they often paste word-bearing fragments into their pictures, rather than draw or paint them, counts for very little: The newspaper with *Le Jour* belongs in the same space with the pipe, the pitcher, the mandolin, or whatever.

The other, and in some ways older, tradition has words occurring in the pictorial space without belonging to the reality shown there. In his great political allegory in the Sala dei Nove in Siena, Ambrogio Lorenzetti writes the word PAX above the head of the female figure who personifies Peace, JUSTITIA above that of the woman holding a sword and meant to emblemize Justice, and so on. These words do not belong in the space the women occupy in the way that the bench on which they sit does, but then Lorenzetti was not doing a painting of women on benches, but of Peace and Justice ensconced, and the work is to be read as if it were a text. He was not bent upon illusion, as in a sense Botticelli was; hence the edges of the allegory are not the frame of a window through which we look onto the domestic scene of the Virgin instructing her doomed son. They are the edges of a pictorial text the words help us read. Obviously, words could occur in both ways in a pictorial text—e.g., if JUSTITIA were holding a book on which the word LEGES appeared because it was a law book. Still, the difference has to be drawn between a pictorial text like Lorenzetti's and pictures that include texts as content, like Botticelli's (or those of the Cubists). Pictorial texts were standard in Siena largely, I would argue, because the matrix of Sienese art was the book, and it is standard for words and images to appear together on the same page. The matrix of Florentine art was the window, and hence illusion goes with the one style but hardly with the other. The Sienese impulse survives in such places as the political cartoon, where the nondescript individual with glasses has the tag TAXPAYER attached to his jacket; but depicted texts tended to disappear from Western art, especially as high painterly style made it awkward to depict *lisible* texts, and it may accordingly have seemed as if the Cubists had broken, if not a boundary, then at least a taboo in bringing words back as legitimate subjects of depiction.

Holzer, in any case, belongs to neither tradition, in part because her medium is language rather than words, and also because any critical assessment of her work must inevitably bring in considerations that belong to rhetoric or to poetry, and issues of truth and falsity arise in ways that have no application in the traditions I have sketched. If

she is to be situated in a tradition, I suppose, one has to bracket her with Blake, whose "Songs of Innocence," for example, were etched onto plates and so had to be appreciated as graphic art and as textual art at once. Holzer's language must be considered in terms of tone, voice, and speech acts, and of the associations awakened by the sorts of surfaces on which the language is arrayed. To some degree, this double aspect belongs to poetry of the written tradition, in which the way the poem is shaped on the page has to be computed as part of its effect. On the other hand, the page is not the natural locus for Holzer's language. Her words appear on T-shirts, on caps, in the polished surfaces of sarcophagi and memorial benches, on throwaway sheets, bronze tablets, in electronic displays, and the like, each of which has a distinct set of associations in our culture, all of which have to be taken into account. It is her choice of surfaces, taken in the knowledge of what such surfaces mean, that makes Holzer a visual artist, even if there are no images to speak of in work that in its other dimensions would be purely verbal. And since each work exploits the tensions and sympathies between word and nonverbal medium, the excitement goes well beyond what the words alone can explain.

"Laments" occupies an entire floor at the Dia Foundation and is divided into two spaces. The smaller one contains thirteen polished stone sarcophagi in green marble, red marble, black granite (there are nine of these), and onyx. These are laid out side by side, and each bears an inscription of the lament of the putative occupant rather than an epitaph. So the occupants are anonymous, though there are two children, ten adults, and one infant, and the sad facts of their lives can be inferred from the superjacent words. The space is somewhat spookily illuminated, as if a shrine. In the larger space are thirteen vertical signboards, the laments there appearing in the medium of lights. They shoot up from the floor in sequences of increasingly complex arrays, after which the space reverts to darkness. I found these ascending lamentations extraordinarily powerful, and they evoked a memory of a memorial service for Ivan Morris, the great Orientalist, at which Yoshito Hakeda—Sanskritist, monk, and former kamikaze pilot—intoned a Sanskrit prayer. One goes to such services in part for deliverance from the power of the dead, but the speakers that day had been brittle and unshriving. Hakeda's voice rumbled like some Himalayan avalanche, and one felt an answering echo in the depths below our feet, which rose to fill the spaces of St. Paul's chapel for as long as the chant went on. Laments *should*, literally, rise.

As an installation, "Laments" expresses a singular symbolic imag-

ination. And it provides an experience, in consequence of its symbolism and its multidimensionality, well beyond anything that painting or sculpture alone is capable of, or even the architecture of sacred spaces. "Death is a hard subject," Holzer told Diane Waldman in an interview printed in the catalogue (as if the truism were her natural mode of speech), but she has certainly found an artistic equivalent to its hardness, even if, for the most part, death is hardly the subject of the laments themselves. And in truth I am uncertain whether her language, in its own right, is altogether up to the level of the installation. One lament begins, "With only my mind / To protect me / I go into days" and ends with "make the audience / Laugh until their / Insides bubble." There is an incoherence in a voice that says its owner "goes into days" and in the same discourse also says "insides bubble." In another lament, the beginning words are "If the process starts / I will kill this baby / A good way" and it ends with "Fear that is / Cause and Result." It is as if a speech by Medea ends with some philosophical jargon. Or as if Holzer's speakers are not up to the poetic occasion, which could be a deeply human and even touching fact if intended. But this erratic unevenness infects the voice of the Truisms, and perhaps Holzer's voice if the Truisms are hers, rather than implicitly coming from the mouth of a fictive speaker. In one series, Holzer has written, "You are trapped on the Earth, so you will explode." This cannot be something she believes, so we have to infer a character she has created who does believe it—and where then is she? What messages are hers? Or are there any?

These questions deepen at the Guggenheim, where in fact there are two installations. One, in the high gallery, as it is called, consists of six files of white marble benches, ranked in even rows, from two to seven benches in each file, in exact cardinal order. The benches bear what I shall call "communications" at once disconcerting and reassuring: "It takes a while before you can step over inert bodies and go ahead with what you were trying to do." There is something uncanny in the sepulchral order and color, and one wants an explanation of why exactly twenty-seven benches in just that arrangement. Are we supposed to progress through the benches? Is the file consisting of a single bench missing? Could there be a file of eight benches? These are inescapable questions, with no answers—after all, this is a work of art, not something made by a government or a cult, and it serves no occasion other than a meditation on itself.

The second installation occupies the floor and central core of the

museum, for Holzer has seized the first three turns of the helix as a band on which to display running messages, chasing upward toward the top turn to disappear. Beneath are curved red benches forming a circle. These, too, are inscribed, but as they are occupied, it is difficult to tell whether they correspond to the messages that flash above one's head. For that matter, it is difficult to know how many messages there are. There is no accompanying script. So, though it begins and ends, the beginning and ending are not part of the experience. As with the rest, it is difficult to ascribe the messages to Holzer herself. They are messages from an oracle, or a sibyl, or a fortune teller, or someone's slightly dotty aunt, or, like texts that might wash up in a bottle, they are too remote from their (unidentified) source to do more than disturb. Art, for a long time, was thought to be illusion—fooling the senses, getting us to believe what is false. Here, just because speech is the medium of truth, there is another order of illusion: we falsely believe the words are addressed to us, and that, as with most words, they are asserted by the speaker and believed by her to be true. The work is consistently deeper than the words.

—*The Nation*, February 12, 1990

Tim Rollins + K.O.S.

MY FIRST EXPERIENCE with the work of Tim Rollins + K.O.S.—
a name initially as mystifying as that of many rock groups—came from
the striking cover of *Artforum* for May 1988, which showed a fragment,
as I learned, from one of their *Amerika* tableaux, which was reproduced
as a whole but in black and white, and much reduced in size, on the
contents page of that adventurous publication. The image on the cover
was of work very little like anything I was aware existed in the art
world of that moment; and indeed, it was unclear from the image alone
whether it was contemporary at all, since it was composed of what
appeared to be trumpets, keys, and crosses, all in gold against a whitish
background, and looked, at first glance, as if it might be a marvelous
illumination from an old ecclesiastical text or a celestial emblem from
a medieval work, or even an ornament, elaborate and intricate, from
some goldsmith's hand. Closer examination of the background would
have revealed it to be made of pages from a printed text, evidently
pasted down like oblongs of gold leaf. There were twelve columns of
such pages, each column eight pages high, and one might have com-
puted the size of the trumpets and other forms from this, and even
have inferred, from this curious use of printed pages, that the work
must be fairly recent. But such forensic deductions were forestalled by
the curatorial legend on the contents page itself:

Tim Rollins + K.O.S., Amerika X (detail), 1986–88, watercolor, charcoal,
and bistre on book pages on linen, 60″ × 175″. Executed in the South Bronx.
From the "Amerika" series, which was begun in 1984, and takes its name

from Franz Kafka's novel *Amerika*. The images of each work are painted on the pages of the book. See p. 111.

On page 111, one encountered the cover article, by Donald Kuspit, devoted to "American Activist Art Today." A survey as well as a critical analysis, Kuspit's piece was dense with the proper names of those artists through whom the author was seeking to plot a movement afoot in the art world, as he believed, of a new sort of politically or socially engaged work. Toward the end of the piece Kuspit wrote, "The exuberant yet elegant work of Tim Rollins and K.O.S. asks its audience to go beyond questions of formalist eloquence to arrive at a larger definition of what constitutes effective activist art-making." As nothing further was said about the presumed activist art maker, I turned back to the remarkable cover image, which had by then begun to look rather rococo, as if an embellishment from a Bavarian baroque church, and tried to feel the imperative to go beyond its elegance and exuberance to the larger questions regarding activist art making I was intended to ponder. But either I or the image was not up to the task. I still greatly admired it, but realized, once more, that one of my grandfather's wise utterances has an equally wise converse: You cannot judge a cover by the book. Nothing in this exceptionally rich issue of *Artforum* especially clarified its stunning face.

I find it odd, in retrospect, that Tim Rollins + K.O.S. received so few words of explanatory text when one would have thought an important statement about their work was being made by choosing it as the cover illustration, which after all confers immense prestige. May 1988 was an important issue to the editors of *Artforum*, for it marked the twentieth anniversary of the student uprisings in Europe and the United States in which many of them had participated. The editors marked the occasion with a portfolio of photographs of outstanding works of art from 1968 which seemed to them to have promised a new beginning for art and for everything else. It was their view that the art in question emblematized the revolutionary politics in which they had been engaged. The photographs themselves were black-and-white, and because they had a metric scale printed at their margins, as well as a sort of bar logo in one corner, they carried a feeling of documentary exactitude. These grainy images would, to someone unfamiliar with the works themselves, convey a sense of utter bleakness and desolation: it was as if they recorded the devastation of the world. Included were some rolls of lead sheeting, as if for a fallout shelter never built; a pile

of plaster in the otherwise bare corner of a bare room strewn with soldering irons, looking as if it belonged to a torture chamber; a set of fiberglass cylinders appearing to have buckled under a terrible explosion. There were boxes of rocks, a roomful of dirt, some excavations in a wasteland—and a pile of near-naked bodies, connoting some infinite horror. These were, in fact, works by Richard Serra, Joseph Beuys, Eva Hesse, Robert Smithson, Walter De Maria, and members of the Living Theatre. As images they seemed utterly inconsistent with the "euphoric denial of limits" of which the editors nostalgically wrote, or of "imminent and profound change." They no more conveyed these hopeful messages than the cover image communicated the question Donald Kuspit said it did. There is some sort of lesson here, I daresay, about the differences between what images say and what art critics say they say. And yet the work presented on the cover exemplified, if it did not exactly express, a certain activist kind of art making.

As nearly everyone must know today, since the media have since bestowed upon them a celebrity hardly anticipated in 1988, K.O.S. is an acronym for Kids of Survival, a name its designata conferred upon themselves. They come, as a group, from the South Bronx, and many of them would be classed as having learning problems because of dyslexia, which would exclude them from the systems through which there might have been a slight hope of fighting their way out of a destined membership in the underclass of a rough world. Tim Rollins is a conceptual artist, politically left, who found his calling as an art teacher through experiences in ghetto and near-ghetto classrooms. As an alternative, he set up the grandly named Art and Knowledge Workshop, to which he attracted a core of nonstarters to read and discuss certain works of serious literature, which they then in extended collaboration transformed into images. Kafka's *Amerika* is one such work, and the *Amerika* tableaux—there are to date twelve of these, each roughly the size of *Amerika X*—are the product of sustained collaborative execution. Both the idea of collaboration and that of finding a creative outlet for the blocked gifts of racially and economically dispossessed youth would, one must feel, be a vindication of some of the visionary aspirations memorialized twenty years after *les événements* by this issue of *Artforum*. Ida Panicelli, the editor of the magazine, told me that she had selected the May cover in order to celebrate the ongoing if transformed activism in the arts which was the subject of Kuspit's essay. Still, it remains for me an external fact about the work that it is "activist art," and, as I shall argue in a moment, it is perhaps

central to its mission that it conceal its activist procedures and that one should be struck, as I was, not so much by the knowledge of who made it and under what conditions as by its artistic distinction alone. It may have broken limits, as art and certainly in the standing conception of the artist, but it appears, merely, as a marvelous and fascinating image.

The following February, I received a packet from the Dia Art Foundation containing transparencies of all the *Amerika* tableaux as well as some catalogues and clippings about K.O.S., and an invitation to write a catalogue essay. Dia was sponsoring an exhibition in which all the tableaux were to be brought together for the first (and very likely for the last) time, together with a number of auxiliary studies of forms that found their way into the tableaux. Now, there is in me enough of the bleeding heart to be moved, powerfully, by the image of a dedicated teacher bringing the lilacs of artistic creation out of the wasteland of human disenfranchisement. One is dutifully moved by choirs and dance ensembles that someone has had the mission and conviction to fashion out of ghetto voices and grace. But there is also something morally uncomfortable in the spectacle of black or Latino youngsters regimented onto the stage for the entertainment of white and prosperous audiences filled with a sense of their own goodness in having made the spectacle possible. Moreover, singing and dancing superlatively well are, like athletic (or sexual) prowess, believed to go with a certain limiting myth of black or Latino capabilities. ("Such a wonderful sense of rhythm! What energy! What spontaneity!") Painting seems in another category altogether. To be sure, scarcely a decade ago there was a flutter of art-world interest in graffiti, which was in every sense the equivalent, at the level of painted form, of the more characteristic ghetto expressions of break dancing and rap music. And liberals, like radicals, have tended to insist that minorities should be encouraged to value "their own" art and to cherish "their own" traditions—exhibition of which in "our" museums seems to me often as uncomfortable as black voices in white auditoriums. What nobody expected, ever, was painting of a kind that would stand up to critical judgment as well as any of the best art making being done. This would be like heeding parents' entreaties to come hear their child sing and to be bowled over as the eight-year-old sings, thrillingly, "Vissi d'arte" from *Tosca* or the *Kindertotenlieder*. Bleeding heart or not, I would have had no great interest in writing about an experiment in alternative education in art. But the images bowled me over. They were not just good *for* (blacks, teenagers, dyslexics, or whomever). They were quite

as beautiful as the cover of *Artforum* would have led me to expect. (Of course I agreed to do the essay.)

"In the time just before the first 'Amerika' painting," Rollins writes in the Dia catalogue, "there was the pressure, the desire, *the need* to create a work of art that was political, vital, critical, and yet *beautiful* all at once." I think, in fact, that his discovery was that the work he helped bring forth could not be political unless it was beautiful. He speaks of "an art political not so much in its form or content . . . but political in the very way it was made." So the *Artforum* cover did not wear its activism on its face, except that its beauty was a condition for the attainment of its activist purposes. For the same reason, the texts he works with could not be politically significant unless they were great in the first place as literature. The kind of carping at the canon that has the academic establishment lashed with acrimonious bickering is rooted, Rollins perceives, in middle-class attitudes. He is concerned with the transformative power of the best, and his respect for the canon is as profound as his admiration for the great art of the past. He takes it at the value it has always assumed in its most exalted moments. Kids of Survival read Hawthorne, Orwell, Defoe, and Kafka, and they look at Goya, Grünewald, Leonardo, and Paolo Uccello. It is less as though he were rescuing adolescents from the ghetto than using them as a way of rescuing the great cultural tradition of the West—or they rescue one another.

At the same time, I think, he has been able to bring these remarkable works into existence with the collaboration of K.O.S. only because a certain stylistic openness has been made available to them through the postmodernist discoveries of the past decade. Postmodern painting is defined through discontinuities, conceptual jumps, juxtapositions of antithetical images in conflicting scales, appropriations of motifs and manners from past art, disregard of spatial uniformities and illusions other than those to which appropriations give rise, and a propensity to use the surface of the work as opaque—that is, not as an Albertian window into a perspectival or theatrical space. I am uncertain that Modernism could have opened itself up to the kind of collaborative diversity that enables K.O.S. to express themselves as one. There is an irony in the fact that Post-Modernism has also been cynical, exploitative, pretentious, bombastic, inflated, and insistently ugly, whereas the panels of K.O.S. radiate optimism, clarity, a true sweetness, and a touching hope.

The *Amerika* tableaux are K.O.S.'s great achievement, and it is a

wonderful, really an exhilarating experience to see all twelve of these
intricate and joyful works displayed on one of the ample gallery floors
of the made-over warehouse that is Dia's main exhibition space. Each
of them, like the fragmentary panel reproduced as the cover of *Art-
forum*, is a dazzle of golden horns, in intricate symbiosis with mono-
grams, staffs, crosses, and other forms painted upon a background of
carefully pasted and smoothed-down pages from the texts they trans-
late. The relationship, at once physical and emblematic, of image to
text has been a formula for K.O.S., but at the emblematic level it works
out best—it works out spectacularly—with Kafka's odd novelistic med-
itation on faith, hope, and charity, and especially its last chapter. In
this, the protagonist, Karl Rossman, good and innocent and a kind of
moral stooge, after a sequence of demoralizing adventures, is beaten,
broken, and robbed. He is as misperceived in the novel as Plato's just
man who *appears* perfectly unjust, but he finds a sudden hope in the
Nature Theatre of Oklahoma, where everyone is qualified to do some-
thing ("From each according to his means") and where anyone can
advance. The Nature Theatre of Oklahoma is a benign version of a
Mitteleuropa bureaucracy—more commonly thought of as Kafkaesque
except that here its immense and ramified apparatus is put to the ends
of serving rather than frustrating individual purposes. It is an image
of America that even or especially in the South Bronx was evidently
felt to be a true allegory. Young people one would have supposed
disenchanted with the American myth instead found it a compelling
vision. And they seized upon that moment in the great chapter where
Karl approaches the recruiting agencies of the great outdoor theater
and sees, poised upon pillars and robed in white, all manner of per-
sonages, including an acquaintance of his, blowing golden horns in
cacophonous immensity, like the tooters and brayers in Times Square
on New Year's Eve—a crowd rather than a society.

The trumpet is a metaphor for glory, triumph, splendor, and
though I know no Zarathustra-like prophet whose saving message was
"I say unto ye, ye are all trumpets and shall all *be* trumpets!" I would
have no difficulty in grasping the meaning. It is certainly the visual
message of K.O.S.'s *Amerika* tableaux. The overall tangle of interlaced
horns resolves, upon closer inspection, into individual components, few
of which prove to be pictures of real musical instruments. Rather, the
most improbable forms—leaves and bones, sticks and viscera, plants
and artifacts—find themselves fitted with mouthpieces and bells, each,
one feels, blowing itself, making its own music; and while the im-

mediate aural consequence may indeed be a kind of racket, the promise of harmony is also there as each learns to fit its voice into the ensemble, just as its visual form fits into the painterly composition of K.O.S.

I heard an art critic whom I respect observe one evening on a late-night television panel that in some ways Tim Rollins + K.O.S. are more interesting for the process by which they arrive at their productions than for those productions themselves. This is both true and false. Many of the same processes were involved in K.O.S.'s earlier projects—*The Scarlet Letter, Journal of the Plague Year, Animal Farm*, and others. These, though they had their individual successes, do not *vindicate* the process as the *Amerika* series does as a whole. The Dia Foundation is responsive to the kind of politics and social enterprise Rollins displays in his creative pedagogy, but it is also aesthetically exigent, and I could not imagine it giving up the space (and time) to any of the other K.O.S. suites. It is by being as artistically successful as they are that the *Amerika* tableaux are accorded their extraordinary interest. It is not mere benevolence that explains the acquisition of these remarkable works by the Museum of Modern Art, the Philadelphia Museum of Art, and other private and corporate collections. In the hateful idiom of the moment, K.O.S. is "hot." And I expect that if they cared to, Tim Rollins + K.O.S. could industrialize the *Amerika* format and take orders the way hot artists do today, selling pictures in advance of painting them. That cannot of course be Tim Rollins's intention, but it is the heavy shadow artistic success casts today, and it, taken in conjunction with the social facts that gave rise to K.O.S., creates for them a dilemma that cannot but concern those who reflect on the bitter price of hotness in American artistic culture.

The other TV panelists that evening could not avoid certain painful paradigms. There were, on the one side, the graffiti "writers," encouraged by an exploitative art world to inscribe their imagery on panels to be sold in a greedy market. That imagery, in my view, belonged to a form of life as ritualized as that of the Toltecs, with its own sense of history and concept of criticism and its proper set of aesthetic rules. The writers were finally unable to navigate between that world and the art world, where the conditions of creativity were altered and the meaning of their signs distorted. The promise of bucks faded with the passing of the season. They would have to be reborn into that world—by going to art school, for example—and the cynical art world would have no interest in them under those circumstances. On the other side was Jean-Michel Basquiat. Basquiat was really a kind of

genius, and today one cannot see his work without being struck by his powers. Like Pollock, he could lay paint down in a way which gave it instant authority and life. But Basquiat was spoiled by fame because he interpreted it against the only model he knew, that of the spoiled rock star in a world of splurges, sexual binges, and drugs. I sense that he was encouraged in this by his "advisers," and, lacking the moral counterpart of an immune system, was destined to crash.

Neither of these bad examples was on my mind when I wrote my catalogue essay on K.O.S. I thought, rather, of the Pre-Raphaelite brotherhood and its incapacity to adhere to the communitarian ideals it believed in sufficiently to think of itself as a brotherhood. I attribute that to the dominance over the production of art of the idea of the individual genius. The Pre-Raphaelites, who invented the art market as we know it, knew that it was a condition of success that work be seen as emanating from original genius, even as they longed for another form of life. The ideal of the individual genius, Basquiat notwithstanding, is losing its grip on the art world today—though one of the TV panelists felt the purpose of K.O.S. was to find the hidden Leonardos of the South Bronx! Collaboration is the ideal of this hour.

Tim Rollins is an inventive man, with extraordinary social gifts. Even he, I think, is uncertain where things should go next. Some of the Kids have expressed ambitions to be artists. This is wonderful, but it is also not the point of the Art and Knowledge Workshop. Somehow, the production of really important art here is a means to social and political ends. What, finally, Rollins is aiming at is the Nature Theatre of Oklahoma in all the South Bronxes of the world.

—*The Nation*, January 22, 1990

Furniture as Art

BOTTICELLI'S *Primavera*, which condenses in sweet allegories the longings and the learnings of its age, would turn up on everyone's short list of Quattrocento masterpieces. So it is instructive that it evidently spent its first years adjoined to an elaborate settle, or *lettuccio*, in an alcove next to the bedchamber of Lorenzo di Pierfrancesco in Florence, and that, in the view of current scholarship, settle and painting were designed together as parts of a single ensemble. Indeed, Ronald Lightbown, an expert on Botticelli, writes, "The fact that the *Primavera* was intended to be hung or fixed above a piece of furniture at or slightly above eye level explains the gently rising plane on which the figures are distributed." Strictly speaking, then, we are looking at a fragment when we contemplate this gentle embellishment alone, in which the spring zephyrs of the Renaissance innocently stir. The fact that Lightbown refers to the other fragment as "a piece of furniture" testifies to a deep prejudice, long at work in our culture, in which art belongs on the other side of a line separating it from items of mere utility, as if the boundary between the bottom edge of *Primavera* and the upper edge of the *lettuccio*'s cornice were the metaphysical boundary that divides spirit from crass body—as if, indeed, *lettuccio* and painting together compose a kind of monster, like the centaur, half beast and half human, that Botticelli painted with such compassion for that same Florentine chamber.

Nothing could better demonstrate the conceptual distance at which we stand from the Quattrocento than our insistence on a borderline that artists and patrons in the Renaissance never thought to draw. In the larger scheme of life, after all, nothing could have been more

overpoweringly utilitarian in that era than the altar of a church. And since the altarpiece was standardly conceived in terms of the practicalities of prayer and in the hope of holy intervention, something has been irremediably lost, even from the perspective of formalist aesthetics (like accounting for the "gently rising" ground plane of *Primavera*), when we remove the altarpiece to the museum as an object of disinterested contemplation. Aesthetics was a late-eighteenth-century invention: in the Renaissance, and long after, the beautiful and the practical were as much an undifferentiated unity as are, in philosophical truth, the body and the mind.

My sense is that we owe the invidious distinction between the fine and the (merely) decorative arts—as we do so many divisions, both hidden and obvious, that define our attitudes toward the things of life—to the French Revolution. It was Jacques-Louis David, functioning as artistic commissar, who decreed the division, classifying furniture making as an inferior art in contrast with the high arts of painting, sculpture, and architecture. He did so on two grounds. That order of furniture which might compete with painting in terms of skill, ingenuity, expressive power, and beauty he associated with the discredited values of the *Ancien Régime*. This, if true, means that aristocratic patrons did not especially discriminate between painters and furniture makers of the highest quality, and hence did not respect a boundary greatly attractive to David, which exalted artists as natural aristocrats, so to speak. Ironically, the values of the dispossessed nobility must then have anticipated the ones later endorsed by John Dewey and his mentor, Albert Barnes. They sought in their writings, and in the case of Barnes, in his strategies of exhibiting painting and sculpture in the same space as ornamental ironwork, to dissolve the distinction that David helped make canonical.

David's second ground of discrimination was that painting and sculpture were capable of serving the highest purpose of art as he conceived of it: namely, to give moral instruction to its viewers, making them better persons—and, incidentally, politically correct citizens—in consequence of their experiences in museums of art. His own paintings of the period were hortatory and edifying to a degree we find painful today. It is clear that David's second ground was somewhat weakened by his first: it was precisely because the bergères and fauteuils and elaborately worked ormolu fittings for escritoires and gaming tables imparted the wrong sort of moral teachings that David impugned them. It is at the same time perfectly evident that the style of furniture David

would tolerate in spaces over which he exercised any control must transmit the same order of moral meaning as the kind of painting in which he believed. Furniture condenses the values and moral gradations of its owners, and can be as eloquent or as tendentious as sermons.

From the transformations in moral and political perspective of the 1880s, David came to be regarded as having been something of an aesthetic villain for having politicized the straight line when the *curved* line, which emblematized the rococo style, came to be esteemed as somehow essentially French. And in fact there was an intense effort to rehabilitate the rococo style not simply in terms of painting and decoration but in terms of the modes of moral meaning implied by the form of life for which the rococo stood. It followed as a matter of course that the Salon should open itself up to furniture makers by 1890, and that the leading artists of the Belle Epoque should express themselves in the design of dinnerware, textiles, stained glass, wall coverings, and screens, not to mention graphic design. In the early modernist vision of Vuillard, Lautrec, Bonnard, and above all Gauguin, decorativity came to be the defining category of aesthetics. That "decorative" has reverted to a term of critical abuse is evidence that we have returned to the Davidian program of art—minus, to be sure, the moral didacticism.

In the 1890s, the decorative arts generally went with an agenda of social transformation and an often utopian politics. Recently, when he was seeking a new sort of politically engaged conceptual art, Tim Rollins recalls coming to think, "The textile and wallpaper designs of William Morris and his workshop . . . pointed a way to reconsider the languages possible for a new political art—an art political not so much in its form or content, but political in the very way it is made." If we think in this way of art as a "language," then it is irresistible to invoke the singular thesis of Ludwig Wittgenstein: "To imagine a language means to imagine a form of life." (Rollins goes on to suggest that "the greatest indictment of capitalism can be found in but a yard of Morris's perfect, beautiful materials.") In any case, by comparison with the great transformative visions of Art Nouveau in France, of Jugendstil in Germany, and the Vienna Werkstätte—and of course Morris's Arts and Crafts movement in England—most explicitly political art has the dimension of a cartoon. It was an early premise of the Museum of Modern Art in New York that the formalist aesthetic, as much embodied in articles of daily use as in modernist painting, should bit by bit transform the patterns of daily life and in consequence the moral character of

those who lived those patterns. These attitudes weakened in the immediate postwar years. Artists turned from politics with a kind of loathing and heroized painting as a disengaged act of pure expression. But it was perhaps inevitable that by the late 1960s there should be, as one aspect of the elimination of social divisions perceived as oppressive, an effort to erase the boundary between high and low art, or between the fine and the practical arts. It was part of the spirit of the times that furniture makers should begin to claim that so far as art making was concerned, there was no conceptual distinction between what they did and what painters and sculptors did.

Until that demand for equal ontological rights, furniture makers generally had been characterized by the essentialism that tended to mark the ideology of art in our century: to identify what it was that essentially sets furniture apart from everything else. Essentialism goes hand in conceptual hand with Purism. Theorists of painting, for example, came to view picturing as not essential to their subject, and undertook in the spirit of pure painting to purge their art of pictorial content and the very space that made this possible, which meant that the truth in painting went with the absolute flatness and two-dimensionality of surfaces. Others came to identify painting with the very act of putting paint on, which then led to an aesthetic of the heavy brushstroke and ultimately the drip. Or painting became identified with the material basis of the art, which yielded paintings that drew attention to their own shape and that flaunted canvas and stretcher. When video art made its first tentative claims to aesthetic privilege, its makers looked spontaneously for what was essentially video, which then relegated everything else to the status of contaminant, and yielded the parameters of video criticism.

It was unavoidable that, when furniture makers began to think of themselves as artists, their first effort was to essentialize their practice or their product, and various alternatives immediately suggested themselves. There was the mysticism of material, for example, the exaltation of the "woodiness" of wood, which impelled the entire art to celebrate and enhance grain, luster, and, in radical cases, the natural shape of wood. And there was the parallel celebration of artisanship, in particular the virtuosity of joinery, of inlay, of veneer, and of polish. There was even, at a certain stage in this itinerary of artistic self-definition, an effort to subtract what seemed to be that feature of furniture which keeps it from the precinct of high art—its utility—so that the furniture maker who aspired to the higher calling might produce objects of

beautiful material, exquisitely crafted, but almost flagrantly nonutilitarian, as with certain transitional works by Wendell Castle, who was among the first of those who wanted to be at once artists and furniture makers.

There were other subtractions, once the movement was under way. Richard Artschwager, originally a furniture manufacturer, started to employ Formica, that most aesthetically despised of domestic substances, in a reaction against the effort to identify furniture, when art, with beautiful materials. Artschwager thus effected a double erasure: by dissolving the line between fine woods and plastic, he overcame in an eccentric way the line between furniture and fine art. But the gesture I find most admirable in this singular history is a subtraction of subtractions—a negation of negations—achieved with a cabinet made by a California *ébéniste*, Garry Knox Bennett. It is made of padouk (a Burmese rosewood), artfully joined, with a craftsmanlike finish and elegantly designed fittings. And when it was done, Bennett drove a bent sixteen-penny nail into the façade, surrounding it with a halo of dents of the kind hammers make in unskilled hands. This Rimbaud-like gesture ("One evening, I sat Beauty on my knees. And I found her bitter. And I abused her") repudiates three decades of essentialist quest, and is itself the very essence of the postmodern spirit in art. What Bennett hammered home was the truth that art, whether in painting or in furniture, is a matter of meaning. And that extends to high craftsmanship and rare materials as well as to their subversion, such as in the work of Bennett and Artschwager. Furniture can be an art when it is about its own processes or its own substances or even its own functions, as Wendell Castle demonstrated, though by no means is its vocabulary of meanings restricted just to these.

A few years ago, the Architectural League of New York sponsored an exhibition of chairs, an open competition they called "The Chair Fair," in which 397 entries were displayed with marvelous fanfare and enthusiasm. I was invited to deliver a lecture as part of the celebration, and it was then that the rich symbolism of the chair in human life began to impress me. I spoke first of the chair *in* art—the empty throne in a Buddhist work from Amaravati, Van Gogh's portraits of himself and Gauguin as chairs, and Warhol's electric chairs, with which, characteristically insightful into the language of symbols, Warhol raised the question of what dignity we feel ourselves according to the victim when we execute him or her in the sitting posture (rather than lying down or standing up). And then I tried to raise what it means for a

chair as such to be art, pointing out, as I went, the way different chairs imply different philosophies of life: the wing chair, the sling chair, the salon chair, the BarcaLounger, the chaise longue, not to mention the fact that the President sits in a desk chair while the Pope permits himself the palanquin, intolerable in a democracy. Erica Jong has the heroine of an earlier book complain when Leila, the heroine of her new book, lies weeping on the floor: "Couldn't she weep in a chair for once?" To which Leila responds, "Could you?" What is implied about the depths of sorrow that is inconsistent with its being expressed while sitting, requiring at least that one lie in bed or, even better, that one sob from the lowest position available, on the floor, kicking to get lower?

The twenty-six contemporary furniture artists who were invited by the Museum of Fine Arts in Boston to produce a "masterpiece" for inclusion in an exhibition titled "New American Furniture: The Second Generation of Studio Furnituremakers" are alive to the referential powers of furniture as a bearer of meaning, and it would be rare to find an exhibition of contemporary painting or sculpture as radiant with a collective intelligence, wit, knowledge, expressiveness, skill, and beauty as this set of brilliantly conceived and executed objects. I was taken through the show by Edward S. Cooke, Jr., who conceived and curated it. He opened doors and pulled out drawers with an infectious gusto, explaining a good many things that he had described in great detail in the accompanying catalogue. Each artist selected a piece of furniture from the past—a seventeenth-century trestle table, a New England trundle bed, a kneehole bureau table from about 1760, a Philadelphia high chest from about the same date, and a wonderful chest by the American artist Charles Prendergast, which is a descendant of the *cassone* that formed part of Botticelli's *lettuccio*. Each then constructed a piece that expresses something of the spirit of the one to which it refers, but at the same time carries the quite different sort of meaning that a chest or a chair meant to be integrated into contemporary discourse must transmit.

The Prendergast chest was selected as a paradigm by Judy Kensley McKie, whose work makes a boisterous use of animal motifs as decorative components. She did a couch once with a back made of leopards, nose to nose, their tails coiling out to form its arms. She also made a jewelry cabinet with inlaid Keith Haring dogs. For this occasion she placed a chest on corbeled legs and entwined on all its surfaces (including the undersurface of its cover) gold-leaf leopards, grinning amid plant forms. It was Wendy Maruyama who deconstructed and

reconstructed the Philadelphia high chest. The upper cabinet is topped by a copper-leaf pyramid and buttressed by what look like giant commas. The lower chest is set into four heavy mahogany legs, which seem to want to be streamlined, as if to dissociate themselves from the awkwardness of the body of the piece, which is painted a funky green, accented with pink slashes, and ornamented with cigar-shaped pulls. With its copper helmet and its rolls of pulls, like buttons on a uniform, it stands like some sort of sentinel, amusing and imposing, full of goodwill, making a point of being useful despite its crazy charm.

Garry Knox Bennett has confected what looks like a kneehole desk out of an improbable assortment of materials, including aluminum and brick. It is at once sinuous and ponderous and conveys the authoritativeness that the owner of a desk so heavy must possess, and at the same time it projects a certain unrepressed whimsy through its shape and color. It would be ideal for the CEO of a joke factory. Tom Loeser has built a chest of drawers consisting only of drawers, which, as if having escaped the rigidities of a confining frame, are of different sizes, shapes, and colors, and stagger upward as if piled one atop the other. But they open with the same assurance with which the door of a new car closes, revealing the craft that their staggered disorder seems to mock. By contrast, Hank Gilpin has constructed a wardrobe whose inspiration was a chaste paneled door from a house in Massachusetts, and door and wardrobe alike are exactly the kind of furniture David would have endorsed had he cared to revise his thesis that, unlike painting, furniture is morally mute. There is, by Thomas Hucker, a high chest of drawers that refers to a chest of the William and Mary style. Its polished mahogany façade curves outward like the side of a cylinder, and is placed against a less dramatically curved black back panel. Both upper components are poised with an elegant dignity upon six precisely turned legs. It conveys a very different code from that which can be read in Gilpin's austere and almost Puritan piece, which in turn repudiates the lighthearted values of Maruyama's punk and rowdy artifact, which keeps its good craftsmanly manners hidden.

Boston has been something of a center for studio furniture. A good many of the artists originally set up shop in the area, and there are several galleries showing their work. On the other hand, a considerable political distance has been traversed since the first workshops were set up in the 1960s, at a time when woodworking seemed, by its own nature, to make a kind of political statement and crafts communes were much the order of the day. The attitude was resolutely anti-elitist,

and the earlier pieces doubtless reflected, in style and matter, the place that furniture as an expressive art was to occupy in the form of life that the craftspersons themselves believed in (as did so many in the communes that sprang up across the nation in those years). It is perfectly plain that whatever the politics of furniture-as-art were originally believed to be, the work in the Boston show hardly could be more elitist. This order of skill, working upon rare materials, cannot come cheap, any more than it came cheap in the days of Du Barry and Madame Pompadour. And, like painting, furniture that is art is made possible by the existence of a set of connoisseurs and collectors. Making these chests and tables and desks is finally as exacting as making paintings, perhaps even more so, and it is an interesting question why they should cost so much less than paintings of comparable power. Perhaps it is because we continue to carry a romantic prejudice in favor of expressive fervor—and there is no way in which a tortured furniture maker can give vent to creative frenzy by impulsive dovetailing or emotional mortise-and-tenoning, the way the artistic Genius can wipe and swipe pigment, or her counterpart in sculpture hack away emotionally at stone or wood, or shape clay with fury and passion. The myths that support discriminating borderlines are tentacular. The contemporary world remains suspicious of skill and elegance in art.

—*The Nation*, April 23, 1990

Monet's Serial Paintings
of the 1890s

MONET'S *Impression: Sunrise* of 1872 gave Impressionism its (originally abusive) name, as Monet himself gave the movement most of its defining attitudes, its archetypal vision, and its heroic myth of the artist who overcomes immense personal difficulties and, in the face of the derisive resistance of critics, produces works so infused with joy in the visual surfaces of life that it is difficult to see why anyone would paint, or even greatly care to look at, pictures of any other kind. From about 1899 until his death in 1926, Monet devoted himself, obsessively and finally exclusively, to recording the transient appearances of his celebrated water garden at Giverny; and he enjoyed a second artistic coming in the 1950s, when the Abstract Expressionists recognized, in the vast scale of his water lily paintings, in the near-abstractness of their interdissolving forms, in the dense inscription of painterly gestures, and the urgent impasto of painted strokes, anticipations of their own expansive surfaces and depths, which were like those seen through watery lenses. Monet led an increasingly reclusive life at Giverny, sheltered by his ability to separate his own environment from the powerful forces of Modernism (the Fauves, Cubists, and Surrealists), cultivating his own garden literally and figuratively. Thus he was able to carry, out of the imperatives of a nineteenth-century artistic movement, the evolved axioms of a mid-twentieth-century artistic movement as a kind of gift when the world was ready to receive it. In 1922 he had the uncharacteristic impulse to give, *sans récompense*, the immense cycle of water lily images to the French nation. These are the works widely known from their reverent installation in the Orangerie. It must have come as a shock to the Parisian art world in 1926 to realize that Monet

had just died, when there was every reason to suppose him long dead; and the water lily tableaux must, then and for a quarter-century afterward, have seemed like the last flaring of a great style of painting impossible to imagine that anyone could still have been practicing—until after 1950, when it seemed as if the old Impressionist had been incredibly ahead of his time and had discovered the Expressionist vocabulary of scale, pigment, brushwork, surface, and gesture before anyone else understood or accepted it.

There is something immensely moving in the image of Monet narrowing his world to the boundaries of his own garden and then, to the exclusion of anything else, endeavoring to capture its fugitive looks at different moments under different lights in different weathers, and so beneath different reflected skies, but in a sense he had prepared himself for this almost allegorical labor through the serial works of single motifs that he executed in the 1890s—of the façade of the cathedral of Rouen, or the poplar trees at Giverny, or the muffin-shaped stacks of grain in the fields behind his house—viewed, often but not always, from the same vantage point but in different atmospheres and even seasons. The serial works were conceived as such and exhibited as such, so that, ideally, part of one's experience of any single work belonging to the series was to have been informed by the knowledge that it was part of a wider exploration and a larger statement, like (to speak with a qualified anachronism) a frame from a filmstrip, understood as implying a trajectory of temporal representation and possessing, in addition to its own artistic merits, the aesthetics of a fragment, a glimpse, an aspect, an instant, a movement stopped and frozen. Such were the pressures of the market (and Monet's own canny merchandising impulses) that the separate panels were distributed among different collectors in various countries, and though it has become a piece of everyone's art-historical knowledge that these works in some sense belong together, it is rare that they are experienced together except in books, and nearly impossible that a given grain stack or poplar painting should be experienced with all or even most of the others with which it was originally conceived. The Boston Museum of Fine Arts has had the imagination and the enterprise to mount a show composed of all of Monet's series, bringing together for the first time in a century all, or almost all, the members. So we have the immense privilege not only of seeing, for example, a favorite grain stack painting with most of its peers but also of seeing the grain stack series together with all the other series Monet achieved in this momentous decade. And we have,

beyond this, what no one in the 1890s could have had: the knowledge of what was to come in the crowning serial works, the water lily tableaux, to which Monet devoted the last twenty-five years of his life. This is one of the great, obligatory exhibitions.

It would be poetic but, I think, false to construe the various series of the 1890s as searches for a motif to which Monet could devote his life—as a sequence of relationships undertaken in the hope of finding an abiding relationship, with scenes and objects whose visual limitations were revealed after a time the way the emotional limits of one's partners are revealed, until one finds at last the single partner with whom a true marriage is possible, the person becoming, like the water garden for Monet, an entire world. This was the way it worked out with Monet (who even had an unsatisfying visual affair with Venice in the midst of his marriage to the garden at Giverny); but it was not, I think, *what* he was seeking, even though his serial adventures prepared him for the culminating commitment of his being. The deep historical question the exhibition raises is why Monet became a serial artist in the first place, and our answer to this has to become a factor in our understanding and appreciation of these protracted engagements with identical subjects over time. My sense is that he entered the decade with motivations very different from those with which he left it.

Indeed, I believe Monet left the 1880s with motivations very different from those which were to drive him in the 1890s. Visitors to "Monet in the '90s" would be well advised to arrive early enough to spend some time with Monet in the 1880s in the MFA's ample nineteenth-century galleries, under far less crowded viewing conditions. There are even, among the sparkling and ingratiating landscapes of the 1880s, some that address the very motifs Monet was to take up in the 1890s—the *Poplar Trees at Giverny* of 1887, for example, or *Fisherman's House at Varengeville* of 1882. The latter is especially interesting for the fact that the house really looks like something fishermen might have something to do with, whereas in the 1890s the house all but dissolves into the landscape, like an outcropping of rock, leached of its human overtones and its connotations of warmth and shelter. There are no human presences to speak of in the paintings of the 1890s, except, perhaps, for the almost insectlike crawl of coaches and pedestrians, browned and blurred by fog, as they crowd Charing Cross Bridge in London in a series from late in the decade. But there are human presences within the paintings of the 1880s and, one might also say, outside those paintings as well, meant by their presence to

give pleasure to those who viewed them. The MFA has on permanent loan the wonderful *La Japonaise* of 1876, in which Monet depicts his wife, Camille, striking a geisha pose against a wall of fans, wearing a kimono embroidered, across her backside, with a fierce Japanese swordsman. It is full of bluff comedy, and reminds us that Monet started out to be a caricaturist. There is neither wit nor visual blandishment in the paintings of the 1890s, and certainly none in the first series to strike the eye upon crossing the threshold, which consists of a single, uncompromisingly dour view of a harsh and rock-strewn landscape in the valley of the Creuse.

In the first images of the Creuse we see the identical rise of land at various moments of the day—in sunlight, at sunset, at twilight, and under gray skies. The brushstrokes are angry dabs that make no effort to fuse into forms, and the colors are almost poisonous, like the brutal green at river's edge in *Valley of the Creuse (Gray Day)*, which looks like industrial pollution. The Creuse series was executed and exhibited in 1889, and the disjunction between it and what Monet had been painting immediately before is so abrupt that one feels the idea of the serial work must be connected with the shift. It is so abrupt, indeed, that it seems to testify either to some profound personal change or to some equally profound artistic decision—or, as must be the case when art and life are so much of a piece, as they came to be in Monet's case, of both at once.

Paul Hayes Tucker, who curated this show and wrote the searching and illuminating catalogue, argues that Monet had been put under considerable pressure as an artist by the theories of Georges Seurat and their exemplification in *A Sunday on the Island of La Grande Jatte*. Seurat was young, brilliant, and charismatic, and in the art world of Paris in the late 1880s, his invention, Pointillism, was perceived as a challenge to the premises of Impressionism, and in particular to Monet as the embodiment of Impressionist ideals. Pointillism was "scientific," grounded in the latest color theories: tiny dabs of pure color were carefully juxtaposed on rational principles to achieve predictable optical effects, and thus contrasted completely with Impressionism's entire address to the world, which was, well, *impressionistic*, which meant to set down, without benefit of any special theory, the way nature presented itself to the collaborative artistic eye. In many ways, the Paris art world of the 1880s was like the New York art world of the 1980s —competitive, aggressive, swept by the demand that artists come up with something new or perish. The difference was that a kind of plu-

ralism had settled upon New York in the 1980s, whereas the modernist intolerances of the "incorrect" way to paint had already begun with Seurat. Pissarro, for example, defected from Impressionism and began to follow the new color theories of Divisionism, according to which pigments were not to be mixed but placed "pure" against one another to achieve an effect of great luminosity and vibrancy. (Divisionism put into effect the color theories of the American scientist Ogden Rood, a professor at Columbia University.) In a sense, Divisionism interacted with Impressionist views on color and touch somewhat parallel to the way in which Lavoisier's theory of combustion interacted with Priestley's theory of phlogiston. And just as one could continue to believe in the existence of phlogiston by making adjustments here and there in the theory, so one could continue to be avant-garde and Impressionist—but only by making suitable changes in the way one painted.

The difference between the sorts of narrative lived by artists in Paris in the 1880s and in New York in the 1980s was this: history was defined as progressive in the first but merely successive in the second. In the 1980s, artists bent on getting attention had to come up with something new, whereas in the 1880s the demand was less for novelty than for advance. Impressionism was redeemable only if it could meet the scientific challenge of Pointillism by showing itself to be just as "scientific." And that, in my view, is at least part of what the series paintings undertook to do.

Eighteen-eighty-nine was a most important year for France, being the centennial of the Revolution, and the country marked the anniversary with the ambitious Exposition Universelle, the chief remaining souvenir of which is the Eiffel Tower. The Exposition was meant to celebrate progress, scientific and political, and the tower itself was its metaphor, an emblem of "the immortal law of progress." Visitors saw the very latest in machinery and engineering and, given the immense and palpable prestige of science at that moment, it is hardly a matter of surprise that an artist anxious to be taken seriously by those expected to visit Paris would claim science as the principle of his art. When Monet exhibited that year with Rodin, the catalogue essay by his friend Octave Mirbeau sought to establish Monet's scientific credentials: the paintings make visible "living nature . . . with its cosmic mechanisms and . . . laws of planetary motion." Across the Champ de Mars from the Exposition, Gauguin showed work in Volpini's Café des Arts that, as different from the academic painting given prominence in the Palais

des Beaux-Arts as was Monet's, shown in the rue de Sèze across the river, also boasted of transmitting intellectual values of the highest order. Every advanced painter in Paris was retreating from mere aesthetics in favor of something rational, intellectually respectable, a logical step forward in the conquest of appearances. Those are the deep historical reasons why Impressionism had to change or perish.

Now, it is my sense that the concept of serial painting was Monet's response to the charge that he produce a body of work at once Impressionistic and scientific. "I felt it would not be trivial to study a single motif at different hours of the day," Monet is reported to have said, "and to note the effects of light which, from one hour to the next, modified so noticeably the appearance and the coloring of a building." Monet may have had this idea before 1889, when he painted the valley of the Creuse, but it had become urgent, by that date, that he embark on some sort of observation in order to cast his natural painterly idiom into a scientific mode. The philosophy of science has come a long way since the time when it was supposed that science was simple generalization drawn from careful observation, but this empiricist view certainly dominated philosophical views of science in the 1890s, and indeed it defined the basic tenets of logical positivism well into the 1950s in its analysis of scientific discourse. Monet would have had every reason to think of himself as behaving scientifically in noting "the effects of light . . . on appearance and color." The Creuse series is devoid of almost any interest except this. The scene is barren and the painting ugly, as if declaring its sole motivation to be observational truth. These paintings have the appearance of having been transmitted from some remote meteorological outpost to which the painter had been sent on a scientific expedition to gather visual data for the enhancement of human knowledge.

Unlike Degas, Monet did not, so far as I know, centrally rely on photographs, and it is difficult, given the effects he was chasing, to see how he could have. But it is possible to wonder if the idea of the moving picture, widely discussed in French art circles through the famous images of the movement of men and animals by Muybridge, did not suggest the strategy of distinct frames as a way of stopping the movement of light across a surface. Monet's method was singularly unwieldy (but so, after all, was Muybridge's, who used banks of cameras successively tripped). Monet worked on several canvases at once, and only someone with his enormous physical energy and programmatic ambition would have been capable of plein air painting in which canvases

were lifted on and off the easel as the atmosphere changed. (Why did he not use banks of easels, exactly like Muybridge?) He would work on as many as fourteen or fifteen canvases at once. So variable was the climate in London that, Tucker tells us, "by nine o'clock in the morning he could already have worked on five canvases; by noon fifteen." It was as though he enacted in himself the mechanism of the motion-picture camera, spatializing time, as Bergson might say, since all the changes would in effect be displayed simultaneously. Something like thirty of the grain stack paintings have survived; and though these were painted in different seasons as well as at different times of day, Monet claimed, of this series in particular but by implication of all the others, that the individual pictures "only acquire their value by the comparison and succession of the entire series." So the experience should be like having spread before one the consecutive linked records of "the effects of light on appearance and color" of these powerful forms. Tucker contends that grain stacks have a special meaning for the French, who sentimentalize rural life and countryside. And perhaps that does enter into the explanation of why Monet selected them as motifs. But that cannot be the explanation of the serial nature of these works, which is after all the dominant artistic property of the grain stack paintings taken as a single work with some thirty modules.

The idea of seriality underwent its own changes in the course of a long and productive decade. Seurat died in 1891, taking away part of the pressure, and the imperative to be scientific itself weakened as French artistic individuals sought another ideal. (The wider social determinants of this change are brilliantly narrated by Debora L. Silverman in her *Art Nouveau in Fin-de-Siècle France: Politics, Psychology, and Style*, University of California Press, 1989.) Decorativity, for one thing, became a general ambition for art: the water lily paintings are explicitly designated "decorations," and refer to the wall and the shape of the room they're in as much as to the pond itself. The poplar series, with its rhythms and graces, as if a metaphor for a chorus of dancers, exhibits, beyond the registered changes in light, remarkable shifts in parallax, some very exciting croppings, and a self-conscious audacity of composition. And though there is very little variation in perspective in the Rouen façade series, this may be due to the exigencies of location and the need to remain at a fairly fixed viewing point. There is a sense in which the densely ornamented cathedral façade made demands of a special kind on Monet's draftsmanship, regimenting the brush, inhibiting the fallback to reflexes he had developed over the decades of

rendering leaves and grasses, clouds and sun splashes, wind-tossed treetops, flowing water, flower-strewn fields.

I have tried to write an essay in what Michael Baxandall has termed "inferential art criticism"—inferring to the best explanation of seriality, construed as a response to the art world of a century ago. Of course, there is more to the show than this. It is a demanding exhibition but a rewarding one, a tour de force, really, appropriate to its astonishing contents. If you don't like this explanation, you must find your own. You cannot, I think, escape the question.

—*The Nation*, March 26, 1990

Postminimalist Sculpture

IN A RECENT ISSUE of *Daedalus*, the Indian artist Gieve Patel contrasts the tradition within which he perceives himself as working with that of the West. He remarks particularly upon "the absence here of successive schools, movements, and manifestos, each attempting to progress beyond the last one in its understanding and portrayal of pictorial space." Patel is cynical, or at least skeptical, about the history of constant self-revolutions in art: "We attribute this quick turnover . . . largely to the demands of an aggressive market." Yet it would be difficult to find a moment in which artists' progressive efforts to understand the processes and defining truths of art were pursued with greater intensity, or with a higher degree of disinterested idealism, than in the period surveyed by the current exhibition at the Whitney Museum of American Art, "The New Sculpture 1965–1975: Between Geometry and Gesture." In 1984, the Whitney mounted a brilliant show called "BLAM!" after a famous painting by Roy Lichtenstein. "BLAM!" undertook to define the movement in American art from Abstract Expressionism to Pop in the years 1958 to 1964, when art had moved from downtown to uptown and from an innocent poverty to a certain mercantile glamour. The museum seems to be constructing an exhibitional narrative of American, and in particular of New York, art history. The movement from the end of the BLAM! era into the middle 1970s, inadequately designated Postminimalism or, by the curator and critic Lucy Lippard, Eccentric Abstraction, saw a shift of creative gravity back downtown, in what would soon be known as SoHo, though some of the early exhibitions took place in certain adventurous galleries on Fifty-seventh Street.

Pop, in its raucous effort to erase—or explode—the boundaries between high art and low art, answered to a deep distrust in the American psyche of an elite culture, even if Pop's practitioners, with their wit, strategic brilliance, and intellectual dazzle, embodied the virtues of the culture they sought publicly to negate: only someone literate in high artistic culture could get the jokes. The Postminimalists reverted to a certain puritan devotion to the highest values of high artistic culture and shunned whatever might ingratiate them with a wider public. But this too answered to something deep in the American spirit—the quest for rectitude, for a private but exacting morality and a utopian mode of social being. Both dimensions of the American ethic were in the ascendant in those years of visionary political upheaval, and the exhibition's reduced and demanding Postminimalist sculptures reflect and enact their times at the level of aesthetic experimentation. The work on display is tentative, inelegant, almost squalid in its materials and awkward in its forms, but by its means the sculptors themselves were endeavoring to drive back the conceptual boundaries of artistic practice, albeit with little support from the market. They were fortunate in having worked during the last period in our history when one could be a poor urban artist, for the downtown loft had not yet become prized and pricey real estate. There were a few relevant galleries—Marilyn Fischbach's in midtown and Paula Cooper's in SoHo. There were sympathetic and supportive critics such as Lucy Lippard and Robert Pincus-Witten. The magazine *Artforum* was particularly receptive to reflections on this difficult art, which usually were at least as opaque as the art itself. The Whitney played its own role in the history it now memorializes: in 1969, Marcia Tucker and James Monte put on an exhibition there called "Anti-Illusion: Procedures/Materials," in which several of the artists and even some of the works featured in the current exhibition were first brought to the attention of a puzzled public. In 1973, the Guggenheim Museum gave a memorial showing to the work of Eva Hesse. There was a certain European interest in the works, especially in Germany and Holland, and there must have been some intrepid collectors, more likely driven by belief in the art than the thought of investment; but it is surprising, even today, how many works in this show are identified as being from the "Collection of the Artist," and how many of them, deliberately ephemeral, were reconstituted for the present occasion. It was quiet, intellectual, even philosophical work, of interest only to initiates.

Hesse favored cheesecloth stiffened with latex as her material, and

many of her pieces, gone brittle over the years, have their lives short-
ened each time they are shown and exist solely as tangible traces of
the processes of making them, construed as actions: it was the process
of making that was central, the key concept, and the product was merely
the mode of production. The New Sculptors inherited from the Abstract
Expressionists the theme, which they applied to their own media, that
the painting is the *act* of painting, and the canvas is therefore to be
appreciated for what it reveals of its generation, as with the whipped
and dribbled surfaces of Jackson Pollock or the stratified successive
soaks and stains of Morris Louis or the charged swags of pigment of
De Kooning. Traditionally, processes had been disguised: the polished
marble skin of Canova's sculpture and the enamel-like surfaces of
Ingres's painting testify to the proposition that the magic of art is to
produce images that put the viewer in mind of what the images are
of—goddesses, saints, princesses, a duke—without reference to how
the image arose out of material manipulations. The fingers of the artist
would remain visible only in the clay studies, or the preparatory
sketches, which would be cherished by other artists or by connoisseurs
less concerned with reference than with touch. Touch was not espe-
cially valued in Postminimalism, nor, as a general rule, was there a
sense of craft or secrets of manufacture to be hidden. Rather, the stress
was on impersonal processes, the works wearing the history of their
production on their surfaces in such a way that viewers could tell how
they were done—or, for that matter, do them themselves. And the
materials were chosen primarily and perhaps exclusively to preserve
the visual record of the process. Thus Richard Serra's *Splash Piece:
Casting* of 1969–70 (reconstituted for the present show) is made by
splashing molten lead where floor meets wall. The metal ingot, prized
away from its "found" mold, can be arrayed with other splash pieces
in rows, or it can be left where it was, with the drops and spatters of
splashed lead showing on wall and floor. Barry Le Va's descriptively
titled work of 1968–71 (again specially reconstructed for the show),
*On Center Shatter—or—Shatterscatter Within the Series of Layered Pat-
tern Acts*, is composed of five sheets of glass, each 59 inches by 9 inches.
(And I imagine it inconsistent with the impulses of this art that these
should have been "cut to size.") One shatters a sheet of glass by drop-
ping something on its center, lays a second sheet over that, shatters *it*,
lays a third sheet, and so on: standing over the work, one can read its
fractured narrative. Or Richard Tuttle draws a skinny pencil line on
the wall, then nails a thin piece of wire at various points along it so

that a skimpy shadow is cast. The work is then line, wire, and shadow, and there can be no mystery how it was made, for it is not a virtuoso line or an intricate bit of nailing. All these pieces—splatters, shatters, scatters, nothing matters—are exceedingly *democratic* works. The originality lies in the concepts that the works make concrete. The substance is readily available, inherently undistinguished, industrial, and cheap.

There is another interesting influence from its predecessors, this time from Pop, that materially affected the forms the New Sculpture assumed. Claes Oldenburg's "soft" works held a special meaning for these artists. Oldenburg had taken over one of the most famous images of modern art—namely, the limp watches of Salvador Dalí. Because their limpness was incongruent with the rigidity that watchcases are supposed to have if they are to protect the delicate works within, Dalí's image became an emblem of Surrealism. It was just this incongruity that Oldenburg exploited in his soft telephones and soft typewriters, though there was something comical rather than dreamlike about these fabrications in plastic or cloth, and especially about the helpless, shapeless way they collapse about themselves like beanbags. Doubtless part of the appeal of Oldenburg's work lay in the sudden vulnerability of these instruments, which, deprived of their rigidity, can no longer dominate their users. The New Sculptors appropriated the softness but subtracted the content, making variable nonrigid shape one of the devices for achieving antiform. Bruce Nauman's 1965–66 *Untitled* is a piece of rubberized burlap, 14 inches by 49 inches by 35 inches, that takes whatever shape is accidentally given it when flung into a corner. Its visual interest is about as null as it is possible for a visible object to attain to, but, like much else in this decade and certainly in this show, its essence is the history of its renunciations. In light of this, its being sackcloth gets to be almost allegorical, as sackcloth, made waterproof, gets to be almost a joke, like the minimal garment of an anchorite concerned to keep dry. Eva Hesse's *Untitled (Rope Piece)* of 1970, a casual-seeming network of latex-coated rope, string, and wire festooned across a corner as if by a giant but inept spider, is of variable dimensions and arbitrary shape. The substances of this show—rope, string, wire, fiberglass, glass shards, burlap, stones, lead sheets, lead pipes, molten lead, chunks of rough wood—are the materials of impoverishment (of what came specifically to be called *arte povera*), and the processes of the show are radically egalitarian. Barry Le Va subtracted some ball bearings from one of his works on grounds of irrelevant elegance. And he invented a use for flour as an artistic material,

dropped into patterns on the floor but subject to rearrangement through drafts. Le Va's flour pieces embody to perfection the two principles so far discussed—process and antiform—and they carry all the iconographic meanings that belong to the movement: rawness, roughness, shapelessness, virtually as political or even religious metaphors. Like the hacked, the distressed, the broken, the shattered, the clumsy, the ugly, the coarse, the crude, the uneven, the unpolished, the unfinished—properties possessed in some distribution by all the works in the exhibition.

Yet the work is not at all dour. In fact, for all the collective probing into the metaphysics of art, for all the implied radicalism in repudiating the institutional bases of elitist art ("What do we do now," asked one of Le Va's friends, who had helped him strew flour on the floor, "just sweep it up?"), there is a quality of comedy, of conceptual laughter, of affirmed absurdity that ripples through the entire show. Perhaps the first work to strike the eye as one enters the gallery that would be first in a chronological ordering (on the second floor) is a cluster of black, elongated, wurstlike forms hung by strings. This is *Several*, by Eva Hesse, and it is made by coating balloons with papier-mâché and tying their rubber cords together. Possibly its connotations are phallic (Hesse's work sparkles with erotic innuendo), but only if the phallus is thought of in distinct analogy to the balloon, as something that stiffens and goes limp, and provided we can imagine circumstances in which phalluses are bunched together, as balloons are—but, connotations aside, turning balloons into sculpture is a pretty funny idea. Diagonally across from *Several* is *C-Clamp Blues*, a title I find puzzling for a work consisting of a square panel coated with cement out of which emerge two sets of wires attached to a plastic ball, which hangs beneath the panel. Out of the panel protrudes a bolt, which the artist has painted pink. The pink bolt *could* be a penis, as the plastic ball could be an emblematic womb; but if it is a sexual joke, it is even more a sculptural one. Hesse characterized her artistic ethos as "absurd" in a profoundly moving interview with Cindy Nemser, published in *Artforum* in May 1970, the very month she died of brain cancer. In it she said, "I want to extend my art perhaps into something that doesn't exist yet." I think this is, in part, the motive of the entire group, even if the exploratory wit is seldom as exhilarating as it is in Hesse, with its dangling and drooping anatomicities and its wry preposterous juxtapositions. And the deep question is: What boundary was it that the artists felt they had, in Hesse's phrase, "to reach out past"? What needle's eye was it

that art had to be made thin enough to slip through—and into what? Could there have been, I wonder, the sense of an end, so that what everyone was pressing against was the end of art, construed as Gieve Patel's progress, which was to go on and on? As though everyone were feeling their way along a wall for an opening when the history of breakthroughs and progresses was really over and done? Did she want, Nemser asked, to fall off the edge? Hesse's answer was: "Yes, I would like to do that." All ten artists in the exhibit are seeking an edge off which to fall.

I feel this vividly in the later work here of Joel Shapiro, especially in a cast-iron piece of 1973–74, which has the form of a very simple chair, but with startling dimensions: it is 3 inches by 1¼ inches by 1¼ inches. In terms of scale and subject, it is difficult to imagine a work more antiheroic; but this would be a mistake, as it would be to view it as a classy piece of dollhouse furniture. It has been installed, sitting on the floor, in a space relatively large in proportion to its own unassuming dimensions, though not vast enough, I think, for it to manifest its true strength. It requires a very large empty space. One's initial experience would then be, at first, of a tiny object ludicrously disproportionate to the enveloping space. But soon a tension would grow as the object began to pull the space around itself and define it. The tension would grow infinitely in magnitude as the object approached zero, and if the object vanished it would leave behind an unendurably charged space almost too dense to penetrate.

The show's ending is a boisterous confection by Lynda Benglis, *Primary Structures (Paula's Props)*. It is composed of some stumpy metallic Ionic columns, one of them broken, all placed unevenly on a runner of bunched blue velvet. To one side is a white column with an artificial tree placed on top, stuck in a white plaster container. The tree is covered with artificial flowers of a garish color. *Primary Structures* is a mischievous title. It could refer to columns, as columns refer to trees, and carry the sense of something primary, elementary, minimal. But in fact the work is in exuberant bad taste. It proclaims the end of purity, and the end of the artistic era to which its artist had belonged as an explorer among explorers, erasing boundaries between sculpture and painting, taking up with enthusiasm the imperatives of process art. It declares the opening of a new era and the end of renunciation.

This is a flawless exhibition, the Whitney at its best, doing what it understands, meticulously and theatrically. With it, the museum's

trustees condemn themselves for the terrible way in which they fired the director of the museum, Tom Armstrong, who was outstanding. It is everything the trustees said the Whitney was *not* under Armstrong's stewardship: serious, historical, scholarly, and resolutely as untrendy as the impulses of the work shown were. It is historical in an especially difficult way, giving historical shape to a period that would be difficult to grasp without it and the superlative catalogue that accompanies it. Had the trustees known about the show, they could not have said what they did about Armstrong. It follows that they were paying no attention whatever to what their museum was about to do: put on one of its best shows ever. It follows further that the reasons they discharged this director must have been personal and frivolous, as everyone suspects, and the action itself one by men and women used to getting their own way, the institution be damned. They stand red-handed and shamed by an excellence to which they have no right.

—*The Nation*, May 14, 1990

Francis Bacon

GRAMMAR MAKES certain sentences available to us that are useless
for any purpose other than philosophical jokes. "I am screaming," for
example, is what philosophers term self-stultifying: the conditions un-
der which it could be true are inconsistent with its being uttered, so it
cannot but be false if said or even written. Thus the lie is transparent
to all but the writer when the hateful and ludicrous Fanny Squeers,
in *Nicholas Nickleby*, puts into a letter "I am screaming out loud all
the time I write" as an excuse for mistakes. One cannot scream and
write letters at the same time, in part because the circumstances that
explain the scream rule out the possibility of concurrent rational action.
The scream ordinarily implies some loss of will, something the
screamer cannot help despite resolutions of silence, as in the torture
chamber or the pit in hell. But that does not leave the will free for
other pursuits. Or, if we can imagine someone knitting and screaming,
it would have to be someone mad, and the scream, like the lunatic's
laugh, disconnected from the network of circumstances in which either
expression has the meaning of terror, say, or mirth.

Much the same considerations apply to cases in which an artist
paints a scream. It is always a reasonable inference in such cases that
the scream cannot be the artist's own, for the mere fact that the rep-
resentation is clear enough to be recognized as a scream is inconsistent
with that. Painting, in whatever way it facilitates the expression of
emotions, cannot *be* a kind of scream if it is in fact *of* a kind of scream.
This is an important truth to keep in mind when viewing the painted
screams of Francis Bacon.

Bacon's images of screaming popes are among the great defining

images of twentieth-century art, and certainly they were taken, in the early postwar years when they first appeared, to be artistic summations of an era of unspeakable agony and horror. And they affect us even today, and against the body of Bacon's far less compelling subsequent work, perhaps because we cannot be indifferent to screams—not even when we know, for example, that someone is only practicing for a part that requires him to scream, just because that particular sound, issued through a human mouth, must trigger in us reflexes over which we have as little control as screamers themselves are supposed to have at the moment of impulse. And a painted scream comparably summons up associations through which it is vested with moral meaning. This is especially so when, as with Bacon's popes, there is no context, within the painting, to account for the scream. When Poussin paints a woman screaming in his *Massacre of the Innocents* (a painting frequently cited as among Bacon's early influences), her scream is a natural response to the butchery of helpless children. When Eisenstein shows the screaming nurse in *Battleship Potemkin* (another source unfailingly cited for Bacon), there is, in the massacre on the steps, all the explanation we need for the grimace of impotence and despair and pain condensed in the shape of her mouth. Seen just as a frame, clipped out of the film, the scream of Eisenstein's nurse still implies a narrative which the shattered glasses and shot-out eye enable us to fill in. There is no available narrative for Bacon's screaming pontiff, all the less so when we appreciate that the painting is itself a modified appropriation of the celebrated portrait by Velázquez of Innocent X. The occurrence of the word "innocent" in two of Bacon's acknowledged sources is possibly worth keeping in mind, though the papal name, in the case of this particular bearer of it, was one of the great examples of ironic nomenclature in the history of mislabeling. Velázquez's portrait simply shows the wily churchman, in white lace and red silk, enthroned in a curtained chamber, wearing an expression that rules out screams.

Everyone, in fact, admires the psychology of Velázquez's portrait, and the larger meanings to which the psychology must contribute. Innocent is looking up from some document held loosely in his left hand, and looks out at us beaming authority, power, mercilessness, guile, defiance, resolution, and contempt from his terrifying eyes. It is the look a shepherd might direct to his sheep only if his mind were fixed on mutton. Innocent may have been indifferent to the expression Velázquez gave him, or possibly he was pleased by it as an outward sign of a man dangerous to trifle with, but one cannot, today at least,

refrain from drawing lessons from the fact that this highest position in the universal church should have been occupied by a man whose character was so at odds with the charity and love that ought to be emblematized physiognomically. It is a tension not easily rationalized, though in its own right it may express a deep truth of Catholicism. Bacon's pope has no psychology to speak of, since the scream leaves no space for other expressions and is in any case not really an expression of someone's character. A scream implies an absolute reduction of its emitter to whatever state it is that the scream outwardly expresses. There are no wry screamers, no crafty screamers. The scream is a momentary mask. Still, the fact that it is a pope who screams raises some delicate questions of interpretation. In the language of symbols, the image of the pope carries the obvious meanings that flow from his position as Christ's surrogate on earth and intercessor for the salvational needs of mankind. The question is why someone with the extreme moral weight of a pope should be shown screaming when, within the canvas, there is nothing that accounts for the act.

It must, of course, be decided whether the pope is screaming *at* something—whether there is an object—or whether, like the screams of the damned and the tortured, he cannot help screaming because of unendurable pain. There are screams of horror, after all, where the witness is overcome by something seen or heard. The pope's scream cannot be objectless, one feels, since he is seated on his throne or on his palanquin (which is one way of reading the yellow curves in Bacon's painting), unless he is supposed insane, like a crazy in the park. He could, if this were an internal symbol for Christians, be screaming at Christ's agony, or in grief, like one of the Marys so often shown at the base of the cross. Whatever the object, it must be commensurate with the stature of the pope as pope. Think, for contrast, of the famous screamer in Munch's *The Scream*, of 1895. A woman (one assumes) is shown running toward us, over a bridge, with a couple in the distance walking away, as if indifferent to her anguish. The screamer's object (if there is one) must, one is certain, be some fraught personal situation she finds unendurable: the image is a depiction of personal extremity. And this fits with Munch's work—his themes are sickness, jealousy, bereavement, madness, sexual torment—as well as what we know of his character and his life. But none of this would fit with the screamer's being a pope, all got up in ecclesiastical regalia. Neither, in truth, does it fit with Bacon, from what we know of him as a person. And the assumption would have been, in the postwar years, that the pope was

screaming as the only appropriate moral response to the fallenness of mankind and the world as slaughter bench. As such, it could not but be a powerful image, even if somewhat crudely painted, save for the lavender capelet. Somehow, if a message, it must have seemed too urgent to be conveyed through a piece of elegant painting. The powdery white, the swipes of yellow, and the vertical slashes that are vestigial reminders of Velázquez's drapes, though they also suggest a deluge, are secondary marks of the moral lamentation of the howling prelate. One would have wanted to scream in sympathy: "And with that cry I have raised my cry," as Yeats writes.

All of Bacon's work in those years, whether or not of popes, appears to be of screams or to call for screams. In his *Painting*, of 1946, an early acquisition by the Museum of Modern Art, which is honoring Bacon with a retrospective exhibition, the screamer is in a business suit, a yellow boutonniere in his lapel and the upper half of his face cast in shadow by his umbrella. He is surrounded by butchered meat, including, behind him, an immense gutted carcass hung by its legs. The carcass of beef, in Rembrandt's painting of one, seems to connote helplessness of a nearly cosmic order and comes across as a symbol of suffering, as it does in a bloody painting by Soutine. There is a harsh contrast in Bacon's image between the regular rhythm of bones and teeth and that of torn flesh and a world torn by the scream of the man, whose umbrella is an affecting symbol of ineffective protection, certainly against the forces that rend flesh, eviscerate bodies, consume in pain and flame. *Painting*, in context, had to have conveyed some political message and, to use the irrepressible word from those days, existential mood. And there are several images of heads that bear out this heavy inescapable reading, for they seem to have no discernible features other than toothed cavities, as if their owners had died, beaten to some pulp, with a terminal scream on their lips. In some cases, the screamer is seated, as the pope is, but in such a way and in such a space that it could be the electric chair the screamer is in. And in all or most of these, the vertical lines rain down, cleansing perhaps, purging, or just adding to the agony, having no connection to the vertical fall of drapes from Velázquez.

So, if not strictly Bacon's screams, these depicted screams seem to entitle us to some inference that they at least express an attitude of despair or outrage or condemnation, and that in the medium of extreme gesture the artist is registering a moral view toward the conditions that account for scream upon scream upon scream. How profoundly dis-

illusioning it is then to read the artist saying, in a famous interview he gave to David Sylvester for *The Brutality of Fact: Interviews with Francis Bacon,* "I've always hoped in a sense to be able to paint the mouth like Monet painted a sunset." As if, standing before one of those canvases, Bacon were to say, "Well, there, I think, I very nearly got a screaming mouth as it should be painted. Damned hard to do." Or to read that "horrible or not . . . his pictures were not supposed to mean a thing." So Cézanne painted apples, Renoir nudes, Monet sunsets, Bacon screams. To paint a scream because it is a difficult thing to paint, where the difficulty is not at all emotional but technical, like doing a human figure in extreme foreshortening or capturing the evanescent pinks of sunrise over misting water, is really a form of perversion. As a perversion, it marks this strange artist's entire corpus. It is like a rack maker who listens to the screams of the racked only as evidence that he has done a fine job. It is inhuman. As humans, however, we cannot be indifferent to screams. We are accordingly victims ourselves, manipulated in our moral being by an art that has no such being, though it looks as if it must. It is for this reason that I hate Bacon's art.

Bared teeth and exposed bones play a referential role in some of Bacon's later works, particularly in two triptychs, one of which, *Three Studies for a Crucifixion*, shows the victim hung upside down in the right panel, like an emptied carcass, with his head lying in what one supposes must be his own spilled viscera. But by this stage in his development, Bacon had begun to treat his figures virtually as viscera, as lumps and gobbets and tubes of flesh, not easily identified anatomically, pink and red and white, as if his subjects were what was left when skin and bones were removed. So shapeless are they, as piles and puddles of scraped and squeezed paint, that one is grateful at times for the mouths, as dentated wounds, to serve as some point of orientation. In the middle panel of this triptych, for example, a figure lies, like a pile of guts, on an elegant chaise longue, blood splattering the pillowcase and rising, like red bubbles, up past the black window shade in some piecemeal ascension. The teeth locate us in the gore, so we can identify eye sockets and a neat wound in one foot. In the left panel stand two uncrucified figures—witnesses, perhaps, patrons, executioners—one of them in a business suit, which could be Bacon himself, the other a blob in what might be black leather. The three panels, paradoxically in view of their content, are done in cheerful decorator colors, apart from the figures themselves: flat planes of pompeian red and cadmium orange, with black window panels. One cannot help

thinking of Auden's great poem on art and suffering, as the old masters showed it: "how it takes place / While someone else is eating or opening a window or just walking dully along." Auden went on, marvelously, "They never forgot / That even the dreadful martyrdom must run its course / Anyhow in a corner, some untidy spot / Where the dogs go on with their doggy life."

How appropriate, one thinks, that the crucifixion should transpire in a tasteful salon, amidst the sort of *fin de siècle* color scheme Odette de Crécy would have favored when Swann at last found his way to her body. After all, the act of love, thrashing bodies and flashing teeth and animal hoots, also takes place in those ornamental spaces. (Bacon, who had some success as a decorator and designer of Art Deco furniture, also likes to paint coupled figures smeared against one another in damp intercourse.) Or one thinks of the crucifixion as a metaphor for terrible interrogations that took place behind shuttered windows on quiet boulevards that the screams couldn't reach. There is a certain insight in Nietzsche that it is not suffering so much as *meaningless* suffering to which the human mind is opposed, so that it was, in Nietzsche's view, the genius of Christianity to have made all suffering meaningful. Certainly, we stand before works like this—or the *Triptych Inspired by the Oresteia of Aeschylus*—compelled, despite our will, to cover the brutalized bodies with a balm of interpretation, a redemptive coating of allegory, if only to comfort ourselves. So again one feels oneself to have been manipulated in some way when the artist disowns any meaning whatever, and draws our attention, in his interviews, just to paint, almost as if he were some sort of Abstract Expressionist with no antecedent view of what he was going to do when he faced the canvas. Why is he then not an abstract painter—why choose these charged images only to elicit, as involuntarily as a scream, an interpretation he rejects, categorically, as beside the point? We cannot see gore as just so much scraped red pigment, cannot disinterpret a writhing limb as simply a marvelous wipe of white paint. And this stance is reinforced by the fact that we cannot succeed in giving meaning to a lot of what Bacon does in his portraits and figure studies, where the subjects are liable to distortions that ought to have an explanation in the world to which the figure belongs but which will standardly be given an explanation from the world in which painting takes place—as something that happens not in meaningful spaces but on meaningless surfaces.

There is one absolutely marvelous painting in the show, worth anyone's time to see. This is *Study for Portrait of Van Gogh III*, of 1957.

It shows us what Bacon could have done had he given to the whole painting what he instead gives to isolated faces and figures. He shows Van Gogh as Van Gogh might have shown himself in a world that looks the way he represented it in paint—as if the world were made the way paintings are—trees of black paint squirming up out of fields of red paint, past fields of yellow paint and green paint. The artist stands on heavy feet, the kind that belong in his famous shoes, in a field of pink mud, casting blue shadows. He has a black all-purpose face; it could be the face of a horse as well as a human, or even of a fish. The face does not matter: it is the world according to Vincent, and we are seeing it from within. For its allusiveness, its power, its brilliance, its total engagement with its subject, it makes the rest of the show look like posters for some avant-garde Grand Guignol of yesterday. The portrait of Van Gogh is a homage, a celebration of the only values Bacon allows himself to mention, the values of painting as painting. It shows what his deflected talent is capable of when his heart is in his subject.

—*The Nation*, July 30/August 6, 1990

Trompe l'Oeil
and Transaction:
The Art of Boggs

ONCE, I ACQUIRED, for a five-dollar bill, a painting of a five-dollar
bill by the American money painter, N. A. Brooks. The circumstances
were these. I saw the painting, in a gold frame, displayed in the window
of a junk shop on West 110th Street in New York, perhaps twenty-five
years ago. Fine paintings always have a light of their own, and though,
from the bus window through which I spied it, I could not make out
what sort of image it was, it was immediately plain to me that it was
the work of a master, violently out of place amidst the cheap furniture
and tawdry bric-a-brac piled in disorder in this nondescript storefront
of a marginal, sinking neighborhood. I ran back as quickly as I could,
instantly perceived that it was a serious painting, and inferred that the
shopkeeper had not perceived this fact, or he would have tried to sell
it as such, rather than as just another item in his uninspired inventory
of secondhand merchandise. I asked how much he wanted for the
frame, and was told by the proprietor that I could buy it only if I gave
him a five-dollar bill in place of the one he had tried unsuccessfully
to remove. The frame was mine for seven dollars more. So for the sum
of twelve dollars, I came into possession of an exemplary work by a
minor master of American trompe l'oeil painting. Brooks's signature
was as clearly written as the bill itself was painted, though the latter
was somewhat the worse for the failed history of its detachment.

The storekeeper, doubtlessly, congratulated himself on having
found someone gullible, ignorant of how firmly that treasury note had
been glued down. For him, I surmise, the object belonged to that genre
of mementos with which small businesses preserve, for good luck, the
first piece of money taken in after an opening. This is ritually withdrawn

from circulation, like a sacrifice to the gods of commerce, asked to favor the prosperity of the new enterprise. It maintained the ritual that the bill should be of small denomination—no one would frame a thousand-dollar bill—but also be significant enough so that framing and hanging it rather than spending it meant, literally, that a *sacrifice* had been made, much as the ancient Greek warriors did when they burned a piece of flesh for the benefit of Zeus.

I have often wondered whether it would have pleased Brooks to know that his hand was cunning enough to fool the innocent eye of a shopkeeper who had, if no very strong conception of art, certainly a hands-on familiarity with small bills.

Endeavoring to touch is the spontaneous reflex of someone not sure of the eye's capacity to distinguish reality from illusion. My sense is that the money painters found their triumph in fooling eyes that had lost their innocence long ago, trying to get them to touch because they could not tell by sight alone whether the artist had painted a five-dollar bill or had pasted down a real one in order to get the viewer to believe he had painted it. Everything in these wonderful paintings was calculated to enhance those doubts, a flat object flattened against a flat surface, and the viewer is obliged to decide whether the surface of the object is *in* the shallow illusory space of a painting or *on* the nonillusory surface of a flat panel. Flatness diminishes parallax to nearly zero, eliminating recourse to the treacherous illusory device of perspective. And maximally flat objects cast minimal shadows, and so provide weak visual cues as to whether the source of light in the painting differs at all from the source of light in the room where the painting is seen. "Trompe l'oeil is such a ritualized form," wrote Jean Baudrillard in a well-known essay: "The absence of a horizon . . . a certain oblique light . . . the absence of depth, a certain type of object (if it would be possible to establish a rigorous list of them), a certain type of material . . ."

We might add to this checklist the visual intricacy of legal tender, meant through its extravagant use of florid ornamentation to thwart the counterfeiter and, for that reason, to make it appear as though the painted bill *must* be real money, so that the viewer of a money painting is locked in an agony of epistemological indecision from which touch alone can release him. It is when the sophisticated viewer, looking to right and left to see if the guard can be counted on not to see him, runs his fingers over the surface to discover that it is after all only paint, that the artist, were he present, could voice his gloating

"Gotcha!" and taste the triumph of his demonic gifts. The miraculousness of my Brooks was that it even passed the touch test!

Boggs—he has a first name but prefers not to use it—has in common with the American money painters—Harnett and Peto, Brooks and Kaye—illusionist skills, respect for the ritual dimension of money, and above all responsiveness to and respect for the elaborate faces of banknotes and greenbacks. For they are marvelous constellations of images and symbols, intricate embellishments and ornamental flourishes, signatures, numerals, letters in various styles—virtuoso set pieces of the engraver's art, visual expressions of the power of the state whose authority they emblematize. It is, on the other hand, no part of his task to fool the eye, deceive the viewer, raise vexing questions of appearance and reality, provoke doubts about the authority of the senses. Everything is, as it were, aboveboard, largely because in a great many cases it is central to his effect that he be seen drawing, and in the act of demonstrating his dazzling draftsmanly powers. And the superlatively drawn note exists initially to precipitate a complex happening in which the "Viewer" is induced to play a role and run a risk. Boggs's is a postmodern art form, a mode of interaction between audience and artist in which each takes chances which go considerably beyond the traditional concept, central to the ideals of painting since ancient times, of cognitive error, of taking painted grapes for real fruit.

Images of money served the money painter as a kind of bait, a means of cognitive entrapment, in which his delineative skills were matched against the Viewer's visual skills in a game of right and wrong. Boggs also uses money as a form of entrapment, or at least seduction, but in a new order. He seeks to engage the Viewer as a Participant in a fascinating interchange based on the disparity, widely recognized, between the face value on a drawn piece of paper money and the variable value of the drawing of it as a piece of art. It would be rare that the "face value" and the exchange value should be equal, as in the case of my five-dollar bill; an equality, in any case, based on someone's ignorance that the bill was art. In Indian literature, there is a standard example in which someone takes for a piece of silver what in truth was mother-of-pearl. It appeared to have a value, which dissolved in the knowledge of what it really was, proving the treachery of appearances. By rights, if someone takes for a five-dollar bill what is in reality only a few cents' worth of paint, the same transformation should take place. Instead, what appears to be a real five-dollar bill is really a work of art and, as such, worth more—and perhaps a great

deal more—than it would have been worth had it merely been a piece of money. Boggs's enticed Participant knows this, which gives him an incentive to play the game. For while Boggs's money drawings are only drawings of legal tender, and as such not backed by the tresorial might of the government, they are backed by the institutions of the art world and by the fact that there may be others prepared to exchange serious money for them.

The game is played as follows. Classically, Boggs displays himself drawing a piece of money, making it perfectly plain that deception is in no sense part of his means or aim. His aim, initially, is fascination: the Viewer is fascinated both by the way the money is drawn and by how real the drawn money looks. Were Boggs to set up a table in public and draw pieces of money, he would quickly draw a crowd. Among the onlookers there would certainly be some who would wish to buy the drawings, ready to exchange real for simulated money, but much in the way buyers of drawings exchange real money for simulated faces or bodies, the only difference here being in the subject matter of the drawings. Boggs's drawings are not, in this sense or at this stage, for sale, however. He instead wants to "spend" the drawn money, quite *as if* it were real. No one is fooled: he is not trying to pass off counterfeit money. The truth is available to all that he made something that looks like money only to the point of *reproducing* the money's overall look: the details will differ, and Boggs enjoys improvising all sorts of joking substitutions—signing his own name where that of the Secretary of the Treasury officially belongs, writing "Measury" for "Treasury," and the like. The point is to transform Viewer into Participant by getting him to treat the drawn money as if it *were* what it is only *of*, and giving over goods in exchange for it, at the accepted market value of the goods, just as if this was a perfectly ordinary transaction. Since the price is always lower than the face value of the bill, Boggs expects real change.

Once the transaction is achieved and Boggs is in legal possession of the goods or service for which his "money" was exchanged, the money is transformed into a work of art, and the Participant into Owner. The game does not end here, however, as it does with most sales of art. Of course, the Owner could play the same game with some new party as Boggs had played with him: he could endeavor to "spend" it, as Boggs had. But as it is art, it may now be worth a great deal more than it could be "spent" for, since the rules of spending require that whatever is purchased have a fixed price. But the drawing's value as

art is indeterminate. And the Owner must now make a delicate decision: to keep and enjoy the work, or to endeavor to sell it and realize a profit—or to keep it and enjoy it with one eye while the other is on the art market. Will works by Boggs become more and more valuable, or less and less? When is the right time to sell, if you are going to sell? Either way, there is a lot to enjoy in the drawing, including being able to tell the story of the transaction itself through which one came into ownership of it. I enjoy my five-dollar bill, but I also enjoy telling the story of how it came to be mine. I also know that works by N. A. Brooks are going up in value, and I may someday decide that it is time to sell. The public is now more aware of the art market, and is more conscious of the potential increase or decrease in the value of any work of art. Boggs counts on that consciousness, thereby keeping the Viewer-Participant-Owner engaged.

In a way, Boggs's work is less the drawing than the transaction the drawing facilitates. After all, it is a drawing of a piece of money, and in truth the transaction could take place, as in some cases it has, if instead of drawings these were laser-reproduced facsimiles of real currency. Still, the actuality of their being drawings plays a certain role in the transaction, mainly because of the quality of the drawing and the pleasure the Owner takes in the artist's evident and palpable skill. If, indeed, the Owner keeps the drawing, one would think Boggs would be fulfilled as an artist, but in fact this is not altogether true of a *transactional* artist. If the Owner keeps the drawing, Boggs will have earned only what he has been able to spend the money for, and considering the amount of energy, the amount of sheer nerve that it required to bring off such a transaction, the risks Boggs runs of being mistaken for something other than he is, the reward—at least the momentary reward—is not great. His real income as an artist will depend upon whether the Owner perceives the drawing not as a drawing, but as the key part of the transaction, and at this point additional components come into play. These are the pieces of change or ephemera which Boggs has documented in some way as belonging specifically to this transaction: the bill of sale, the canceled ticket—together, wherever possible, with the goods, or documentation of the services, for which the money was originally spent. The transaction includes these components. And Owner and Boggs will each have part of the work —the Owner the drawing, Boggs the rest—each in consequence a hostage to one another. Either of them can sell his part of the transaction to a third party, who can then engage in new negotiations to bring the transaction into another completion.

The piece of money, however brought into being, is the nucleus around which a number of objects orbit in a constantly changing series of transformations, bids and bets, calculated risks, in which individuals and objects play different roles, take on different metaphysical identities, face losses of money and philosophical status. It is a kind of happening. The happening climaxes when the drawing, in becoming art, confers the status of art on a number of things not ordinarily thought to enjoy that exalted position, and not perceived as art save against a knowledge of the narrative of the transaction and of its rules. It is a kind of magic. The components enter the world of art together as a "Boggs," something to be collected, reproduced in catalogues, interpreted, and enjoyed in the way works of art are. It has become a privileged, transfigured object. And the game can go on and on!

To understand the transaction is to appreciate the transfigurative power of the institutions of the art world, which intervene at appropriate moments. It is also to grasp a narrative of dangers and metamorphoses. At the heart of the narrative, of course, is Boggs as a kind of seducer, a tempter, a provocateur, a conjurer, initiating the transaction through which there is the chance, as in some sort of financial deal, for everyone to prosper. Boggs must be appreciated, then, within the realm of the performance artist, and a word must be said about this remarkable genre of art making. It is here that the artist places himself or herself at the boundary between art and life, and in doing so, courts genuine peril in the distant hope that some powerful transformation may occur. The performance takes place on two levels: it is art and real life at once. The drawings themselves are art and money—art that looks like money which becomes money if trusted as such and can, like real money, be cashed in for real goods. It exposes Boggs to real risks just because the government holds a monopoly on the issuance of currency, and Boggs, in getting the Viewer to participate in the transaction by accepting the drawing as money, immediately criminalizes the action.

Performance artists characteristically expose themselves to comparable dangers of being injured or attacked. Their art emerged at a moment when artists were, in various ways, protesting the institutional character of the art world, and sought to colonize the real world in the name of art. I have often thought of the performance artist as a kind of priest, prepared to sacrifice himself or herself in order to restore to art its edge of danger, and to collapse the barrier between reality and art, which protects the two from leaking into one another. In *The Birth of Tragedy*, Nietzsche describes the frightening excesses to which an ancient community became susceptible when it undertook what began

only as a dramatic performance. The actor might, just might, at the climactic moment, be possessed by a god, at which point the chorus will be transformed into celebrants, the barriers between chorus and audience become obliterated, and the entire community gets caught up in the sort of orgiastic sacrifice one reads about in the *Bacchae*. When the barriers between men and gods are breached, the barriers between art and life are swamped, and something horrifying and liberating at once takes place—something so powerful that the dangers are worth courting. It is possible to argue that the dark memory of this power and danger accompanied the ancient Athenians when they attended dramatic festivals, and that what Aristotle speaks of as catharsis is a reenactment of ancient transfigurations.

Nothing secular has an aura more seductive than money, which, when one thinks about it, yields a qualified metaphor for man. Human beings are supposed to possess a certain value, just by virtue of being human, whatever they do with their lives, however morally soiled they may become. A five-dollar bill is worth five dollars, however torn and crumpled, worn and frayed. I have often thought the old money painters chose conspicuously used bills for their models in order to mount a kind of religious allegory. Those bills of humble denomination retain their worth, however many hands they may have passed through, whatever indignities they may have suffered. It cannot be an accident that we use the word "redeem" in connection with souls and money. The worn and torn have as great a value as the new and crisp. Bills of great denomination enter too marginally into circulation to yield these moving parallels. If the religious analogy were protracted, the bills of high denomination would be like saints, as outside life as it is possible to be while still being within life. The bills of low denomination are taken for granted, since nothing is more commonplace than money, and it is inevitable that a celebrator of the commonplace, like Warhol, should have painted dollar bills—and, more peculiarly, two-dollar bills. Boggs's interest in money is the polar opposite to that of Warhol. He is interested in money for its visual beauty—something of which we are rarely aware as we count bills or stuff them into wallets—and part of his output consists of works which magnify, hence glorify, money as beautiful, as if the outward intricacies of design and symbolism were emblematic of money's inner worth. Indeed, if we paused to look closely and carefully we would see that, as an engraving, a mere dollar bill should be worth far more than its face value (I once read of a man who advertised steel engravings of George Washington for twenty-five

dollars, and sent dollar bills to those who answered the ad). Boggs makes magnifications of different currencies so the Viewer can see, without benefit of a jeweler's loupe, what ordinarily cannot be seen with the naked eye. Of course he takes great liberties with these magnifications as well: he showed me a large ten-dollar bill on which he intended to place a picture of the Supreme Court Building in place of the United States Treasury. And he takes pleasure in making sly and impudent alterations. Easily overlooked, so that, in a sense, the shadow of illusion falls across the faces of these large paintings, but at a different point than that of the money painters. No one thinks a very large bill is a real bill, but it is easy to believe that Boggs's big bills are but enlargements of small ones. And Boggs's punning wit plays across these handsome surfaces, laying traps for unthinking eyes.

Once, under instructive circumstances, I acquired a work by Boggs; not a drawing of a dollar bill but a modification of one. I was at the opening of a show of his at the Vrej Baghoomian Gallery. We were to meet afterward, and someone gave me an address. I had no paper to put it down on, but the surroundings prompted me to fish a dollar bill out of my billfold to write down the information. When Boggs, from across the room, saw this act, after all a homage to his own vision, his eyes gleamed. Like the character in *The Madwoman of Chaillot* who, when asked whether a hundred-franc note belonged to him, replies that *all* hundred-franc notes are his, all money is Boggs's province. He took the bill from my hand and began writing. He wrote his own name over the signature of the Treasurer, and he crossed out the serial number, putting in one of his own. And then he dedicated the work to my wife, Barbara, and me by writing at the top, "For A & B." I intend to frame it, and hang it just below my five-dollar bill by N. A. Brooks. The space between them will be a metaphor for the philosophical distances which unite and separate two ways of turning money into art.

—*J.S.G. Boggs: Smart Money (Hard Currency)*, Tampa Museum of Art, 1990

Hans Hofmann

THERE IS a photographic portrait, taken in 1960 by Arnold Newman, of Hans Hofmann in his studio. The artist, then in his eighty-first year, is leaning on a table (which holds seven tubes of oil paint, a coffee can, and two large brushes) peering directly out at the viewer, while his left arm points over his right shoulder to the painting behind him, placed upright on his easel, as if to say: Behold! The painting, at first glance, is typical of Hofmann's work of the early 1960s, and indeed of the last phase of his life, in which he found himself as a painter. It is a composition of juxtaposed rectangles, in various proportions, but large in relationship to the canvas, and so far as I can tell it is not among the works assembled in the large retrospective exhibition devoted to Hofmann at the Whitney Museum of American Art, though there are a good many works from the same period that differ from it scarcely at all. The object on the easel is nevertheless extremely puzzling. Both the gesture of the artist, straight out of the repertoire of baroque portraits in which some personage points to something to which the viewer is meant to respond, and the fact that the work is signed and dated (1959) imply that the painting is finished and the easel used merely for purposes of display. But if we look carefully at the photograph, we find that the painting seems still in progress, for Hofmann has fastened several rectangles of paper to the surface with pushpins, which was a standard part of his procedure in those years: moving rectangles of colored paper around on the surface until they looked right to an eye that had been looking at paintings this way all his life. And then, when they did look right, translating paper rectangles into painted ones by tracing the outline of the paper and filling it in with paint.

At a certain point in the life of the work, it would resemble a sort of abstract bulletin board, with odds and ends of blank colored paper pinned to the canvas, with, at the end, a painted record of the final disposition, the work itself, which the bits and pieces helped visualize. The work itself could, uncharitably, be said to look like a painted abstract bulletin board, but in fact the redemption of paper by paint was a transition from rectangles affixed to a surface to rectangles both on the surface and within a represented space, and this double locus of the painted rectangle was pretty much what Hofmann taught that painting was all about. Painting, he tirelessly maintained as both teacher and writer, was inherently representational, which meant that the picture plane must be preserved in its two-dimensionality and at the same time achieve a three-dimensional effect. The paintings through which he showed this were made of rectangles or had rectangles among their chief components. But whereas all paintings are representational, Hofmann's, in addition, are about pictorial representation. This concept of representation was more vernacularly, even jocularly, designated "Push and Pull" in Hofmann's schools of art, where it became a kind of affectionately repeated slogan, as if it were a school cheer, as it condensed the master's view of "the laws of painting."

They are indeed laws, and as such there is nothing an artist especially need do in order that they apply, though bringing them to consciousness doubtless spares a painter a certain degree of frustration, should she or he seek to work against their grain. Every painting is a two-dimensional surface, even the rather "fat, heavy, and eloquent surface[s]," as Clement Greenberg describes them, that Hofmann influentially effected. No doubt, in the interest of illusion, painters in the past at times sought to render their surfaces invisible, or absolutely transparent, putting the viewer in immediate contact with the scene depicted as if through air. No doubt again, in the interest of anti-illusion, painters sought to render pictorial space invisible by treating paint so opaquely that the question of seeing through it could not arise. But the most polished surface remains a surface, while the flattest surface implies depth, so the laws come into effect the moment one draws a line, makes a smudge, a dab, a stroke, or floats a wash or a glaze. What perhaps can be said is that Hofmann's rectangles make Push and Pull particularly perspicuous. If as an artist what you wish to teach is the truth of Push and Pull, then rectangles will serve admirably as a means, just as tiled floors or coffered ceilings are perfect means for demonstrating perspectival depth. As a general rule, artists

did not make perspective thematic in their work, as it was what was taking place in space—crucifixions, adorations, martyrdoms, ascensions—that was the primary occasion of the work. Hofmann too was interested in matters other than Push and Pull, but as a painter he was mainly a teacher of painting, and if not Push and Pull, then various of the other Hofmannian categories would pretty much be the substance of his work. His teaching and his practice were very largely one.

Hans Hofmann was an inspiring teacher, and his schools were among the shaping institutions of American art in the 1940s and 1950s. That is what justifies an exhibition at the Whitney Museum of American Art for an artist born in Weissenburg, Germany, who moved to this country only when he was in his fifties, when the institution otherwise cites American birth as an exclusionary principle of self-definition. Perhaps it would have been a fitter tribute to have had a show of his many students—Krasner, Frankenthaler, Rivers, Grooms, Diller, Vytlacil, Holty, and many others perhaps less well known but as good or better artists than they. "I have students all over the world," Hofmann wrote in 1956, "many thousands of them who have become ambassadors for the spread of my basic ideas, and every one of them is doing it in his own individual way." It confirms the truth that Push and Pull is invariant to painting, that there is no "Hofmann style" among his students, as may easily be seen from the list just cited. (Diller, Grooms, and Krasner hardly look as though they could have come out of the same curriculum.) But it could also be explained by the fact that Hofmann's own style, or really set of styles, was not particularly infectious. There is something about Hofmann's paintings that would lead me, were I a painter, to want not to paint like him. I am not one who supposes there to be an incompatibility between doing and teaching, any muting of creative powers—in the field I know best, that of professional philosophy, there has hardly been a thinker of the first magnitude since Kant who was not also a teacher. (For some among these, teaching was also the substance of their thought, or part of it, as in the case of John Dewey, though the principles that animated Dewey's views on teaching bore on logic, epistemology, value theory, aesthetics, and metaphysics.) I think Hofmann probably was as good a painter as he was a teacher, but that the principles of his teaching were also the substance of his painting. For him, more than any other artist I know of, the art school was his world, the horizons of the art school the horizons of his art, even when he decided at age seventy-eight to close his schools and devote himself full-time to painting.

Consider, once again, the painting in Arnold Newman's photograph. I am not certain how to remove the contradiction between, on the one side, the date and signature and, on the other, the pinned-on rectangular swatches. Hofmann could have signed and dated a painting in 1959 on which he was still at work in 1960; or he could have decided in 1960 that the painting needed more work, despite the signature and date, and it was at some moment of revision that Newman captured him on film. But there is another explanation possible—namely, that he was not so much working on the painting as he was showing someone, perhaps Newman, the truth of Push and Pull, and how one moves from cutout to painted rectangles, in the timeless processes of pictorial transubstantiation. Hofmann had turned his school into his studio, but the spiritual truth is that he *was* the school, whose codes and motifs totally defined his estimable but limited vision.

The installation of the Whitney show is intelligent, even if dictated by certain architectural exigencies, as explained to me by guest curator Cynthia Goodman. What you first see are in effect Hofmann's last paintings, to your right as you exit the elevator. These are large but not immense canvases, still easel paintings, representational in Hofmann's sense, but abstract. Many contain his signature rectangles, which are large and somewhat awkwardly placed, and these share the spaces of the picture with some energetic brushing, some strokes of impasto, an occasional flurry of drips and drops, and sometimes a thread of paint that could have been squeezed out of the tube onto the canvas. *Song of the Nightingale* of 1964 has a large green rectangle and a cadmium yellow one that overlaps a white one floating above it. These look sharp-edged, especially in contrast with the smoky-edged rectangles that are brushed into clouds of pigment, but they are not simply mechanical transfers of sheets of paper, and have nice painty edges that trespass their geometrical boundaries. I suppose the sharpish rectangles Pull and the smoky ones Push—the one comes forward and the other one goes back. To the right is a pink rectangle overbrushed with white dabs, which is partly Pull—it has two sharp upper corners—and partly Push—its bottom corners dissolve into something more fluid, less definite, less geometrical, more paint and less form. *Song of the Nightingale* is typical of Hofmann's late production, with its balanced combination of sharp and fluid, filled-in and brushed-on forms. It defines a sort of norm. There are other paintings, like *Flaming Lava*, which is almost all scraped- or brushed-on pigment, with a lovely passage in which some coral strokes play against an ocher form en-

deavoring to become a definite oblong; and still others, like *Cathedral*, where rectangles abut one another like tectonic plates and where there is very little of the swinging brushiness, everything seeming heavily regimented, vertical and horizontal. The titles suggest some reference beyond Push and Pull. *Sun in the Foliage* has a bright yellow rectangle (the sun) swagged with green scrubbed paint around one corner and reddish brushed paint around another (the foliage). *Rising Moon* has a yellow disk in the upper left corner. If they can be abstract and representational at once, they can be abstract and referential at once as well. With a lot of the abstract work of Hofmann's era, one could chase down references—to a tree, a bird, the sun, some flowers—so that the paintings could then be taken as abstract landscapes, still lifes, interiors. The point in Hofmann is less that these are references to real things than that they refer to genres of academic painting. Looked at this way, the painting that serves as cover to the catalogue, *Cape Cod—Its Ebulliency of Summer* of 1961, resolves itself into a vase of red flowers with some green foliage, the upper right blue square becomes a window, the elongated yellow vertical below it a patch of sunlight.

I have always been lukewarm toward Hofmann's work, though I have wanted very much to like it. I have vivid recollections of walking through shows of his at Kootz's gallery, trying to respond to them when they left me cold, exercises in Push and Pull, in lime and magenta, crimson and orange, straight and brushy, desultorily referential. There was always the explanation that Hofmann was difficult. Greenberg wrote in an important essay in 1959, happily reprinted in the Whitney catalogue, that "Hofmann . . . is perhaps the most difficult artist alive—difficult to grasp and to appreciate." But hardly more difficult, one would have thought, than work I found enthralling without the benefit of reading what critics and theorists had written about it: that of Rothko and De Kooning, Barnett Newman and Motherwell, Pollock and Kline. Besides, Hofmann's did not really *feel* difficult—it seemed sunny, and ingratiating, but without depth. It was like a wine that comes on with a certain rush but has nothing to follow it up, was without levels and allusions and depths. Greenberg said, "The only way to begin placing Hofmann's art"—and it is striking that for him difficulty meant difficulty of *placement*—"is by taking cognizance of the uniqueness of his life's course, which has cut across as many art movements as national boundaries, and put him in several different centers of art at the precise time of their most fruitful activity." Well,

that is what this exhibition seeks to do, and in which its great value lies. We leave the last work and enter, so to speak, upon the life, and then, following Hofmann's career through six decades, we return to the beginning of the show and the flamboyant climax of his art. Let me stress that I found the last paintings no more rewarding than when I had seen them, or their peers, at Kootz's. But the exhibition helped me answer the question not so much of Hofmann's difficulty as of my difficulty with Hofmann.

The show begins with some figure drawings done in 1898, life studies of figures not as they are seen in life but as in art schools: nudes on platforms, kneeling, stretching, seen from the back and from the front. Hofmann was eighteen when he did them, and his mature life accordingly overlapped the entire history of modern art—the Fauves, the Cubists, Kandinsky's first abstractions, German Expressionism, Surrealism, to mention the movements that seem to have impinged on his sensibilities most. He sketched alongside Matisse at the Académie de la Grande Chaumière. He got to know Picasso and became friends with the Delaunays. But impingement remains the exact relationship in which Hofmann stood to the history through which he was living. He was keeping up with current events but not contributing to them, and his subjects remain those of the atelier: the vase of flowers, the posed figure, the occasional portrait, the still life, the studio interior, the harbor view with sailboats; and this canon of suitable subjects became the basis for his abstractions, when he went abstract. The work over this long stretch of time is a geological record of styles and mannerisms as adapted to the studio canon. Consider just the *Self-Portrait with Brushes* of 1942. It is an exercise in assimilated Cubism, wherein loose areas of color are drawn through and given definition by black painted lines in which forms are in effect drawn with the brush. Hofmann was sixty-two and vigorous, but merely a master of academic Modernism, and still doing what must be called student work, however advanced. Two years later he was doing dripped abstraction, learning the next lesson that the great correspondence school of history sent his way. Or, if you like, until the late style, the Hofmann corpus is like a Platonic cavern, on the walls of which the great historical happenings cast their shadows. It is still art-school abstraction when he becomes something more than a practitioner and adaptionist.

Abstractionism is not so much a liberation from the subject as a license to take on subjects that could not have been treated, except allegorically, within the framework of similitude that defined Western

painting. Greenberg commends Hofmann for not expanding the scale of his work, but for the masters of the New York School, expansion of format was a metaphor for the expansion of themes. Pollock, De Kooning, Newman, and Gottlieb were metaphysicians and shamans, and their themes were magic and mystery, force and flesh, spirit and suffering, energy and death, passion and self. The geometrical abstractionists of the 1920s were looking for doors into the fourth dimension, Platonic reality, mathematical beauty, intellectual absolutes. Hofmann's vision was severely limited, alongside these, bounded by the pedagogical motifs of the life class, the class in advanced composition, the outdoor painting class. In the academic tradition, before Modernism, these motifs were steppingstones to the grand historical paintings and the large political and religious themes. By Hofmann's time they had become vestigial, ends in themselves, steppingstones to the depiction of reality so long as reality was supposed to consist of pots of flowers on gueridons, sailboats and bathers, girls in armchairs, the fisherman's shack of Rockport, the trees at Fontainebleau, barns against the Vermont hills, self-portraits with brushes. How little this reality was reality remained for the Pop artists to show.

Art criticism sometimes is little more than seeking reasons for responses. I have been seeking some explanation of what it is about Hofmann's work that stops me, but these reasons may count for nothing if your responses are different and in agreement with those of impressive critics who think him great. You will have to see for yourself. Whatever your reaction, the exhibition is very deep, raising questions about art through Hofmann's art that were never raised by it per se.

—*The Nation*, September 10, 1990

Gins and Arakawa:
Building Sensoriums

MADELINE GINS has been described to me as a genuinely advanced poet, by a genuinely advanced poet, of whom there are not all that many. Her advancedness is defined by the boundaries of writing and thought, which it is her mission to extend, even to transcend. So one would not expect sonnets, sestinas, odes, or limericks from her, save in the spirit of verbal mischief; nor would one read her for evocations of childhood lost and innocence vanished, love thwarted or fulfilled, hopeless passion or settled melancholy, daffodils at eventide, white swans in black waters, or laments and ornamental suspirations of the ordinary metrical sort. She is metaphysical, cosmopolitical, medico-practical, epistemographic, sci-fi, phi-psy, cognito-cerebral, semio-logical, postutopian, aristico-heroical, visionary, and wickedly funny. Her topics are spacetimematter, the limits of language, the transcendence of mortality and the salvation of the world through art and what one might call spiritual engineering. She reads like Einstein as adapted for Wittgenstein by Gertrude Stein.

Gins is the wife of Arakawa, a genuinely advanced artist, of whom much the same characterization would be true, allowing for the differences between writing and painting; and the two have been collaborators in everything the other has done, so that the mind of Arakawa cannot be thought of in abstraction from the mind of Gins, and reciprocally, Arakawa is present in everything Gins has done. Their chief explicit collaboration until now has been the remarkable book *The Mechanism of Meaning*, first published in 1971 as *Der Mechanismus der Bedeutung* in Munich, with an introduction by Lawrence Alloway, my predecessor as art critic of *The Nation*. Europe has been more

receptive to genuinely advanced artists than the United States has, and so far as I know, no American museum has given Arakawa-Gins the sort of exhibition their work merits for its ambition, intelligence, cleverness, and (to use an expression that has recently become controversial in the art world) high quality. It is somewhat ironic that the book should have first appeared in German, since most of the paintings in it are done in English—a kind of concrete poetry. So a readership unequipped with English would be hard pressed to respond as peremptorily demanded by the works: Each of the images is an exercise designed to awaken illumination in regard to the nature of language, written and spoken; to treacheries of meaning, the ambiguities of form, of color, of space, designation, direction, depth, reality, pictorial identity, truth, illusion, possibility and option, perception and decision, memory and imagination, deception and revision. The viewer is issued instructions and given what is required to comply with them—but is also given to see that in certain ways compliance is hopeless. Wittgenstein wrote that there could be a philosophical work consisting only of jokes. *The Mechanism of Meaning* (whose latest version was published by Abbeville Press in 1988) comes close to filling this prescription, and not surprisingly has become a cult text for logicians. It is a masterpiece of valuable disappointments and conceptual wrong turns, but it leaves the participant/reader (both "reading" and "looking" are too passive to characterize the proper relationship to the text) some distance further along the path to understanding the processes of reading and looking than when he or she set forth. A bit like aesthetic bodhisattvas, Gins and Arakawa are determined to nudge the rest of us onto higher and higher planes of awakened consciousness.

At the same time, they have attained to a view according to which the designations "poet" and "artist" are archaic, and belong to the language of an era it is their ambition to pass (and perhaps even their claim to have passed) beyond, into one in which we are to speak instead of "engineers of softness and of impressionable stretching." I take these formulations from "Reversible Destiny," a sort of user's manual issued a few years ago for a polydimensional construction toward which they have been working since perhaps 1973, a model or prototype of which is the central exhibit of their thought-and-work, at the Ronald Feldman Fine Arts Gallery. *Reversible Destiny* is the name of the bridgelike construction, in its present state forty-three feet long but meant to be built as a permanent structure exactly ten times that length. It is, like everything Arakawa does, exceedingly handsome, an object

of sculptural elegance and, in this instance, of engineering exactitude. Black and metallic-looking, a sequence of sleekly geometrical forms —cubes, spheres, cylinders—linked by multiple planes of wire mesh, the work resembles a high-tech Cubist rendering of a scientific instrument of daunting precision: a psycho-cerebroscope, perhaps, or an isotopic thought accelerator.

If "poet" and "artist" are archaic designations, "work of art" must be no less archaic. So, much as Wittgenstein characterized his writings as related to "what used to be known as philosophy," *Reversible Destiny* is an evolved descendant of what were once called works of art, and the experiencing of it is only distantly related to the sorts of aesthetic transactions held canonical to the experiencing of its forebears. Its beauty is a kind of trap, since its function lies elsewhere than the provision of pleasure to the eyes. Like *The Mechanism of Meaning*, as much and as little a "book" as *Reversible Destiny* is a "work of art," our relationship to this device is meant to be participatory and collaborative—and, as with its predecessor, its output is intended to be the transformed users. We should exit from *Reversible Destiny* as very different beings from those who entered it, with our destiny reversed. This would be a great deal to ask of works of art, even those intended to change one's life or which had that effect whatever their intention. But it is for just this reason that Arakawa and Gins have felt it urgent to go beyond the concept of the work of art and of aesthetic distance. You can get a pretty good idea of what *Reversible Destiny* is supposed to be, as well as the flavor of Gins-Arakawa writing, dense with stifled merriment and spoofy seriousness and ironic vision, from this prefatory passage to the text:

Once it became indisputably clear that the ways of the world would never be revealed by means of verbal language alone, or, for that matter, by the use of any single sign system alone, a group of people set about constructing the first full-scale worked-out and enterable basis of inquiry, and by this act they did inaugurate what is known today as the Post-Utopian era.

That is what *Reversible Destiny* is minimally to be understood as: an enterable basis of inquiry. Inquiry into what? one may ask. Probably into inquiry. Which makes it a form of architectural logic, if we understand logic, as Dewey did, as inquiry into inquiry.

The nearest of artistic kin to *Reversible Destiny* would be, I surmise, *The Large Glass* of Marcel Duchamp or, even better and closer, his

notorious *Etant donnés* ("Given that . . ."), the work to which he gave the last twenty years of his creative life and which is permanently installed in the Philadelphia Museum of Art—and which you know you are approaching when you begin to hear shocked giggles from startled spectators, whom the work reduces to voyeurs. One sees a heavy pair of closed doors, with irresistible peepholes. What one sees, revealed through a rough opening in a brick wall, is the spread and splayed torso of a woman, with a hairless vaginal cleft. Her head cannot be seen through these holes, and she may have none, though in her left arm she holds a flaming gas lamp, like the Statue of Liberty, and behind her is an illuminated waterfall. In a sense, the work exists only when seen, as if it provided a negative answer to the artistic version of the old conundrum of whether a tree makes a sound when there is no one to hear it fall in the forest. For the essence of *Etant donnés* is not to give the answers to the questions it inevitably raises for vision; it demonstrates, among countless things, the way art springs into being only through the collaborative intervention of the viewer. Gins and Arakawa declare or even proclaim the end of "the great but still frivolous . . . age of Marcel Duchamp, under which . . . the spectator or posterity ultimately acts as the true maker of the work of art." Now, "a still more collaborative, as-yet-unnamed era would begin, one in which the accepted state of affairs would be for true bodies of spectators to be actually originated through works of art." And that, ideally, will be what *Reversible Destiny* does: it is to be a means of creating a new order of spectator. Nietzsche has his persona, Zarathustra, say, "What is great in man is that he is a bridge and not an end." If this metaphor applies to *Reversible Destiny*, then it too is a bridge and not an end, hence not something to stare at but to cross over, an instrument for changing the state of its users.

The bridge is punctuated by a number of distinct chambers or parts, each of which is conceived from the perspective of some aspect of perception—of what I suppose might be called "The Mechanism of Sensing," which explains the overall title of the show: "Building Sensoriums 1973–1990." Sensoriums are what Webster's Collegiate Dictionary (Ninth Edition) cagily defines as "the parts of the brain or the mind concerned with the reception and interpretation of sensory stimuli." Well, which really is it—brain *or* mind? In that period in which engineers of softness as of impressionable stretching were still known as poets and artists, the text informs us that "philosophers had not yet shaken themselves free of the fog of dimensional confusion."

Lexicographers can only do as well as their philosophical informants, and since Webster's Ninth was composed in the pre-postutopian times in which we live, the mind-brain fog is the philosophical soup in which we all paddle about; if I understand their intentions, Arakawa and Gins have designed the bridge as a sort of fog dispeller. It is constructed as a kind of philosophical gymnasium, in which by working out we may discover our metaphysical identity. So the various segments or chambers of the bridge are like the various plates in *The Mechanism of Meaning*: strengtheners of the muscles of the mind. There are—I believe—twenty-four such segments, and there is a helpful footpath beside the bridge, in which those are marked out in diagrammatic fashion, so that in walking it you can know what part of the bridge is adjacent. Each section bears a name, like "Bodily Conjecture at Light" or "Point-Blank Entranceways into the (Provisional) Dissolution of Spacetime" or "Cradle of Reassembly" or (the terminal segment) "Forming Inextinguishability." And this brings me to the subtitle of the show: "For Determining How Not to Die." Gins explained to me that since we don't really understand body-mind, we don't really *know* that death is our destiny. The bridge, in bringing to awareness the nature of our nature, prepares us for inextinguishability. So, when the full-scale bridge is erected, I expect users will approach the last segment of it with a certain rapt trepidation. I asked how long it would take to reach it, and Gins proposed forty days. But, as the saying goes, we'll cross that bridge when we come to it.

I shall now endeavor to describe the two end points of the bridge. The entrance is filled with an immense sphere, equal in diameter to the width of the bridge. The floor is marked with black and white squares in the form of what psychologists of perception call a "visual cliff": perspective gives the sense that the floor is dropping abruptly away. The enterer must squeeze under the lower quadrant of the sphere, perhaps made to feel vertiginous by the visual cliff, and there encounters "Bodily Conjecture at Light," which is an enormous cylinder with a panel that looks as though it is impenetrable brick but is, Gins assures me, supposed to be penetrable. "Who entered here would by so doing find a new definition of his or her own body." I am as yet unclear (inevitably) on what this experience is like, or what the internal architecture is like. But, as part of the exhibit, Gins and Arakawa have been abetted by the architect John Knesel in the construction of a room they label "Stuttering God," which you can go through.

The experience is unsettling and exhilarating. You have to squeeze

your way through and among plastic bags filled with some sort of compressible content, now and again catching a glimpse, through holes in the brick wall, of some serene internal space. The passageway is high and narrow, and though I emerged, so far as I could tell, with the same body(-mind) that I brought to SoHo with me, I got an intimation of a new sort of sensation, and hence an awakened sensorium.

The terminal component of the bridge has the shape of an octagonal tank, at least from the outside; sloping away from it, like the wall of a pyramid, is a structure bisected by a passage. One exits from the octagon and enters the passage, whose walls diminish as one advances until, free at last in all senses, one is on the other side. Metaphorically, one is walking between the legs of a geometrical sphinx, so perhaps the octagon is construed as a womb and exiting as a kind of rebirth. If this is true, then the sphere could be an abstract head, as the final space is the division between abstract legs, and the whole bridge is then a kind of relative of Duchamp's nude, with its component parts perhaps analogous to the perceptual parts—or sensorium—of the reclining body. So it could be a very powerful enactment to traverse the apparatus.

The art-historical pedigree of the bridge leads us, in one way or another, back to Duchamp, and I incline to the view that among its true ancestors are those artists of early Modernism who saw in the idea of a fourth dimension an escape from our limitations. This was an idea that gave rise to more modernist art than you would suppose, had you not read the pioneering and courageous work of Linda Dalrymple Henderson, *The Fourth Dimension and Non-Euclidean Geometry in Modern Art*. Many of the Cubists, the Constructivists, the early Abstractionists believed in the reality of the fourth dimension exactly as Captain Cook believed in a fabled Southern Continent or the Northwest Passage, and a great many works that hang in museums of modern art were efforts to make this invisible dimension accessible. Duchamp believed that three-dimensional objects are projections of four-dimensional ones, as two-dimensional shadows are projections of three-dimensional objects. And *The Large Glass* is implicitly filled with fourth-dimensional allusions: "I thought of the idea of a projection, of an invisible fourth dimension, something you couldn't see with your eyes," he told an interviewer. (Incidentally, the present show will be followed by an exhibition of Arakawa's paintings titled "Paintings for Closed Eyes.")

Duchamp disclaimed any special mathematical expertise, and I

expect those seekers after the fourth dimension knew, and needed to know, as much about the scientific truth as their peers needed to know about ethnography when they found inspiration in "primitive" fetishes and masks. It was enough that there was the idea of it, exciting and advanced, and full of redemptive utopian promise. The physics itself could be, as Duchamp said, "playful." Gins and Arakawa, for as long as I have known them, have defined their horizons differently from other artists, and certainly theirs were not the horizons of the art world itself. They have sought interchange with philosophers, psychologists, biologists, physicists, and others, whom they have sought to enlist as collaborators. Once, I was told, a group of German physicists came to a gathering to tell Arakawa what he felt he needed to know, and nothing better exemplifies the spirit of his conception of collaboration than the question he put to them: "What, really, is the smallest thing?"

It cannot be said that Arakawa and Gins have been especially successful with art critics, who after all have been trained as either formalists or archivalists. The entire matrix of thought Linda Henderson has so usefully resurrected is, but for its presence in Gins and Arakawa, virtually absent from the art scene. Critics for the most part have been wary of Arakawa and Gins, suspicious of their language, uncertain of their motives, content if they can find something in the work that another artist might have done before, so that they can dismiss it. Like Duchamp's, the bridge of *Reversible Destiny* at the very least is an undertaking of ironic displacement of the common assumptions of the meaning and nature of art—so the *common* assumptions won't carry you very far in dealing with it. But it is work of immense intelligence, spirit, wit, and ambition, and in an art world that today is largely scruff and shrieking, it might be time to put between ourselves and the common assumptions a certain skeptical distance.

—*The Nation*, October 15, 1990

High & Low at MoMA

WHEN I LEARNED that the Museum of Modern Art in New York was to mount an exhibition of high and low art, I hoped for something as tonic and brilliant as the great second act of *Ariadne auf Naxos*, in which the tragic heroine is thrust into the same dramatic space as a band of scruffy buffoons, who seek to distract her from her drawn-out sorrows by snapping their fingers and singing rowdy songs. The first act of Strauss and Hofmannsthal's masterpiece was given over to a debate between representatives of opera seria and opera buffa as to which should take precedence in an evening's entertainment, when Monsieur Jourdain, rich and vulgar, ordains that both operas be put on at the same time, so that the singing will end early enough for a fireworks display afterward. The second act is the result: the classical heroine sings her heavy heart out on the barren island on which her lover, Theseus, has abandoned her, also inhabited, through an impossible artistic collage, by a company of commedia dell'arte figures, who undertake to amuse her out of her *Schmerz* and give her some useful pointers on how to handle men. My hope was that the low art in the projected show would do something along those lines—be antic and wry, say not to take matters of art too seriously, that there has to be some basis in fun for the existence of art, that it can't be all sopranic lamentation and tragical sighs and prayers for divine intercession.

In the early years of Pop Art's ascendancy in the New York art world, the situation of Ariadne's improbable island was often enough repeated, with artists of high calling and shamanistic pretensions encountering the new irreverent stars who had challenged the premises of their painting: it was like watching misdialogues between Prince

Hamlet and Mickey Mouse. In Victor Bockris's superb life of Andy Warhol, there is an eloquent anecdote about a party given by Larry Rivers in the Hamptons, at which Warhol approached an admittedly drunk Willem De Kooning with an affable "Hi, Bill!" He was rebuffed with the following aria: "You're a killer of art, you're a killer of beauty, and you're even a killer of laughter. I can't bear your work." (As someone who took the scenario of the comic strip seriously, Warhol *had* to have said "Ulp!!!") It was an operatic, or at least a dramatic moment. The Abstract Expressionists perceived themselves as in touch with chthonic forces and the dark metaphysical tides of Being. They believed in magic, mystery, and art's high spiritual vocation. And suddenly the art world was invaded by twerps who painted soup cans and fashioned hamburgers out of plaster-soaked muslin, and who monumentalized Chef Boyardee spaghetti (the pasta revolution had not as yet overtaken the land) or actually made paintings of Donald Duck and Goofy, or the teary faces of vapid girls, those vehicles of teenage love dreams expressing moony sentiments in thought balloons.

"A painting by Lichtenstein," Max Kozloff wrote in the art pages of *The Nation* (!), "is at once ingenuous and vicious, repulsive and modish—the latest sensation." In another journal he ascribed to these artists "the pin-headed and contemptible style of gum-chewers, bobby-soxers, and, worse, delinquents." This attitude lives on in those whose artistic ethos was formed in Abstract Expressionist times, though it differs greatly from my own. When *The Nation* denounced Pop, *The Journal of Philosophy* declared it philosophically profound; and when, in a review of Warhol's posthumous retrospective at MoMA, I proposed that he was the nearest thing to a philosophical genius the art world had produced, even good friends turned on me. It was essential to their estimate of art and of themselves that Warhol be dumb and *buffa*, while the art that his succeeded was smart and *seria*. And the fact that Pop's images were intinctured with the logos and slogans of commercial semiography contributed to the general suspiciousness with which it was received by high culture, whose priests looked down the very noses that had been popped out of joint.

One of the marvelous expressions of Pop ideology, which affirmed as it subverted the stigma of commercialism, and at the same time sought to paint out the boundary between high and low art, was Claes Oldenburg's *Store*, which operated on East Second Street in Manhattan from December 1961 to January 1962. The very idea that art might be purveyed in a store rather than displayed in a gallery, that it might

exchange hands across a counter and consist of objects that engaged ordinary men and women in the ordinary moments of life—little monuments of the commonplace, as it were—was in its own way as intoxicating as the aesthetic collisions in *Ariadne*. Here were cheeseburgers with lettuce, slabs of pie, girls' dresses, and gym shoes, fashioned out of plaster-stiffened cloth and painted to resemble items in the *Lebenswelt* that no one who lived in the everyday culture, to which they belonged, could fail to recognize. They might, to be sure, have some difficulty in recognizing the objects as *art*. But, as if to forestall that problem, Oldenburg dripped paint over their raw surfaces in such a way as to give them a kind of gaiety and an artistic authenticity at once, inasmuch as it was the reigning dogma of that moment that painting was paint-ing: that paint itself, fluid, shiny, puckered, dribbled, dropped, and dripping, was the soul and substance of art. It was through the handling of paint that Oldenburg claimed oneness with the heroes of Abstract Expressionism who disdained the subject matter he celebrated joyously. Paint may, indeed must, have given these works their artistic authenticity in the terms of that era; but what Oldenburg was interested in was the language of everydayness. "I am for an art," he wrote, in a manifesto that has since become famous, ". . . that does something other than sit on its ass in the museum. I am for an art that grows up not knowing it is art at all, an art given the chance of having a starting point of zero. I am for an art that embroils itself with the everyday crap & still comes out on top."

It is, of course, among the ironies of artistic success that coming out on top, for an artwork, means just "sitting on its ass" in some museum or other. It somewhat symbolizes the spirit of the exhibition, "High & Low: Modern Art and Popular Culture," that its authors, Kirk Varnedoe and Adam Gopnik, should have made an ingenious and metaphoric salute to Oldenburg's *Store* by appropriating a window, rarely if ever used before in the architecture of MoMA, and treating it *as* a store window in which several of Oldenburg's confections of that era are displayed: *39 Cents* (*Fragment of a Sign*), *Auto Tire with Price, White Gym Shoes*, and so on. It is a delicate, elegant gesture of fraternity across the decades, but it is easily subject to the gross critical discourse of our own sour era, which sneers at what it sees as the commodification of art and is already disposed to regard the museum as a kind of store for the elite, in which cultural bric-a-brac carry implicit price tags (to be sure in $$$$$ rather than in ¢¢¢¢¢). And inevitably, inasmuch as the identification of high art with spirituality

often coexists in the same critical breast with that attitude, Varnedoe himself has been attacked as a latter-day Monsieur Jourdain, whose philistine disregard of class differences among artworks has forced the tragedians of high art to consort with the ragamuffins and low-lifers of pop culture. "The museum, having abdicated its role as cultural referee by putting what used to be out on the streets inside its sanctuary," ironizes the editorialist of *The Journal of Art*, "sheds the dreary temple/tower image that threatens the triumph of populist tolerance." And Varnedoe—who "claims the sacred mantle of Alfred Barr, Jr."— is accused of playing to the galleries in both senses of the term, attempting to please both the pinheaded gum chewers and the merchants who traffic in art (but clearly not the high-minded editorialist herself).

In truth, the wonderful window, which opens the museum to the street in a complex metaphorical transfer in which the light of art spreads outward as the light of day spreads inward, is a precise expression of what the exhibition is really undertaking to do. Its intention is to relocate, in the historical conditions that gave them nourishment, works of art that have been "sitting on their asses" as eternal aesthetic presences for too long. "We hope to take objects that have too often been isolated as 'timeless' or 'transcendent' and resituate them within the changing, dynamic contradictions of real life," says the catalogue. It is the genius of modern art that it has drawn heavily on vital fragments of popular culture, just as it was the genius of Wittgenstein to find philosophical inspiration in Street and Smith's *Detective Story Magazine,* or the genius of phenomenology, which Sartre was thrilled to learn from Raymond Aron one boozy night in Montparnasse, to make philosophy even out of cocktail glasses. It is in part a *causal* and an *explanatory* thesis that the exhibition advances and sustains, a partial art-historical narrative in which, instead of the influence of genius A on genius B, the story is told of how genius C and genius D found inspiration in scraps of newsprint, theatrical posters, and commercial labels, in the sullen scrawls of prisoners and delinquents, or in the lurid imagery of the funnies. "It is quite a feat to subsume Dubuffet and Cy Twombly under the category of graffiti inspired artists," *The Journal of Art* sneers. It is no feat at all if the thesis is one of historical explanation. Nor is it in any sense a reduction of these artists if the explanation in fact is true, for it does not in the least imply that no artistic criterion distinguishes Dubuffet and Twombly from the chalk scribbles and scratchings each may have drawn upon. "High & Low" is in fact a heroic and difficult *exposition à thèse*, but one almost im-

possible to mount and completely impossible to indemnify against critics unprepared to rethink the categories of modernist works, when construed as cultural artifacts with complex genealogies.

Wittgenstein said, powerfully and beautifully, that "an expression has meaning only in the stream of life." Much the same may be said of art, with suitable qualification of expressions, even if art historians and critics tend to treat works as though they draw their meaning only from the stream of art. Standard historical and critical practice sees works evolving out of other works by formal modification alone, so that the history of art is a string of begats, and works are scions of other works. That is by no means an absolutely wrong way to think of art history, and it is certainly a way of thinking congenial to Varnedoe. But in this show he has undertaken something grandly different, by inserting some of the icons of Modernism into the lifestreams that nourished them and to which they owe dimensions of their meaning. The re-created store window—literally a window of opportunity—is one of several built into the Fifty-third Street façade of MoMA in the renovations of 1984, but it normally is blocked up by Sheetrock to increase the sense of blank enclosure and intensify the sensory focus to which the museum's galleries have mainly aspired—chaste cubicles of visual delight. In uncovering the window, Varnedoe is symbolically opening the museum itself up to the stream of life, to the world of commonplace objects from which his displayed objects derived their sustenance and vitality.

There is more than a simple causal thesis of lifestream-to-artwork implied in this show; the artwork-to-lifestream influence, though somewhat understressed in the exhibits, was prominent in its intention. The catalogue cites a 1954 text from an in-house publication of Young & Rubicam: "If we were to eliminate, in any one issue of *Life*, all advertisements that bear the influence of Miró, Mondrian, and the Bauhaus, we would cut out a sizable proportion of that issue's linage." And the "modern" look has itself been aspired to by designers for whom MoMA (when it was still referred to as "The Modern") was an immense quarry for forms that became adopted as emblems of modernity: the boomerang-shaped coffee table, the black-and-orange butterfly chair, the kidney-shaped silver brooch, the mobile over the crib. In the ideal life-art-life cycle, "stylistic inventions often propelled the movements of specific manners and strategies from high to low to high to low again: billboards affect avant-garde painters whose work later affects billboard designers . . . or techniques of sales display get picked up in structures of art that in turn change the look of commerce."

The structure of such a cycle is more apparent in some of the five categories of "low" genres with high-art resonances than in others. "Comics" and "Words," for example, work somewhat better than "Caricature" and "Graffiti," and all those rather better than "Advertising," which is in many ways a seriously flawed installation, despite its inspired moments.

Consider, to begin with, "Words." By this the curators have in mind words *as printed*, where the mode of lettering carries meanings beyond those carried by the words themselves. Thus, the characteristic sans-serif style of the newspaper headline conveys a kind of annunciatory or proclamational significance. There are, one might say, "print acts" in definite analogy with what philosophers have termed "speech acts," where the fact that the speaker uses certain words or intonations augments or modifies the meanings of the words themselves were they to be taken merely lexically. The Cubists, for particular example, tore out fragments of banner headlines for insertion into early collages. These allowed the possibility of mischievous puns. Picasso incorporated only "UN COUP DE THÉ" from a headline which had to have read "UN COUP DE THÉÂTRE." The latter doubtless referred to a political happening of some drama, but the fragment to a shot of tea or even a cup of tea—just the thing for a still life. But it also allows an interpretation in which the dramatic event is a tempest in a teacup. In *Landscape with Posters*, Picasso took the word "KUB"—the brand name of a bouillon cube widely advertised but singularly apt in a (K)ubist composition, since it denotes but fails to exemplify cubicity. The sans-serif style of lettering gets taken up by the Constructivists, who used it brilliantly in posters and for book designs, conveying the urgency of headlines. One such book cover, by Aleksandr Rodchenko, gives graphic excitement to a volume of Mayakovsky's poetry. This 1923 design is appropriated by the curators of this very show for the cover of their catalogue, and its handsome red exclamation point—a high wedge over a low dot—serves as the show's emblem. So lettering migrates from newspaper to painting to design. And the catalogue cover is ambiguous as to whether it is merely graphic art or a high-art statement in the postmodern genre, referring to a style it also appropriates and endorses, to make a sophisticated statement of the theme of the exhibition.

The placement of Picasso and Braque near the threshold of the show has exposed it to some severe but, in my view, misguided criticism. The critic of *The New York Times*, uncharacteristically intemperate, writes, "Mr. Varnedoe and Mr. Gopnik review the inception of Cubist

collage as if last year's 'Picasso and Braque: Pioneering Cubism' had never happened." To begin with, paintings have different meanings in different streams of life and art, and it is instructive to situate Cubist works in the stream of graphic design and convention. But second, not every visitor to the show will view it as a professional critic does, comparing show with show the way sportswriters compare games with games. *Landscape with Posters* has an altogether different weight and reference in Varnedoe's inaugural show than it could have had in Rubin's valedictory show. The difference that exhibitional context can make when viewing identical works—which carry differing meanings and references in various exhibitions—is one of the things a show like the present one makes clear. On the other hand, it exacts a heavy price from the viewer, who must identify from the work alone the stream in which it is to have the meaning that Varnedoe and Gopnik mean to evoke (if the show is to be experienced as they intended). But sometimes there is no obvious reason why a work is included, and unless one has recourse to the extremely detailed and ambitious catalogue, one will be in the dark. In fact, the catalogue stands to the show in a very different relation from that in which catalogues normally do. These days, catalogues are vast scholarly achievements, even the lifework of historians and specialists. They are indispensable to other specialists (and, in candor, to critics required to review the shows) but generally optional for the average museum visitor, depending upon his or her interest. "High & Low" is a catalogue-driven exhibition, however, to the point that a great many of the exhibits make no sense unless one has read the text (and may still make little sense afterward). In a way, the individual exhibits serve as illustrations for a text. And the text cannot be easily deduced from the illustrations alone.

Take, for egregious example, Duchamp's notorious *Fountain* of 1917, which we all know is a urinal signed "R. Mutt" and dated. Why is it in the "Advertising" section of the show? And why alongside it is Meret Oppenheim's hardly less notorious fur-lined *"coup de thé"*? The *Times*'s critic has every reason to complain that "the visitor might as well be upstairs in the museum's permanent collection galleries." But even when one reads the text that is to justify inclusion of these Dada works, the connections are tenuous: "[Duchamp's] statement also has a curious parallelism with the way the merchandisers of plumbing promoted their wares." And the catalogue shows us as well some vintage photographs of plumbing supply houses with windows full of sinks and tubs and toilets. But who, even if long immersed in the discussions

surrounding *Fountain*—philosophical, critical, historical—could conceivably appreciate *this* connection between Duchamp and advertising? And which ordinary visitor could infer that this was the sort of point being made in locating the work in a vitrine in the "Advertising" portion of the show? The principle for including in the same section works by Joseph Cornell is hardly more compelling. The blissful rednecks that *The Journal of Art* fears MoMA's curators are pandering to will hardly be up to the erudition in ephemera that an appreciation of the show exacts as a condition.

The show—and of course the catalogue—concludes with "Contemporary Reflections." This may be read as an effort by Varnedoe as a new director of MoMA to come to terms with the difficult and perhaps intractable art history of the present moment, in connection with which this particular museum has a particular problem of identity. "Modern" must originally have been in part a kind of indexical term, indicating *now* in contrast with *then*. But "modern" also turns out to have been a pretty identifiable style—exactly that style the Young & Rubicam writer must have had in mind in referring to the derived stylistics of the 1950s magazines. If MoMA identifies with that style, its contents and its missions are historically circumscribed. If it adheres to the temporal sense of "modern," these limits are modified, but the work it must deal with is now no longer *modern* in the stylistic sense. It remains open to question whether location in low-high-low cycles is the best way into the art of the present moment. It may be the best entry into the work of Jeff Koons, but hardly, one must feel, with the works actually shown. There ought, instead of stainless-steel decanters and displayed vacuum cleaners, to have been his mega-kitsch frights on which Gopnik has written so instructively elsewhere. Possibly there is a low-high connection for Jenny Holzer, with whom the show closes, inasmuch as she has found inspiration in LED banner billboards for putting her thought up in lights. And, with the help of the catalogue, one can find out why Elizabeth Murray, clearly a favorite of Varnedoe and Gopnik, belongs here. Her work has a kind of cartoon derivation.

One of Murray's works can be seen as a gigantesque pair of shoes with holes in them. These, she claims, derive from the comic strip *Blondie*; and the catalogue concludes with an almost lyrical celebration of big shoes, as a sort of leitmotif of the show. It integrates the big shoes of Mickey, or the trucking character of R. Crumb, perhaps the white gym shoes of Oldenburg, and other works as well. The shoes are emblems of a kind of aesthetic pilgrimage the curators themselves

have made, and the walker through the show will have made as well, into the present, so far as it lies across the final threshold of the show. "The deal is that you have to go without a map, and you can only get there on foot." You cannot, however, get through the show itself without a map, and even with one in hand you will at times be lost. Still, it is a remarkable and valuable exhibition, the implications of which for the temple of modern art itself we shall all now watch for with the greatest interest.

—*The Nation*, November 26, 1990

David Hockney as Set Designer: *The Magic Flute* and *Turandot*

THE FAMOUS CRITIC Roger Fry once questioned whether opera was possible as a genuine form of art, or "only a jumbling together of different arts, leaving now one and now another sticking out in painful or pleasurable prominence." He concluded that one of these arts must be taken as the substance of the opera, with the rest subordinate to it. So if the music is dominant, the words need not be sublime in their own right, and if song is central, we would not want scenery to usurp our attention. Why then would a strong artist consent to design sets for operas, especially for one so independently marvelous as *The Magic Flute*? He or she would be aesthetically at fault if the designs distracted from the music. But—and this is the dilemma of the artist turned stage designer—what is the point of subordinating one's style to some larger artistic whole? The same dilemma faces the opera's producer. It might seem initially attractive to commission a Picasso, a Chagall, or a Hockney to execute sets for a new production of a famous opera. But can the artist be counted on to function as a member of a team? "The theater is an area where you're forced to do certain things," Hockney has said. "You work from literary sources, and in opera you have to be true to the music. The theater world tends to think that a strong artist won't cooperate enough." The artist may, of course, be well paid. But the financial reward scarcely can equal the sale of paintings that might have been made with the same amount of energy and time, and no sacrifice of autonomy. What can be the incentive for subordinating oneself to the imperatives of another artistic will?

The Magic Flute is a miraculous amalgamation of high and low, of slapstick and sublimity, of erotic fantasy and spiritual ordeal, of

illusion and redemption, of danger, love, and submission. But beyond all this, it is a celebration of the power of art, and so offers every artist who participates in its staging and performance an opportunity for rededication to art as a spiritual vocation. Tamino, a princeling, is possessed of a beauty which the ladies who rescue him from a serpent cannot better characterize than like that of a painting: "So schön, als ich noch nie gesehn." "Ja, ja, gewiss zum Malen schön." ("More beautiful than I have ever seen." "Yes, yes, indeed as beautiful as a painting.") And Tamino falls instantly in love with Pamina on the basis of a painting of her given him by her mother, the Queen of the Night: "Dies Bildnis ist bezaubernd schön, wie noch keine Auge je gesehn." ("This picture is bewitchingly beautiful, more than eyes have ever seen.") This *Götterbild*, as he calls it—this "godly image" —fills Tamino's heart with a feeling he cannot identify but which is like fire burning in his breast, and which we know is love. So we have the story of a man who is as fair as a picture in love with a picture as fair as its subject. Small wonder that Papageno, not the cleverest of men, finds it difficult to tell Pamina apart from her image, and persists in addressing her as "Schönes Fräuleinbild!" ("Beautiful Fräulein-picture!")

It is widely believed that *The Magic Flute* celebrates the power of *music*; certainly the magic flute itself, which charms the animals and protects its player, is a metaphor, like Papageno's silvery glockenspiel, which causes fiends to dance away from their intended victims, for music's transcendent effects. But Hockney's sets pay tribute to the power of painting, which embodies dark dangers at the beginning of the opera, and the exaltation of order and rationality at its end, toward which the tableaux progress as from dark to light, and paralleling the spiritual ascent of the lovers. Indeed, as a sequence, the images almost recapitulate the history of painting from the naïve realism of the Italian trecento through abstraction to the abstract realism of Hockney himself. The first scene is one of a primitive world stalked by terror—the first words of the opera, after all, are a call for help—in which Tamino is pursued by a monster which has a certain art-historical familiarity, since Hockney has appropriated it from Paolo Uccello's ornamental dragon done in by his St. George. The dragon—rather a free interpretation of what the libretto identifies as but a snake—looks as much like its picture as Pamina looks like hers. The chase takes place in a Giottoesque rockscape. The sets are dense with references to art which Hockney has managed to make his own and at the same time to

constitute as the world of the opera's action. He has even taken over the grand staircase of the Metropolitan Museum of Art (not the Metropolitan Opera House!), transforming it into a temple staircase in Act II, and in fusing museum and temple in this way, constructing an instantaneous metaphor of the identity of art and religion.

The opera is traditionally situated in Egypt, but it would not have been the opulently imperial Egypt of *Aida*, nor need it be an Egypt of archaeological exactitude. Hockney decided it should look the way the eighteenth century imagined Egypt must look, with pyramids and temples, pillars and palm trees. "My designs for *The Magic Flute* used that naïve approach," Hockney observed. "They also reflect a Renaissance view of Egypt that you see in early Italian painting." So the first scene is Egypt as visualized in the charming Flights into Egypt of Siena or Florence in the fourteenth century, where Uccello's dragon would be right at home. The stage becomes identifiably Egyptian in Act I, Scene 2, where animal-headed deities face one another across a table under a patterned frame; but despite the pyramids atop the three temples in Scene 3, and of course the pyramids in the distance, the severe perspective of the backdrop gives the stage a Surrealist atmosphere, and the clarity and dryness of sharply receding fields and gardens has the feel of playful severity one finds in Miró's *The Farm*.

It is consistent with Hockney's vision of the opera as a progression from chaos to rational order, that Act II, for all its comic turns by Papageno and its menacing interventions by the Queen of the Night, revealed as an evil force, should present a sequence of increasingly abstract images. The ordeal by fire makes the viewer think of one of Morris Louis's *Veil* paintings, though the ordeal by water, with its overlapping Niagaras, could only be by Hockney, who has after all made of water one of his signature motifs. The final scene is of a brilliant sunrise, in which the alternation of sunbeams and darkness, overlaid by semicircles, looks at once like an Art Deco stage setting for a finale at the Radio City Music Hall and that amazing striped headpiece worn by Tutankhamen, perhaps everyone's idea of Egyptian design in 1978, when Hockney first executed his sets for the Glyndebourne Festival.

If one juxtaposes this sunset with the barren site of Tamino's helpless panic as he enters, carrying a bow but without any arrows, prey to the scary monsters of an uncertain world, one will have a visual equivalent to the optimist spirit of Mozart's opera. And that marvelous concluding sunrise, fusing pharaonic splendor with musical comedy

kitsch, embodies to perfection the relationship between those geniuses of love, Tamino and Pamina, and those fleshly clowns, Papageno and Papagena. In fact, with its overtones and associations, the final image pays tribute to Mozart *and* to Schikaneder. The entire design, in fact, is a visual celebration of their two visions of art.

TURANDOT'S PEKING IS a grotesque and cruel site, where lopped heads are suspended from brooding gables. It is a place of chill power, of blood and torture, suicide and execution, the testing place for royal suitors who stake their lives in a terrible game with the icy princess. The rules are that she must give herself to the one who solves her riddles, but as the contestants are driven only by their own will to power, she is never wedded and the suitors always die. The severed heads tell the story of lost matches, and Turandot herself is now the image of arrogance, disdain, contempt, and indifference to the deaths of princes she knows would be as unforgiving as she. Love is literally and allegorically the stranger in the imperial precincts.

The cruelty is in the music, and it must be made visible in the scenery. The lingering light of sundown silhouettes the heavy eaves, which look like the toothed jaws of dragons against it, open and menacing. "The dragons are there, in the music," Hockney says, and so they must be present in the sets, which he construes as the translation of musical meaning into visual forms. The sets, in brief, are not simply props intended to lend specificity to action and furnish background to song and to processions. They are meant to stand in the same relationship to the music as the music stands to the words. Changes in scenery are parallel to changes in the musical soul of the opera.

It is clear from this artistic ambition that certain ways of situating the action would be inconsistent with it. The drama takes place in China, but it is a visionary and fabulous China, even perhaps a dreamt one, its exoticism a metaphor for the operatic representation of the contest between love and the fear of love, of the sacrifice of lovers who are fulfilled through surrender. It would accordingly be contrary to the feeling Hockney aspires to that a sort of sinological exactitude be sought, or that the stage become a cabinet of chinoiserie. There are no ornamental dragons outside the palace, only the implication of dragony presences through ambiguous architectural shapes. Until this production, the sets for *Turandot* had been the conventional drop-and-wing kind, instead of which Hockney has used essentially sculptural

forms, suggesting an architecture determined more by feeling than Oriental authenticity. The artist visited China in 1981, and later published a volume of photographs, some of which are of the sorts of structures he has abstracted from in realizing *Turandot*'s spirit. The red of palace buildings is the red of the walls and parapets of the opera's placement. The green of Chinese tiles is the green of those admonitory eaves that catch the moonlight and display the heads of bested princes. The curves of Chinese gables are amplified in the mandible-like forms that sweep above the chorus. There is an entire drama of light and shape enacted to capture the colors of the music, setting the moods but also communicating to us Hockney's view of points on which the text is silent.

Princess Turandot does not sing in Act I, she merely makes her appearance when the moon lifts, to command by a gesture the Prince of Persia's execution. The moment she appears, the Unknown Prince who is to melt the ice that encircles her heart is fired with a passionate love. Hockney has her appear in a bubble of light, like a vision in a baroque painting. The vision is for the Prince's eyes alone, and for us, seeing with his eyes. He sees her as *divina bellezza* while everyone else sees her as implacably condemning a princeling to death with an imperious signal. Until the Prince saw her as lovable and not a prize to possess, none could win her. When, at the end, she tells the Emperor that she knows that the Stranger's name was Love, we understand that the initial grotesqueness was as much due to the absence of love as the presence of death. And when the Princess is transformed, the site will be as well. Hockney knots the lovers together in a sort of abstract heart, and as the music nears its final chords the light grows brighter and brighter. They are both bathed in the uncanny radiance of the Prince's first vision—what Puccini, early in the composition of this final work, describes as "the amorous passion of Turandot that for so long smoldered beneath the ashes of her great pride." It was as if he wrote the opera to liberate that damped and hidden love. At the opera's end, he wrote, "love should pervade the whole stage."

The action of *Turandot* unfolds from emotional dark to emotional light in an almost seamless flow from sunset and death to sunrise and love. Since the sets, as forms and lighting, are to express the emotion that language and music express, they had to have been designed also as a temporally unfolding whole. This fluid, one might even say melodic, treatment of settings and changes of setting was facilitated through technologies of design which would not have been available

to earlier efforts. Having access to whole performances of the opera on tape, for example, enables Hockney to saturate himself in the music in ways earlier designers could not have hoped for. He could finally *hear* the sets in the music. He did not begin with drawings but with models he could modify to suit the music, and which he could illuminate by means of a sort of lighting console as sensitive as a keyboard. And he was able to register all this, sound and form and light, on videotape, itself susceptible to nuanced editing. The scene builders then had a model which incorporated real time, rather than a set of static images and verbal directions. And once the sets were in place and rehearsals began, Hockney could make a record of how it looked as a totalizing totality by means of a camcorder. He could use this then to make changes in the sets, with the confidence that the final product would look just the way he wanted.

Nothing of this formidable technology forms part of the experience it makes possible. The sole justification for a process as time-consuming and as costly as this is the achievement of an enhanced theatrical illusion. *Turandot* is absolutely operatic, in that its substance is not the transcription of real events but the making real of actions and feelings which exist only in the realm of fantasy. Even love is limited in life: real women do not move from frigidity to tenderness in so few bars of music, and perhaps the human breast is too constrained for such dramatic changes. Puccini has been wrongly criticized for failing to rationalize what, in truth, from its first version in the Venetian theatrics of Carlo Gozzi, had only the power of myth. The triumph of fire over ice, of love over pride, of sacrifice redeemed and cruelty vanquished with a single kiss—these are themes only operatically credible. The great contribution of Hockney's art is to make visually present the feeling we must accept if the illusion is to work.

—*Stagebill*, October 1991

Abide/Abode

IN THE SUMMER of 1974, the American artist Jennifer Bartlett set out to create a work of extreme ambition, as much in scale as in subject. *Rhapsody* is composed of nearly a thousand panels, each a foot square, and was intended, as she put it, to "have everything in it." In fact, it has but four things in it, repeated in different combinations and executed in various styles: water, mountain, tree, and house. These, she tells us, were the first four things to have occurred to her, and it is hardly matter for surprise that "everything" resolves, analytically, into certain basic components out of which whatever else there is must be composed, nor that the house should at once have been on the short list of basic entities and have come immediately to the consciousness of an artist poised to reenact the fabrication of the whole world.

Nothing, on the other hand, more exactly divides a human sensibility from a divine one than this charged symbol, for in framing the universe, God of course put water, mountains, and trees together to make a world, but there would have been no houses in the prelapsarian condition of human existence: the house is *Menschenwerk*—our contribution to the overall scheme—and testifies to that condition of vulnerability defined as ours since the Expulsion.

It was, on the biblical account, shame that moved Eve and Adam to cover themselves when they became conscious of their fallen condition, so clothing was, initially, less a matter of protection from sun and chill than the expression of a moral intuition in the language of garmentry. By the same criterion, one would suppose the house, as a form of covering—as essentially a roof—must have been the sponta-

neous symbol of our difference from the angels, the second mark of our deep humanity. It is this, perhaps, that justifies the stirring claim of the German philosopher Martin Heidegger that *dwelling* is the primary attribute of our being—our essence in effect: "We do not dwell because we have built," he wrote, "but we build because we dwell, because we are *dwellers*." Dwelling, if indeed the human condition, entails that the house is as much a meaning as a means.

In drawing a house as the first, or nearly the first, thing it draws, the child expresses an innate understanding of its condition as human (and it is suitable that one of the styles Bartlett appropriates for the house is that of a child's drawing). A work of art that has a house in it has *us* in it, in our basic condition as dwellers. It is the basic symbol, if Heidegger is right, and all other symbols for ourselves derive from it. Defined as "structures intended for dwelling," houses of different styles imply different forms of life. And different interpretations of the house as symbol define different philosophies of life.

As with the other objects that, as we say today, encode the metaphors through which we represent our nature to ourselves, the house connects, in a single uneasy whole, both aspects of our difficult metaphysical nature as spirit and body. Consider, for example, the chair. As the *seat*, it is where we sit in judgment and from whence we rule —so it is the emblem of superiority and domination. The throne, the bench, the seat, the chair, the *cathedra* specify different foci of authority when occupied by the monarch, the magistrate, the representative, the professor (or the chairman), the bishop—and often the design reflects the symbolic weight of the figure whose role requires ritual sitting as a perquisite. But we also sit just to take the weight off our feet—to repose, relax, recuperate—acknowledging through the act the limits of our powers as physically embodied beings, flesh and blood, heir to shocks, weary and weak.

The house, too, is a ruling place, as in the Houses of Parliament and the House of Representatives. And it is the ruling families that are synecdochically designated a "house," as in the House of Hanover or the House of Orange. This, I think, is not the primary connotation of "house" in English, which as a word carries an opposite meaning, connected with the dimension of frailty in our image of ourselves. But there is a family of English terms that refer back to the Latin *domus*: domicile, domesticate, dominate, dominion, domain, (con)dominium, dominus, domineer; and through these the house speaks to us precisely as the symbol of rulership, ownership, mastery, power.

Dwelling, in this interpretation, is having in effect conquered, having made the world one's own (*owning* it), and so having the rights and privileges that such honorifics as those that refer to *domus* carry like badges: Don, Doña, Dame, Madame (or madam, whose house is not a home). That which is in*dom*itable is literally that which we cannot bring within our house: untamable, wild, undisciplined, undomesticable. Just to have a house is to possess symbolic authority (under an older system of government, to have a voice or vote), and the house is the embodiment of our dominance. The philosophical picture projected by the house-as-*domus* is one where we impose ourselves on the world through possession, transforming the heretofore untamed into the means of habitation. The house is the form that our will-to-power takes as characteristically human.

A house, as an architectural entity, exemplifies the philosophy conveyed by the concept of the *domus*. A house has to stand (a house divided against itself must fall), and the straight line, the level surface, the right angle imply the ruler, in both senses of the term: the house communicates the proposition: I stand, I am upright, I am straight, I am rational, I *am order*. These propositions are conveyed through the vocabulary of columns and beams, which must be respectively plumb and level to "house" the thought we ascribe to them. But these same propositions have nothing to do with walls, which belong instead to the language of enclosure and connect us to the other range of meanings that belong to the concept of the house—meanings that have little to do with domination, but instead with our essential weakness, as needing shelter from the wild world without.

As a word, *house* carries us back to the dark forests of Germania, in contrast with *domus*, through which order and civilization are defined in the sunlit peninsulas of the Mediterranean. In Old English, *hus* means exactly shelter. It is cognate with *huden*—to hide, conceal, cover; and it expands into such modern terms as hut, huddle, hoard, and, through its first syllable, into *hus*-band (house-bound, tied to a dwelling as a condition of survival). This is the fragile, threatened, exposed side of our self-image as dwellers: beings that need protection, a place to crawl into, if only a hole or cave—and our walls announce our vulnerability.

The idea of the *home*, as a place where goods are stored and husbanded, is already inscribed in the house as *hus*, where rationality has less the implication of rule and order than of reasonableness, thrift,

frugality, moderation. For who knows what the future may bring or what needs will have to be met? The house as home is the place of comfort, safety, where we can let down our defenses. It contrasts with the jungle world of savages and predators "out there." It implicitly characterizes the world as precariousness.

Hegel sees the house as the primary artistic product of the human intellect, since its form has no direct model in nature. It differs, thus, from sculpture, which initially takes its form from that of natural objects, and especially the human body. So, as spiritual product, the house inevitably gives an outward embodiment of our inner reality, hence to our nature as rational. And this translates into the political metaphors of domination, as with *domus*. But as shelter, I think, the house draws initially upon what nature itself provides: the cliff, which protects me from behind as I sit between it and my fire, or the cavern, which surrounds me. It is thus that frame and wall speak in different voices, and together express our nature as reason and as flesh, as order and disorder, as beings of thought and need. It is our most eloquent philosophical symbol, and it is not difficult to understand how it would have forced itself immediately into Jennifer Bartlett's consciousness.

It is instructive, in the light of this symbol, to consider the temple as the dwelling of the god. Clearly, as *dominus*, God does not need shelter. But God must be present among us in the condition of the *domus*, and it is as *domus* that the architecture of the Lord's house impresses itself upon the community: it will be the highest structure, and the *dome* transmits absolute authority. This means, in effect, that the walls must themselves aspire to an absolutely nonfunctional role, which is to say: non-load-bearing, to express the fact that God is not, like us, in need of housing. The Gothic cathedral, of course, in reducing wall to window, executes this imperative to perfection. The Gothic genius lies in discovering how to make walls possess purely symbolic value, and for this purpose, glass is the ideal material. It says, accordingly, a great deal about our increasing security in the world that glass itself grows larger and takes up greater and greater portions of our total domestic enclosures. The glass house is the final emblem of a world well ordered. What immense optimism is expressed by the glass towers of the modern city!

Glass today is a social partition that divides many dwellers from the homeless, those whose powerlessness is double. Deprived of the house as *domus*, their impotence is multiplied by their lack of the house

as shelter. As dwellers without anywhere to dwell, the homeless are at the farthest edges of humanity. They are mirror images of us whose meaning resides in our means.

—*Housing: Symbol, Structure, Site*, edited by Lisa Taylor, Cooper-Hewitt Museum, 1990

Titian

TWICE IN HIS LIFE of Titian, whose supremacy as a colorist he
conceded, Vasari deplores the Venetian master's deficiencies in
disegno—a term that means drawing but carries the further implica-
tions of design. On both occasions the criticism is put in the mouth of
another artist. Sebastiano del Piombo felt that had Titian gone to Rome
and studied Raphael and Michelangelo, he might have become the
equal of these exalted models, for though he stood as "the most perfect
imitator of Nature of our times, as regards coloring," Titian must be
found wanting in "the great foundation of all, *disegno*." And Michel-
angelo himself confided to Vasari, "If this artist had been aided by Art
and knowledge of *disegno*, as he is by nature, he would have produced
works which none could surpass." It is fascinating to overhear the
critical carping of the Florentine art world circa 1540, which evidently
perceived Titian as a stunning copyist of Nature's chromatic array just
as it presented itself to the eye but virtually without the mediation of
intellect or knowledge, and hence without "art"—like a fine camera
with color film, had they possessed this mechanical analogy. Vasari
makes the point that it is as important to study other artists as it is to
address nature, for otherwise "one can never attain to the perfection
of adding what may be wanted to the copy which [the artist] makes
from life, giving to it that grace and completion whereby Art goes
beyond the hand of Nature, which very frequently produces parts that
are not beautiful." The consensus appears to have been that Titian
was a great replicating machine, an imitating prodigy, lacking edu-
cation and refinement.

Yet deficiency in point of draftsmanship would scarcely present

itself as a disfiguring dimension of Titian's work to one who visits the spectacular exhibition of his work at the National Gallery in Washington. But that perhaps shows the degree to which our concept of drawing differs from the concept of *disegno* in the vocabulary of cinquecento critical discourse. So perhaps before entering the show we might reflect on the turbulence created by the introduction of Venetian criteria of painterly excellence into Florentine consciousness, which was clearly threatened. Giorgione, Titian's model and effectively the inventor of the Venetian strategy, is described by Vasari as having held that "to paint with colors only, without any drawing on paper, was the best mode of proceeding, and most perfectly in accord with the true principles of *disegno*." But it is clear that Giorgione was changing the meaning of that latter word, and in effect redefining the act of painting itself, by eliminating preparatory designs and beginning directly with color. Vasari objects to this way of going about things: "To give order to his compositions, and arrange his concepts intelligibly, [the artist] must first group them in different ways on paper, to ascertain how they may all go together; for the fancy cannot fully realize her own intentions unless these be to a certain extent submitted to the corporal eye, which then aids her to form a correct judgment."

The Florentine paradigm would involve a careful planning of the work, which stood to the preliminary drawings as a piece of architecture does to its plans. One would not, after all, just begin with bricks and mortar and see what sort of building emerged. The Florentine was systematic, rational, computational, and in fact it seemed altogether natural that the same skills that enabled one to be a painter could as easily have been put to the ends of designing buildings. Venetian art, by contrast, seems spontaneous and romantic, full of risks and un-anticipated triumphs, open to revisions, sudden inspirations and an almost erotic engagement with the painting, rather than subject to some imposed cold artistic will. The Venetian painting is summoned out of pigment, and it really is difficult to imagine Titian as an architect, approaching structures in the same spirit as that in which he ap-proached painting, which in Venice became a different sort of art. If we were to look to sculpture for comparison, the Florentine would be a carver, removing excess marble to reveal the form within, awaiting release like an imprisoned Platonic essence. The Venetian would in-stead be a molder, evoking novel essences out of lumps of clay. Would God make preliminary sketches in fashioning humans out of dust?

There were, then, two distinct conceptions of drawing in Vasari's

147]

art world and, of necessity, two distinct conceptions of what it was to paint. In one approach, drawing stands to painting as an idea stands to its realization, or its transcription into the medium of color. In the other, idea and realization emerge together out of the act of painting, and the work is in no sense a transcription of some external pattern. Drawing might, in this approach, be simply the first stage of the painting, not a preliminary to the painterly act. It is clear that the impulses of the New York School belong to this second approach, and that Pollock and De Kooning are in their philosophical address to art Venetian to the core. It is simply unimaginable that Pollock should have made preliminary drawings and projected them onto canvas, which he then translated into paint! (It is also difficult to imagine Pollock as an architect.) The Venetian conception of painting went with an entire transformation in the materials of the artist, with canvas esteemed for its texture and paint for its physicality and brushes for their gestural responsiveness. The Florentine surface was textureless, the paint was transparent, the brush valued for leaving no trace of itself on the surface of the work. There was now a choice between artistic philosophies and distinct material complexes that enabled those philosophies to be carried out. What Michelangelo perceived as a deficiency was in truth an alternative vision of painterly creation. Vasari thought that the developmental history of art, construed as *disegno*, had culminated and effectively come to an end with Michelangelo. What he perhaps could not see was that a new history of art, construed as *colorito*, had begun with Giorgione and Titian.

We can join the discussion if we care to, inasmuch as the very painting Michelangelo and Vasari were debating is among the wonders assembled at the National Gallery. This is Titian's *Danaë*, which the two Florentines saw when Titian had just finished it in the Belvedere, in Rome—"a nude figure representing Danaë, with Jupiter transformed into a shower of gold in her lap," as Vasari described it. Danaë is shown in her bed, propped up on silken cushions, with a look of tender voluptuousness on her face, as she gazes adoringly at the burst and dazzle of gold into which Jupiter has turned himself above her luminous body. Her left hand clutches the bedclothes in anticipatory passion, and her legs are poised to open, to receive her transfigured lover. At the right, Cupid tiptoes out of the picture—and the bedchamber—staring curiously up at the golden presence, holding his mischievous bow. Behind Cupid we see a pale morning (or evening) sky, but the bedchamber itself is dark, and Jupiter explodes into it like an orgasm of gold, showering golden coins onto Danaë's glowing flesh.

Danaë shines with an inner light, the way the painting itself does, and one feels that the painting is in fact a metaphor of erotic transformation for which the myth it illustrates is only an occasion. It *shows*, it makes visual, what it *feels* like to be the subject of intense fleshly consummations. Alongside it, the art of Florence looks chill, abstract, contrived, cerebral. Titian evokes a dream in which the longings of the senses are impossibly fulfilled. It is radiant with an inner glory. Jupiter, Danaë, and the painting that shows them are all three incarnations of light. It is as though the painter had the same transmutative powers as the god. The painting gives concreteness to De Kooning's marvelous observation that flesh was the reason oil painting was invented.

For all of *Danaë*'s palpable eroticism, it is difficult to suppress the thought that resolving himself into a shower of gold put Jupiter into much the same relationship with the glorious girl beneath him as the one sustained between God the Father and the submissive Virgin in Titian's late depiction of that theme—as if Perseus (Danaë's son) were immaculately conceived. There is an unmistakable visual analogy between Jove and Jehovah in these two paintings, each an incandescence, each finding a way through light to impregnate a human female. It is in the representation of divinity as an *éclat* that *colorito* pays a sort of dividend: the brushy evocation of an intense luminosity seems more suited to the being under depiction than the treatment of him as a whiskered gentleman who required the mediation of a dove. It shows an advance over the bearded sky-flier in Michelangelo's fresco. And though light must early have recommended itself as a metaphor for the mystery of the Conception, no better illustration of the difference between *disegno* and *colorito* can be found than by placing side by side Botticelli's treatment of the Conception as so many rays of light and Titian's as a great volcanic eruption in which the skies part to reveal a blinding radiance beyond. There is a wonderful contrast in female receptiveness between Danaë and Mary. Mary is dark, heavy-lipped, serious, and she simply lifts her veil to allow the light passage, merely observing, detachedly and as if it had nothing to do with her, the intense fall of light onto her right breast and into the whitened pages of the book she has put aside to accept the tremendous infusion. *How* powerful the event was is transmitted to us through the Angel of the Annunciation, who places her hands protectively over her breasts, as if in empathy for the assault on Mary's body. That Mary is calm while the angel is agitated and even agonized defines acceptance in a way so visual as to be beyond the power of words to capture.

Titian's paintings possess an opulence that situates them in the

world they depict, a world whose *substance* is opulence, manifesting itself as gold, as velvet, as jewels, as the hair and flesh of women who, in contrast with Danaë, are as tranquil as Mary and as unaffected by the lusts they arouse as pearls are by the cupidity they stimulate. This is nowhere more powerfully shown than in the magnificent *Venus with an Organist and Dog*, on loan from the Prado. Venus, like Danaë nude except for her jewelry, is stretched luxuriously upon a velvet coverlet, resting against silken pillows. Her right hand is on her thigh, and she fondles with her left hand an agitated little dog which has its own jeweled collar. Venus is the embodiment of *luxe, calme, et volupté*, which is underscored by the adjacent animal excitedness of the dog, whom the organist clearly envies. The organist has twisted away from the keyboard, as if pulled by Venus's fleshly beauty, acting at a distance, and he leans into Venus's space, unable to take his eyes off her. Whatever the charms of music, earthly love trumps art. The space into which the organist is crowded is filled with frenzied rhythms (Venus occupies just over three-fourths of the canvas). There is the rhythm of the keyboard, the regular, even rhythm of the organ pipes, which is transmitted to the poplar trees ranked in the garden outside. The organist's pants are rhythmically slashed and his sleeve is a shudder of silk, a spasm from shoulder to wrist. Venus is interested only in the foolish dog, but indolently at best. The painting is a study in erotic tension, which is concentrated into the organist's space. It is a universe of longing, spiced with a whiff of perversity.

My overwhelming feeling as I walked through the show was how mysterious the paintings always are, even the earliest ones. With Michelangelo, one feels power but rarely mystery—or if there is mystery, it is, I think, remediable and due only to our ignorance. With Titian, the mysteries are inexpungible and ingredient to the world he depicted. Recently, I spent a few moments revisiting the beautiful *Concert Champêtre*, once thought to be by Giorgione and now confidently ascribed to Titian instead. There are two opulent nudes, one drawing water, the other holding a flute. Between them are two clothed gentlemen, absorbed not in them but in the music, in contrast with the organist. The painting vibrates with a sense of meaning, even of portent, but we know that it is not something that will yield to disencoding: it disdains and escapes us, as Venus disdains and escapes the organist, whose gaze is a metaphor of impotence. It is as if the paintings internalize, as their cognitive essence, this relationship between the viewers and themselves, as an incarnate mystery of being that we can neither resolve nor forget.

In the terrifying *Tarquin and Lucretia*, from the Fitzwilliam collection, it is as though the organist has become Tarquin, has unsheathed his knife and seeks by force what will not be yielded to him by grace. Lucretia is certainly a transformation of Venus, whose heavy arms cannot fend off the rapist, whose knee already is between hers. What is amazing in this painting is that it is *she* who gazes, admittedly in terror, and it is to her gaze that our own goes, rather than to her flesh, still nude, but not visually available to us: her gaze pulls ours away from her body to her eyes, and to their fear and anguish. Tarquin will get what he wants but only at the price of destroying it. Something priceless has to be sacrificed. The space between eye and painting has to be kept inviolate or meaning flees. Venus has meaning only as long as she is not ours.

The deep analogy I sense between painting and flesh in Titian strikes me as a possible metaphor in the almost unendurably painful *Flaying of Marsyas*, with which the exhibition concludes. Marsyas, a satyr, has lost the musical contest to Apollo and, as the stakes were that the winner could do what he wished to the loser, Marsyas is being skinned alive as he hangs from his heels. It is a very late painting, and one wonders if it can be a sort of self-portrait: Michelangelo depicted himself in *The Last Judgment* as the flayed skin of St. Bartholomew. Of course, Marsyas does not look like the aged Titian, who depicted himself as Joseph of Arimathea in an Entombment. But the message could be more universal and more figurative, as if losing one's skin were the equivalent of losing one's artistic powers, even if to a god. It must be a supplemental agony for Marsyas that a violinist is playing while he undergoes his awesome martyrdom. Venus's little dog is lapping up the blood that has pooled beneath him. A fanged dog, obviously bent on devouring the exposed flesh, is being for the moment restrained by a putto in the lower right. And Midas, for whom everything touched became gold, as it did for Titian, sits pondering, within the painting, the same mystery we contemplate from without. It is a furious testament.

—*The Nation*, December 31, 1990

Van Dyck

AN ARTIST whom I greatly admire achieved at one point in her career a considerable, if local, reputation through drawings she produced of Boston and Cambridge. Her images were products of her own exuberant style and of the styles of the characteristic streets and edifices of brick and wrought iron and ornamental window frames and cornices that define those places visually. But there was a third variable in the unmistakable equation of her work that was less visible than these other two when her celebrity was at its flood, when her drawings were collected and reproduced in books and made into posters and widely imitated. She came to recognize this factor only years after she had left Cambridge for New York, and had returned to the site of her early success, which she now could see through unillusioned eyes. The places she had drawn with such affection were still quaint and quirky, and possessed of a picturesque charm. But she saw them for what they were now, and no longer as enwrapped in a cloud of magic. She had, in ways it would repay a seminar in art history or aesthetics to study, created a visual myth of these places, and it was this myth that made her images so compelling to those whose own perceptions she had somehow made objective. She had defined for her viewers the reality as they wanted it to be; but because she and they really saw things as she drew them, they did not realize that they had enveloped visual reality with a myth of enchantment. Saul Steinberg, in his famous *New Yorker* cover, depicted the world as seen by New Yorkers, making a way of seeing instantly recognizable. My artist did not bring her enthusiasts' way of seeing to conscious awareness in that way, which is why it remained a myth. She had intuited what they had wanted to

believe about their city, and presented it to them as if it were visual truth, charmingly drawn. Later she was able to see the myth as itself because she no longer shared it and was viewing it from the outside.

Between the style and the subject of an artist there can often be found this third quality, which is the sense of a world to which artist and subject together belong—a way of seeing, a sense of being, a mode of mythic perception. The style of the Impressionists, for example, is unmistakable, and their characteristic subjects can almost be listed: fields of flowers, distant stands of poplars, women in flounced skirts under bright parasols, boaters, waltzers, drinkers in boulevard cafés, the Seine, the Norman coast. But style and subject together are in the service of a shared vision of life, and it would have been this further sense of having given visual embodiment to a world that drew to the Impressionists their first patrons, and that gives their works today the poignancy they possess for those of us who can see that world from without, as something that excludes us. There must have come a point in the history of Impressionism when the fact that there was this em-bodied world became visible, for discrepancies between it and reality revealed the former for what it was—a visual myth. Whenever that difference dawned, after it Impressionism remained an artistic option only as a manner, as an archaism, as a posture of external address. Whatever the explanation, the world of the Impressionists vanished as something one could live, and it survived only in their paintings, which enable us to enter it vicariously.

What one might call the world of Anthony Van Dyck is perhaps the single most striking feature of the paintings he did in the greatest period of his energetic, truncated career, from the time of his knight-hood and appointment in 1632 as "principall Paynter in Ordinary to their Majesties"—Charles I of England and his Queen, Henrietta Maria—until his death in 1641. Strictly, it was no more his world than it was the world of those very majesties, whom he portrayed as they believed themselves to be and as those who formed the society of their court believed them to be: as the incarnation of heroic virtue and the embodiment of love and beauty. The Caroline court was in a sense encapsulated in English society—a bubble of ritual and of refined etiquette fragilely afloat in a rough, coarse population of louts and fanatics, and inhabited by men and women who believed themselves to occupy an almost Platonic plane of exalted being. And what Van Dyck achieved was the portrayal of this world from within, giving external expression to a vision that was instantly accepted as truth.

Everything in his paintings of those years is penetrated and is explained by the feelings he objectified, and the body of his work has passed into history intact with the world that gave it life but did not long survive his death.

The objective conditions that gave credibility to Van Dyck's world ceased to hold in a way he could not have imagined, nor can we imagine what would have happened to Van Dyck as an artist when the world he and his subjects believed in was unmasked as myth. "He had recorded the luminous, tranquil years that Whitehall would not see again," wrote C. V. Wedgwood in her masterly *The King's War*: "Men of dimmer vision and clumsier hands would record the worried faces of the coming decade." (Writing at the end of the 1980s, when it is said all around that New York will not see such times again, one wonders if the world of those years is not present in their paintings, to become visible at a later time.) Van Dyck's subjects of those years stand bathed in the haunting brilliance of a remembered dream not known for what it was by those who dreamed it. In the dream, men and women were almost wholly spiritual beings. In truth, they were as human—all too human—as the rest of the country: greedy and lustful, ambitious and intolerant. But it is a tribute to Charles and Henrietta Maria that they were able to impart to such persons this sense of the court as a blessed precinct; and it is a tribute to the art of Van Dyck that he captured this feeling so convincingly that his patrons might see themselves in his paintings as little different from what they believed they were seeing in their mirrors. Van Dyck's style, of course, lived on into the nineteenth century as the conventional framework of English portraiture. But in the astonishing span during which Charles ruled as a god (as he would have seen it) or as a tyrant (as a fair number of his subjects viewed it), Van Dyck's world was not regarded as a manner or a convention, a knack of the brush or an exercise of virtuosity, but the spiritual truth shown as visual reality.

The first of the canvases that convey this conviction in the splendid exhibition of Van Dyck's work on view in the National Gallery of Art in Washington, D.C., is a brilliant double portrait of the King and Queen, done in the year in which Van Dyck arrived in London to take up his artistic responsibilities. Indeed, it is possible to view the sixty-odd works that precede it (beginning with an amazing head of an elderly man in ruffed collar, which Van Dyck painted as a prodigy at fourteen!) as the artist's preparation for his call to England and the artistic mission of his life. Charles I had a passion for painting—he

was said, by Rubens without flattery, to have been a connoisseur, *le prince le plus amateur de la peinture qui soit au monde*. But beyond that he had a profound sense for the power of images, and it is to his immense credit that he sensed in Van Dyck exactly the artist he required to give pictorial definition to the meaning of kingship as he believed in and lived it. From his father, Charles took over the belief in the divine right of monarchs to rule, and that a king was a kind of demigod vested with a transcendent political authority, and under obligation to project this awesome vocation in the entire style of his life: "God gave not Kings the stile of Gods in vaine" opens James's treatise on kingship. So the "stile of Gods" was intended to demonstrate to those who understood it as a symbolic language that the divine kingdom was an earthly reality. Everything—manners, costumes, facial demeanor, cuisine, syntax, furniture, decoration, the structures of leisure, and, in Charles's court, above all the masques in which the King and Queen danced before their courtiers the allegories of their relationship to one another and to the world—belonged to this language, which, just as Wittgenstein would say, specified a form of life. In point of faith in the efficacy of ritual enactment, there is little to choose between the masquers of the Stuart court and the rain dancers of the Zuñi.

It was altogether natural, against this background, for Charles to have sought an artist who would not so much represent the court as embody the meanings that defined it *as if* merely representing the court, and Van Dyck intuited what was required of him. His portraits were not to be so much exact physiognomic likenesses as enhanced visual equivalences of his sitters, translated into paint. The great marriage portrait thus manages to make the cloudy allegory of the marriage relationship into a convincing emotional presence. It knots into a single image religious acceptance, married love, war and peace, art and political authority. The King and Queen, after all, belonged to different religions, and what better image could be found for the harmony of faiths than the wedded condition of the adherents? Protestants and Catholics were tearing at one another's throats in 1632, the unspeakable atrocity of the Thirty Years' War having scarcely run half its tortured course by then. The King has his left hand on the pommel of his sword, showing his readiness to fight (Charles's readiness to fight was perhaps what did him in), but with his right hand he has extended an olive wreath to his wife. She holds the emblem of peace with her left hand as she prepares to hand him a sprig of laurel with her right,

as if the crown of poetry were to be the reward of peace. It is like a double-ring ceremony of solemn interchange. The King, in an opulent suit of rose-colored silk, looks with great tenderness toward his wife, who looks outward to the viewer, as if to ascertain that their complex transaction has been duly registered. Charles wears the Order of the Garter, and beside him are the golden paraphernalia of royalty. The Queen wears the kind of dress in which Van Dyck chose to portray his women subjects, in this case oyster white silk with an intricate lace collar, and ribbons the color of the King's coat. Dark curtains swag behind the royal couple in order to set off the luminousness of their garments visually and to reveal, symbolically, through the parting between them, the sun manifesting itself through breaking clouds. But beneath the play of symbols there is in this great painting an unmistakable emotional reality: Charles and Henrietta Maria were in truth married lovers, and Van Dyck succeeds in showing them to us as they were seen in each other's eyes. It is this that gives conviction to Van Dyck's image and situates it, with Rembrandt's *Jewish Bride* and Van Eyck's *Arnolfini Wedding*, in the anthology of artistic testimonies to the wedded union of two persons.

One has the sense that the Caroline court was sentimental to an almost Victorian degree. *Thomas Killigrew and William, Lord Crofts* shows the former in an elaborate mourning costume, against a broken pillar whose meaning is transparent, wearing an expression of melancholy grief. His dead wife's wedding ring is fixed with a black ribbon to his wrist, her cross attached to his sleeve. He is being comforted by his friend, reading to him what we must assume is a text of consolation, though Van Dyck has left the page blank, deliberately, one must suppose, more confident perhaps in the power of his image to convey sympathy than in the power of words to override loss. It is somehow extremely moving that Thomas Killigrew, bereft at twenty-six, should have commissioned Van Dyck to depict him just when his sense of loss was at its keenest, and should have wished to be preserved, for as long as the painting endured, as a man who showed acute feeling, as though nothing that might happen to him in after years could erase or diminish this severe moment. But there is a sense of melancholy in all the portraits of these years, nowhere more marked than in *Charles I in Three Positions*, which Van Dyck executed for the use of the sculptor Bernini, who would be able, from the right profile, full-face, and left three-quarters view of Charles (in different costumes as well) to fashion a marble portrait of the King. Writers have remarked on Charles's *volto*

funesto, and Bernini himself is credited with having seen inscribed in sad features some foreboding of his tragic end, and the end of the courtly dance he inspired and led. But the triple portrait was executed in 1635–36, when the King was at the pinnacle of his period of absolute rule, and was almost certainly protected, in part by the illusions of courtly life, in part by his own profoundly shortsighted views of political reality outside the court, from any premonition of it all coming to an end. That the King should be executed was unthinkable, as close to a contradiction as Charles could have imagined. It has been argued, by Roy Strong in a fascinating essay on Van Dyck's *Charles I on Horseback*, that the King's look is instead part of an official expression of philosophical melancholy, worn by members of the Caroline aristocracy as they wore lace collars, to convey a fashionable image of elegiac sensibility. Even feelings, after all, are social constructs of a kind, and without wishing to diminish Thomas Killigrew's feeling of bereavement, it is almost certain that his facial expression suits the occasion of his displaying it, the way his slashed black garment does.

What is difficult to ascertain is the extent to which this look was as much the invention of Van Dyck as was his way of giving figures a certain elongation and slenderness, and their fingers that unmistakable combination of delicacy and strength that presses against the boundaries of caricature. Van Dyck's women, in their trailing skirts of white or crimson satin, are often shown with small accompanying figures to enhance their height—children depicted as particularly short to achieve this effect, or blackamoors looking adoringly up, as if to the face of a goddess, or, as in one standing portrait of Henrietta Maria, with a splendidly proportioned dwarf carrying a monkey on his velveted arm. And the faces of the women are cunningly reduced to make the thinned-down body soar. An art-school formula has the head equal one-seventh the total height of the well-proportioned figure, but I compute Henrietta Maria as being something over nine heads tall—not too noticeable an exaggeration, and concealed by the ample sweep of her skirt, but enough to confer upon her the dimension of a goddess, which she perhaps thought herself to be, as Charles certainly believed himself a god. It helps illustrate how distant we are from the premises of Caroline London that a belief that would qualify someone for insanity in New York today was taken as a simple truth of the universe in 1640, when the last masque was staged, and until 1649, when Charles stepped bravely to the scaffold. But what model would a painter have had for depicting a god's face in 1636 other than the face of

Christ, with its soft beard and eyes of sad acknowledgment and lips of resigned acceptance? Charles was, like Don Quixote, a Knight of the Sad Countenance. It was only an artifact of history that he was destined for execution: Van Dyck merely made him fashionably *triste* and suitably divine.

Or, in the deflationary words of C. V. Wedgwood: "The inhibited, adenoidal face of King Charles, unflatteringly rendered by Mytens, [was] transfigured by Van Dyck's hand with indefinable spiritual grandeur." Mytens was a Dutch master who held Van Dyck's position before the latter came and rendered the former's style obsolete. Still, Mytens has a value for us in showing what people looked like before Van Dyck cast his transfigurative spell and turned them into what they believed they were. Occasionally, we get glimpses of the truth from other sources. Imagine someone who knew the court only as we know it, from Van Dyck's paintings of svelte lordlings and elegant ladies in rich garments, tall and sad against metaphorical skies. Princess Sophia, the sister of Prince Rupert, at first knew only such pictures. But then she came to Whitehall, and confided to her diary that "the Queen (so beautiful in her picture) is a little woman with long lean arms, crooked shoulders, and teeth protruding from her mouth like guns from a fort." No one could see this in Van Dyck's wonderful portraits of her, which even so have their inner truth if, as I imagine, they show the Queen as the King, her lover, believed her to be, as the essence of love and beauty, as the very image of the goddess Venus on earth, as she was depicted in one of the masques.

I think Van Dyck a difficult painter to appreciate today, and to do so one must certainly find a way into the world he created and try to see his subjects as he enabled them to see themselves. I would head for the great marriage portrait first, to let it work on you. You might next seek out another double portrait, whose internal nexus this time is friendship rather than marital love, and that shows Van Dyck himself with his friend and patron Endymion Porter. Their two left hands rest side by side, not touching but in communication, on the back of a chair. Van Dyck's right hand points toward his heart. He displays himself as a Caroline gentleman—it would not have been compliant with *his* visual myth to portray himself as a painter, muddling about the studio. He is the equal of his friend, but, as the mark of friendship, he shows himself as smaller than Endymion Porter, and much less splendid. A small, dapper, handsome man, Van Dyck diminishes and darkens himself in order to give greater splendor to his friend, broad

and luminous in his white costume and ribboned sleeves. Endymion, as Romeo says of Juliet, is the sun.

Whatever one's sympathies, religious or political, finally one will be gripped by the spirit of this world, and can then proceed at leisure to study its emergence, as one of the miracles of the painterly art, through the extraordinary work that led up to it. You might pause before the double portrait of Cornelis and Lucas de Wael, done in Genoa in 1626, with its forecast of the self-portrait with Endymion Porter of nine years later, when Van Dyck's power was at its height. Or before the illustration of a scene in Tasso, *Rinaldo and Armida*, which is about the power of love. It was ordered by Charles; Endymion Porter served as the middleman and is reputed to have occasioned Charles's invitation to Van Dyck. These are external ligatures whose transfigurations as *internal* bonds animate the world you will have entered.

—*The Nation*, February 4, 1991

Max Neuhaus:
Sound Works

CONSIDERING THE NUMBER of Americans who view the New Year's Eve ritual of merrymakers awaiting the ball's descent at Times Square, the archipelago of nondescript pedestrian islands created by the intersection of Broadway and Seventh Avenue just north of the One Times Square tower must count among the most familiar landmarks of Manhattan. They are, for the most part, empty on New Year's Eve, as police barriers keep the crowds massed along the sidewalks; but they are largely as unoccupied as desert islands anyway, and serve mainly as pausing places for harried New Yorkers bent upon traversing the difficult intersections on the urgent missions that take them east and west. The northernmost island has a certain identity because of the TKTS pavilion, where people queue up seeking discount tickets to Broadway shows; and the southernmost island is home to an armed forces recruiting station, long a landmark of the area. The rest have some hopeful trees in wooden planters, placed there "for the beautification of Times Square," according to bronze plaques set flush with the pavement in 1964 by the Broadway Association and the City of New York. The wedge-shaped islands are in any case sufficiently inhospitable so that these efforts at aesthetic redemption are virtually invisible, unless one is paying particular attention to the sparse inventory of light poles, traffic signs, subway grates, and the trees. It is altogether appropriate, in consequence, that the archipelago's most singular monument should be a work of art whose substance guarantees its invisibility, inasmuch as it is made of sound.

Once one knows this artwork exists, it is impossible, looking down upon the islands as one sees the New Year in, not to visualize it as a

perfectly transparent prism of sound rising up an indeterminate height from its base, defined by the wedge-shaped grate at the north edge of the island between Forty-fifth and Forty-sixth streets and, like Ariel on Prospero's island, "invisible / to every eyeball." Indeed, knowing it is there, one can imagine it contributing to the midnight cacophony of hoots and toots its own vertical, unwavering sound. Still, it remains discrete and does not register upon the ear unless one walks through it—and even then one can easily fail to register it. Now and again, though, someone passing through it at some less celebratory moment of the year may wonder (if it evokes a memory of Ferdinand's words in *The Tempest*: "Where should this music be? I' th'air or th'earth?") what the noise is all about. A kind of high-pitched, unrelenting drone, it is a sound that belongs to art by contrast to the honks of passing taxis, the screech of trains underground, the mingled shouts and mutters of the passing millions. But it somehow also goes with these sounds because of its tough and uningratiating character. It would be ill suited to the context were one who walked across the grate to hear what Caliban described as "sounds and sweet airs that give delight and hurt not." It does not emanate from, as Stephano put it, "a brave kingdom . . . where I shall have my music for nothing"; this island is no tarrying place, and the sound is not intended to be listened to, merely heard. It really is more like the "groans [that] / Did make wolves howl and penetrate the breasts / Of angry bears," which were emitted by poor Ariel when he was enclosed in a pine tree—perhaps similar to those in the nearby wooden planters—by the witch Sycorax, and left there until liberated by Prospero a dozen years later. This howl has been here, filling the shaft that its precisely defined space creates, since 1977. Its title, appropriately, is *Times Square*, and as a work of public art it is exemplary in excluding no other uses to which its island might be put, and in being, through its nature, immune to desecration by graffiti.

Times Square is by Max Neuhaus, at one point in his career a very advanced musician, a virtuoso percussionist, in fact, who gave his final recital at Carnegie Hall in 1965 and who made his final recording for Columbia Records in the fateful year 1968. For reasons no doubt personal and conceptual, but also, given the spirit of those years, for reasons of what one might call political aesthetics, Neuhaus reconceived himself as a kind of visual artist who happens to use sounds rather than colors, but for whom shape is as central as it is for sculpture. As part of the general critique of institutions that swept popular con-

sciousness in those years, it struck Neuhaus that the contrived production of sound was too important to be restricted to the artificial circumstances of the concert hall, while at the same time he was certain that the commonplace washes of music that we wade through in lobbies and elevators—what he terms "decorating with sound"—belong to a practice too shallow, finally, to function in the way that art is supposed to in the exaltation of the human spirit. Given his musical gifts, he could, like the harpist Daphne Hellman, who gives concerts from time to time on subway platforms, set up his drums and bells on street corners and gather a crowd. But this would simply be to make the atmosphere of the concert hall portable: he would in effect generate a bubble of aesthetic space around himself, and passersby would form themselves into an audience, which would listen, applaud, and look for a tambourine in which to drop a coin. This would not constitute a true aesthetic transformation of the environment, any more than the bubbles of air that astronauts wear on moonwalks transform the moon's atmosphere.

What Neuhaus aspired to was the enhancement of ordinary life through sound—*ordinary* life, as it courses along, and with whose aural surfaces he could *interact* rather than whose flow he might *interrupt*, as with music. The concert hall, like the museum, is a special precinct, with rules and conventions that define the conduct of those who enter it, and whose walls, so to speak, are like parentheses that bracket the experiences had within, and segregate these experiences from the flow of life. An analogy can be made with churches. Someone might decide to "bring religion to the streets" by setting up a pulpit and declaiming the Gospel on busy corners. But this, in effect, would be a portable tabernacle, a bubble of sacral space encapsulated in midtown life, which flows unheedingly around it, save for those attracted as a momentary congregation. Someone whose religious mission corresponded to Neuhaus's artistic one would be concerned, rather, with what Feuerbach powerfully describes as "sacramental celebrations of earthly truth." Neuhaus's work, then, involves what one might think of as minimal displacements of the real rather than *replacements* of it through the insertion of contrived artistic entities, which carry their own imperatives and inducements.

It is central to the enterprise, accordingly, that one should merely *happen* upon the sounds, discover them as unexpected aural presences or—in the case I shall describe in a moment—as aural absences, when Neuhaus inserts a certain shaped silence into the flow of aural expe-

rience where it is least expected. Thus there is no plaque, at Forty-sixth Street, marking the fact that here is a work by Max Neuhaus, installed in 1977. One simply hits, as it were, an unresisting wall of sound, to which one may or may not pay attention, and which may or may not register on one's awareness. After all, the sound work does not shut out the surrounding noises, and one does not visit the island to admire the installation—not, at least, under the intended effect, which presupposes an initial unawareness of the work's existence. In the intended scenario, I suppose, the pedestrian carries away an impression of the sound life of the place having been intersected but not interrupted, as though a sound had occurred that left everything as it was and yet at the same time transfigured.

Neuhaus sees himself as something of an acoustical benefactor, and it is characteristic of his sensibility that he sees aural squalor where the rest of us merely perceive noise. Anyone who has driven city streets knows the panic of hearing a siren, knowing one should pull over to allow the emergency vehicle to pass, but not being sure it is even on the same street. The noise seems everywhere, and nowhere. We take the ambiguity of sirens as a necessary evil, as do those who drive the emergency vehicles, they being unable to hear any noise other than their own siren. (There have been, as a result, calamitous accidents between police cars whose drivers could not hear one another.) The solution is to put "holes" in the sound, Neuhaus has told me, and then shape the siren so that its direction and velocity are clear. It has been difficult, however, to get funds for such research, since the National Science Foundation considers Neuhaus an artist and the National Endowment for the Arts does not subsidize applied science, and police departments have other priorities and are not disposed to fix what isn't broken. Neuhaus is not an artist like Christo, for whom the politics of getting his work accepted and installed is part of the artistic process. For Neuhaus, these are merely trials, even though a fair amount of his time is spent in getting support for his projects. A great deal of testing enters into the shaping of sounds, and a lot of electronic bricolage. The bills run up when art crosses the boundaries into everyday life, and it is far from plain that we shall ever get the humane sirens of Neuhaus's visionary imagination. We are fortunate to have the sound works we do have.

Times Square is the only public sound work by Neuhaus in New York at present, and one of only two of his works in the United States. The other is permanently installed in the stairwell at the Mu-

seum of Contemporary Art in Chicago, where it is in aural symbiosis with ordinary building sounds like those made by elevators and air-conditioning systems. For the most part, his works are found here and there in Europe, where he resides. He did have a piece in the 1983 Whitney Biennial, and its presence there is testimony that his work shares enough boundaries with the visual arts so that the ones it shares with music do not disqualify it as a kind of sculpture, inasmuch as spatial contours are part of its essence, and its shape can be dia-grammed without special notation. *Performed* music, of course, has shape, and the design of concert halls takes into consideration the question of the ideal location for listening to it. Stereophonic emission undertakes to achieve the same effect. But traditionally, spatial factors have no presence in the score, and it is as if shape were the price that melodies pay for being heard, an artifact of our hearing apparatus having evolved in such a way that we cannot help giving sounds a location. Spatial considerations tend to define a difference between our experience of music and our musical experience, and do not strictly belong to the latter, any more than do the coughs of a concert audience, which belong to the former. But then, because spatial considerations are essential to sound works, they cannot be classed as music. More-over, for reasons I shall come to, a sound work cannot be recorded. It has to be experienced at the site for which it was designed.

In the case of the Whitney work of 1983, the site in question was the so-called sculpture court in front of the museum, on Madison Avenue, which is transected by the familiar noises of chugging buses and slamming truck gates, urgent sirens and impatient taxis, and the amiable chatter of those waiting to enter the museum, or of school-children passing by in groups. *Time Piece* was composed, in perhaps both senses of the term, of these live sounds, which Neuhaus then "colored" and shifted somewhat in time, but in such a way that the slightly enhanced street noises heard by the museum visitors would have been heard as precisely those street noises and nothing more. But every quarter of an hour, the coloration ceased, leaving in its place an abruptly noticeable silence: the presence of a momentary absence. "For the few seconds after the sound is gone," Neuhaus writes, "what could be described as a transparent aural afterimage is superimposed on the everyday sounds of the environment." These periodic silences he terms a "silent alarm clock," using, in effect, the silence to awaken us to the noises of the passing world. Neuhaus has created just such a time piece for the Kunsthalle in Bern, Switzerland, where, on each hour and half

hour, a sound, insinuated into the flow of sounds that constitute the aural fabric of life as it flows around that institution, suddenly ceases, striking the hour and half hour with heard silences. It is as though the ordinary world is restored to consciousness, through these silences, every thirty minutes. It is, in fact, a very poetic idea.

Neuhaus had proposed such a clock for the Whitney, but it was rejected, in my view rightly, in favor of the more restricted *Time Piece* executed for the sculpture court. The idea of what he calls a "silent public clock for the immediate neighborhood surrounding the museum" would be invasive. The Bern Kunsthalle, so far as I can judge from photographs, is fairly isolated, and my sense is that the periodic kernels of silence would be heard mainly by those already approaching the site, and expecting artistic experience. But invading people's private spaces with public sounds and silences, even if art, raises questions of morality. The Whitney has had extreme difficulties in getting a new design (which I felt was marvelous) accepted by its neighborhood, partly on grounds that it did not "fit" (the existing building, by Marcel Breuer, would have been shot down had present sensibilities been in place when it was proposed). But at least it would only be seen, and then only by passersby or those directly in front of it. A public clock would penetrate the entire area. Neuhaus himself has observed that "it is possible for most people to stay and even be comfortable in a room which is painted a color which they dislike—but few of us wish to remain in a place with a sound which annoys us."

Not long ago, *The New York Times* ran articles on a vexing noise in midtown, which was tracked down to a specific building, some of whose fittings were acted upon by the wind to create a sound neighbors found agonizing and unremitting. The noise was a side effect, unforeseen by the architect. But let us imagine, under the "1 percent" provision, which mandates that 1 percent of architectural costs be devoted to art attached to a building, that an architect were to collaborate with a sound artist, who in fact had designed the noise everyone found so noxious. Suppose it was an office building, and the artist defended his sound piece as "site specific," despite which neighbors petitioned for its removal. Then we would have a controversy almost exactly parallel to the one that arose over Richard Serra's *Tilted Arc*, when cries of censorship filled the air, and the art world testified as one on behalf of artistic freedom. Admittedly, in the case of the midtown building, part of the agony may have been due to the fact that its victims did not know from whence the noise came; but it must be remembered

that Neuhaus's art in part depends upon being "found" by people who do not expect it, and don't in any case always know from whence it comes. An annoying sound at Federal Plaza would have been even worse than *Tilted Arc* was felt to be, and this suggests some of the limits of public sound pieces, and perhaps of public art itself: it should not be invasive. And that may explain some of the blandness of much public art. The public sound artist has to pursue enhancement, and at the same time avoid the cost of annoyance. That agenda was set by Caliban, after all not quite the insensitive soul we thought: "Sometimes a thousand twangling instruments / Will hum about mine ears, and sometime voices / That, if I then had waked after long sleep, / Will make me sleep again."

Max Neuhaus has only the resources of electronics to work with, and not, alas, Prospero's potent staff. So *Times Square* hardly meets Caliban's criteria. But I have read of a lovely piece he created in Cologne, next to the de-belled church of St. Cäcilien, now a museum for medieval arts. It is called *Bell for St. Cäcilien*, and it consists of a disembodied bell sound that materializes out of nowhere in the little park that the former church flanks. It is like an aural memory of the edifice's former function, and a true piece of artistic magic. It must be a perfect aural experience to hear it, rich with its associations of place, just as *Times Square* is rich with the associations of its very different place.

—*The Nation*, March 4, 1991

Piero della Francesca's
Resurrection

WRITING IN HIS *Lectures on Fine Art* on the portrayal of Jesus in the Christian visual tradition, Hegel is doubtful whether it lies within the capacity of painting to represent those awesome moments in which the specifically divine aspects of Christ are revealed—in the resurrection, the transfiguration, or the ascension. Painting has no difficulty in showing Christ in his human or earthly aspects, as a teacher, a preacher, a leader, a man of anger and forgiveness, and of course as a man capable of terrible suffering. But where "his Divinity should break out from his human personality," Hegel writes, "painting comes up against new difficulties." It is easy enough to say, in words, that Christ was at once man and god, but to show this complex metaphysical nature in a way that is visually convincing tested the powers of a painterly tradition that defined its achievement in naturalistic terms. "The means at the disposal of painting," the philosopher says, "the human figure and its color, the flashing glance of the eye, are insufficient."

Piero della Francesca's *Resurrection* (circa 1463), in the Palazzo Communale of Borgo Sansepolcro in Tuscany, presents the nonnatural occurrence of a human being who has come back to life, an event without which the entire Christian faith, according to St. Paul, must collapse: "If Christ be not risen, then is our preaching vain." As a painting, it overcomes Hegel's difficulties so magnificently as to emblematize the miracles to which visual art may aspire. Piero has shown us what it must have felt like to be the subject of a resurrection, and expressed it in a way that each of us, whatever our religious convictions, can understand. Christ recognizes that something undeniable has

taken place, which nonetheless strains the limits of credibility. He is shown at an instant of stunned triumph. His is the expression of someone who accepts, and is even awed by, what he has no way of doubting but cannot altogether believe. To be sure, he had predicted that it would happen, and his followers were enough convinced of its inevitability that the Romans were obliged to take precautions, sealing the tomb and stationing soldiers there to prevent the body's being stolen and resurrection falsely claimed. The guard at the extreme right seems to have awakened, even to have seen the miracle that he must have interpreted as a dream, for such is the torpor of his body that he seems to be sinking back into sleep, having raised himself on one arm. Only Christ is awake, but in a sense of "awake" that contrasts not so much with "asleep" as with "dead." He is alive in a new dawn, and in a barely imaginable way.

Christ stands erect, with one foot still in his sarcophagus and the other placed almost arrogantly on its edge. He plants the banner of Christianity on the ground outside his tomb, occupied by the sleeping Roman guards. He stands like a great discoverer, about to climb out of his boat onto a new land that he will claim in the name of his sovereign. Except that *he* is the sovereign of this still-somnolent world, which stretches out to include us, as viewers of the painting and witnesses to the miracle. Unlike the soldiers', our eyes are open, and there can be no question of the point from which we are intended to observe. The sarcophagus is presented absolutely head-on: we do not see it from above or from below. Piero was a master of the art of perspective and wrote a standard treatise on its geometry. The chronicler Giorgio Vasari describes a drawn vase "which is treated in such a manner that it can be seen before, behind, and at the sides, while the base and mouth are equally visible; without doubt a most astonishing thing." We have to be at Christ's feet to see the tomb as we do. Christ looks out, with unflinching eyes, over our heads, toward a horizon he alone can see of the world in which he is about to set his foot.

There was never a face like this in the art of the ancients, nor was there a body such as this, inasmuch as the experience Piero was called upon to depict was not available to the ancient world's psychology. The feeling and the idea are both of the new era. Think, for comparison, of the archaic torso of Apollo that the German poet Rainer Maria Rilke describes in a sonnet as being radiant with erotic power, sensuousness, and animal vitality: "We did not know the legendary head, / In which the eyeballs ripened." Little matter: the god gazes at us from every

point of his body's surface. And we see ourselves through that distributed eye as pale, limited creatures. Similarly, we see our own vulnerability reflected in the strength of Christ's body. Were Christ's head lost through some cultural tragedy—evidently Piero's fresco, somewhat abraded, was plastered over in the eighteenth century— we could almost imagine being able to reconstruct it from the posture alone, the figure poised at the edge of the transcended tomb. And it is interesting to ponder the difference between the archaic sculpture and the painting from this perspective. Each envelops the viewer in a mood that unites him with the subject. But a sculpture could not give us the chill, still, silvery feeling of the dawn. Not sunrise, as it were, but daybreak. Christ is the sun, in his dawn-colored robe, under his halo. How are we to read the fact that the clouds seem lighted from above though the literal sun has not yet broken the horizon? The light must be the light of God, bathing the whole world in luminosity.

Medieval moral philosophers distinguished the natural virtues, listed by Plato and Aristotle as wisdom, temperance, justice, and courage, from the supernatural virtues of faith, hope, and charity. We can work at acquiring and strengthening the natural virtues, but faith, hope, and charity are only given by grace. Infused with grace, the other virtues are transformed. The courage of the warrior is different from the fortitude of the martyr, or of the Virgin who accepts the burden of the Lord as flesh, destined to die before her. All of this had to be rendered visually by the artists of the Christian West, and the glory of their art lies in the ways they invented for infusing natural appearances with divine presences, and yet leaving the visual world intact. No one can look at Piero's image without feeling that there is something momentous transpiring through its uncanny calm.

Piero's contemporaries, according to Vasari, held the *Resurrection* to be the greatest of that great master's work in his native city—"Nay," Vasari adds, "of all that he performed." "The mood felt by the painter and instilled into our souls," wrote the English scholar John Addington Symonds, "makes this by far the grandest, most poetic, and most awe-inspiring picture of the resurrection." Nay, one wants to say, in the manner of Vasari, the grandest, most poetic, most awe-inspiring painting of all. Like its subject, the work breaks through limits felt to be absolute. Like its subject, the faithful stand at once incredulous and certain. It is possible to imagine that there is in the appreciation of works of art a distinction that corresponds to that between the natural

and the theological virtues. We outside the circle of faith can know the relationship in which those inside it can stand to such a painting as the *Resurrection* without being able to stand in that relationship ourselves.

—*ArtNews*, Summer 1991

Kazimir Malevich

*1913: In February, Malevich tells Matiushin that the only meaningful
direction for painting is that of Cubo-Futurism.*
—JOOP M. JOOSTEN, *"Chronology," in Kazimir Malevich: 1878–1935*

WHEN THE WINDS of aesthetic doctrine blow across the medium of
artistic production, the surface is formed into waves, or movements.
Groups of artists, often unacquainted with one another, begin making
works that appear to belong to a single defining impulse. These, rather
than the lives of individual artists, are the basic units of art history,
though too little is understood of what one might term the undular
mechanics of such surface perturbations to pretend that we know very
much about what causes the swells, the crests, the breakers, and the
foam tides—or for that matter what accounts for the attenuation of
movements when they at last subside. All that we know is that we have
grown accustomed to view the history of art in terms of the sweep of
such movements, of which there must, in the past century and a half,
have been hundreds and hundreds. An author I once met, whose project
is the history of manifestos, told me she had collected upward of five
hundred of these, each presumably defining the ideological spume of
a distinct movement, however fleeting. And there must have been any
number of others that swept unmanifestoed across the present and into
the archives, borne witness to by scraps of colored cardboard intended
to convey in nonverbal terms the new aesthetic and its transformative
implications for human consciousness.

"If there were no wind, there would be no waves," the treatises
say, which must then mean, since there are no movements to speak
of in the art world today, that (improbable as it sounds) that world has
run out of wind, since the rate of artistic production continues undi-
minished. Of course, the claim of surface calm may be disputed. The
art world is never without its volatilities. But the bulk of contemporary

effervescence has less to do with artistic movements as such than with what we might think of as the artistic wings of political and social movements possessing their own drives and urgencies. The current debates over quality, for example, given prominence in an important essay by Michael Brenson in *The New York Times* last November, or over censorship, or even over pluralism, are but translations into aesthetic terms of larger and more important controversies having to do with claims and counterclaims on rights, liberties, privileges, justice, and the like. Now, it is true that artistic movements have almost always been associated with political and spiritual agendas and visions of new social orders. The Pre-Raphaelites, for example, imagined an entire revision of industrial society together with their imperatives of visual truth. Minimalism, perhaps the last of the great modern movements, was internally related to a critique of social institutions and was never merely the vehicle of some particularly austere doctrine of form. But in all these cases—Surrealism and Futurism are two further examples—it was art itself that was believed to be the fulcrum of the revolution. By contrast, I should think, relatively few feminists would see in art as such the chief agency for resolving the injustices of gender. Rather, the injustices of the larger world would be present, predictably, in the institutions of the art world, and their rectification there would be but the political agenda for that particular front, among many. My sense is that the faith in art as a primary means and agency of spiritual transformation has almost totally vanished, and that this explains the vanishing of art movements as such. Art today is pretty much just art. The winds that stirred the waters into waves were those of higher promises and almost religious assurances.

This was certainly true of the movement in the Russian avant-garde of around 1915 that entered—and remade—art history under the name of Suprematism. Its founder and chief exponent, Kazimir Malevich, was perfectly clear that his was not simply the latest and perhaps the final style of advanced painting but, as the very meaning of the term "supreme" implies, that the ultimate of art had been attained through Suprematism, beyond which, accordingly, nothing could be imagined that was art. Something beyond art, however, and higher than art—for which what we might call "suprematizing" was the way and the means—could be imagined. "My new painting does not belong solely to the earth," Malevich wrote in his characteristic prophetic idiom. "The earth has been abandoned like a house, it has been decimated. Indeed, man feels a great yearning for space, an

impulse to 'break free from the globe of the earth.' " To enter a Suprematist painting, accordingly, would not be like entering a Renaissance painting, whose spaces were those of the earth, filled with people and trees and houses and mountains. It was, rather, to enter a stratosphere of the spirit, beyond the cognitive limits that define earthbound existence. Inevitably, given the most advanced technology available to him for metaphorical extravagance, Malevich thought of his activity in the idiom of aviation. "I have torn through the blue lampshade of color limitations, and have come out into the white; follow me, comrade aviators, sail into the chasm—I have set up the semaphores of Suprematism."

Suprematism was, in Malevich's vision, a system of artistic practice—"a hard, cold system, unsmilingly set in motion by philosophical thought." Its artistic form was a kind of nonobjective painting in which, typically, simplified colored forms were deployed against a neutral white background. But the prepositional "against" is somewhat misleading. What Malevich intended is that these forms—triangles, slightly irregular bars, squares, or circles—should be perceived as floating in a kind of cosmic space, emblems of having broken free of the earth, metaphors for a form of spiritual flotation. I take it that they were meant as more than abstract illustrations of a spiritual condition, however. They were meant to be liberating for the viewer, who was, through them, to find a way into those very spaces, to float, in effect, among other forms. So it was, beyond a system of artistic practice, to be understood as a system of spiritual exercises. I am uncertain whether Malevich used "suprematize" as a verb, but if it can be one, then suprematizing takes up where art has attained its limits. To suprematize is to exist in a higher dimension of spiritual fulfillment than earthly life allows.

It is, I think, exceedingly difficult for a viewer of today to see these often gaily colored showers of form, distributed like confetti across white canvases, pleasing to the eye and to the sense of design, as being dense with the kinds of meanings and means to the states of awakened spirituality that Malevich expected them to be. In part, of course, this is because, however startling nonobjective painting must have appeared in 1915 when Malevich was showing Suprematist works, a long history of abstraction stands between us and those exhibitions. And this history inevitably mutes their energy, and diffuses it, as we view them through the subsequent evolution of abstraction as an artistic commonplace. And in a way, we see them, as well, as merely

examples of a style of design to which they in fact gave rise. *The Oxford Dictionary of Art* closes its entry on Suprematism by saying that "although his direct followers in Russia were of minor account, Malevich had great influence on the development of art and design in the West." Nietzsche once wrote, "I listened for an echo, and heard only applause." Malevich might similarly have lamented, "I looked for fellow aviators and saw designers instead." A man who gives the grandiose name of Suprematism to his work, who defines his life as one of suprematizing, who felt he had broken through boundaries that had imprisoned human consciousness, and who had embarked upon a new exploration of an unimagined space, would hardly be consoled by the assurance that his designs were stunning. In fact, they are so successful as designs that they stand in the way of being perceived as the Suprematisms they were supposed to be.

Because Suprematisms are almost always handsome and bright, they suffer the sort of dilemma a particularly beautiful man or woman must who really wants to be taken seriously as a thinker. It is as though anyone that beautiful must be frivolous and content to be but ornamental. Books on modern art will frequently display something by Malevich on their covers, not alone because his designs exemplify the sort of work to be discussed within but because they are such wonderful embellishments. And often they are discussed as merely that. Consider, for example, the classic study by Alfred H. Barr, Jr., *Cubism and Abstract Art*, reissued a few years ago as a paperback by Harvard University Press. The cover illustration is identified as "Suprematist Composition: Red Square and Black Square." The title could not be more descriptive: a black square is placed squarely in the upper left quadrant of a white rectangle, higher than it is wide, while beneath it, and set at an angle, is a somewhat smaller red square. Barr's text was a pioneering one, as was the exhibition at the Museum of Modern Art in New York, of which he was the director, and for which the text served as catalogue. Barr was indeed among the first to purchase Malevich in any quantity, and he deserves all sorts of credit. Still, it is instructive to read how his text treats the work. "A study in equivalents," Barr writes: "the red square, smaller but more intense in color and more active on its diagonal axis, holds its own against the black square which is larger but negative in color and static in position." This is formalist criticism in its pure state: a work of art is treated in the terms we learn to use in classes in design, if we are artists, or in art appreciation, if we are viewers. It is as if Malevich had brought off a particularly fine solution

to a problem of color, shape, and placement, viz., "Given two squares of different sizes and colors, compose them in such a way that the smaller holds its own against the larger." It would be difficult to explain the subtitle of the work against this reduced way of describing it: "Color Masses in the Fourth Dimension." The "fourth dimension" was a kind of promised land for geometrical cranks in the early years of this century, but without reference to it as a dimension, the work collapses into merely felicitous design. Barr's is really an almost classic docent's mini-lecture. But because the way of looking at abstract art—at any art—that it embodies has become the official way of looking at and thinking about art, it is hardly matter for wonder that we are blind, or numb, to what justified Malevich's art in his own eyes.

A Suprematism of 1920 brightens the jacket of Roger Lipsey's *An Art of Our Own: The Spiritual in Twentieth Century Art*, which Lipsey describes in the body of the text in terms that would have been acceptable to Barr:

A great black triangle, bisecting three freely aligned orange-red bars, floats in quiet equilibrium above an orange-red form, not quite a regular square. There is nothing more, apart from the blank sheet of paper that reads as undifferentiated space. Design, one might say—a happy juxtaposition of form and color that creates visual drama by "floating" a heavy form in a spacious environment. The slight wobble of the beams contrasts nicely with the axial alignment of triangle and square and accentuates the floating sensation. And one is done; one has seen the work and is ready to move on.

But Lipsey, one of the rare writers sensitive to the spiritualist impulses in much of early modern art, impulses occluded by the radical formalism of recent decades, does not move on. He pauses, contemplates, and bit by bit there registers upon him what he speaks of as "some magic more difficult to define than the visual order of the work." He cites a striking phrase of Malevich: "We must prepare ourselves by prayer to embrace the sky." And he begins to feel Suprematism, surely as Malevich would have wished him to, as something that embodies another order of reality in the way an icon does when one believes the saint to be, as Byzantine theorists insisted, mystically present in his or her images. Icons and Suprematisms express the same order of immanence, and if indeed there is a passion for formal purity, this is but a transformed and deflected passion for purity of a different order altogether. When the early modernists spoke of the fourth dimension,

they did so as if it were a plane orthogonal to earthly reality, onto which we might enter as transfigured beings. The question is not whether we want to share these beliefs but whether we can understand the art without knowing how the art was driven by those beliefs.

It is very much, in Suprematism but not only there, as if the pursuit of nonobjectivity were the secular counterpart to the mystic's effort to slip the finite world and enter into oneness with the One. Malevich expresses himself exactly in these terms:

In the year 1913 in my desperate struggle to free art from the ballast of the objective world I fled to the form of the Square and exhibited a picture which was nothing more or less than a black square upon a white background. The critics moaned and with them the public: "Everything we loved is lost: We are in a desert. . . . Before us stands a black square on a white ground."

The Black Square certainly did achieve the status of a kind of icon in the minds of Malevich's sympathizers, and in a photograph of "The Last Futurist Exhibition" of 1915, we can see it displayed, hanging not flat against the wall but at an angle across the meeting of two walls, up near the ceiling, in the position, according to scholars, that the chief icon in a traditional household would occupy. In another photograph, of Malevich laid out in state just after his death, the Black Square is shown hanging just above the artist, not flat against the wall, like the other paintings with which he is surrounded, but leaning over him, as if in solicitude. Malevich was cremated in a Suprematist coffin, and his grave is marked with a white cube on which is a black square. His last paintings, not in any obvious way Suprematist works but strange and unsettlingly traditional portraits, bear the Black Square as signature. It is clear that whatever the Black Square may have meant in the shuttle of influences, to Malevich and to those close enough to him to think about his life and death and art, the image was bound up with meanings of the most profound spiritual nature. Needless to say, not everyone was prepared to see it in such terms. There are always deflationist critics, one of whom put it down as "the greatest by far among the fairground tricks of instant culture." But for Malevich, the Black Square was "depicted with the greatest expressiveness and according to the laws of art."

The original Black Square is not to be seen in the magnificent exhibition of Malevich's work organized by Angelica Rudenstine, which is on view at the Metropolitan Museum of Art. It is evidently

too fragile for travel, but there are two bold Black Squares done at later times, one of them the same dimensions as it. There is as well a Red Square from 1915, and the supreme Suprematism, the notorious and intoxicating White Square on White of 1918, which is among the defining works of the Museum of Modern Art. Each of the squares is somewhat subversive of what one might think of as conduct appropriate to the order of squares. Black Square, for example, is fiendishly unparallel to the geometrically correct square upon which it floats. Red Square is rather vehemently skewed, as if it had not yet attained square-hood, or had just escaped the confines of equiangularity. And the White Square virtually dances on one of its corners in the abstract whiteness of the containing White Square. Each has some distinct meaning and personality, and the sequence from black through red to white obviously connotes some complex itinerary. We have the evidence of his death, however, for the thesis that it was the Black Square that retained the greatest meaning for Malevich until the end.

The exhibition seems a little anthology of the successive movements of Modernism, through the medium of this single strong artistic personality. Malevich was an Impressionist, a Post-Impressionist, he passed through a phase of Art Nouveau, and he put on and discarded the stylistic vestments of Expressionism, Cubism, Futurism, Cubo-Futurism. Perhaps indeed these reflect his "desperate struggle to free art from the ballast of the objective world." When one enters the galleries devoted to Suprematism, one has the sense that now this fiercely eclectic artist has become an abstractionist—until one realizes that here he is not responding to movements from abroad but has found his own. These works have a kind of exultation and triumph that communicate as joy. It is somewhat more difficult to know how to respond to the Post-Suprematist period in Malevich's life, with its stylized and often faceless peasants, which are succeeded by the altogether mystifying portraits in a Renaissance manner. The show concludes with a self-portrait in which the artist shows himself, to my eyes at least, as Christopher Columbus. He is wearing a biretta of Suprematist red, and his hand is cupped beneath an invisible globe. If this indeed is the interpretation of the work, nothing could have been a more fitting image for this great explorer of the deepest spaces—the artistic Admiral of the Ocean Sea.

—*The Nation*, April 8, 1991

Liubov Popova

IN THE CATALOGUE for the posthumous exhibition of the work of
Liubov Popova held in Moscow in 1924, six months after she died of
scarlet fever at the age of thirty-five, the artist is cited thus: "No artistic
success has given me as much satisfaction as the sight of a peasant or
a worker buying a length of material designed by me." This is the
summary manifesto of an artistic revolutionist, and it condenses a
transvaluation of artistic values that the retrospective of 1924 must
have embodied, consisting as it did of seventy-odd paintings (which
represented artistic success as Popova construed it before the Russian
Revolution) and also some textile designs, a few book covers, and some
posters (which defined artistic success in the postrevolutionary era in
which Popova played an exemplary role).

The syntax of the exhibition of Popova's work on view at the
Museum of Modern Art in New York must be very like that of the
Moscow show of 1924. It is essential to recognize, in viewing it, that
the later work, from about 1921 until the artist's abrupt death, is
not simply what follows, chronologically, the earlier work but what
represents the impact upon this artist's life of one of the major his-
torical events of this century. The later pieces—decorative and utili-
tarian—represent her response to that cataclysmic intervention. What
is striking is the way in which Popova applied what she had appreciated
and absorbed as a modernist painter who had worked through the
sequence of avant-garde movements available to Russian artists in
the prerevolutionary years of the century—Cubism, Futurism, Cubo-
Futurism, Suprematism—to projects she might in those earlier years
have dismissed merely as applied art. What is ironic is that Popova

came truly into her own as a designer, and that the Revolution enabled her to become what she essentially was as an artist. Popova was the daughter of a high bourgeois family—privileged, educated, well traveled, and, on the testimony of Rodchenko, who knew her in those earlier years, snooty. She was a strong painter but not an especially original one. She would certainly have disdained as being of lesser artistic moment what, when she internalized the aesthetic imperatives of the Revolution as she and so many of her artistic comrades understood them, she executed so brilliantly and finally with such originality.

The Institute of Artistic Culture (Inkhuk) was established in 1920 as the official body charged with formulating what the task of artists was to be in a Communist society. At a plenary session of Inkhuk in November 1921, it was determined by majority vote that easel painting was finished as a historical possibility; that it belonged to an earlier historical moment; and that the true artistic expression appropriate to the moment was to be found in industrial and applied art. As Popova voted with the majority in this matter, she must have regarded her earlier work—those heavy exercises in analytical Cubism that seem today more the application of formula than inspired contributions to a new style—as emblematic of a phase of historical expression the world had lived through but must reject. "Art is finished!" wrote Alexei Gan. "It has no place in the working apparatus. Labor, technology, organization—that is today's ideology." Ilya Ehrenburg, who was close to the artists, expressed the overall feeling of the moment: "Art has died, once and for all. . . . It is no longer necessary to anyone." So the task of those who used to be artists is "to turn life into an organized process and thus to annihilate art." Popova is identified with the Constructivist movement, at least one wing of which said, "We declare uncompromising war on art!" A convenient formulation, which in its own way echoes Marx's Eleventh Thesis on Feuerbach, states: "We, the Constructivists, reject art since it is not expedient. Art by nature is passive, it only reflects reality. Constructivism is active, it not only reflects reality but acts itself."

It might appear in some degree inconsistent with the theses of historical materialism to *decide* by majority vote what ought by rights to have been left to the mechanisms of historical inevitability. Art, after all, was part of the passive superstructure of society, supposedly reflective of the economic forces that were the true determinants of social change, and causally inoperative in its own right: Art but distantly mirrors, as "the abstract ideal expressions of . . . social relations," the

real engines of history. Such was classical Marxist theory, according to which, in the end, art was one of the ways in which human beings become conscious of the material conditions that shape their lives. But of course the claim would have been, after 1917, that history was essentially over, with all the objective contradictions having worked themselves explosively out. So for the first time, perhaps, art might be active rather than epiphenomenal. And one might then suppose it would be a moment for an artistic pluralism, parallel to the condition benignly promised in the pages of *The German Ideology*: "In communist society, where nobody has one exclusive sphere of activity . . . society regulates the general production and thus makes it possible for me to do one thing today and another thing tomorrow . . . just as I have a mind to." So one can be a Cubist in the morning, a Futurist in the afternoon, a Cubo-Futurist in the evening, and after dinner design textiles, unless one feels like executing Suprematist squares. Alas, as we have learned (not only) from the postrevolutionary period of Soviet history, human beings do not operate with that degree of institutionalized generosity. They are (and artists are no better than bureaucrats: think of how Chagall was hounded out of Vitebsk by the fervent Malevich) concerned to stipulate the artistically correct line, and to intimidate into conformity whoever resists aesthetic dictatorship.

Still, the early 1920s in Moscow, when Popova found her vocation, must have been intoxicating times for artists who had the license of the Revolution to find out what art was to be good for in the new society, and then the opportunity of a society in upheaval to put their cracked theories into practice, sometimes, as with Popova, with stunning results. In that era, "art" and "artist" were what philosophers have termed "essentially contested concepts." On the one side, the view was that the artist is more by far than a craftsperson, that art in its very essence is a spiritual activity, concerned with the enhancement by spiritual values of the higher dimensions of human life, and that art must inevitably be useless and superfluous in a society construed in practical, utilitarian terms. Art and practicality, from this perspective, are sufficiently opposed so that, in becoming practical, art stops being art. This was certainly the view of Malevich, as it was of Kandinsky. On the other side was the predictably contrary attitude that the artist in the new society must of necessity be a technician, whose slogan (as voiced by Rodchenko) must be "Art into life!" This in effect meant the abandonment of paintings, including the Suprematist paintings of Malevich, conceived of by him as points of entry into a realm of spirit and

a "fourth dimension." Instead, artists must concentrate on enhancing the lives of workers in the three-dimensional world of reorganized industrial reality. The studio, whose output had been the repudiated object of aesthetic delectation, was to be transformed into the laboratory, whose products were literally to be designated "production art."

This basic division appeared within as well as between artistic movements. Constructivists, for example, divided over the demand that art serve socially useful purposes. Pevsner and Gabo rejected this even though it was their view that art should reflect modern industrial processes and machinery, and even that it should use industrial products like glass and plastic. Tatlin and Rodchenko held to the inverse demand, according to which unapplied art is unacceptable. So when Alexei Gan, in a text titled "Constructivism," proclaimed the death of art, it was specifically art as a form of religion, as Malevich among others believed it to be, that Gan had in mind. "Let us cease our speculative activity," Gan went on, "and take over the healthy bases of art—color, line, materials, and forms—into the field of reality, of practical construction." Popova was among those most successful in making the transition, and we hardly need the moving declaration recorded in the 1924 catalogue to sense her exultation: all the works she did of applied art, and most especially her designs for the theater, express her sense of having found herself, of being at one with her work, of having found triumph, meaning, value, beauty, and fulfillment.

With Popova, it is as if she were never so free a spirit as when she sacrificed her freedom of creativity to some end more social than the making of a painting. Consider, for example, the abstract works she did in her Suprematist period, roughly from 1916 to 1918. Her forms are largely the ones Malevich used—rhomboids, slightly eccentric rectangles, triangles, and bars. Malevich, however, deploys his forms against a white space that conveys a sense of boundlessness, in which the forms float as if liberated from earthly constraints. They are painterly metaphors for spiritual freedom, intended as devices for the real liberation of the viewer's spirit: everything soars, or floats, or flies, or hovers. Popova crowds her forms into the shallow spaces of Cubist painting: the distance from surface to background is almost infinitesimal; it is as if the forms are pressed between them, like leaves between the pages of a book. So her forms feel as if pasted against one another, without room enough to breathe. Malevich's colors have a singing clarity and are almost translucent: they imply light. Popova's colors

are the colors of paint in its most material sense: scraped and scumbled on, opaque and chalky and heavy. In a way, her Suprematisms seem like Abstract Cubist works, and in some of them, like her *Painterly Architectonic* of 1916, the background has those parallel horizontal strokes one finds in the backgrounds of the Parisian Cubists. They are painterly paintings, but sullen: there is none of the dance of the brush but rather the sense of paint being pushed on with a trowel. With Malevich one feels paint is a means rather than the matter of his work, and that all his effort went into the dematerialization of his work, so that he would have used light had he known how to, or floated color onto space without the mediation of paint. For Popova, paint is of the earth. These are not exultant works.

Compare these claustrophobic exercises, which feel as if they were executed by someone who believed in abstraction as a kind of duty but who held none of the high-flying beliefs in its benefits (which fired Malevich or Kandinsky), with what I think of as Popova's masterworks, her brilliant costume designs for Meyerhold's production of Fernand Crommelynck's *The Magnanimous Cuckold* of 1922. There are three wonderful drawings of "working clothes" for the actors, who were indeed to wear "production clothing." The designs are like proclamatory posters, with red and black lettering declaring that the image is *prozodezhda* (production clothing) for *Aktera No. 5* (or Actor No. 6 or No. 7). The image itself is luminous and alive: Actor No. 5 is a woman wearing a blue overall with a black apron. The apron is a clever composition of Suprematist forms—squares, rectangles, horizontal and vertical bars, separated by thin white spaces. The sleeves are trapezoids, the collar triangles, the skirt a hexagon. In the *prozodezhda* for Actor No. 7, a red square looks like the lining of a cape held open, while the outer side is shown hanging, an irregular triangle, off the actor's shoulder. Everyone is given a visored cap, one is given goggles. The designs simply sing. They are imaginative, luminous, playful, gay, and radiant with intelligence and taste.

In 1921, Popova began to paint what she termed "Space-Force Constructions," in which it appeared that she was endeavoring to comply with Constructivist injunctions by using industrial motifs painted on undisguisedly industrial material, in this case plywood. Oil paint on plywood, one feels, is an effort to yoke art and industry together by external conjunction; and the paintings, which are crisscrossed bars, like struts in a trestle or a suspension bridge, are not especially successful. Mixing marble dust with the paint does not greatly help. One senses the urgency and intelligence that the works seem only to frus-

trate, emblems of a thwarted artistic will. It is one thing for elements to be irregular in Suprematist imagery but quite another when they are intended to designate *industrial* forms. Throughout this series, one has the impression of an artist preparing herself for some achievement that has not disclosed its nature to her. And then, like an external destiny, a commission came from someone who saw her promise. This was the great dramaturge Vsevolod Meyerhold, who invited Popova to teach stage design, and more important to execute the set for *The Magnanimous Cuckold*.

Popova's set was conceived of as an apparatus for actors. From contemporary photographs, but most particularly from the unsurpassed drawings she made, we see the somewhat flaccid crisscrosses of the Space-Force Constructions stiffen and come to life as a scaffolding, with stairs and ramps that enable the actors to move from level to level, to slide down and shout across, and, since it is an erotic comedy—a farce—to look up skirts and dart in and out of bedrooms. The setting in Crommelynck's play was to have been the interior of a mill, and indeed there is a system of wheels in Popova's set, black, yellow, and red wheels that evidently functioned like a mechanized chorus to mark the degree of excitement in the action by rotating at various rates. At the upper left are the blades of the mill wheel itself. In Constructivist theater, the structures were meant to be nonrepresentational, or at least nonrealistic, and were intended merely to organize the space for action, to create what was understood literally as the actors' working space. Apart from Popova's scaffolding, the stage was to be empty, and audiences were shocked to see the bare brick of the house's back wall. And the actors, of course, were to wear "work clothes," roomy and comfortable and uniform, to enable them to execute Meyerhold's severe "biomechanical" stage directions. The basic idea of biomechanics is that the body is a machine, that we stand to our bodies as workers stand to machines, which we must learn to run efficiently and productively: there is no room for psychology, character, feelings. But the characters in *The Magnanimous Cuckold* in fact are driven by very strong feelings. The husband, Bruno, is jealous to the point of insanity; the faithful wife who endeavors to humor him is pressed by guilt and desperation. All this was to be translated into the mechanics of motion, which demanded extraordinary athletic prowess. Popova's set at the time was compared to an acrobat's trapeze, which has little by way of intrinsic beauty and is totally nonrepresentational. Its beauty is in its function, what it enables the acrobat to do.

The drawing for the stage set is, for me, the high point of the

show. It brings the artist to the threshold of greatness. The drawing has again the look of a poster, with red and black sans-serif lettering and a witty metrical scale up its left edge. In the center is the stunning scaffold, with the system of wheels and ladders, and biomechanical stairways running in and out of either side. At the base of the left stairway, an actor is posed in a *prozodezhda* coverall, all in angles, like a Cubist lampstand. This does not constitute the imposition of a specific modernesque format on the human individual. It embodies, rather, the biomechanical ideal. The body looks like a mechanism of joined limbs, almost a robot, about to commence its jerky ascent, up the stairs and across the space like a jumping jack, prepared to execute the almost impossible directions of the inspired—or possessed—Meyerhold.

The Russian modernist painters were profoundly influenced by the French, whose work was made available to them through the hospitable collections of Shchukin and Morozov. Popova herself had gone to Paris to study with the lesser Cubists, Le Fauconnier and Metzinger, whose teachings she rather mechanically followed. It must have been the artistic authority of Paris that determined the presentation of Crommelynck's play, first staged in Paris in 1920. It is a strange and dreamful erotic comedy, whose heroine, Stella, has the ineluctable innocence of Krazy Kat. There is something almost bizarre in the thought that this should have been the great Constructivist theater, the vehicle for all that revolutionary aesthetic and for the symbolic representation of the ideal in a society of machines, in which feelings are extirpated and only efficiency counts. Popova's figures are faceless. But the drawing, like the set that translated it into three dimensions, is celebratory and engaging, and snaps with wit, cleverness, and plastic verve. There were ominous rumblings from the *nomenklatura*. The commissar of education, Anatoly Lunacharsky, called *The Magnanimous Cuckold* "a decline for theatrical art, since a seizure of its territory by the clowns of the music hall." But the production, and especially Popova's sets and costumes, was a great hit. The scaffold itself became a cliché of advanced theater.

The catalogue I began by quoting goes on to say that in the very spring in which she died, "all Moscow was wearing fabric with designs by Popova without knowing it—vivid, strong drawings, full of movement, like the artist's own nature." I find it profoundly affecting that this artist should have found herself at last where she would, in her beginnings, least have expected it. Her paintings all look like pictures

of movement that merely aspire to vividness and strength. These qualities, which eluded her in fine art, are triumphantly present in her designs, and in looking at them we cannot but feel that we are in the presence of this powerful and finally fortunate woman.

—*The Nation*, May 6, 1991

The 1991 Whitney Biennial

I HAD AN INSTRUCTIVE encounter on a return visit to the latest
Whitney Biennial, which I was trying to bring into critical focus. As a
general rule, I am as interested in learning what I can of the public's
responses to a difficult exhibition as I am in testing my own earlier
responses to it, but it rarely happens that the public declares itself so
directly as on the present occasion. The encounter took place on the
museum's lower level, just outside the dining area, where I was looking
in a desultory way at a kind of painting executed on the east wall by
Jessica Diamond. It consisted of a large rectangle of an uningratiating
green—the green of newts or of slime mold, of bile or of reformatory
walls—on which the artist had dashed off a text in crude, uneven letters.
"What *is* that?" a scornful and indignant voice exclaimed. I ventured
to identify it as a piece of activist art. Under a headline that read "No
Inside, No Outside/No Job Well Done" there was a listing of various
foul-ups of the present age: oil spills, crashes, meltdowns, emissions.
And beneath these Diamond had written, "Just the Top Forty." It was
like a latter-day Leporello cataloguing failures. "It is not activist and
it is not art," the stranger said flatly. "In fact, I am going to deface it.
I'm just going to take my lipstick out and write all over it, the way they
want us to." She looked at me conspiratorially and added, "I really
will if you dare me to." I thought such a gesture might create some
badly needed excitement for the show—more, certainly, than the fact
that, as I had been told, someone had stolen the teddy bear from the
installation on AIDS by Group Material in the lobby gallery, since the
culprit there may only have been one of the second-graders I saw
trailing through the display. But I was disinclined to be an accessory

to an act of aesthetic vandalism, which is not my style of art criticism. "*Nation* Critic Incites Angry Aesthete to Graphic Riot" splashed across the front page of the *Post* would no doubt do my reputation a world of good, but I let fate pass me by. Every critic has some technique of evaporating in awkward social encounters, as when challenged to defend a recent column or perhaps to define art. So I slowly dematerialized, leaving my fierce companion to consult her conscience. She was a well-dressed and cultivated woman, and her response was an index of how thin the atmosphere of respect toward art is beginning to grow in our museums of advanced art.

I had little doubt that it *was* art. For one thing, it embodied its own content in that it was sloppily enough done so that, if not among the Top Forty agonies of a collapsing world, it belonged somewhere on its own list. So it was self-referential in the accepted postmodern manner, presenting itself as an example of what it was about—perhaps the kind of painting deserved by a world that has so forsaken the ethics of workmanship that no job, inside or out, is any longer well done. And, because it moralized through self-exemplification, the painting might be activist enough to issue an injunction to "shape up." The interpretation might be taken even further. By cagily embodying its moralistic message, perhaps the work is *well* done (not, certainly, as painting, but perhaps as art: its goodness depends upon its badness). The badness might be in the eye of the beholder, but only because the artist had planted it there, by an aesthetic blow. My companion had clearly responded as to a sock in the eye, and she felt victimized. Her impulse was to strike back. And here, I think, the work failed, if not as art, then as activism. An activist art should fulfill itself through convincing those it reaches to attack its targets, not itself. There is a sad lesson that activist artists must sooner or later learn: the goodness of the messages of art does not translate into goodness of art.

There is a corollary. If an activist artist is sufficiently exercised about a cause to want to advance it through art, and sufficiently moved by the sad lesson just cited to want to make her art good in proportion to her message's urgency, then she faces the decision of whether the energy required to do this might not be better spent in attacking the issue directly. But this perhaps explains why a secondary message is sent by the artistic crudeness of so much activist art, the artist in fact implying that there are more urgent matters, calling for more immediate interventions, than applying aesthetic polish to the vehicle through which the message—Don't just stand there admiring, do

something!—is advanced. So formal values become the enemy of po-
litical ones. This is perhaps the secondary message of Group Material's
AIDS Timeline, whose format is that of the elementary-school project,
wherein the gallery is transformed into a kind of schoolroom, with
posters and displays advancing the theme. That theme is the incre-
mental increases in the epidemic that ravages the art world. It is a
terrible message. Will it be mitigated by a poster of Jesse Helms as a
farmyard animal? Perhaps the classroom project is the best the art
world can come up with at the moment, suggesting that the artists are
engaged in AIDS activism and have no time for more. Or perhaps the
art world has not yet found the form for responding artistically to the
disease.

There are many differences between us and the residents of Flor-
ence and Siena in the fourteenth century, but there are a good many
similarities as well. Theirs also, in the words of art historian Millard
Meiss, was an experience of "economic failure, pestilence, and social
conflict." And there were those, like the master Taddeo Gaddi, who
said of the art of the time that it "has grown and continues to grow
worse day by day"—a sentiment not foreign to critical lips today. In
part, the art to which Gaddi referred was that which sought to be
responsive to the harsh realities of trecento Tuscany, and which cer-
tainly, as we have learned from Meiss's great work *Painting in Florence
and Siena after the Black Death*, could have been perceived as an almost
unthinkable falling-off from standards attained by Giotto, who had
died about fifty years before Gaddi's sour assessment was published
(this was in 1390). What Meiss demonstrates is that the advanced artists
of the trecento's *fin de siècle* had evolved a form of expression meant
to be responsive to the terrible plague that had ravaged the population:
in the summer of 1348, more than half of Tuscany's inhabitants died
of bubonic plague. We, of course, know a great deal more about the
provenance of our plague than they did about theirs, but apart from
safe sex we have as yet no clear way of dealing with it. They were pious
folk, and saw divine displeasure where we see the effects of a retrovirus.
Making art is perhaps the closest we can come to acknowledging our
frustrations in a ceremonial fashion, and though the distance is astro-
nomical between the Strozzi altarpiece by Orcagna, the greatest artist
of the age, and *AIDS Timeline* by the collaborative Group Material,
the impulses of the two works are almost parallel. And the artistic
intentions are at least analogous. Orcagna's altarpiece was propitiatory
and was accordingly a form of activist art suitable to its age, since it

was enacted on behalf of a suffering population that knew nothing better than to placate God in times of trial. It is, of course, beautiful, as propitiatory gestures are required to be: the Homeric heroes always sought to please the gods with the fattest bits of slaughtered animals. *AIDS Timeline* is certainly not beautiful, nor is it in the least apologetic. It is angry, ugly, and aggressive. It blames an indifferent society for the illness it seeks to represent. This, too, is activist, for it means to provoke the society into doing something. Its scruffiness is the emblem of its rage. But then, as happened with my companion before Jessica Diamond's piece, the artists must not be shocked if the audience is angered by it rather than by what it points to. It may be that beauty has no place in an art dedicated to AIDS, though I have been to enough funerals of people with AIDS to know that these have become an art form in their own right, often designed by the dying, who spent their last days thinking of how they wished to be memorialized. And beauty plays a great role in these moving services.

Though the two works I have discussed are located on the lower levels of the museum, Jessica Diamond and Group Material are really what we may now term Fourth Floor Artists, using the label implied by the overall design of the Biennial. The Whitney, in a gesture of institutional wholeheartedness, has given over the entirety of its exhibition space to this show, putting its permanent collection on furlough, with the exception of the talismanic *Circus* by Alexander Calder. And the curators have organized the show by floors, so that the closest we can claim by way of established masters are Second Floor Artists (Johns, Rauschenberg, Kelly, Twombly, and the like), while the Third Floor Artist is one who has achieved renown in the 1980s. The fourth floor houses the young, some of whom may become Third Floor Artists in a decade's time, and some even Second Floor Artists, whose works will be furloughed to make room for future Biennials, should this kind of exhibition survive. But Fourth Floorness is not merely an external matter of age and attenuated reputation. The Fourth Floor Artists have in common a certain mood as well, already sensed in the work of Diamond and of Group Material. It is a mood found in some Third Floor Artists—e.g., Robert Gober, who displays the bottom half of a human being protruding from the wall with a musical score, which I did not pause to try to hum, inscribed across the buttocks—but that does not really penetrate Second Floor sensibility. The Taddeo Gaddis among us, in walking through the exhibits of the fourth floor, may feel that we too are witnessing some terrible degeneration, and that between

those of our Second Floor Artists who might be the living counterparts of Giotto or Cimabue, Bernardo Daddi or Buffalmacco, and those who are the living counterparts of Orcagna or Nardo di Cione, a loss of artistic power has taken place. But some Millard Meiss of the future may instead say that the Fourth Floor Artists represent the consequences of immense social change, and that between the third and fourth floors falls a shadow not so different from that which fell in the 1340s: failing economy, pestilence, homelessness, racial malaise, and the general unraveling as pathetically recorded in Jessica Diamond's work, grown suddenly affecting. The artists of the second and third floors had the luck to work in fortunate historical times.

Third Floor Art tends, on the whole, to be about art, and its images often have other images as their implicit content. Cindy Sherman is represented, for example, by two of her marvelous appropriations of Old Master masterpieces, in which the artist poses herself in the garments and with the accoutrements of the Melun Madonna, of Jean Fouquet, or as Botticelli's Judith carrying the severed head of Holofernes (in this instance, in the ready-to-hand form of a rubber Halloween mask). Mark Tansey appropriates and thematizes a kind of laconic all-purpose illustrational style from about 1920, and his works, while in a sense realistic, are polemics against Greenbergian aesthetics. His witty *Derrida Queries de Man* places those two deconstructionists in the famous image by Sidney Paget in which Sherlock Holmes and Dr. Moriarty endeavor to deconstruct each other at Reichenbach Falls, though the precipitous world as depicted by Tansey is a text, as in a sense it is for all the Third Floorers. Richard Misrach pictures photographic reproductions of two pages of *Playboy* that had once been used for target practice, and so are full of bullet holes: an advertisement with Andy Warhol in a testimonial for Sassoon shampoo has his eye shot neatly out, and part of his nose, so it looks like a memento mori (and by inclination belongs on the fourth floor). Elizabeth Murray displays her familiar cartoon borrowings; Mike Kelley uses woollen dolls to whatever obscure effect; David Salle's paintings are replete with borrowed images superimposed and juxtaposed. Allen Ruppersberg has an entire frame shop as his exhibit, with images from here and there, including an advertisement that promises to make philosophy simple. Louise Lawler shows us several tinted photographs of walls of paintings and tables of sculpture. McDermott and McGough have appropriated the sepia tones of the dated photograph, showing figures who might be contemporaries of Lewis Carroll, performing

simple experiments and demonstrations from the era of parlor science. Keith Haring uses graffiti to promote his messages. Philip Taaffe paints patterns to advance an aesthetic that Tansey repudiates. Not all the Third Floor Artists are necessarily meta-artists, though both Jennifer Bartlett and Joseph Santore, who clearly have other agendas, are working with problems of the relationship between surface and depth. Only perhaps Eric Fischl and Ellen Phelan seem untroubled by philosophical impediments to painting. But in the main, the Third Floor Artist seems to be a philosopher of art, forced to reflect on matters the Second Floor Artist could take for granted. The third floor is the second raised to a level of philosophical self-consciousness.

The fourth floor could not be more different from the third, and one is grateful for the historical punctuation the device of different floors makes available. It enables us to place brackets around the eighties, and to see the decade as having an unsuspected unity: I feel I understand it better, now that it is over, and see even artists I never especially liked, like Salle, fitting into its array of options. The Fourth Floor Artist appears to have put questions about the possibility of art aside. The work seems angry or sullen, confrontational or condemnatory, arrogant and menacing and hostile.

But let me now describe some examples. To the far right, as one enters the fourth floor, is an untitled waxwork by Kiki Smith consisting of two large realistic naked figures, male and female, hung from metal poles as if the displayed bodies of an executed couple, pale enough to look as if bled white. There are blood marks upon them here and there, but more compellingly, there are white streaks beneath the woman's breasts, meant to represent milk, and along the insides of the man's thighs, meant to represent semen. They look as helpless as meat on the table, to use an image I once read in an Arabic poem, and some strong statement seems to be made about our inhumanity to one another. Until, that is, it strikes us that the piece may embody and not just represent inhumanity, and that it is the viewer who is the victim of it. This suspicion is reinforced by the second and less ambitious piece by this certainly accomplished sculptor, which is of a female bust, but one with empty crumpled breasts, as if paper sacks hung from her chest. The waxen couple could emblematize moral victimhood but the woman with crumpled breasts is only the artist's victim—for whatever metaphor she is after, those paperlike and scrunched breasts represent nothing that can happen to flesh, for all the versatility of its sufferings. So the bust radically diminishes the impact of the bodies, by causing

them to appear the product of a warping artistic will rather than the expression of an injured moral will.

In the gallery space to one's left is an assemblage of works by Nayland Blake, which imply some form of recreational cruelty. One is a set of ankle fetters, attached to the base of a stainless-steel mirror; another is a kind of stainless-steel gantry on which are displayed black leather leg pieces and a coil of heavy black rubber hose. The piece is hung around with meat cleavers. The message to the art world is that the cutting edge is the cutting edge. These are fantasy pieces of the S/M sensibility that make Mapplethorpe's photographs look as sentimental as valentines. And with their implication of torture, Blake's works form a pendant to the works of Kiki Smith, and between them they form a field of affect into which the viewer enters. Cady Noland's intolerable and patronizing exercise, *This Piece Has No Title Yet*, composed of stacked Budweiser cans together with cutouts of Patty Hearst with the symbol of the Symbionese Liberation Army behind her, and of a perforated Lee Harvey Oswald, all placed in a kind of heavy chain-link enclosure, forms a third piece, and the pressure exercised by these on the remaining works on the floor inflects those with the same mood of aggressiveness patent in the three paradigm Fourth Floor works. The viewer is cast in a very different relationship to these works than to those on the other two floors. My iconoclastic companion expressed it to perfection. The viewer is put on the defensive. The viewer is a target. And since the whole fourth floor is a kind of attack, one wonders, in sustaining it, whether the works are after all merely weapons, and the true agents of aggression the curators who chose them.

The publicity for the Biennial employs the Whitney as its own logo—a silvery photograph of the building itself, sharply vignetted against white paper. No logo is semiotically innocent. Is this logo a gesture of conciliation to the "Save the Breuer" crowd or a declaration to the neighborhood that the museum has forsworn its expansionist ambitions and means to remain within its own boundaries? It was not until I read the essay by Lisa Phillips, "Culture Under Siege," that I realized that the Whitney, shown from underneath so that it looks taller than it really is and more menacing, is presenting itself as a fortress. Architecture is destiny. Of course, Breuer's inhumane construction was fortresslike all along, a kind of extruded bunker with moat and drawbridge, and windows that look like the gunports on a tank rather than openings onto the world. It is a tribute to the benign directorship of Tom Armstrong that one thought of the Whitney,

against the architectural grain, as a place of fun. The fourth floor symbolizes culture at bay, fighting back. The visitor feels like the enemy. Guy Trebay, in *The Village Voice*, describes it as looking like a "Reverend Donald Wildmon nightmare," and goes on to fantasize "the Methodist crank trapped on Madison Avenue for a Freudian eternity." There is even a suite of photographs by Wildmon's bête noire, David Wojnarowicz, who brought a suit against Wildmon for having violated the artist's right of free expression.

On a recent Sunday, in *The New York Times*, the extraordinary Senta Driver reflected on the circumstances that have caused her to leave the world of dance. Among the complex set of causes, she cited her conflict in asking for public support when money for the arts might come at the expense of those who need it more and need it desperately. "We're being forced into the image of these people who use the money for the homeless to create art that will frighten and offend. I have found it tremendously discouraging to see how artists are hated by the general population," Driver said. "The artists have no friends anymore, except each other." This is an exaggeration, to be sure, reinforced by the intensity of her own situation. But it seemed to me to express with a chilling exactitude the spirit of Fourth Floor Art. Beyond question, art has as one of its functions the moral arousal of its audience. But at a certain point the question has to arise as to whether, if the artist cares that deeply, art is the best way of dealing with the issues. Senta Driver is leaving the field of dance to become a nurse. In any case, one feels that the social issue closest to the heart of the Fourth Floor Artist is the issue of art itself. So, in a way different from Third Floor Art, Fourth Floor Art finally is art about art: art of, by, and for artists under siege. It has constituted the Reverand Donald Wildmon the single most powerful artistic influence of the moment—a distinction he perhaps deserves.

The 1991 Whitney Biennial cannot in any sense be said to be, as the headline to the *Times* review of the exhibition put it, "a Biennial That's Eager to Please." If anything, it is eager not to please. But for just that reason, it is the most serious Biennial I have seen, raising the hardest questions that can be raised about art today and making us face the hardest truths. It does a great deal more than show what is happening in art: it shows what is happening to art in a world in which we are all players. You owe it to yourself to visit the show and make up your own mind.

The afternoon of the press opening, I attended with special ea-

gerness, after the experiences of the Biennial, an exhibition of work by MFA students of the school of painting and sculpture at Columbia University. I thought I would steal a march on the future and see what the Fourth Floor Artists of the coming decade are likely to show us. It may come as welcome news that the next generation's heart seems altogether to be with the Second Floor Artists.

—*The Nation*, June 3, 1991

Site-Specific Works
at the Spoleto Festival

IN AN IMPORTANT and influential essay published in *Partisan Review* in 1948, Clement Greenberg reported "the crisis of the easel picture." Such pictures, he claimed, are "a unique product of Western culture [with] few counterparts elsewhere"; he drew particular but passing attention to the fact that easel pictures are portable and are meant to hang on walls, and that in consequence they are created in isolation from the particular architectural circumstances of their eventual display. It is through these somewhat external features of such pictures (and, we may remark, their affines: the detached and portable statue, the fine print, the master drawing) that a market in art is possible, in which works are sold and exchanged and collections formed and art museums thinkable. The easel picture makes possible as well the traveling exhibition, which forms so central a feature of the art life of recent times. So if *it* is in trouble, pretty much the entire art world, in which temporary display and possession are institutionalized, is in trouble, as is that complex webwork connecting artists, dealers, collectors, and curators, not to mention the aesthetic in which the masterpieces of easel painting serve as paradigms of artistic value.

Greenberg was rather less interested in these institutional considerations than in what we might term the internal features of easel pictures. Those, he saw, were undergoing profound changes in consequence of a sustained and collective assault, begun as early as Manet, on the ideal of spatial illusion. It was Greenberg's brilliant perception that every part of the Impressionist canvas shows "the same emphasis of touch," which was a stage in an evolution toward considering paintings as mere flat rectangles in which spatial illusion, the strategies of

which had been the glory of Western narrative painting, was being systematically dismantled in favor of all over patternings of surface. But then, it seems to me, the crisis was one of illusionist painting, and the easel picture was affected only insofar as it participated in the history of illusionism, the major vehicles of which were not easel pictures but frescoes on walls and ceilings, or, when on canvas or panels, then as parts of altarpieces or other ecclesiastical furniture which very often existed in architectural symbiosis with their sites. Caravaggio's *Madonna of the Rosary* was in no sense an easel picture, though it hangs in Vienna's Kunsthistorisches Museum; yet we can infer its intended locus from its internal features. So if the easel picture in truth is in hot water, this cannot be due to an internal evolution in the medium of painting but rather must be a consequence of external attacks, political or at least ideological, on the institutions that are defined by the marketability of these pictures—and that therefore bear connotations only marginally connected with the easel works' representational content, which would, at least in approach, be shared with works typically immovable and fused with their architectural settings. There are plenty of easel paintings that meet the most exacting standards of abstract purity and pictorial flatness. The internal pursuit of these essentially abstract ideals did not threaten the easel picture as a format at all, and in fact, making, buying, and displaying easel pictures remains the primary institutional form of artistic life today.

In fact, the crisis of the easel picture was, and remains, a commonplace of political radicalism, and it is my sense that Greenberg appropriated and transformed an attitude toward such pictures that formed part of the political atmosphere he breathed. Alice Neel, for all her radical sympathies an unrepentant easel painter, recalls a studio visit by Philip Rahv—an editor and defining spirit of *Partisan Review*—who told her in 1933, "The easel picture is finished." The easel picture had been consigned to historical irrelevance in 1921 in Moscow by majority vote of artists charged with determining the role of art in the new society: for them, it was inseparably connected with the bourgeois values discredited by the Revolution. "Why paint just one person?" Rahv asked Neel, then as ever a great portraitist. "Siqueiros paints with Duco on walls." It would be possible to compose a history of art forms alternative to easel pictures that were construed as correct by the political agendas that invalidated the easel picture. It would begin with the three-dimensional Constructivist works fashioned out of industrial material and include most of the applied art

made in Russia in the early twenties, as well as the Mexican murals of the thirties together with some of the Works Progress Administration mural art inspired by them. It would incorporate a lot of Minimalist and Postminimalist art of the sixties and seventies, and especially the kinds of sculpture and painting endorsed by editors of *October*, in the pages of which the death of painting was enunciated as a historical truth. Taken chronologically, these works would objectify changes in radical political theory, which would have to be spelled out in order for the viewer to understand what the work was intended to mean. What each of the positions would share would be hostility toward the easel picture and, as corollary, a scorn, scathingly expressed, for "the commodification of art." The positions, in turn, would favor some venue other than the commercial art gallery—or the art museum—both of which pivot on the movability and exchangeability of works of art. The factory, the Duco-covered wall, the earthwork, are so many critiques of the kinds of works that make commodification possible. This history is not the history of aesthetic experimentation to which Greenberg appealed in his 1948 essay. This instead is the history of ideology realized in artworks that aspire to institutional alternatives.

The most recent addition to this sequence is the site-specific work, which in its conception is hardly separable from the most recent developments in political critique from the Left. There really is a crisis in painting today, but it has less to do with any internal unfolding of pictorial difficulties than with the fact that, once again, painting seems to belong to an institutional framework under a renewed form of political criticism, which in turn expresses values and attitudes widespread in the art world today. It is almost as if the easel painter is identified with the gender and race and culture deemed oppressive. So the site-specific work does not exemplify contemporary aesthetics in isolation from contemporary political beliefs. It objectifies the ideologies of the moment.

Now, creating site-specificity is a very old practice, and one which is altogether consistent with illusionist painting. Nothing could be more site-specific than Pozzo's stupendous ceiling painting *The Triumph of St. Ignatius* in the church of St. Ignatius in Rome, which cannot easily be thought of as movable, since it makes reference to the interior architecture of the edifice, which seems to continue up into the heavens along with the skyborne saint. Giotto was site-specific, as was Titian on occasion, or Caravaggio, or Michelangelo, or Bernini, or even Boucher and Fragonard. The Elgin Marbles were specific to the pedi-

ments of the Parthenon. As a general rule, site-specific works are not commodified, primarily because they are commissioned, with the final form a matter of negotiation between the artist and whoever controls the site in question. Art that is not site-specific might be termed "free-market art," and it is to this latter genre that easel paintings typically belong (though, of course, portraits too will commonly have been commissioned). Free-market art has always been commodified—and not simply under capitalism, inasmuch as the practice of collecting art goes back to ancient times. And with collecting came the concept of art as something with investment value and a certain degree of liquidity. The Impressionists, so far as I can think, were never site-specific but always commodified, as were, with some guarded exceptions, the Dutch of the seventeenth century. Chardin's greatest work was free-market, and so was most American art: even the WPA had a category for easel painters (Neel was one). Obviously, power and money can mobilize anything, as witness the cloisters at the Cloisters, the Temple of Dendur at the Metropolitan Museum of Art, or Veronese's *Wedding at Cana*, which was trundled in wagons over the Alps by Napoleon's forces, though specific to the site of a refectory in San Giorgio Maggiore in Venice. And let us not forget London Bridge, now a tourist attraction in Arizona.

Old as the practice is, the term "site-specific" is sufficiently recent that I could not find an entry for it in *Artspeak*, a lexicon published in 1990 for those wishing to acquire fluency in current jargon. I believe the expression entered art-world discourse primarily in connection with Richard Serra's controverted *Tilted Arc*, whose alleged site-specificity was tendered as a reason it should not be moved from the somewhat banal locus it endeavored to redeem artistically but which, in the opinion of those required to live with it, was achieved at the cost of making the site useless for any purpose other than aesthetic contemplation of the sculpture. In effect, the work transformed its site into an annex of the museum. Still, the location was construed almost purely in formal and geometrical terms—of curves echoing curves—and questions of history, of meaning, and of human needs other than aesthetic appreciation were effectively suppressed in favor of sculptural imperatives.

It is, by contrast, this widened concept of site as something dense with meaning and eloquent with history that underlies the spectacular assembly of seventeen site-specific works commissioned as its contribution to the visual arts by what has heretofore been mainly a celebration of opera, dance, and theater—the Spoleto Festival U.S.A., itself

situated in Charleston, South Carolina. Dispersed across that marvel-
ous city, its own architectural magic steeped in history, "Places with
a Past" gives a powerful incentive to anyone interested in art to visit
that city, where the largest artistic controversies of the present moment
are being enacted. And one must do so before the pieces come down.
(When they come down, they really will come down, for it is part of
the intention of this show that the works be ephemeral, specific, as it
were, to the *temporal* site of the Spoleto Festival.) *Their* site-specificity
is clearly not a reason for keeping them where they are forever, though
some of them are of sufficient merit that it would enhance the already
monumental richness of Charleston to keep them where they are.

The work, according to a festival press release, "reflects the desire
of artists to reach audiences in ways that are more direct, unpredictable,
and, often, confrontational than can be achieved in gallery or mu-
seum." This is not strictly realized, inasmuch as three of the works are
sited in Charleston's Gibbes Museum, sometimes, I think, to their
detriment. Thus, Chris Burden has placed three full-sized robotic sail-
ing ships—the *U*, the *S*, and the *A*—in an upstairs gallery, when these
would have looked marvelous on the floor of the U.S. Custom House,
whose corners instead are taken up with tiny arrangements of framed
petit point by the Australian artist Narelle Jubelin, the iconographic
content of which certainly is Charlestonian but the scale of which is
so disproportionate to the immense interior space of the site as to have
its power diminished by that. *They* would have been shocking in the
museum, where the viewer, peering closely, would have been made
uncomfortable by an embroidered slave with a terrifying iron neck
piece, and "Black Ivory" primly woven in, as if by an antebellum
maiden. But Jubelin's *broderies* have in common with many of the
works that the past with which they seek to confront audiences is not
the past of military glamour for which Charleston is famous, nor the
rich past of plantations and pale ladies in crinolines or balls in col-
umned mansions, but rather the past of the dispossessed and the dis-
enfranchised. And it is this that connects the site-specific works of
Charleston to current ideology.

This philosophy of history is explicit in a work of Ann Hamilton
installed in a vacated garage on Pinckney Street and by wide consent
one of the successes of the show. Its main component is an immense
mound of neatly folded blue shirts and work pants, piled one upon the
other—14,000 pounds of proletarian laundry on a large platform. Be-
hind this singular presence is a person engaged in erasing the pages

of blue-bound books, said to be the kinds of texts from which we learn about history as composed of great events and the actions of heroes— events like the firing on Fort Sumter, for example, or Pickett's charge. There is a third component to the work, a sort of rickety upstairs office in which sacks of indigo are suspended, which connects to the work clothes and book covers through color, to Charleston through the fact that indigo was once an important crop, and—who knows?—through felicitous etymology to the Native American population that once lived on the peninsula: "indigo," from the Greek *Indikos*, Indian. The work clothes embody, in any case, a history very different from the history narrated in standard texts: it is the history of labor, of the lives of countless forgotten men and women led at a level of existence rarely noticed by traditional histories. The symbolic juxtaposition of two kinds of history, one of which is being erased in order to reveal the other, the history that is rarely memorialized or monumentalized, is very dramatic and visually compelling. The connotations of the clothing, the visual immediacy of the mound, the unsettling sight of books being erased, fuse into an image that requires very little by way of auxiliary explanation. It is beyond question "from the bottom up" history that is celebrated throughout the site-specific works installed here: the history of the unhistorical, of laborers, of women, of servants, of African-Americans, and especially of slaves. And in consequence there is a heavy strain of moral didacticism in almost all the works. In a sympathetic article on the show for *The New York Times*, Michael Brenson wrote that "almost all the artists came to Charleston to learn from the city, not to tell its citizens what to think." This is true and false. It is true that the artists found the sites through which to make their points in wonderfully unpredictable places. But the points they make are widely made in the art world today, as in the Decade Show in New York: points about women, about people of color, about minority culture, about cultural pluralism. And these topics are reflected in the roster of the artists themselves, with women and black artists prominently represented.

Now, didacticism in art is jarring even when one is sympathetic to its imperatives, but it is also true that "didactic" becomes a term of criticism only when the message fails to be transformed by its vehicle. This does not happen in Ann Hamilton's superb piece, which shows what it means to say through symbolic enactment so successful that the viewer feels in the presence of moral truth made real. Symbolic enactment attains an even higher level in the astonishing installation

by Antony Gormley, who has taken over a prison house built in 1802 and turned it into a metaphor for the human condition. The floor of one large cell is packed wall to wall with a multitude of clay figures, all alike, whose only manifest feature is a pair of eyeholes as they look upward for release, or meaning, or revelation. Another cell has three immense iron balls, emblematizing, I imagine, the chained weights that impede movement and signify the truth of captivity. In yet another cell, seven suspended male figures, their heads seeming to penetrate the ceiling, convey the meaning perhaps that they are ascending. On opposing sides of a wall that separates two adjoining cells, similar figures (we are told) are encased, as if in paired chrysalises, their mouths and penises connected through tubes. Speech and sex, if the avenues through which we escape from solitude, confer a symbolic meaning on a tube that enters the space of another cell from the ceiling, as if connecting the space of the prison with the space into which the headless men may be rising. There is a final cell, which is flooded, reflecting the patched and peeling walls and the barred window frames. It is a work of immense power.

And so is the work of Liz Magor, who has transformed, with photographs and cannonballs, what was once a home for Confederate widows. It is a cloisterlike space, in the garden of which she has strewn cannonballs as if merely spherical ornaments. (Cannonballs, lethal and maiming, have been ornamentalized throughout Charleston, and piles of them stand alongside clumsy mortars and spiked cannons pointed blindly across the water; in her work, Cindy Sherman shows dismembered legs and hands, as testimony to what cannonballs could wreak when they were virile smashers of body and bone.) Magor has hung photographs of reenacted scenes of the Civil War, which has become a form of recreational history for those who want vicariously to know what it was like at Bull Run or Gettysburg or Antietam. Magor spoofs these costly mimes with titles that just fail to match them. At the other end of the house are photographs of couples, the man in military costume, but *this* room is also piled high with cannonballs, the emblems of war invading the parlors, making widows. In a room along the passageway is a photograph in a foolishly sentimental frame of a woman holding what I take to be a real daguerreotype of a dead soldier.

None of these astonishingly moving works, it seems to me, would have been possible had the easel painting not lost its ascendancy, especially in the seventies and eighties, when women artists, especially, turned away from painting and toward modes of expression perceived

by them, and especially by the theorists in whom they believed, to be more appropriate to the constraints and powers of their gender. This was a moment when, for example, many of what had been invidiously considered mere crafts were seized upon as vehicles of high art. Ann Hamilton was described to me as a "fiber person" by an artist who is herself a fiber person. Magor's background is in bookworks. Joyce Scott, whose work in Charleston struck me as well intentioned but visually garbled—an assemblage of beads and branches suspended from the tops of some columns which had once belonged to a museum that had burned down—internalizes a boundary between art and craft once regarded as absolute. Whether, in truth, fiberwork, beadwork, and bookwork are truly fitter vehicles than easel painting for women's artistic impulses is not something anyone can be said to know. But the ideology that licensed the belief clearly widened and redrew the boundaries of art in a singularly liberating way, opening up opportunities for artists of either gender to work in ways far distant from what the aesthetics of the easel painting stipulated as the essence of art. So the question of whether *these* works were art could scarcely be avoided by the Charlestonians, who divided, according to an informal poll kept by a monitor at one of the sites, sixty to forty, pro and con. Moreover, this alternative aesthetic cannot as yet be altogether separated from its licensing ideology, so in addition to the issue of what is art, the Charlestonians were obliged to deal with substantially more by way of politics than the usual displays in the Gibbes Museum would have trained them for. It was a lot for a single community to handle, especially when the problematics of appreciation were heightened by some polarizing statements by Gian-Carlo Menotti, the spiritual head of Spoleto, who disavowed the art vehemently and threatened to leave Charleston and to take his festival with him. Given the economic and cultural role Spoleto plays in the life of the city, it was difficult for the citizenry to take a disinterested view. There is in the very air of Charleston something that seems to force the great issues that divide the human soul. It is fitting that the civil wars of late-twentieth-century art should have received their sharpest definition here.

I wish to say only this: Those site-specific works are artistically most compelling that require verbal narrative the least, where the artist has found, like Hamilton and Gormley, Magor and, with partial success, Barbara Steinman (who suspended an ornamental chandelier in a circular old pump house of nearly the same diameter), visual ways to convey the meanings less successful art must achieve with words.

Obversely, works of visual art are always to some degree open to con-flicting interpretations, so some verbal gloss seems always in order—especially when, as in the world of site-specific art, there is as yet little by way of a common visual language. *House of the Future* was the work of the legendary black artist David Hammons, who chose a site in a black neighborhood rarely touched by the Spoleto festivities. Its chief component is a sort of model of the classic Charleston single house, only comically thin, about as wide as a doorway. It is deliberately underfinished, and on the side facing the street the artist has written a message about the myths that African-Americans have accepted re-garding their character. The work is intended to elevate the conscious-ness of the local youth, to teach them something about architecture, carpentry, themselves. And it may achieve those ends. But friends of mine visited a nearby church and discussed the house with some of the blacks, who were deeply fearful that *their* future was tied to such skinny houses, that maybe they were going to have to live in houses like that, and instead of hope the alien presence of this building in their midst had awakened a sense of powerlessness and trepidation. It is a noble idea to bring art to the people, but the people have to be brought to the art as well: images alone cannot always communicate what they are intended to mean.

Still, it really is a noble gesture, and I feel that the managers of Spoleto, like the people of Charleston, are greatly in debt to Mary Jane Jacob, one of a new breed of independent curators, who seems single-handedly to have made this extraordinary event actual.

—*The Nation*, July 29/August 5, 1991

Ad Reinhardt

THERE IS A FORMULA in Jean-Paul Sartre's unwieldy masterpiece, *Being and Nothingness*, that is so precisely true of the late paintings of Ad Reinhardt that if it is *also* true of human beings, as Sartre supposed it was, then human beings and works of art must be far closer philosophical kin than is commonly realized. "We are what we are not," Sartre wrote, "and we are not what we are." The main task of this paradoxical characterization was to establish the deep distinction between human beings and mere things, which, in contrast with us, "are what they are and are not what they are not." Mere things are defined by the Law of Identity, but *we* have no identity beyond our unremitting negations: we are only what we are not. The main task of the philosophy of art, made urgent in our century by the aesthetic experiments of Marcel Duchamp and Andy Warhol, is similarly to establish the deep difference between mere things and works of art—between, for example, mere squares of canvas painted black, on the one hand, and monochrome black paintings on the other. And Sartre's formulation may be of some use in this, inasmuch as Reinhardt's paintings, which aspire to reduce art to its very essence, exist through negating everything in art other than what is essential: "Art is not what is not art," Reinhardt wrote in one of his many manifestos. Most art, including the art of his contemporaries, contained, in his view, a great deal that he impugned as not art. So *his* canvases survive by philosophical subtractions. They are, in his words, "art-as-art . . . a concentration of art's essential nature." But anyone who then goes on to say that Reinhardt's paintings just are what they are—monochrome squares of black paint—is going to have a hard time accounting for the power his works

have by contrast with mere squares of black-painted canvas, which have no power at all. And part of that power may derive from the fact that Reinhardt's austere works hold the entire remainder of art at bay by active negation—by what Sartre calls "nihilation"—which mere painted canvas cannot do. Thus, a black painting by him is not merely black, the absence of color: It *negates* color. "Color as anti-art," he wrote in another of his exercises in the aesthetics of negation.

Reinhardt's paintings do not stand apart from the history of art by the fact of their nihilations but only by the sheer quantity of those. After all, a great many paintings are internally defined by their re-pudiations. The Pre-Raphaelites rejected everything they believed had been introduced into painting by Raphael, and distanced their art from everything academic. Nonobjective painting put itself into opposition with whatever paintings had objects. The Strozzi altarpiece shunned Giottoesque naturalism. The Impressionists negated paintings with black shadows, the Cubists perspectival space, and Gauguin's canvases grandly swept the whole Western tradition into irrelevance. These are not what we might term external negations. There are countless things a Cubist painting is not interestingly not—it is not a cat, a thistle, a ham sandwich, a motorbike. What a Cubist painting *interestingly* is not is the kind of painting of which it is in fact a criticism. In Sartrean terms, it is the sum of its nihilations, and thus is internally related to what it Just Says No to.

Sir Ernst Gombrich once raised the profound question of why painting has a history, and then why it has the specific history it does. Gombrich's view, in *Art and Illusion*, is that the history of painting has a parallel in the history of science, construed in terms of progress. The history of art is the history of the conquest of visual appearances, of "making and matching" the world's visual arrays, at which artists got better and better. This covers a great deal, to be sure, but it cannot easily account for the history of Modernism, where the matching of perceptual appearances has lost most of its energy. My own sense is that the history of Modernism is driven by philosophical theories re-garding the nature of art, and negation plays a central role in this history since so much of it consists in refutations. In fact, in the West at least, the history of art has been the history of philosophical nihi-lations, perhaps none more massive than the one that distanced early Renaissance painting from medieval art, and that started painting on the course Gombrich's narrative partially captures.

But if the history of art is essentially philosophical, and to that

degree dialectical, then negation is the very substance of art, as it is our very substance—again, if Sartre is right. But that means that we cannot *but* experience art historically, and hence in terms of its successive rejectings. Just imagine that the history of painting had begun with works which in fact look very much the way Cubist paintings look. We certainly could not understand them as rejecting perspective, and adopting shallow depths to that end, for perspective would not as yet have been invented. (We might characterize them as "nonperspectival," for just this reason, but that would be an external rather than an internal negative fact about them, as it would be an external negative fact about Chinese painting, which existed in a culture in which pictorial perspective had not been discovered.) So this internal "notness" is what makes possible the sort of history that paintings have. Mere pieces of painted canvas are outside this history altogether, and have no internal negative relationships with works of art. Even if Reinhardt's canvases were completely monochrome, they would have as their substance the immense number of nihilations of everything Reinhardt was convinced was not essential to art. Their richness would be a function of the totality of those denials, and to experience them as art would require grasping this as an objective fact.

One final remark on negation before I address myself positively to Reinhardt's work. Not every artistic tradition is woven out of nihilations of previous art—I do not believe that the history of Chinese art can be understood in those terms at all, inasmuch as Chinese painters not untypically sought to achieve what their predecessors had sought, often by deliberately imitating them. But in those traditions that are so woven, a certain kind of art criticism is an internal dynamic of artistic change. Every change of historical direction implies a conscious critique—so criticism does not stand outside the history of art. All historically innovative artists have had to be critics, yet a good many critics who were not painters, or at least not historically innovative painters, have an internal place in the history of art. Clement Greenberg belongs to the history of art because artists who belong to that history internalized his agenda. Mark Tansey, who does not write criticism, belongs to the internal history of art in part through the fact that his paintings call into question the Greenbergian agenda. Reinhardt was a critic (though perhaps never a reviewer) and a painter whose works realize the intent of his words. In his critical writing, he rather absolutely insists that art be shapeless, imageless, lightless, objectless, colorless, wordless. The contraries of these, and many other terms,

compose his critical vocabulary. His work embodies the totality of his many critical interdictions. They are what they are not, in the mode of not being it, to borrow a handy piece of phraseology.

The period and place of Reinhardt's critico-pictorial enterprise— New York from the late thirties until the mid-sixties—was an arena of critical strife so fierce, dogmatic, and intolerant as to bear comparison with Byzantium in the years of the Iconoclasm strife, or Alexandria in the era in which anyone who fell off the high wire of Christological truth plunged into the dark abyss of heresy. The bickering was over the essential nature of art, understood almost without question as the essential nature of painting, with which art was spontaneously identified. The recent Whitney Biennial was revealing of many things, not least of which was the uncertainty of this identification in contemporary artistic consciousness. (Almost none of the younger artists represented were painters.) In June 1946, Reinhardt published a cartoon in the newspaper *PM* titled "How to Look at Modern Art in America." The work is as revealing for what it does not show—perhaps a subconscious nihilation—as for what it does. The tree of art has about two hundred leaves, each with the name of a contemporary American artist written on it. These were all painters, as far as I can tell. Sculpture figures in the schematism only as part of the soil in which the tree is rooted— but my sense is that Reinhardt included "Negro Sculpture" primarily because of the influence it had on painters like Picasso. Fifteen years later, he drew a modified version of this for *ArtNews*, and while one branch had by then fallen off and the leaves had considerably thinned, "modern art" remained "modern painting" without question. "Sculpture," Barnett Newman said in the fifties, "is what you bump into when you back up to see a painting." It is difficult to see, in retrospect, how the arguments about artistic purity could have been sustained had anyone asked what pure sculpture would be like, or what flatness, of which Greenberg and his followers made so much, could have had to do with sculpture. Perhaps the implicit view was that sculpture's history was merely epiphenomenal, reflecting the history of painting. The disputes really came to an end when all the things that had been discarded in the name of purity reentered painting in the mid-sixties, by which time, in any case, painting had lost much of its priority as the historically effective medium.

Reinhardt, as personality, as writer, and as painter, emblematized that period of artistic strife, which he did not survive. He died in 1967, just after the triumph of a major retrospective of his work at the Jewish

Museum, at that time the New York institution most committed to the display of advanced art. His art, however, survived its historical moment, in part because it seemed to belong to certain movements, like Minimalism, with whose program Reinhardt did not live long enough to disagree, as one is certain he would have, inasmuch as the affinities are external and finally deceptive. But it survived for less accidental reasons as well, having little to do with the subsequent history of artistic movements. In the final analysis, his paintings at their greatest negate their own negations and seem to rise above their historical station, into a realm of what one feels to be timeless, spare beauty. The final paradox of Reinhardt's works is that they negate the context of historical negations that explains their very being, and seem to turn into transhistorical presences of great spiritual power. They seem to belong less to their immediate historical moment than any paintings I know. If less is more, then least is most and nothingness is everything.

The elegant retrospective of Reinhardt's work at the Museum of Modern Art in New York traces an itinerary of what feels like mystical ascent. It is impeccably installed, though any installation of this work faces internal obstacles I shall discuss below. One passes blowups of some of Reinhardt's art-world cartoons on either side in approaching the painting galleries. These are like curricula for courses in the moral history of modern art: Reinhardt set himself up as a kind of conscience for artistic conduct as well as for the conduct of artists, and as a cartoonist by profession saw in the form a perfect homiletic vehicle. Thus, the lower branch of the Tree of Modern Art in 1946 is in danger of breaking off because of weights that include subject matters of various genres (the nude, still life, landscape) as well as anti-essentialist influences (like Mexican painting and regionalism generally) and, finally, commercial forces. That branch, precarious in 1946, appears no less so in the 1961 rendering, though the main and seemingly healthy branch has inexplicably fallen away as the threatened one has acquired a new set of pressures. These high-spirited comic drawings are full of a sparring intelligence and an acerbic wit, and are dense with stylistic references to the history of art. For archaeologists of the art world of those years, they are indispensable guides to the ruins and invaluable as well for identifying Reinhardt's own nihilations. More than that, they are alive with a kind of graphic energy altogether lacking in the jaunty, syncopated abstraction to be glimpsed through the entryway into the painting galleries. One feels that he more surely belongs to the history of art through these cartoons than through the roomful of

abstractions that follows, though I daresay there would have been no way of treating the cartoons as art in those years. And indeed, it is not until Reinhardt achieves in the paintings themselves some of the same negativity these cartoons exhibit in their roughneck way that the former take on a proportional vitality. This happens when he more or less drops everything from that first abstraction, *Number 30* of 1938, replacing its eccentric bars and off-squares with heavy and symmetrical forms, and sacrifices the harlequinade of colors for brooding monotones. Except for being abstract, to which he remained ideologically committed through his entire career, *Number 30*, done a few years after he graduated from Columbia College, is a demonstration piece of what he came to believe was not a part of art. The early abstractions have an astonishing diversity, as of so many short pathways cut and then abandoned. They testify to the probing of an artist who recognized that he was on the wrong path without as yet knowing which was the true one.

In making the transit from the cartoons to the great final gallery in which twenty of Reinhardt's last "black paintings" are hung, one passes through two suites of monochrome works that are extremely beautiful: a suite of blue paintings and a suite of red ones. These present the inherent obstacles to installing a retrospective of Reinhardt's work, which the present exhibition does not solve, and which perhaps none can. Let us consider the way the paintings are arrayed on the west walls of the two galleries in which the red and the blue paintings are respectively assembled. On each of these walls, the installer has made very fetching arrangements. A large vertical red painting has a pair of similarly colored paintings on each side of it; and two matching blue paintings, large and vertical, are paired with a smaller blue painting on either side. These arrangements give the impression that the paintings belong together, as components in an assemblage, rather than having each a singular identity, meant to be seen independently of one another. I mean that the one groupment of five paintings and the other groupment of four paintings, made up of works nearly if not exactly identical in color but not in size, generate a' sort of syntax when hung as they have been, as if they form a sort of pictorial proposition or perhaps a melody. It is irresistible to see them this way, just as one cannot hear "tra-la-la" as three independent sounds upon hearing them close enough together. And this inadvertent syntactic ligature I felt to be utterly at odds with the puritanical motivations of the work.

Perhaps it was to abort this propensity that Reinhardt resolved,

toward the end of his career, to paint everything the same size and shape—five-foot squares, more or less. Even so, it is difficult to avoid the illusion of syntax, for on the final wall, just before the exit, are three almost unindividuated black squares, and the viewer has to decide whether it is a single work of three matching panels or three works that resemble one another importantly but are intended to be seen and experienced as distinct. No doubt the fact of their sameness is to be an element in one's experience of any of them, but so is the fact of their numerical difference. It is, however, extremely difficult to stifle what one might term the artifacts of syntax in a show like this, where all the works of the mature period resemble one another so closely. There may in consequence be an inconsistency between the spirit of the works and the exigencies of a retrospective committed to show many of them. Reinhardt said at one point that his paintings hang uncomfortably with the paintings of others, but one might add that they hang uncomfortably with one another. Perhaps the ideal way to see Reinhardt's works is one at a time, in a room given over entirely to it, which the work then might transform into a kind of meditative chapel. The interesting truth is that however much the history and theory of painting went into their formation, it is not painting to which the mind goes in contemplating them but something a good bit more mysterious and powerful.

The black paintings, though monochrome—or monotonal—are in fact not homogeneous, and when one peers at them intently and protractedly, certain forms disclose themselves, as if at the bottom of a very dark pool. The last of the square paintings in fact are composed around a sort of blocky black H-form, where the outer edges of the H form the sides of the square. The H feels like a kind of bridge, and if this is too literal a reading of an abstract painting, it is not inappropriate as a metaphor. In any case, there will be two inner squares, above and below the horizontal part of the H, and these are of a tone as close in value to it as they can be without becoming *as* black. These just-noticeably different squares advance and retreat, as if the paintings held a kind of movement. I don't know what to think of these contained shapes. Are they the eye's reward for sustained looking? Or do they diminish what would be the absolute power of completely black squares, had Reinhardt been able to bring himself to those as the terminus of his itinerary along the *via negativa*? You'll have to make up your own mind on that, I'm afraid.

As we began with an existential philosopher, we might close with

one. This movement of black within black comes closer than anything I can think of to being the visual equivalent of that extraordinary activity Heidegger describes in *What Is Metaphysics?* as "nothingness noth-inging." This may sound better in German as that which one experiences when *Das Nicht nichtet*—but maybe it ought to be difficult to state, as the experience is meant among other things to reveal the limits of what can be said, as Reinhardt's paintings at least approach the limits of what can be shown.

—*The Nation*, August 26/September 2, 1991

Rosemarie Trockel

THERE ARE CERTAIN respects in which there is a stronger affinity between Leonardo da Vinci and Marcel Duchamp than between them and their respective contemporaries. I like to think that Duchamp, who gave himself a female identity as Rrose Sélavy and had himself photographed in drag, acknowledged this affinity by drawing a mustache on the Mona Lisa, his predecessor's most celebrated image (which some scholars have argued is a self-portrait of the artist disguised as a woman), and by memorializing Leonardo's propensity for secret codes by adjoining the mysterious letters L.H.O.O.Q. to the wittily vandalized postcard. But what I have chiefly in mind is that each of them redefined artistic practice in such a way that the production of works of fine art, such as paintings, was only a subgenre of art making. Leonardo was clearly the stronger painter, but to define Leonardo's style as a visual thinker we have to find some position outside the paintings from which we can view them, the strange inventions, the visionary fortifications, the metaphysical speculations, the arcane inscriptions, the caricatures and the treatise on painting as a single corpus animated by a mind too restless to restrict its domain to mere picture making. And it is this that connects Leonardo with Duchamp, whose *Nude Descending a Staircase* was an effort to represent motion more advanced than Leonardo's studies of rolling water and rearing horses and rushing clouds, and whose *The Bride Stripped Bare by Her Bachelors, Even* employs contrivances—a chocolate grinder, for example— as fantastic as any of Leonardo's mechanical imaginings. Duchamp's is a style of mind and spirit, of cognitive audacity, of witty transformation too protean to find satisfaction in pictorial representation. He

liberated artists, as he would have said, from their addiction to the smell of paint, and showed them a practice as free from the traditional weight of the materials of the artist as poetry is. Indeed, he excluded almost completely from the appreciation of his art any reference to hand or eye. But with this withdrawal of touch and aesthetic delectation, he vested the objects of his art with the aura of enigma even when they were outwardly as ordinary as snow shovels and urinals. As with Leonardo, his achievement was the creation of mysteriousness, for which the Gioconda smile has been the standing metaphor.

Since Duchamp, it has been possible to be a visual artist without being a painter, a sculptor, a draftsman, or even a photographer, or without displaying much by way of skill in the incidental employment of these crafts, as long as one has the right sort of transfigurative intelligence. His two greatest followers have been Andy Warhol and Joseph Beuys (there are even photographs of Warhol as a double transvestite—dressed up as a woman dressed up as a man, to prove his Duchampian affiliation). The genius of these two artists lay in their magical gifts, eliciting meanings of the deepest human sort from the most unprepossessing of objects—soup cans and Brillo boxes in the case of Warhol, fat and felt in the case of Beuys, who managed to fuse these substances with the whole desperate weight of our most basic needs. And both these were political artists in ways alien to Duchamp and to Leonardo. I once heard Meyer Schapiro lecture on Leonardo as a Renaissance man by drawing attention to things in which he had no interest whatever, politics being one. Leonardo famously advised artists to "flee before the storm," and Duchamp certainly lived as if in compliance with this imperative. But Warhol and Beuys, in their admittedly different ways, were concerned to alter political attitudes and even moral consciousness. For all its squalor, Warhol's Factory was an experiment in utopian living as much as was Brook Farm. And Beuys transformed the art school in which he was a professor into a prototype for a new society. Both used unpromising materials—grainy film, silk screen, dime-store photographs in Warhol's case, dirt and rust in that of Beuys. Warhol was perceived as a revolutionary in Europe, for whose market he obligingly and cannily painted a series of Hammer and Sickle studies in 1977. Beuys was perceived as a pretty scary figure in America, with his signature felt hat, open vest, and the free-associational urgencies of his discourses—a figure out of Beckett. But it is only necessary to recall the large retrospective exhibitions of Duchamp and Warhol at the Museum of Modern Art, or of Beuys at

the Guggenheim, to appreciate that we are dealing with a form of artistic creativity of an altogether different genre than that of Matisse or Motherwell or Pollock or De Kooning. These were aggregates of puzzling objects, often aesthetically repellent but always conceptually exalting. They were shows one had to think one's way through, one object at a time, but that touched feelings and aroused wonder in ways inaccessible to the more conventional modes of artistic expression.

Rosemarie Trockel is a young German conceptual artist who belongs in this descent, a third-generation Duchampian who occasionally makes an internal acknowledgment of this kinship. She is not especially a photographer, but photographs play a role in the heterogeneity of her work, each item of which seems to define a distinct and often novel genre. One of the photographs connects her endeavor with that of Duchamp in a way that requires some knowledge of the latter in order to grasp what is being gotten at. *Rose of Kasanlak* is a kind of political still life, in that it shows a perfume bottle with a modified hammer-and-sickle logo as label (the bottle would be familiar in Eastern Europe as containing a sort of attar known as "Rose of Kasanlak"). It is placed on a cloth decorated with the same logo, and the ensemble is shot with a sort of fashion-photograph glamorousness. The logo itself is modified: the hammer has been replaced with a rose. I suppose inscribing a rose in the familiar position of the hammer connects flower with power in some way, or at least it insinuates a feminine component in the dour and threatening emblem that has lost its power to intimidate and has become a sort of political trademark. Nietzsche wrote in his wild autobiography that it is necessary to philosophize with a hammer, and I suppose Trockel is showing how it is possible, through replacement, to philosophize with a flower. In any case, some sort of dialogue is being transacted through the altered logo, on the subject of radical politics and female power—but the deep references of the work connect it to art, and specifically to that of Duchamp. One of Duchamp's unforgettable works was a modified perfume bottle whose label reads, impishly, "Belle Haleine." This is a pun on "Belle Hélène," and quite untranslatable, since "Beautiful Breath" does not in English carry the sounds of "Beautiful Helen." (Duchamp was fond of puns of this sort: a window he had painted black is titled *Fresh Widow*, which is like saying "French Window" with a bad cold, but which in any case cannot be translated into French, not least of all because French windows are not called that in French.) Duchamp has reprinted on the label a photograph of himself as Rrose Sélavy, and it is perfectly clear that

Trockel wants to take the opportunity of connecting Rose with Rrose and Rosemarie herself with Marcel himself, trumping his hammer with her flower. It is in any case a marvelously intricate image that looks, at first glance, like a fashion ad for a magazine designed for Communist ladies but that yields instead to a metaphor connecting male with female, art with politics, feminism with revolution. And as with Duchamp, it speaks with the spirit of play.

The *Rose of Kasanlak* image perhaps connects the two artists in a further way. The modified perfume bottle has been placed, as just described, on a folded cloth with a regular, allover pattern of sickles and roses. If Duchamp is saluted with the former, Trockel is identified with the latter, for her best-known pieces are hangings with logos woven in. These, too, are invariably impish. *Made in Western Germany* is a particularly handsome hanging, possibly self-referential in that its logo, densely and regularly repeated, is "Made in Western Germany," in bluish-green thread against a dark green background. Usually, of course, stickers declaring "Made in U.S.A." or "Made in Japan" are not part of the products whose provenance they specify, but this weaving makes such marginal information its central meaning: the product consists of the information regarding its country of origin. But there is clearly something absurd in an industrial product whose usefulness is confined to such information. (Trockel is not to be imagined sitting before her loom: she designs the woven works and has them fabricated, which could not more vehemently exclude reference to the hand; a work by her called *Woven by Hand* would surely be self-falsifying.) One assumes it was produced in "Western Germany" for export to a country that hardly can have much use for it, especially since the "weavers" appear not to have full command of English—"Western Germany" sounds like "Northern Dakota." Or in fact it is exported not as an industrial product but as a work of art—I surmise from the catalogue information that it is in an American collection. It is in any case an image made of words, and as elegant as it is puzzling, as funny as it is serious, its handsomeness a means to communication rather than an object of aesthetic pleasure.

I enjoyed walking through Trockel's show at the University Art Museum in Berkeley with its co-curator, Sidra Stich, though I found myself frequently disagreeing with what I felt were Stich's somewhat heavy feminist readings of the work. For example, she is convinced that weaving is traditionally women's work, and that some reference to this is woven into such works as *Made in Western Germany*. A great

many of Trockel's works are in fact woven and do in fact make sly feminist points, but their being the product of a loom does not seem to me especially to contribute to this. There is, for example, *Dress*, made in 1986, which indeed is a feminine garment by a female artist, and woven of pure wool. It proclaims its essence by employing as its sole ornament the familiar pure-wool logo, that triple loop manufacturers use to proclaim the truth of their products—a sort of schematized ball of yarn. This garment has in fact two pure-wool logos, each quite large, and placed precisely where the wearer's breasts would be, and an ambiguity of denotation gets immediately set up as to whether the logos refer to the cloth (why then two of them?) or to the female body under the garment. It is here, it seems to me, that the feminist text is to be located, rather than in the fact that women knit things more, as a general rule, than men do. The viewer, for different reasons depending upon whether male or female, is made slightly uncomfortable by the awkwardly placed logos and at the same time is amused by the treacheries of placement. In a way, the pure-wool logo becomes a sort of metonymy of the female breast and hence of the way men think of women in Trockel's work. There is a woven work of 1985–88 in which the pure-wool logo is repeated over and over in gold against red, making it seem a counterpart to *Made in Western Germany*, in that it appears to have made something marginal to the work itself its motif and raison d'être. Except that the pure-wool logo loses its purity here, for Trockel has had woven into the other half of the hanging the familiar bunny logo of the Playboy world—and there is a field of rabbits facing a field of schematized yarn balls. The bunny logo sexualizes the wool one.

Sometimes the reference to breasts in Trockel's work is actually frightening. An untitled piece from 1988 uses a waxwork replica of a store mannequin, a bust of a woman with salient breasts and a pretty but vacant head. She is set onto a sort of platform with two flatirons, the plate of each pointed toward a breast. It becomes an immediate image of torture, and a horrifying one at that: the woman does not even have arms with which to fend off the menacing irons. And yet Trockel could have written under the vulnerable organs, in the manner of Magritte, *Ceci n'est pas un sein* ("This is not a breast"). It is only the wax effigy of one. The wax would merely melt, and besides, these are only effigies of irons and they are in any case not plugged in. You can't torture a statue! And yet the mind cannot think the woman out of the mannequin any more than it can dissociate the balls of yarn from the breasts in *Dress*. One has to see this as a woman threatened

rather than as a sort of still life with two flatirons and a mannequin. What we certainly cannot do is agree with the catalogue, which writes that "ironing, the stereotypical 'woman's work' of the laundress and the housewife, is here figured as an assault on the female body." This converts a deep and unsettling work into a flat ideological slogan. Trockel is too nimble a visual thinker, too subtle an artistic activist, to be trapped into banality: she *uses* banality to ascend to works that, even when their theme is Woman, are sparkling, allusive, subtle, and multileveled. And at the same time each of her works has the power of a visual mystery. There is nothing wrong with art being political, only with political art having the single meaning of the political cartoon. One does not want to walk through an exhibition like this with a sort of curatorial lexicon in hand, nailing down symbols, viz., "weaving = woman's work," "ironing = drudgery, usually performed by females."

Consider, for example, an extraordinary work of 1986 that is a sort of glass display case—or perhaps an ornamental and reappropriated aquarium—on elegantly curved legs. In it we see seven ladlelike objects, uniform in size, suspended from that sort of overhead rack one finds in professional kitchens: what the French call a *batterie de cuisine*. The spoon end of the ladles are seashells cast in bronze, but are attached to the sort of prosaic handles that ladles usually have. In the lexicon just referred to, seashells are supposed to mean vulvas; and though nobody, having made this identification explicit, goes on in the catalogue to say that cooking is women's work, the bare sexual identification is pretty reductionist. In fact, the shells in question are conch shells, and could as easily symbolize the phallus as the vulva. Or, if we insist on sexual translations, the conch shell seems indissolubly male *and* female: the fact that we see them from underneath may mean that men have a certain female underside, just as Duchamp sought to bring out. This indeed is far closer, one feels, to this artist's general attitude toward the sexes. She has, for example, employed in one of her works an African fetish that is at once vulval and phallic, as if to underscore our common humanity as well as our sexual differences. (She has woven pluses up one side and minuses up the other of a pair of unisex long johns, a kind of comical emblem of the unity and oppositeness of the sexes.) But once more this leaves the visual impact of her work out of consideration. It has the mysterious inconsequence of something dreamt. It conveys a sort of visual silence, as of a secret hidden, and inasmuch as the hiddenness is the work, the approach is to feel rather than solve it.

The ladle work is called *Untitled*, but Trockel's titles, when she does bestow them, do not usefully resolve questions. They add, if anything, to the mystery. One work, for example, is called *Pennsylvania Station*. It is composed of an abstract stove, reminiscent of the nonfunctional, furniturelike confections of the American artist Richard Artschwager, alongside what looks to be the packing case in which it came. So the two pieces—or components—seem to be united by juxtaposition in some sort of container-contained relationship. But there is a third component, at the bottom of the packing case—a sort of charred and overcooked mermaid. The carbonized monster bears an uncanny resemblance to the screaming figure in Edvard Munch's celebrated image *The Scream*. Its mouth is open in a stifled cry, its hands are covering its ears. It is in some ways a frightening image and in some ways a comic one. After all, the idea of an overcooked mermaid raises the specter of culinary ineptitude in connection with a species it would not ordinarily occur to anyone to pop under the broiler. (Or should mermaids be poached?) Perhaps the mermaid, half fish, half human, is a symbol of our own bimorphic nature? Or is it all female, and martyrized by the kitchen stove—woman's work *noch einmal?* Whatever one offers by way of interpretation leaves unanswered what the various linked and warring meanings have to do with Pennsylvania Station.

New Yorkers, who got a taste of Trockel's work in one of the Museum of Modern Art's "Project" exhibitions, will, unfortunately, not get to see this show. It is composed of seventy-five works, some more conceptually intricate than others but each penetrated with the same spirit of political comedy and artistic intelligence; few can be classified under traditional rubrics, nor do many resemble one another as objects. The style is one of cognitive and moral address, but each has to be worked out on its own terms, though of course there are some inner resemblances—woven works, for example, and as a subgenre, what one might think of as garments of the sexual wars: the dress, the long johns, but also some improbably long stockings, some two-necked sweaters for couples who look for an outward symbol of the tightness of their relationship. And then there are hoods of the kind familiar from newspaper photographs of terrorists, with openings for eyes but not for mouths—balaclavas into which Trockel has woven various logos: the swastika, the Playboy bunny, the plus and minus signs. Some of these are displayed as sets, as if you can wear them for various occasions of terrorism or of play. And then, in a category

of its own, is the Painting Machine of 1990, which looks like a loom, perhaps, but in fact has fifty-six brushes, each made of a lock of hair from an identifiable artist (Cindy Sherman, Martin Kippenberger, Alex Katz, etc.). These are suspended at one end, and, when dipped into paint, make delicate calligraphic marks on pieces of paper pulled through the mechanism. The contrast is vivid between the fierce iron-work of the contrivance and the brushes, emblems of touch and sensitivity, and the locks of hair, connoting sentimentality but put to some artistic use. And finally there is a whiff of politicized absurdity in a machine's being put to the use of making art, in its own way, I suppose, a beating of swords into plowshares. Like everything, it dances with meaning.

What I most respond to in Trockel's work is the sense that she knows all about us—knows us at our smallest and at our worst—and somehow conveys the sense that we are forgiven. This combination would once have been thought of as a womanly virtue, when the Blessed Virgin was thought of as the paradigm woman, and it is certainly comforting to see it in our generally unforgiving era, and to reflect that there are still morally gifted individuals who embody it. Trockel is tough, at times as acidic as Duchamp, at times as frightening as Beuys. But she is also kinder to those she accuses—us—than either of them could possibly be.

—*The Nation*, October 7, 1991

The Sacred Art of Tibet

SINCE AT LEAST the time of Schopenhauer, wisdom has been
deemed the particular attribute of the thought and writings of Eastern
sages, while compassion has long been ascribed to the historical Bud-
dha, whose enlightenment, after all, was the result of cogitating on
human suffering, for which his doctrines proposed a radical cure. "Wis-
dom and Compassion," accordingly, is a wholly natural title for an
exhibition devoted to the sacred art of Tibet, whose religion is based
on Buddha's declarations and injunctions. Tibetan art consists largely
of paintings and statues of the Buddha himself, as well as of various
personages who figure in the increasingly complex cosmology into
which the initially simple and parable-based doctrine evolved. This
complexity is reflected in the art, which depicts these personages, who
have attained varying degrees of enlightenment, enthroned in spaces
thronged with other beings, natural and supernatural, spiritual and
celestial, whose identity would at best be known to learned practitioners
of Tantric Buddhism, as the Tibetan version of the religion is known.
The immense distance between the Tantric system and the clear, sim-
ple discourses and homilies of the historical Buddha (which seem easily
understood and readily applied by the most ordinary of men and
women) marks the degree to which an industry of specialists prolif-
erated, whose practices, though meant for the larger benefit of hu-
mankind, involve technologies inaccessible to the laity and depend
upon knowledge of the most arcane and esoteric order, far indeed from
the common understanding to which the Buddha himself made so
direct an appeal. And ordinary Tibetans, who may have seen these
often dauntingly intricate representations of enlightened beings—hu-

man, divine, or semi-divine—must have been nearly as diffident in supposing they understood what was meant by the art as are we, coming from another tradition, when we encounter them as artifacts from a remote artistic culture. The difference, of course, is that they must have felt that the truths embodied in these hangings and sculptures were momentous and urgent, and in consequence they had to have felt an accompanying gratitude that there *were* those who grasped such truths and labored for the redemption of the others who barely understood them. The complexity of the art thus had to have reinforced the authority of the priestly class to whose endeavors almost the entirety of Tibetan culture was dedicated. There is thus something *tremendous* in the complexity of Tibetan art. I suppose, questions of artistry to one side, an analogy might be found in those blackboards covered with equations whose meaning is opaque to us, but of whose importance to human understanding and welfare we are assured. And so we gladly support the laboratories, the armies of scientists, whom we appreciate as devoting themselves fully to our behalf by probing the secrets of the real.

Nothing, however, in the educated Westerner's own religious background or in his or her acquaintance with Buddhist doctrine derived from one or another college course in comparative world religions is more likely to register sheer conceptual distance from Tibetan iconography than the fact that the characteristic Tantric emblem is composed of coupled deities in fierce sexual conjunction, locked in the rhythm that rocks the world. I once made a pilgrimage to Khajuraho to see the legendary temples ornamented with gods and goddesses depicted making love (Khajuraho is appropriately a site for honeymooners in India). There is an indolent, sunny eroticism about these handsome lovers, with unforgettable smiles on their faces, however improbably intertwined their legs and arms. They may be the distant ancestors of the Tibetan couplers, but if so, intercourse has been raised in the interim from a source of mutual pleasure to a cosmic principle: Tantric cosmo-copulators are not, one feels, lovers so much as collaborators in genital exercise, and sex appears to have become a means to an end distinct from the recreational and reproductive ends it serves in human life.

The reproductive dimension of sex is thematized in Judaism, and in the covenanted promise of multiplication (which is why the Holocaust is in violation of the covenant, as much for the snuffing out of progenies as for the terrible suffering that underscores it; and why

Onan is condemned, not for solitary pleasure, but for spilling *seed*). The hedonistic dimension of sex is thematized in Islam, where the word for marriage is that used to denote the sexual act (though it is primarily a male prerogative: the Koran says, "Women are your tillage," and it is a standing puzzle of what heaven might hold for women, if men are promised protracted orgasms with sloe-eyed beauties already waiting for them there). Christianity clearly regards sex as an evil and counsels abstinence, though Leo Steinberg, in a brilliant and justly celebrated book on Christ's sexuality, has argued convincingly that Christ hardly could be counted chaste if he lacked the wherewithal to participate in sex; and in general it only makes sense that in taking on the humiliations of the flesh, God must endure the sufferings of sexual craving. Steinberg has demonstrated the extent to which Christ is depicted as sexed in a wide range of Renaissance images, but there is no tradition that Christ partook, though he was not indifferent to sensuous gratification, such as having his feet laved with spikenard and rubbed dry with Mary's hair. Mystics in many religions use sexual ecstasy as their best metaphor for overcoming the distance between lover and beloved, and viewers of Bernini's *Ecstasy of St. Theresa* must be struck by the extreme eroticism of the saint's transport. But the actual use of sex to induce mystical ecstasy must be exceedingly marginal in most world religions. It seems, by contrast, central to Tantra, and though what transpires between earthly lovers in conjugal beds has scant proportion to what appears to be enacted by the gods in Tantric painting and statuary, it seems fairly clear that ritualized intercourse was a way of seeking higher union on the part of adepts. "The central *sadhana* of Tantrism, Buddhist and Hindu alike," writes Agehananada Bharati (an amiable monk and anthropologist born into this life as Leopold Fisher, with whom I shared dinners in New York before, alas, he slipped into another life, as he would see the matter), "is the exercise of sexual contact under tantric 'laboratory conditions.' " Bharati describes these conditions in some detail in his book on the Tantric tradition. So adepts, at some symbolic level, enact what is depicted in the art—and there must be some continuity between the ritualized act and its objective correlative.

Anyone the least familiar with Buddhist teaching is aware of the distinction between the so-called Lesser and Greater Vehicles—between the Theravada and the Mahayana practices. The first concerns individuals who seek release from karma (and hence release from suffering) by various renunciations, but chiefly by stifling the propensity

to be attached to things and persons. According to this tradition, the Buddha showed the Way, and it is now up to us to follow it, not always as easy as it may sound, inasmuch as it is exceedingly difficult to detach oneself from lovers and children and parents, or to be indifferent to their sufferings. The Greater Vehicle involves the mediating action of the Bodhisattva, a being of advanced enlightenment who postpones or defers his or her own Nirvanization until everyone, in a single cosmic transfer, passes collectively into the Nirvanic state. It was with Mahayana teaching that Buddhism began to take on a doctrinal and in some measure a philosophical complexity, largely, in my view, because its proponents were obliged to defend their doctrine against the shrewd dialecticians of traditional Indian philosophy. Under Mahayana, Buddhism became a cosmological religion, and there began to be a separation between the professionals, so to speak, and the rest, who were not always able to follow the arguments but more commonly merely said some prayers and tried to lead decent lives. Tantra goes beyond Mahayana by a factor vastly greater than that by which Mahayana goes beyond Theravada. Indeed, it credits itself with subsuming all the texts and teachings that went before, embedding them in systems of an immensity to awe the mind. It required a priesthood able to keep track of the rituals, exercises, codes, and cosmologies well beyond anything dreamt by Mahayana. As priest, I suppose, the Tantric specialist was already detached from the commonplace world of those in whose favor or for whose benefit he supposed himself to be acting. But it was a peculiarity of Tantra that direct mystical contact was sought, and what Bharati terms "sexual contact" was a means to this—a means to emulate deities and their consorts in the intense and transfigurative unions we see depicted in Buddhist art. It is, if executed rightly, the paradigm method of overcoming opposition, of becoming one with what, before the act was undertaken, was another.

Needless to say, with the immense conceptual expansion of Buddhism under Tantra, there is a corresponding modification in the use of basic terms, not least of all "wisdom" and "compassion." The handsome and stunningly informative catalogue that accompanies "Wisdom and Compassion" (and that bears the very title), the current, magnificently installed exhibition in the IBM Galleries, uses as its cover and its frontispiece an image from a magnificent *tangka*, which shows a blue Buddha and his fiery red consort interlocked in a powerful sexual embrace. It typifies the so-called Father-Mother (*Yab-Yum*) format of Tibetan art, found in *tangkas* (hanging paintings that can be rolled

and unrolled) and in metal or wooden figures and figurines. Compassion, we are now told, is "the male principle" and wisdom "the female principle." The sexual union of male and female is in effect the merging of wisdom and compassion as an emblem of the Nirvanic state. Politically, I suppose, for whatever such a speculation by an outsider like me may be worth, compassion is Mahayana and wisdom Theravada, with Tantra as their union, symbolizing through sex their fusion, their individual overcoming and opposition, and then emancipation, as Buddhism understands this.

Be this as it may, on some level of symbolic interpretation the graphic depiction of sexual energy here is overwhelming. The coupling is strenuous (or it would be for humans) and athletic. The pair is standing, with the female's left leg pressed stiffly against the right leg of her partner, as if in a kind of dance step, such as a glide. Her right leg is slung over his left thigh. Her left arm is thrown around his neck and her right arm seems to wave a ritual object in the air. The contact seems almost entirely genital, inasmuch as the male, though possessed of twelve arms, does not seem to be holding his fiery consort with any of them; and even if one pair of arms does surround her, it holds, in each hand, a scepter of some sort. Each of the remaining arms displays a ritual object, including the flayed skin of an elephant, which the male seems to hold as a kind of curtain behind his back. The artist has managed to show the bodies as pressed against each other, and to show especially the female's passion: her head is flung back as she looks up into her mate's eyes (of which there are three in the face that looks out at *us*, over her head, though the male in fact has several faces, which look out in different directions and are of different colors). Their teeth are bared, their lips are parted, their jaws are clenched in tension. The female seems measurably more ecstatic than the male, which may be due to the fact that it is the mark of the Tantric sexual discipline that males practice retention of the seminal fluid, which may be greatly to the female's orgasmic benefit (the fact that the Hindu depiction is consistent with ejaculation may explain the relaxed sexuality of Khajuraho). Their act is a kind of "act." It transpires on a lotus-shaped podium, on which their heavy feet trample figures one supposes symbolize the contraries of wisdom and compassion. Male and female are alike elaborately ornamented. The male wears a diadem of skulls; one hand holds three severed heads. The catalogue will identify all the objects held by the male's twelve hands and the female's one free hand. The amazement is that this great dance of sexual oneness transcends,

artistically, the arcane iconography, which only priests and scholars know how to unriddle. The couple is spotlighted, as it were, by an ornamental mandala, which has the effect of making the embrace a star turn, which in a sense it is. The star couple is surrounded by a chorus, as it were, or an audience (the two being transforms of each other in certain theories of the history of the theater). There are seventy-odd figures, some of them couples with consorts, enacting in their own right the ecstatic drama of the main couple. It is a cosmic sex dance, dense with meaning, a vision of unity, a metaphor for what holds the world together and overcomes all difference. It is a stupendous vision. One has to be reminded of what Nietzsche describes in *The Birth of Tragedy* as "the rapture of the Dionysian state with its annihilation of the ordinary bounds and limits of existence."

One now learns that the male figure here is the Buddha himself, in one of his forms, that of Shamvara. In the Tantric system, there are Buddhas and Buddhas, Buddha worlds and Buddha worlds. The *historical* Buddha, the wise thinker who discovered the Four Noble Truths and the Eightfold Path, is but one of them. If our conception of Buddhism is defined by that marvelous being, we are bound to feel somewhat restless with the multiple limbs, the flayed skins (sometimes human), the skulls, the scalps, the blood, even the exhibitionistic sex. We have in any case come a long way from the direct and simple propositions that make Buddhism so attractive a teaching, or from those affecting dialogues between Buddha and his follower and sidekick, Ananda. Some of this feeling survives in certain of the *tangkas*. There is a very moving one that shows the death of Buddha, for example, in a setting so lovely and tranquil that by itself it almost succeeds in detaching the viewer from the power of death (and how different it is from the gory death scenes paradigmatic to Christianity!). The Buddha is lying on one elbow on a dais set in the midst of a verdant landscape, a garden really, with a pond and ornamental trees and paired birds. There are whorled Chinese clouds of incense rising into the blue sky, and rainbows wave in the air, as if the world has been freshened by rain. The Buddha, in a dotted pink robe, is of course larger than anyone else, and he is saying his last words to his already mourning followers, whom he has told to work out their salvations diligently. Clearly, they have a long way to go, for the fact that they are weeping is evidence that they are still attached. My sense is that the detachment of the Buddha is symbolically embodied in the very beauty of the day on which he has chosen to leave the world: the world he leaves is so

intoxicatingly lovely that one must feel he has determined to quit it
when we would be most attached to it. By contrast to his shaken fol-
lowers, he is supremely calm. It is a very affecting image, defining one
boundary of a system, the other boundary of which is exemplified in
the sexual dance of Shamvara-Buddha and his flushed, tooth-grinding
consort, clinging to him as to a tree. The distance from boundary to
boundary tells the story of Buddhism's evolution. Perhaps the inca-
pacity for detachment, demonstrated in the weeping monks of the first
image, reveals the extent to which we all need help, and hence the
theoretical generating of helpers and the vast hierarchies of priestly
specialists is the institutional response to the need. Nirvana is very far
away, except perhaps through sexual shortcuts.

This has been proclaimed the Year of Tibet, and the unprece-
dented exhibition of Tibetan art is part of a larger celebration, a way
of drawing the world's attention to an embattled tradition and a world
under siege. It hardly need be said that the works assembled here were
never intended as art to be looked at by visitors who then turn the
corner and look at something else—like the exhibition "Pleasures of
Paris: Daumier to Picasso," composed of images from dance halls and
circuses and cafés, also on display at the IBM Galleries, making an
odd worldly pendant to the religious art from Tibet. The *tangkas* or
the gilded devotional figures are for the most part anonymous expres-
sions of the same spirit that unites artist, work, and audience in a field
of devotion to which we, as aesthetic sightseers, are altogether
strangers. What is astonishing, however little one knows about the
tradition, is the power exerted by so many of these works, awesome
and even frightening in some instances, gracious and reassuring in
some others. There can be very few figures more ingratiating than the
Green Tara, in gilt brass, about fifteen inches high, perched on a lotus
in the form of an adolescent girl. Green Tara is an intercessor, a rescuer,
a heeder of the cries of sufferers, and she is revered for her readiness
to step in and offer relief in immediate and palpable ways. It is small
consolation, I should think, adrift at sea or in the midst of flames, to
be told that desire is the cause of suffering: one wants help right away.
Green Tara, as a Bodhisattva, is a Buddhist counterpart to those *not-
helfige Heiligen* of Christianity that desperate Christians call upon in
their straits: St. Roch, St. Blaise, St. Barbara or Margaret or Eustace.
The delicacy, fragility, and beauty of this young girl somehow under-
score her power and her grace: she radiates perfect composure and
confidence from beneath her elegant crown. Green Tara is a response

to a need for deities immediately accessible to human summoning, without the mediation of priests. The great sexual dances may be for our benefit in the cosmological long run, but there is little day-to-day evidence of their effectiveness in the flaming world. Green Tara is among those who fill the void, and in this exquisite figurine she reflects the vulnerability of those she will help: Green Tara is somehow one of us. We must admire the skill with which the sculptor has achieved the impression of diaphanousness in her rippling garments. In *The Pillow Book*, Lady Sei Shonagon records a pilgrimage to Nara, where the priest was so good-looking she found herself distracted from otherworldly preoccupations. She thought it dangerous that priests be handsome for that reason. I felt somewhat the same with Green Tara. Buddhism is supposed to stultify craving, but I craved this marvelous sculpture, and were I to call upon Green Tara, it would be for this image of herself. Like everyone else, I have a long way to go.

This is a good show to visit with a companion. That way, you can work out some of the meanings together—though not too many, for each piece is, as a general rule, quite complex. You may not wish to do more, for many of the images are repellent. Nothing in art, however, quite matches the sexually energized couples in Tantric imagery, and in an era in which the relationship of art, sex, and religion has become muddled, it is worthwhile contemplating a tradition in which they fit together beautifully and harmoniously, each a metaphor for the power of the rest. As a force and metaphor, sex has no equal: the fundamental things apply as time goes by.

—*The Nation*, December 16, 1991

Georges Seurat

THE CALLIGRAPHER Chiang Yee once told me of an instructive conversation between a famous painter of bamboos in China and a collector who coveted the artist's work. At last the painter yielded to the collector's pleadings, but used the red ink Chinese artists employed for their seals. The collector, pleased and displeased, asked the artist where he had ever seen red bamboos. The artist asked the collector where he had ever seen *black* ones. The forms of drawing are generally expected to match the forms drawn, though there are elasticities of correspondence that allow for expression and distortion. But the color of the drawing medium is rarely referential in its own right: at best the relationship of darks to the lights provided by the drawing surface answers to the relationship of shadows to lights in the motif. So in principle the artist may draw in any color he or she chooses, red being no more or less referential than the conventional black of ink. Why it is that black-and-white photography seems more natural to us than, say, the greens or blues or reds of rotogravure may have to do with visual convention, or perhaps a desire for sharper contrasts when older photography aimed for nuanced gradations to parallel the rival art of painting. Western artists have used red crayon or sepia ink without raising questions of where they might have seen red nudes or sepia trees. Georges Seurat drew, all but invariably, in black Conté crayon, but in such a way that for once the color seemed referential: the world he drew was a black world; were he to have painted that world the way he drew it, the paintings too would have been black.

I don't mean simply that the drawings are, for example, of black drays drawn by black horses past the black trunks of bare trees; or of people huddled in black vestments, their faces shadowed under black

hats and bonnets; or of the black arms of a drawbridge extending against the lowering sky while black water melds with heavy shadow; or of black tugs coursing along pale rivers under black clouds; or of a black locomotive puffing black smoke into the barely lighter sky—or just of blackened buildings stark against the night sky. These are descriptions of what Seurat composed in the characteristic and astonishing drawings he did in the early 1880s, descriptions consistent with the way those drawings look. Rather, what I mean is that these vehicles and animals, groups of people or individuals, buildings, trestles, and trees would have looked black in reality no matter what color they had been drawn in: they look as they would if seen at twilight, or at night, or on bleak late afternoons, or perhaps in rain, where the objects picked out by whatever light there is look like their own shadows. It is a black world because it is a nocturnal world, one in which things are seen as dark masses with all interior detail obscured, and there would be no way of knowing, under those conditions of seeing, what their natural colors really were or what their distinguishing features might be. What one is conscious of in the drawings is the heavy crisscross of crayon lines, black against black upon black, until the object seems to be a solid mass whose identity is hard to read: bush or squatting man? pile of leaves or signboard or wagon? And then, by some adjustment of the eyes, as it were, a form begins to emerge—a wheel, a hayrick, a horse. And suddenly the whole shape acquires a structure, and one can see that certain touches and irregularities answer to the object's features and realizes that one is looking at a drawing of astonishing power, which had appeared, until the revelation of the feature that transformed what had seemed accidentalities into further features, like a dense scribble or a sustained smudge. Now, it is the very body of a horse, but if one had not made out that head, the body would have remained merged with the dark of the wagon into an abstract composite of lines, some darker than others, and patches of untouched or barely touched white paper.

One can imagine these remarkable drawings translated into paintings, which would be as black and light as the drawings themselves are, with perhaps a touch of color here or there. They would, however, not look like the paintings Seurat was doing concurrently with those drawings, which were, in the main, Impressionist landscapes with the daubed surfaces of the time, and sunlit colors, more or less. The dabs are a bit heavier, clumsier even, than Monet or Sisley would have made, and at the time one would have judged them the work of a younger painter with Impressionist ambitions who had not as yet found

the way to make the colors dance or the brush dart: Seurat was only in his early twenties. But there in fact was no way to transform the way he drew shapes and forms into the daubed and dotted areas of the standard Impressionist canvas, and I am inclined to say that there did not exist a style of painting in 1882 that would have enabled Seurat to paint the way he drew. One would need, in fact, something like Abstract Expressionism for that, where the artist might use a heavy brush to pull a stroke of pigment across the canvas and at once shape it to form the internal energy of a horse, a man, a van, a house, a river, sky, water, trees. Seurat never got into his paintings the visceral urgency of his drawings, and if in his mature style as a painter his works have a certain mystery, it is a mystery of a different order—a mystery of light rather than of darkness. I am not sure he even tried to paint in the direction to which the drawings pointed, but the existence of these drawings must complicate the picture we have of Seurat as a chilly geometrist, a chromatic engineer, a scientific placer of bitsy dots, an advocate of optical mixture of colors rather than the chemical mixing of pigments, as obsessed by the logic of color as Paolo Uccello is legended to have been possessed by, almost drunk on, the logic of linear perspective.

Uccello, Vasari writes, "would have proved himself the most original and inventive genius ever devoted to the art of painting, from the time of Giotto downwards, had he bestowed but half the labor on the delineation of men and animals that he lost and threw away over the minutiae of perspective." These studies, Vasari continues, "are meritorious and good in their way, yet he who is addicted to them beyond measure wastes his time, exhausts his intellect. . . . Nay, whoever bestows his attention on these points, rather than on the delineation of the living figure, will frequently derive from his efforts a dry and angular hardness of manner which is a very common result of too close a consider[ation] of minute points." This happened in some measure to the artists who followed Seurat, thinking he had found the truth of scientific (as against "romantic") Impressionism, and believing, in terms not only of the Positivism of the age but in the tradition of painting itself, that it was imperative to be scientific everywhere and in all endeavors of life. It is a tribute to Seurat's genius that this did not happen to him, in spite of the rigidity of his theories and the mechanism of their application, and the temptation to take on tasks of virtuoso complexity. In *Les Poseuses*, for example, he depicted three models in various poses in front of his great work *A Sunday on the Island of La Grande Jatte*. The latter painting, of course, is a dem-

onstration piece of *pointilliste* theory, and *Les Poseuses* is a *pointilliste* work as well. So in it Seurat has undertaken to do a *pointilliste* painting *of* a *pointilliste* painting—a complex exercise of double-dotting that bears comparison with doing a perspective drawing of a perspective drawing, geometrizing geometry. It is a blessing that an artist who met so early a death did not then undertake a *pointilliste* painting with *Les Poseuses* as the picture within the picture! In fact *Les Poseuses*, like the *Grande Jatte* itself, transcends its technology and shimmers like a mystery within the drizzle of its painted dots, just as Uccello's great works transcend the earnest labor of drawing rearing horses in strict perspective as if a road in a classical landscape. Still, great and evocative as these two masterpieces of Seurat's are, they achieve their power in a way that bears no continuity whatever with that of his great drawings. It is, despite the vast difference between evoking forms through dots of color and achieving form by gestural scribbles, not quite as if Seurat were two artistic personalities in a single soul. But one has to probe a bit to see what the two efforts have in common, and probe even further to see what unites the *Grande Jatte* into a single corpus with the last paintings of circuses and night halls, while setting the entire body of Seurat's works off from those of his *pointilliste* emulators like Signac or, for a misguided period, Pissarro, who rather ideologized Seurat's painting technique.

I think that what the drawings convey is an air of mystery. The viewer's difficulty in making out the forms is the visual counterpart to making out the meaning of the scene, once clarified in its inventory. One drawing is bisected by a stand of skimpy trees, which cast their shadows forward, toward the spectator, but in such a way as to leave it ambiguous whether some form in the foreground is not outlined instead. To the left is a jumble of black forms that reveals itself, tremulously, as a horse, facing us, with a cart on immense angled wheels behind it. No human being is in sight, or it is uncertain as to whether a few lines and strokes represent a person or not. This is not an observed rural scene but a poetic evocation of a landscape that hovers on the borderline between emptiness and uncanniness. The waning light and the waiting horse transmit a meaning like carriers of some unexplained symbolic weight. In one scene a dog lies in companionable stillness alongside a tilted carriage, but not as if there were some genre scene intended, with dog and empty vehicle. The carriage is evoked against an uncompromising black while the dog lies in a pool of light of inexplicable provenance; the animal and conveyance seem connected by a sympathy as strange as it is palpable. In yet another drawing, an urban

couple is blacked in against a luminous sky, he with a cane, she with a parasol, as if strolling through a landscape—but there is also a plowman emerging with his horse out of the shadows, cutting across their path. Some scholars seek to rationalize this image by saying that it is in the 1880s and that the suburbs are reaching into the countryside. In fact, there is something strange in the juxtaposition of two orders of being who haunt each other's dreams. It is almost surrealistic.

In the *Surrealist Manifesto*, André Breton claimed that only three artists in history had attained a truly Surrealist vision of things: Uccello and Seurat, and Gustave Moreau. Breton's well-known definition of Surrealism says that it is the purpose of the movement to "resolve the previously contradictory conditions of dream and reality into an absolute reality, a surreality." The nocturnal quality of Seurat's drawings, in which dark forms are haloed within an enveloping darkness, seems almost precisely captured by that formulation, with their uncertain identities and their portentous juxtaposings. But the quality of dream penetrates even the paintings, which in every other respect are the drawings' obverses: light rather than dark, defined rather than indeterminate, painstaking rather than passionately realized, scientific, if you wish, rather than romantic. Consider *Les Poseuses* once more. How like a dream the painting finally is when one thinks of the strangeness of there being three models, in various stages of undress. Why three? Why not one model, capable of taking the three poses successively? (Roger Fry, in an early appreciation of the work, sees it as the same model in three distinct poses.) But why not instead see it as the pictorial representation of "I dreamt there were three models in my studio. They began to undress and to enter the *Grande Jatte*. Or perhaps they walked out of the painting and into the studio, where they began to take off their clothes"? We see the two seated models with their hats and skirts, their gloves and their parasols spread out around them. In the painting, we see also a seated woman, *her* hat and *her* parasol placed beside her on the grass. It is as if the nude women are what was suppressed in the *Grande Jatte*, or whose erasure was the price the bustled figures had to pay for the bourgeois decorum of their Sunday stroll among regimented shadows. And we may now, all at once, see the *Grande Jatte* in a new way, with its figures distributed like animate Euclidean solids in Breton's super-reality, an atmosphere of golden clarity like a block of crystal, or of champagne somehow frozen. Even the puffs from the *promeneur*'s cigar seem frozen, comically and impossibly. Everything is observation hybridized by symbol and sublimated by dream.

And that we do not find in Signac or in Pissarro, who thought what they got from Seurat was a method, underwritten by physics, optics, and chemistry, for rendering the chromatic surfaces of the real!

Neither *A Sunday on the Island of La Grande Jatte* nor *Les Poseuses*—nor, for that matter, *Une Baignade*—are in the retrospective exhibition of Seurat's work on view at the Metropolitan Museum of Art in New York, though we have versions of the first two and studies for all three. The immense advantage of not having their intimidating presences is that we can study the drawings, which are their artistic equal, and come better prepared the next time we see the paintings in their various shrines. The drawing style changes with the *Grande Jatte*, in that the figures are more severe and geometrized, and the crayon detaches them from the paper which gives them their vibrancy and life by smooth gradations. I love a study of the park from which everyone has left, as if specters, leaving behind as solid reality only a solitary black dog, sniffing the ground, its grayed legs almost merging with the grass. What nothing will have prepared us for are the strident last works, of prancing dancers and menacing clowns in the Parisian night-town of the imagination, which stand to things Seurat may have observed as his painting of *promeneurs* and bathers stands to what he may have observed before he transformed them into mythologies. I know of no figure in art to compare with the hooded clown, who looks like a figure from the Inquisition, playing the trombone over the heads of spectators who have formed a line to enter the gaslit interior of the circus behind the sideshow, accompanied by the music and by what one supposes must be the patter of an evil boy in white ruff and pointed forelock. The musicians behind the frightening trombonist look like mechanical dolls, the predominant colors are black and orange—a Halloween palette—and it is hard to suppress the feeling that the foolish crowd is being marched into hell. A satanic figure with florid mustaches stands with his back to them. He is a figure who appears and reappears in these paintings—as the bandleader in *Chahut*, as the ringmaster in *Cirque*, perhaps as the masculine figure in the dominant couple at the extreme right hand of the *Grande Jatte*. Because he is a recurring type, like someone who keeps appearing in one's dreams, it is difficult to suppose he is to be explained in terms of a person Seurat happened to have observed. I have no interpretation to offer, but I find it striking that the walking stick of the *Grande Jatte*, the staff of *Circus Sideshow*, the baton of *Chahut*, the whip in *Cirque* seem to be transforms of one another. I am also struck by the transformation that takes

place in the representation of the human figure, from the dilating, smoky beings of the drawings through the geometroid figures of the *Grande Jatte* to the marionette-like precisionist dancers of *Chahut*; and by how the first figures barely have faces, while the second generation have faces but no features, and the final generation, in these paintings of the late eighties—Seurat died in 1891—are like masks, or cartoons of faces, grotesque and empty and possibly evil. In a way, Seurat's art approaches the idiom of the poster; it is as though he took from the posters that advertise the forms of entertainment shown in these pictures—which publicize the Divan Japonais or one or another of the circuses of Paris—a way of representing the people who inhabit these places, who look like their own advertising images. I find it fascinating that Seurat greatly admired and collected the work of the poster artist Jules Cheret. The *pointillisme* of these final, theatrical works seems somehow willed and thematically irrelevant. Or perhaps the tension between the methodical application of dot upon dot was a way of keeping one's head when depicting the wild cancan kicks of the dance hall and the crazy world of the circus.

Oddly, *pointillisme* does not seem irrelevant to the landscapes, which I have left untouched. Nor does it seem irrelevant to the strange and moving portrait of Seurat's mistress, shown in the kind of undergarments that went with gaslight, powdering her face. Her ornamental mirror and her tiny makeup table are her attributes, as if he had to depict her as he would a saint with *her* attributes. She is a *femme forte*, as the French would say, and I find the catalogue contemptible for supposing that Seurat must be ridiculing her for her proportions. One somehow feels as if the touches of paint reenact the touches of the powder puff as she endeavors to make herself beautiful for him, and that between subject and style there is a true sympathy. She was pregnant with their second child when he died, abruptly, at the age of thirty-one. It is impossible to imagine what he would have done had he lived on, particularly since everything he achieved was surprising against the background of what he had already achieved. Everything about him was a mystery, and remains one. For all I know, the insistence upon being scientifically correct was the necessary correlative for a mind drawn to fantasy, dream, illusion—the vaudeville side of the mind.

—*The Nation*, October 28, 1991

Dislocationary Art

PHILOSOPHERS, jurists, and civil libertarians alike have been intrigued by an argument made by Catharine MacKinnon in the so-called Minneapolis Ordinance, which attempted to treat certain representations as being in violation of the civil rights of women. The ordinance spoke of the graphic sexually explicit subordination of women through images or words. It is not only that images that depict women in sadistic fantasies may have as consequences the actual subordination of women because they inspired sadists to realize such fantasies. Rather, the images *themselves*, whatever their consequences, subordinate women through their content. That images have the power to subordinate in this sense is widely conceded: when someone depicted the former mayor of Chicago in drag, wearing frilly underthings, the black community felt that to be a degradation, an unacceptable picture, and undertook to remove it from the wall. Subordination, thus, is one of the "powers of images," to borrow the expression David Freedberg uses for the title of a book that treats the phenomenon of empowered images throughout history. Freedberg's thesis is that treating images as possessing a wide range of powers is at once ancient and universal, and that the attitude persists in many of the ways in which we respond to and think about images: think of the toppled statues of Lenin throughout Eastern Europe, or the way images are prayed to, injured, kissed, or treated as uncanny throughout the world. Freedberg believes, I daresay rightly, that art historians have neglected these powers, and that in consequence there are entire empires of art to which the formalistic and iconographic modes of analysis they (and most art critics) favor have no application. They do not touch that which in images

verges on their presumed magical and moral force. The testimony of the "experts" in the famous trial in Cincinnati over whether Robert Mapplethorpe's images are "obscene" is a case in point: the experts claimed that they saw the work only as "figure studies," as "classical proportions," as "symmetrical," virtually denying the almost shattering sexual energy of those morally challenging photographs.

Even so, a distinction must be drawn between the power of images and what one might call the *power of art*, where the effect of experiencing a work of art can be tantamount to a conversion, a transformation of the viewer's world. Ruskin, for example, underwent just such a transformative experience with Tintoretto's stupendous paintings in the Scuola di San Rocco in Venice: "I never was so utterly crushed to the earth before any human intellect as I was today before Tintoret," he wrote his father in September 1845. "As for *painting*, I think I didn't know what it meant till today." Some years later, Ruskin sustained what he termed an "unconversion" inspired by Veronese's *Solomon and the Queen of Sheba* in Turin. He had just suffered through a dispiriting sermon on the vanity of life, and seeing the great painting against this bleak characterization of the world, he asked, "Can it be possible that all this power and beauty is adverse to the honour of the Maker of it?" His wonderful letter, again to his father, continues:

Has God made faces beautiful and limbs strong, and created these strange, fiery, fantastic energies, and created the splendour of substance and the love of it; created gold, and pearls, and crystal, and the sun that makes them gorgeous; and filled human fancy with all splendid thoughts; and given to the human touch its power of placing and brightening and perfecting, only that all these things may lead His creatures away from Him?

Ruskin's very language belongs to the world it describes, and to which Veronese's painting reconciled him. He was converted from a kind of evangelism to a redemptive form of humanism.

Ruskin's are extreme instances of the transformative impact art can have, and the very fact that such experiences are possible must surely be part of what Hegel had in view when he claimed that art, philosophy, and religion are aspects or "moments" of what he designated Absolute Spirit. My sense is that anyone who has had any sustained intercourse with art must at some time have undergone some such experience, and I hold it greatly to the credit of Robert Storr, in his inaugural exhibition as curator at the Museum of Modern Art, that

he should have sought to reconnect with the possibility of such transformations. "To be moved by art," he writes, in a text that accompanies "Dislocations," as the exhibition is called, "is to be lifted out of one's usual circumstances and taken out of oneself, the better to look back upon the place one has departed and the limited identity one has left behind. With or without metaphysics, and for however brief a moment it lasts, this state may be fairly called transcendence." Of course, such dislocations are rare in anyone's affective history. Countless tourists have trudged through the Scuola di San Rocco thinking of little more edifying than how chilly they feel or when lunch might be. However greatly one admires Veronese, few have been catapulted by his gorgeousness into a totally new moral attitude. And Ruskin, for all his sensitivity, was numb to works that stirred others profoundly. Speaking for myself, I was absolutely knocked off my horse by certain works of Andy Warhol that others found blank or meretricious or cynical or silly. For all their importance, dislocative experiences are unpredictable, and presuppose certain states of mind on the viewer's part that not everyone will share.

Still, dislocation is a bold direction for MoMA to take, not least of all because of the close identification of Modernism with Formalism, not only in the thought and writing of Alfred Barr but in the practice and discourse of any number of curators or docents when they explain works of art to one another and to the world. Formalism, moreover, as may be seen from the responses of the experts at the Mapplethorpe trial, is clearly the lingua franca of art criticism and what is tacitly appealed to and contested in the issue of "quality" that has lately so exercised the art world. It is formalism against which David Freedberg inveighs in his polemic in favor of recognizing the power of images. And it is formalism, however correctly believed to have been the philosophy and critical posture of Clement Greenberg, that has been so polemicized against by those who have sought a more political mission for art, or who practice what is called "the New Art History." The art world, especially that sector of it corresponding to middle management in industry, is today a politicized, indeed an angrily politicized, group of persons, and there can be little doubt that some of the dislocation aspired to by the seven installations of which this show consists is political: the works mean to get those who view them to think differently about matters of gender, race, and war. This is not likely to happen easily, just because so many of those who will see the show already share so many of the beliefs and attitudes of the artists. Even so, I

cannot suppose that the overall aim of a show, the raison d'être of which is cast in such terms as "transport" or "transcendence" or as "mapping previously unimagined spaces," can be construed as political in any narrow way. The aim is rather something like a conceptual revolution, a way of seeing things fresh, of re-placing the viewer in a conceptually recast world. This is a pretty tall order, all the more so if animated by the belief that there are works capable of doing this in any uniform and dependable way. Conversion is hardly something one can promise ticket holders as the reward of a few hours spent in the galleries.

Dislocation, moreover, does not seem to figure greatly in the day-to-day experiences with art of the MoMA cadre, typical, no doubt, of museum personnel everywhere. This is certainly the inference to be drawn from one of the works, "installed" by the French conceptual and performance artist Sophie Calle in the galleries of the museum's permanent collection. Calle's work is called *Ghosts*, which translates the French term *fantômes*, though the latter has a use in French for which we have, so far as I know, no English word at all—though I imagine "ghost" is destined to enter the language as such. A *fantôme* is the photograph of a painting that replaces the painting when the latter has been taken away from a museum wall, together with a label that explains what happened to the work: it is on loan, or being cleaned or restored, or it has been stolen. Calle had the poetic idea of substituting for the "ghost" the memories of the missing work carried by those supposed most familiar with it—curators, administrators, guards, and the like. It is always interesting to find out how images are stored—I have read that Americans divide equally on the question of whether Lincoln faces right or left on the standard U.S. penny—and it is to be expected that even when a painting is as familiar as the penny, memories will conflict and decay. Remembering paintings, in fact, turns out to be almost like remembering dreams, and it is fascinating to read what Calle has written in the blank spaces on the walls where just a few weeks ago there hung a Magritte, a Modigliani, a Seurat, a Hopper, a De Chirico. It is easy to pick out the official MoMA voice. Of De Chirico: "Very sterile, very angular." "It's mostly those typical De Chirico colors, mustard, gold, brown, and blue." The angry feminist voice is readily identified as well. Of Magritte: "It's just one more picture where the woman is naked and the men are clothed." Of Modigliani: "It's like any other nude. It's a horizontal painting of a female lying naked." And then there are the usual bitchy art-world

voices. Of Hopper: "An icon of American art. I respect it historically but I'm not passionate about it." Of Seurat: "There's something anal about it." These are voices of the located, rather than the dislocated. Storr draws a certain moral from Calle's work. It should, "at the very least, give pause to those who declare themselves to be sure of the import of such canonical pictures." "Canonical" is tendentious: I would say it shows how unsure we ever are of the import of pictures, given the immense diversity of individual histories and beliefs. Some of Calle's ghosts are very evocative and poetically confessional. It would be interesting to know at least the rank in museum hierarchy of the different orders of respondents. Are the guards more likely than the curators to say such things as "You have the feeling you are not in reality, you are on a film set, and something is wrong . . ." of the De Chirico? Or of the Seurat: "The painting reminds me of a sequined dress." Anyway, what ghosts would be left behind from the memories of the noncanonical works in "Dislocations"? Ruskins are few and far between.

The closest to a transformative experience was occasioned for me by Bruce Nauman's *Anthro/Socio*, though part of its impact was due to certain accidents of when I viewed it. There were just a few shadowy visitors in the darkened gallery, with a few more crossing the largely empty space. It made no impact on a friend who was at the opening, when this particular room was dense with guests standing in line to see the next exhibit, and paying no attention to the work. Could the fact that I was one of a handful, each of us in fact paying attention, an enhancement of the experience? In any case, it consists of three colossal projections of the same male head onto the bare walls, one of the heads upside down. The heads are chanting, over and over, as if it were a mantra, what sounds like calls for help. The same striking head, sometimes upside down again, appears on several monitors placed here and there in the gallery, taking up the chant, as if a chorus of semblables. The volume of the sound, the volume of the *room*, the repetition, with felt intensity, of the phrases "Feed me/Eat me/ Anthropology. Help me/Hurt me/Sociology," the urgency of the voices, the floor-to-ceiling scale of the dislocated heads, achieve a very powerful effect, especially when experienced in a near-empty gallery where one sees other visitors silhouetted, singly or in pairs, against the chanting heads. But if it was dislocating, it was so only momentarily, and it left me with nothing by way of a transformed philosophy. The world after Nauman looks a lot like the world pre-Nauman. Perhaps that is

because, knowing there is more to come, one is primed to see what the next installation does.

The next installation I saw was Louise Bourgeois's *Twosome*, having taken a wrong turn in the intended progression of the exhibition. Hers has something of the scale of Nauman's, and it enacts an alternation where his merely chants alternations, but her work uses mechanical protagonists rather than explicitly human ones, and does not touch us with the same immediacy of sympathy. Her alternation is what Alex, in *A Clockwork Orange*, calls "the old in-and-out." The work consists of two very large tanks, rescued for the purposes of art from the scrapyard, lying on their sides, but end to end. The one with the larger diameter has windows cut into it, through which a sort of reddish light shines out. The other slides in and out of it on tracks. It is thus a sort of love machine, an emblem perhaps of the act of love in an age of mechanical reproduction. The receiving cylinder can be seen as a kind of shelter, what with the windows, and so a sort of woman-house (or perhaps a house-wife). One senses that some mischievous reading is intended, like: House-wives are screwed. In a personal statement, Bourgeois philosophizes a bit on in/out as the general metaphysical condition of humankind: we are in/out of love, in/out of luck, in/out of debt, and so on. But none of this is made visual enough by a work that seems awfully large to be at best a kind of joke on the circumstances of copulation. One waits for a more ample revelation, but none comes. It in any case diluted the impact of the Nauman.

I ought to have seen Bourgeois's work after passing through an installation by Ilya Kabakov called *The Bridge*. Indeed, there is a bridge, from which one sees, in the dark space of the room it traverses, furniture pushed back against the walls. A narrative is pinned to a bulletin board, telling of what was to have been a critique, in a housing project in Moscow in 1984, of some paintings held to display "dangerous bourgeois tendencies." This event never came off. The furniture instead was all pushed where one sees it, and there, in the cleared space, are what are described as "groups of little white people, constantly exchanging places." Binoculars have been placed along the bridge for us to look at what to New Yorkers have the appearance of cockroaches dusted with boric acid, showing their usual negatively phototropic behavior. One feels that some magic must have leaked out of Kabakov's installation in its transit from Moscow to New York, where it appears as a sort of mess intended to be a hybrid of political satire and science fiction.

I felt there was little magic to leak out of David Hammons's piece on the third floor, the title of which is *Public Enemy*. It consists of a sort of barricade surrounding blown-up photographs of a piece of public sculpture of an earlier era: Teddy Roosevelt, mounted, is flanked by a Native American and an African-American on foot. Some guns lie here and there against the barricade, and there are balloons and streamers coming down from the ceiling, as if a victory were being celebrated, or had been. Hamm is is a legendary artist, latterly much honored, whose work, until no , has been street art, made of things found in the street, for an au ence whose habitat is the street. It is easy to understand the impu to bring a vision such as his within museum space, which I fear ther defeated it. Given his edificatory impulses, he ought to have pu museum space into question, but instead he settled for a political dio ma not worthy of his true powers. Had such a work been created i public space, around a real monument, it might have been inspirin and even dislocative. But here it is merely sullen and artistically ine

Another clear failure Chris Burden's *The Other Vietnam Memorial*, which is doubly efective. It is defective as art, in the first instance, and it is defec e because it ought to have been good if it was done at all. The ide certainly a good one—to memorialize those who died in the confl but are not memorialized in the Vietnam Veterans Memorial be use they were on the other side. It has the form of a bulletin boar with rotating leaves, on each of which is etched the "names" of dead ietnamese, in tiny, tiny letters. It touches no emotions, not least o all because the names are generic Vietnamese names, designating nyone and no one. The power of Maya Lin's masterpiece is that tnere is a direct causal and semantic tie between each name and a specific individual, so that in touching the name one is multiply related to that very person. Had she used generic American names—Smith, Brown, Robinson, Jones—it would have failed just as Burden's does. After all, we are not talking about Unknown Soldiers. It shows disrespect for the very persons it was meant to represent by putting an abstract screen of namelike marks between them and us. No one is moved to touch this memorial.

The final work, by Adrian Piper, is about racial stereotypes. In a sort of amphitheater, an African-American male declaims from monitors positioned atop a central pillar that he is not lazy, not shiftless, not sneaky, scary . . . is not any of the things men like him are said to be. It is not that he is a *Mann ohne Eigenschaften*—a "Man without

Qualities"—but a man of whom those racist predicates are not true. One can be, one perhaps must be, moved by the message without especially being moved by the work. New Yorkers have seen the theme of racism addressed by Piper, who is a philosopher and a teacher of philosophy, in works that show her engaged in an acidic pedagogy, mocking the viewer, insinuating, putting us off balance. When one of these works showed up in the window of the New Museum, passersby who paused to look at it responded with anger. Perhaps this work is diminished by Nauman's, with which it in any case shares the feature of talking heads.

There is a distinction to be made between bad art and failed art. Nothing in this show is bad, but a lot of it fails, perhaps because of the burden put on it by the charge to dislocate us. It has, on the other hand, two successes—Calle's and Nauman's—and a near-success in Bourgeois's affectionate tanks. And the show itself, as distinguished from its contents, is a great success, reconnecting our concept of art with that for the sake of which art, after all, exists: to move the souls of men and women.

—*The Nation*, January 6/13, 1992

Hendrik Goltzius
and Mannerism

ART IS THE CURRENCY of international trust; as nothing in the world is at once more rare and more vulnerable than a painting, no greater sign can be imagined through which the civility of an alien nation is acknowledged than allowing it to host the rarest and most vulnerable paintings in one's possession. It was not so terribly long ago that the superpowers, snarling and lashing their tails like otherwise inarticulate monsters, communicated primarily in the chill language of underground nuclear testing, and the first tentative signs of a more amiable political disposition resided in the discourse of exchanged Impressionist exhibitions. It must have been in order to give the over-worked Monets and Manets a sabbatical that the Russians once sent some Dutch and Flemish paintings from the Hermitage on an ambassadorial mission in 1988, though it will be universally acknowledged that Gerrit van Honthorst's *Christ in the Garden of Gethsemane*—or a self-portrait by Samuel van Hoogstraten—hardly carries the rhetorical charge of ceremonial amity that the meanest Impressionist Norman beachscape spontaneously transmits. And by 1988, it was no longer true that the mere fact that some paintings had been sent us by the Russians conferred upon them an instant aura. I remember the Dutch and Flemish show for two works, a painting of a magisterial hound by Paulus Potter, and the strangest painting I think I have ever seen, a baptism of Christ by Joachim Wtewael. I date my love for Dutch Mannerist painting from that unexpected encounter with strangeness, and though to my knowledge only two museums in this country possess a work by this curious master, it is for the Wtewael that I resolutely head whenever I visit them, whatever their other glories. (The "W," I have

been instructed, is pronounced the way "ue" is in the French word *rue*—so "uetevahl" will give us a reasonably phonetic representation of this artist's name as uttered in Utrecht, where he made his career.) Mannerism as a movement more or less ended—I would like to say culminated—in Wtewael, but in the discourse of exchanged artworks, he must be counted pretty much as scraping the bottom of the barrel. There was nothing to speak of devoted to him in English, save a valuable but unpublished dissertation done at Columbia University by Ann Lowenthal, since issued as a handsome monograph.

Like most names of artistic movements, "Mannerism" was conferred by someone outside and hostile to the art produced. The term was snide in 1672, in the writing of Giovanni Pietro Bellori, whose views are canonical in the history of the Baroque, the movement that succeeded and superseded Mannerism as the international European style. It remains a useful pejorative for critics: Barbara Rose, in conversation with me, once dismissed something like 60 percent of living artists as "mannerist," which in her usage connotes inauthenticity. Authenticity, designating art as coming from the guts with the urgency that things coming from the guts frequently have, is an artifact of Romanticist aesthetics. Bellori perhaps meant the term to indicate artifice as against the "natural" or the "real," so "mannered" would be the kind of appearance that contrasts with the Natural Look in the language of cosmetics, which, applied to art, captures the meaning of *maniera* perfectly. Mannerists flaunted artifice in the century of their dominance (from about 1520 until 1620), as well as elegance, exaggeration, virtuosity, grace, willfulness, sophistication, preciosity, affectation, and caprice—all the things late Romantics despise. I suppose the term "camp," rendered mainstream in the famous essay by Susan Sontag, captures a substantial subsegment of Mannerist attributes. Irving Penn's 1950 photograph of his wife, Lisa Fonssagrives, in a Lafleurie dress, illustrates precisely what the human and especially the female body should look like under Mannerist criteria: she seems a product of Eve and serpent, spectacularly attenuated and tall, and wearing a smirk of metaphysical contentment that in her fortunate case swank has triumphed over physiological possibility. The *Vogue* model of Penn's prime was sufficiently a Mannerist paradigm so that when we realize how many painters of the sixteenth century were painting elongated and skinny figures, the temptation to explain El Greco as having painted the way he did through a particular astigmatism should completely wane: he painted in the *maniera* of Mannerism.

The scholar Arnold Hauser identifies Mannerism's beginnings
with a painting by Raphael called *Fire in the Borgo*, which reverses the
convention of foregrounding the most important figure and making it
larger and more central than the remaining figures. In Raphael's paint-
ing, the chief figure is the Pope, who, standing in the far distance
across an immense piazza, extinguishes a fire with a pontifical gesture.
His power is inversely proportional to his size in the painting. The
largest figures are proportionally the most impotent: the foreground is
occupied by large and athletic nudes endeavoring to climb a wall that,
from its looks, they could just walk around. Mannerism, however, was
always a strategy of reversals and surprising interchanges: Michelan-
gelo, in his design for the Laurentian Library, buttressed the door-
frame, which in any case needed no buttressing, with immense volutes,
whose proper architectural function was in holding up the cornice of
a building: they have no business on the floor. But the placement of
the narratively central figure in some inconsequential sector of the
pictorial space became a Mannerist mannerism. The "Old Masters"
Auden says were never wrong about suffering, in his great poem "Mu-
sée des Beaux Arts," had to have been Mannerists. The central figure
in Bruegel's *Fall of Icarus* is a barely discernible dab of white paint,
easy to overlook. In the same artist's painting in Vienna of the *Con-
version of St. Paul*, what occupies the foreground and takes up most
of the space are the hindquarters of an inconsequential horse, mounted
by a figure of no importance to the event, which takes place far up the
line of horsemen, in the middle distance. It remains an art-historical
problem to locate the bridegroom in Bruegel's *Peasant Wedding* (can
he have gone off for a pee?).

The dominating figure, visually, in Wtewael's *The Baptism of
Christ* is a typical mercenary soldier of the sixteenth century, dressed
in extravagantly slashed silks, with feathers in his improbable hat. He
appears to be dancing, or has been stopped in the act of dancing by a
drummer on the ground, who has grabbed one of his feet, perhaps
because dancing is not suitable to so awesome an occasion. A half-
reclining figure, his back to us, is stripping off his shirt, preparing
perhaps for his own baptism. At the far left stands an Oriental figure
in turban and scarlet robes, to suggest the Holy Land. John the Baptist,
in the middle distance, is enthusiastically dousing Jesus, who looks
pale and pudgy. All sorts of figures in Flemish garb lounge along the
banks or are shown climbing trees, and the sky is filled with angels.
A Roman ruin stands in severe perspective against what looks like a

typical Flemish tavern. It is as though the distinctions between past and future, Flanders and Canaan, Jesus and the man next door, have been obliterated or fused. In Wtewael's *St. Sebastian* at the Nelson-Atkins Museum in Kansas City, the tender martyr is being winged at with a crossbow in the hands of an elaborately ribboned mercenary of the sixteenth century. Wtewael's opulent *Marriage of Peleus and Thetis* (at the Rhode Island School of Design) records the last time the gods sat down to table with humans, and it is quite beyond description. Wtewael's paintings are so filled with wild contrivance, operatic gesture, and historical incoherences, painted with the glassy luminosity of fused enamel, that one feels one can almost infer the mentality of the audience that received them with pleasure. It was doubtless an urbane and possibly a courtly audience, but one must remember that Wtewael and Shakespeare were almost exact contemporaries, and the Shakespearean world of mad coincidences and magical affinities delighted a very popular audience. It helps, in learning to appreciate Mannerist painting, to recognize that the Mannerist sensibility is precisely Shakespeare's.

In any case, I was so excited when I learned that the Philadelphia Museum of Art had acquired a masterpiece of Dutch Mannerism—a rare and eccentric work by Hendrik Goltzius, also an almost exact contemporary of Wtewael—that I put everything aside in order to travel to see it and the show that the museum organized to give the work a context. It is entitled *Without Ceres and Bacchus, Venus Would Freeze*, and it is in a medium Goltzius made his own if not invented—namely, an ink drawing on primed canvas. The choice of canvas may have been dictated by the fact that paper did not come in sheets sufficiently large to accommodate his graphic ambitions. It is carefully designated as a "pen work" by the show's curator, Lawrence W. Nichols, to indicate that it is something more than a drawing in pen and ink. It is quite large—41⅜ inches by 31½ inches—and the combination of scale and technique could not be more Mannerist in spirit. It was clearly intended to amaze as a kind of wonderwork, and to belong through natural affinities with the other wonders in the *Wunderkammer* of Rudolf II, the most energetic collector of his age. Goltzius did a number of pen works on the same theme, including one in which the figures are nearly life-sized which has been lent by the Hermitage for the Philadelphia show. The show, which illuminates Goltzius's impulses and achievements, will soon close in Philadelphia, but *Without Ceres and Bacchus, Venus Would Freeze* will remain on permanent display and is suffi-

ciently astonishing in its own right to merit the trip. So many of the great works that have come onto the market in recent years have gone into private hands that it is a matter for celebration that so great a work should have been acquired by a public museum. (The Philadelphia's unparalleled gallery of Duchamps comes as close to a *Wunderkammer* as may be wanted for the Goltzius to feel at home as well.)

The title of the work sounds like a humanist's paraphrase of some gutsy Dutch saying into the idiom of mythology—the kind of riposte a down-to-earth Amsterdamer might make to the claim that man does not live by bread alone or, in case there were peaceniks abroad in the lowlands, that all you need is love. "Love needs bread and wine in order to burn" is something we can imagine a tubby cavalier saying to his amply proportioned companion as they wave goblets in each other's direction over the plate of oysters and the roast pig, preparatory to climbing through the bed curtains. (Only a few years later, styles shifted, and the Dutch, through some cultural decision it would be interesting to understand, wanted themselves depicted as ruddy and fleshy, as if they had spent their lives stoking the fires of love.) In fact, the title comes from a line in a Roman comedy of 161 B.C. by Terence—*Sine Cerere et Libero friget Venus*—where it is implied that it was an adage even then. In the sixteenth century, it gave artists a theme in which they could show three agreeable deities, one of them emblematically naked, and find a way of conjoining Venus with flames, making possible a sort of lubricious association we find later in some naughty erotica of Fragonard. The Philadelphia Goltzius shows a half-reclining Venus, still half asleep, being peered at by a horned Bacchus and an androgynous Ceres, each bearing fruit. She is indolently fondling the wing of a mischievous Cupid, who looks out toward us and holds his bow behind his back as he raises a flaming torch with his right hand. It casts a ruddy glow over the figures, and especially over Venus's face and lank torso. What is astonishing in the way the color is applied is that Venus gives the appearance of thawing, of turning from ice to fire before our eyes. Ceres and Bacchus have brought the fuel Venus needs to flame forth in love. I will return to my description after discussing the execution of the work—without ink and pigment, art freezes.

An ink drawing on primed canvas, especially on a large canvas, was an unusual enough medium at the time that it seemed to involve an almost superhuman virtuosity. In part this was because the extremely intricate drawing was done freehand, and in part because it

was believed irrevocable: the slightest mistake and all was ruined. There was no room for erasure, or painting over, but only a single sustained act of assured penmanship across a considerable surface. There are four large figures, each with an elaborate coiffure and vibrant facial expression, and a great deal of foliage, as well as fruit, fabric, smoke, and flame. But the wonder does not stop there. The ink line looks like an *engraved* line, so that the painting as a whole has the look of an ambitious print. If one understood why an artist would wish to disguise the freely executing line of the pen as if it were mechanically inscribed with an engraver's tool, there would be little more to Mannerism to understand. It was a style Goltzius used over and over: There is a virtuoso drawing of a right hand (perhaps his own) in the Philadelphia exhibition, with the regularly parallel hatched and dotted lines of an engraving. My sense is that one explanation for the pen line's simulating an engraved line is to make the drawing seem even more confident, since the correction of a system of cross-hatching would be especially difficult, all the more so if the lines go uniformly from thin to thick to thin again, as when the burin responds to the engraver's pressure. Note that the free and brushy style of a Rembrandt drawing does not invite the thought that one mistake and all is ruined: Rembrandt just left his mistakes intact, or brushed over them. Goltzius's was a specifically ornamental and patterned form of drawing. (It would have been even more Mannerist, I suppose, had he used the brush to emulate the drawn line emulating the engraved line.) It might also, though I am uncertain to what degree this could have been a factor in the era, have served as a protection against counterfeiting, the way an engraver's flourishes on a banknote are supposed to do. But in addition to the drawing there is painting on the canvas, and it becomes a challenge to the eye to determine where drawing stops and painting begins. There are various oranges, yellows, and reds—flame colors—differing in intensity as a function of the proximity of the surface to the flame of Cupid's torch. The flame itself, rising in sinuous curves up the right edge of the canvas, is pure virtuosity. For example, we can see the shoulder of Ceres's garment through the flame. The work really is a wonder, and has the kind of magic that reinforces its affinity with the company of strange objects in the *Wunderkammer*. (The art museum as such had not yet been invented.)

Having fully savored the great craft and power of Goltzius's hand, the *eruditi* of Rudolf's court would strive to interpret the work, a task I am certain is quite beyond us today. Here is only the most superficial

level in a stratified reading. Venus has lain frozen (in the fashion, we might say, of a reptile, which has no body heat of its own and is dependent upon external sources for a body temperature that enables it to be active). Bacchus and Ceres are here to arouse her, and their faces are merry as they offer restorative nourishment. Venus's eyelids are still half closed, but she is awake enough to touch Ceres's shoulder, as if to lower her dress, and to fondle Cupid's downy wing: she is already her sensuous self. Cupid is looking over his shoulder for a suitable victim to shoot his arrow into, once Venus is warm enough for him to put the torch down and take up his bow behind him: Venus will need a lover when her temperature reaches normal. But what is the next level of interpretation? And what the level below that? Art in the Rudolfine precinct has a Rosicrucian complexity of secret meanings within secret meanings. In the St. Petersburg version, Venus is fully awake and is making eyes at Bacchus, who teases her with grapes while naked Ceres lolls against his knee. Goltzius has drawn his own portrait in this pen work, as if to attest to the veracity of what else he has drawn, since his immediate patron will know what he looks like, and can thus check the drawing against reality. The Philadelphia work strikes me as the superior, not so much because of the naturalness of the expressions—what has naturalness to do with Mannerism?—but because of the luminosity, the dazzlement, the compactness of interlocking gesture. Because so many of the works in the show are smaller drawings or engravings, you can get a pretty good idea of things by getting hold of the Winter 1992 issue of the *Bulletin of the Philadelphia Museum of Art*, where everything is illustrated and much is explained and analyzed in Nichols's fine essay, which takes up the entire magazine. But it is simply impossible to form an adequate idea of *Without Ceres and Bacchus, Venus Would Freeze*. For that you have to experience the work itself and respond to its cunning and craftiness. Each of the substances drawn—hair, wing feathers, flesh, pearls, fire—is a miracle of drawing and an artistic joy, however little you may know of the circumstances of so curious a work. But neither can you experience it without then wanting to know those circumstances. Just as Shakespeare says about another transformation, nothing in ink and pigment but "doth suffer a sea-change / Into something rich and strange."

The Hood Museum of Art at Dartmouth College has organized an exhibition I'm not sure I will be able to see but which will have venues this year in Houston, Raleigh, and Atlanta and is called "The Age of the Marvelous." It undertakes to reconstruct a *Wunderkammer*,

with volumes of that kind of lore Prospero so cherished, as well as optical illusions, stuffed birds, statuettes, objects of *virtù*, and geological specimens. I should imagine there would be the obligatory narwhal horn, as well as the mandrake root, an ostrich egg, perhaps a coconut, that most mysterious of fruits in sixteenth-century eyes. In an engraving from the catalogue, reproduced in the only account I have seen of the Age of the Marvelous, we see an interior with a half-round vault from which are hung all sorts of strange creatures, including a mummified or stuffed crocodile, upside down. Some gentlemen, wearing costumes of the sort we see in Wtewael, point in amazement at various curiosities. It is the sort of ambience for which Goltzius's masterpiece was conceived, and upon which it drew for its magic and to which it returned a magic of its own. It was never meant for the disinterested aesthetic gaze. To experience the work properly requires us to think of it less as a work of art with affinities to other works of art than as a marvel with affinities to other marvels, artificial and natural and supernatural.

—*The Nation*, February 10, 1992

Whatever Happened
to Beauty?

IN EARLY FEBRUARY, I spent a weekend at the University of Texas, invited there to consider, in the company of artists, critics, historians, and philosophers of art, the question "Whatever Happened to Beauty?" The brochure publicizing the conference described a kind of shift in recent artistic direction, from the active pursuit of beauty to its disregard or even repudiation, as artists turned their energies in political rather than aesthetic directions. This has certainly been the steady complaint of politically conservative critics, who insist, pretty much against the entire history of art, from the Pan-Athenaic frieze and the Dying Gaul through David, Delacroix, Goya, and Manet, to Maya Lin's Vietnam Veterans Memorial, that politics has no place in art. And this shift figures no less prominently in the agendas of radical critics as well, who have undertaken to demonstrate that art has been subversive where it appears to be most purely aesthetic—in the images of the Impressionists, for example. We were in any case to take these matters up, as well as such questions as whether there is an incompatibility between aesthetic pursuit and political engagement.

I wish that in preparing my own contribution I had remembered something the painter Brice Marden said in the course of an interview with his peer Pat Steir: "The idea of beauty can be offensive. . . . It doesn't deal with issues; political issues or social issues. But an issue that it does deal with is harmony." For I would then have realized the degree to which social and political issues are today framed in terms of disharmony, of strife and conflict and confrontation, when in truth the great political visions have been precisely of the harmonious society, and it would be difficult to think of a more exact criterion of political

health than harmony. I might then have proposed that every beautiful work can be viewed as an allegory of political well-being, and disharmonic work as allegorical of social pathology. Instead, I used as my paradigm Robert Motherwell's *Elegies to the Spanish Republic*, inasmuch as they were incontestably beautiful and also had an undeniably political content. To be sure, one elegizes only what is beyond help because dead, and while it is interesting to speculate on why beauty seems our spontaneous need in the presence of loss—why we bring flowers to the graveside, or play music at the memorial service—one is left wondering whether beauty has any place at all when one employs art to change rather than merely lament a political reality. Whatever the case, my example suggested the possibility of an internal connection between beauty and meaning, and that had some philosophical promise I hope to develop on some other occasion.

It was a stimulating conference if an inconclusive one; but it was not until I was back in New York that it occurred to me that something has indeed happened to beauty, though not for the reasons that formed the framework of our discussion in Texas. I don't think the opposition between aesthetics and politics, if there is one, quite accounts for beauty's predicament. What accounts for it instead is a kind of cultural convulsion we have been living through, in which beauty seems all at once irrelevant to the aims of art rather than antithetical to the aims of politics. It is a convulsion in what one might term the deep structure of cultural history, of which the bickering between conservatives and radicals is at best a surface manifestation. I think I had a certain sense of the onset of a convulsion when, in the early 1980s, I responded to the work of Julian Schnabel and David Salle with a kind of historical puzzlement, as if it interrupted rather than continued the narrative of Modernism—as if, really, it had no internal connection with what came before it. This was not what was supposed to happen next. And in 1984—that allegorical year!—I expressed my malaise in an essay called "The End of Art." Thanks in part to the Texas conference but also to a felicitous constellation of recent exhibitions, I think I have a clear understanding of what Schnabel and Salle portended: they were, I now see, part of something much larger than I was able to appreciate at the time, and it is this larger event that I am calling a convulsion in culture.

A week after returning to New York, I attended two openings for artists whose new work would have encouraged this reply to the Texas question: Beauty is alive and well on Fifty-seventh Street. These were

shows of Robert Mangold (at the Pace Gallery) and Dorothea Rock-
burne (at the André Emmerich Gallery). It is striking that both artists
refer to classical motifs: Mangold explicitly terms his work *The Attic
Series*; Rockburne's is a nuanced response to experiences of Rome,
particularly the oculus in the Pantheon's extraordinary vault, which
transforms that vast space into a kind of observatory. I suppose there
might be moments when the circumference of the sun exactly matches
that of the oculus, when the opening becomes a luminous disk—or a
section through a column of light that rests on the floor, as if some
divine visitation. In any case, Rockburne's paintings appear to connect
sun and oculus in patterns of epicycles along sweeping orbits, circle
upon circle, so that the entire pattern feels like a notation for celestial
harmonies. The colors are those of rare stones, jasper and malachite,
onyx and travertine, opal and alabaster. Bars fall across fields of color
like shadows on the floors of churches. Her last show consisted of large
geometries in flamboyant colors and embodied a certain tension be-
tween austerity and abandon. She has not forsaken her mathematical
impulses in the new work but has somehow lyricized them.

And Mangold's new paintings also mark an evolution in thought
and feeling. A few years ago he was showing paired but unmatched
parallelograms with crazy corners and brindled surfaces, and interior
forms, either drawn ovals or cutouts of eccentric parallelograms that
refused to echo the irregular shapes that contained them. The new
works are large, single rhomboidal shapes, with monochrome surfaces
in rich colors, rolled on rather than brushed, but more densely and
somehow more deeply than before, so they seem to coruscate. Interior
to each surface is a single form, some variation on an ellipse, diagonally
spread from corner to corner, sometimes twisted into an elongated
figure eight, sometimes actually divided into subellipses, sometimes
regimented into symmetrical triangles with a common vertex.

Both these shows—intense, ordered, humane, exultant, *beauti-
ful*—are by painters at the peak of their strength and invention, and
they lifted the spirits high enough to be palpably lowered by the ex-
hibition of contemporary drawing at the Museum of Modern Art, in
which beauty seems altogether beside the point. It is the difference in
the art of these three exhibitions that makes the urgency of the question
of beauty somehow existential. Entering the MoMA show is like a fall
from grace, almost literally so as one descends to the museum's lower
level on an escalator, along the path of which are hung Keith Haring's
subway drawings of 1982, white chalk on black paper. Haring's draw-

ings have a charm and even radiate a certain goodness, but they punctuated the shift from Greece and Rome in golden ages to Manhattan in the Reagan years, from sunlight to the netherworld, and they fix one abruptly in the present. Of course, Rockburne and Mangold belong to the present too. But the juxtaposition of the shows suggests a complexity in the present that I am anxious not to see dissolved away by talk of a benign sort of pluralism. Rockburne and Mangold stand in a certain continuity with a past that unites them with classical antiquity, with marble forms and cadenced architectures, with clarity, certainty, exactitude and the kind of universality Kant believed integral to our concept of beauty. With certain exceptions, the assembled drawings in the MoMA show exist in discontinuity with that past, and possibly repudiate it. It is the great merit of the show that it makes this discontinuity vivid and moves one to ponder the convulsion made as manifest as the spikes on a monitor do the fierce collisions in a particle accelerator underground.

MoMA's exhibition does this in large part because the same curator, Bernice Rose, mounted one in 1976 called "Drawing Now," and I think nothing in that earlier show would have enabled one to anticipate what was to happen in the visual arts over the next fifteen years. The difference is reflected even in the titles. "Drawing Now" has an indexical clarity that went perfectly with the kinds of drawings Rose had assembled, which collectively expressed a certain conceptual severity, a cleanness and purity and absoluteness that have all but vanished from contemporary sensibility. The title of the new show is "Allegories of Modernism," and it belongs exactly with the kind of language that entered critical discourse about the time the earlier show went up, but too late to affect either the art or the way people thought about it or described it. This is the discourse of deconstruction, postmodernity, textual metaphysics, of conceptual archaeology, of art as *écriture*. Rockburne and Mangold were included in the earlier show, and their work today belongs to the spirit of it: even the Pop Art then was analytical and somehow Minimalist; many of the works had the look of theorems given graphic embodiment. Only three artists from there survive in the present show: Sol LeWitt, Bruce Nauman, and Brice Marden, whose work alone, or almost alone, would provoke a judgment of beauty. The only earlier artist not included who might still have felt at home in the new show is Robert Rauschenberg, whose work had a layered look, with images torn from advertisements given a narrative role to play in a scrapbook sort of space composed of polyglot

forms and scribblings. Rose's new effort has been criticized for including exactly those artists who are exhibited over and over again in all the big international shows: the large subset of American artists in it compose a mini Whitney Biennial. But this in fact is the show's strength. We are not dealing with the work of marginal figures but with mainstream art; and only because it is so massively mainstream is the contrast so acute between today and 1976. Only a reconstruction of the earlier show, run alongside "Allegories of Modernism," would have made the situation clearer. That way everyone could meditate on historical discontinuity. All one has to do is consult the earlier catalogue to see that we are in very different territory. Whatever happened to beauty happened sometime between 1976 and now.

Allegories are texts—verbal or visual—whose interpretation requires mastery of some symbolic code. The impulse to allegory is to tell one story through another, to reveal a meaning through another meaning. I think it may give a false unity to the MoMA show to suggest that each of the drawings is an allegory of Modernism, that Modernism is the oblique subject of the works or that these are all art about art. That would make Modernism the motif of this show if the substance of the previous one; "Drawing Now" would then be what the new work is about in some deflected way. This may be true for some of the works—but since the remainder seem to participate in much the same aesthetic, it is the aesthetic that requires elucidation. In fact, "allegory" is itself an allegory, adopted to draw attention to the multiple levels on which each of the principal exhibits exists. As such, it is borrowed from an important text by the brilliant critic Craig Owens (who died tragically young from AIDS) published in the journal *October* on the cusp of the new era. Owens writes that an allegory is "one text . . . read through another, however fragmentary, intermittent, or chaotic their relationship may be; the paradigm for the allegorical work is thus the palimpsest." (It is clear from this why Rauschenberg almost uniquely from the earlier show belongs to the spirit of the new one.) Owens cites Walter Benjamin's observation about the propensity to "pile up fragments ceaselessly, without any strict idea of a goal." He speaks of the "blatant disregard for aesthetic categories." He speaks of "hybridization" and of the "confusion of the verbal and the visual." These fragments from an essay on fragments almost constitute a critical review of the present show. If we add to them a thought expressed by Hal Foster in a 1984 volume, *Art After Modernism*, in which Owens's essay was reprinted, we almost get the connection curator Rose's title

implies: "Purity as an end and decorum as an effect" are things that "Modernism privileges." What the present work privileges is instead impurity and the indecorous. Owens speaks of "the fragmentary, the imperfect, the incomplete" and of works so characterized as having an affinity to "the ruin." Rose's thought is this: Modernism itself lies shattered into fragments, an artistic ruin. But since these works consist of fragments, they compose allegories of Modernism—"a new vision of the real."

The answer to "Whatever Happened to Beauty?" can perhaps be seen in part in the work of Sigmar Polke, the German artist we encounter in the first gallery of allegories, having completed our descent. There are six large drawings by him, five of them titled *Untitled*, plus a seventh very large drawing—about ten by fifteen feet—with the title *Motorcycle Headlight*. It is a very crude drawing, on brown wrapping paper, of a scary face with handlebars set against a sunburst of flying limbs. The paper looks as if soaked in grease, and it is held together with yellowing stretches of cellophane tape. "A conservator's nightmare," my companion murmured. "A nightmare," I conceded, echoically. It has the appearance of a Hell's Angels banner designed by a biker high on amphetamines and commanding zero degree of draftsmanship. But in fact almost all the drawing in these works is demotic, the kind that finds its way into tattoo parlors, prison wall graffiti, leaflets advertising garage sales. In the untitled works, several such drawings occur, assembled expressly not to cohere, sometimes occluded by wipes of paint. I freely admit to having problems with Polke, among them the fact that so many whose opinions I respect admire him extravagantly. John Baldessari ranks him with Giotto and Matisse in a pantheon of three. Last fall there was an immense Polke retrospective at the Brooklyn Museum, which I attended in the company of three of his enthusiasts, two of them German. A woman, hovering by, could not help but overhear our discussions and said, "You gentlemen seem conversant with art. Can you tell me something about this artist?" Rainer Crone, who is professor of modern art at Munich, replied with fervor, "He is unquestionably the greatest artist in the world." I remain unmoved. Peter Schjeldahl has written, "To learn more and more about him . . . is to know less and less." So perhaps I have learned too much.

Polke was born in 1941, and it is possible that the aesthetic of ruin derives from childhood trauma in a shattered land. It is also possible that, in the older spirit of Dada, his art is an indictment of

the values of those responsible for the ruination of World War II. But that cannot explain the immense influence he has had on the artists who make up the majority of "Allegories," each of whom seems like a retranscription of Polke: derisive, sullen, hostile, punk. Demotic drawing almost defines the contemporary style, something at the intersection of crude cartooning, boilerplate illustration, and graffiti—charmless, expressionless, flat, mechanical, smeared, logogrammatic. To be sure, there are exceptions, but I am referring to those drawings that satisfy Owens's criteria, that are allegories in the sense Rose has appropriated: anti-aesthetic, palimpsestic, fragmented, chaotic, layered, hybridized. It is this that marks the convulsion I speak of, and there is more to it than this. Anything that explains the emergence of this form of art in the 1970s and its explosive proliferation through the 1980s also has to explain the kinds of critical theory that accepted, justified, and celebrated it. Hal Foster, in the essay I mention, speaks of the impact on American art writers of texts that began to appear in translation in the late 1970s: Baudrillard, Walter Benjamin and the Frankfurt School, Barthes, Foucault, Derrida, Lacan, Continental Feminism. In some way that parallels the art, these texts are marked by radical discontinuity, fragmentariness, obscurity, mock technicality. The writings belong together with the art they were used to interpret. The style of indignant incoherence, which characterizes the typical art writing of our era, is as much a product of Polke and Baudrillard as Attic tragedy was the offspring of Apollo and Dionysus.

The great value of the MoMA show is that you can see what happened to beauty, and set about trying to find an explanation. It is also possible that it is a mirror of our times—and since we have to live them, it is perhaps valuable to see them reflected in art. So in a sense the title for the show is appropriate: it is a lot more than simply what is happening in drawing now; the art is an allegory of the age.

—*The Nation*, March 30, 1992

Andrea Mantegna

ANDREA MANTEGNA'S name turns up in an exceedingly short list of what Ariosto's readers would recognize as history's greatest artists, in the opening verses of Canto XXXIII of his *Orlando Furioso*. It would be essential to the poet's argument that the artists cited be as great as possible, since he wants to claim that there are things even the best of them cannot depict—namely, the shape of things to come. For that, he argues, there must be recourse to magic. It is, in any case, plain from the fact that Mantegna is mentioned in the same lyrical breath as Leonardo, Michelangelo, and Raphael, not to mention Zeuxis, Parrhasius, and Apelles, that he must have been held in the highest esteem some twenty-five years after his death. His reputation was no less luminous during his lifetime: Innocent VIII considered him the greatest painter of the age and pressured Mantegna's patron, Francesco Gonzaga, to release the artist long enough to decorate a chapel in the Belvedere. Notwithstanding this deservedly exalted reputation, Mantegna was early stained with a clever and slyly malicious piece of art criticism that has clouded the perception of his work ever since. Its author was Francesco Squarcione, Mantegna's teacher and adoptive father; and it was occasioned by some youthful work of Mantegna's in the Chapel of San Cristofano in Padua. Squarcione said, "They had nothing good in them because Andrea had therein copied from antique marbles, from which no man can perfectly acquire the art of painting, seeing that stone must ever retain somewhat of the rigidity of its nature, and never displays that tender softness proper to flesh and natural forms." Vasari, who reports this, also tells us that Andrea had formed an alliance with Jacopo Bellini, Squarcione's archrival, putting the

latter's nose seriously out of joint, though he had "previously much extolled the works of Andrea." The epithet of stoniness, even so, has defined Mantegna criticism down the centuries. "It is as though Mantegna had been called to paint a people turned to stone," wrote J. A. Symonds in 1882. "The painting of Mantegna's maturity has always this frozen, rock-like force," writes Lawrence Gowing in the catalogue to the current exhibition of the artist's work on view at the Metropolitan Museum of Art. The stony stoniness of Mantegna—Squarcione's gift to his ingrate foster son's critics, from Bernard Berenson to the reviews of this very exhibition in London's *Times Literary Supplement* and *The New York Times*—is the recurrent explanation of why writers, despite their admiration for and acknowledgment of the master's achievement, find they cannot respond to it with warmth and delight.

In fact, Vasari tells us that while Mantegna was "deeply wounded by these disparaging remarks," they proved of immense benefit to him, for he then took up the practice of drawing from life with such intensity that "he proved himself no less capable of reproducing and extracting the best parts from living and natural objects." For me it is almost inconceivable that any of the writers who had the opportunity to visit, as Symonds, Berenson, and Gowing certainly had, Mantegna's most famous work, the *Camera degli Sposi* (*Bridal Chamber*) in the Gonzaga Palace in Mantua, should persist in this hardly applicable characterization of the artist's style. The *Camera*, which I once bribed a custodian to allow me to remain in alone for half a day, is so dense with lived life, so radiant with the spontaneity of human expression, that it is like a window into the everyday reality of the Renaissance. The room is in part an exercise in trompe l'oeil architecture—the first, I believe, in the Renaissance, with painted pillars and illusionary vaulting. But amid this, the scenes he depicted of the Gonzaga court seem to be taking place in a radiant space so compelling that it really feels as if conjured up through Ariosto's magic. In one famous panel, we see members of the family gathered in a garden. An adorable little girl in a headband leans on her mother's lap, asking permission to eat an apple. The mother is distracted by a secretary who has entered, stage left as it were, to whisper news to her husband, evidently that their son will soon arrive, having been elevated to the rank of cardinal. The Marchese holds the letter in which this important information is conveyed, and it seems clear that the momentous arrival is what the family is awaiting. There is even a female dwarf seeming to look out to catch a glimpse of the approaching scion. On another wall, we see the reunion: the

newly confirmed cardinal, proud and yet affectionate, holds hands with a younger brother who holds the hand of a still younger brother in a tender clasp. On the other side of the door, respectful retainers hold back the family dogs. Though the frescoes are not in the best of condition, I left the room with a sense of lightness hardly consistent with having spent my time with men, women, children, and dogs of stone; and I walked out into the open spaces of Mantua with the feeling of being still in the scene I had left behind. There is no doubt a dignity and an austerity in Mantegna's articulation of his vision—but his characters could not be more alive, or more caught up, palpably, with the events that shape their feelings, fears, and hopes.

Visitors to the present exhibition, alert to Mantegna's standing as among the greatest masters of the early High Renaissance, will of course recognize that there is no way other than a trip to Mantua to see the Gonzaga family in life and triumph, though a colored blowup of a fragment of the marvelous decoration is mounted at the Met show's entrance, raising, perhaps, hopes and expectations that the somewhat cobbled exhibition fails to sustain. None of the famous and familiar masterpieces made the trip either—not the *Agony in the Garden* from the National Gallery in London, not the *St. Sebastian* from the Louvre, nor the overpowering, starkly foreshortened *Dead Christ* from the Brera in Milan. This is the price we pay for Mantegna's eminence: his masterwork is not lightly dispatched to distant gallery walls. The finest painting in the show is one that has been here since 1932, the Met's own *Adoration of the Shepherds*, from about 1450. One can get an exact sense of Mantegna's style from that work alone, inasmuch as he had evidently no reason to change it for the remainder of his life. My recommendation to visitors to this show is that they spend some time letting this brilliant panel work upon their sensibilities, to allow a model to form in their own aesthetic imagination, which will guide them through the often rather minor or marginal works in which the fierce clarity of Mantegna's nearly shadowless world is more dimly present. In a famous passage in the *Republic*, Plato speaks of one who has struggled free from the cave that represents our earthly existence, but whose eyes are still too filled with darkness to gaze upon the Forms of things in their true luminosity. Such persons must look at the reflections of the Forms until their eyes adjust to the light. Here the situation is rather the reverse: one must stare into the blaze of Mantegna's authentic vision, as we find it for example in the *Adoration*, in order to discern its pale and secondary presence in works that have

been abraded, or badly restored, or which are secondary to begin with, or eccentric in some way, like the feigned bronzes of this show. There would, I think, be no accounting for Ariosto's exaltation of the artist on the basis of much of what one may see here.

By contrast with the spotty representation of Mantegna's paintings, there is an exhaustive array of engravings by or attributable to Mantegna, and the actual occasion for the entire exhibition is the rather rarefied issue of which plates are directly due to Mantegna, if any; and which hand or hands of other, lesser artists may have executed his designs. This portion of the show is beyond question a contribution to art-historical scholarship in its most exacting practice. Printmaking is a two-stage process (unless the artist works directly on the plate or block): there is the drawing stage, and then the stage in which the drawing is cut into the plate or block. This exhibition shows every engraving for which Mantegna was the first-stage artist, the question being when and in what way he may have been the second-stage artist as well. Opinions vary. The conclusion reached by the curator responsible for this part of the exhibition is that there are seven engravings in which both stages were executed by Mantegna and four more "attributable" to him, meaning that he may have achieved the second stage in whole or in part. The remaining prints are deemed the work of someone hedgingly designated the "Premier Engraver," the second-stage executor of Andrea's designs. Whether there really was only one such person is perhaps a bone of contention, but the discussion of the entire matter seems to me to rest on some assumptions questionable enough to take up here, though clearly one ventures onto the playing fields of connoisseurship with some trepidation.

The assumption is that it is somehow inconsistent with an artist's holding high rank that he should have himself undertaken "the time-consuming work of engraving the plates." Yet painting itself was pretty time-consuming work in the Renaissance, when artists did not live by the clock and charge by the hour. And second, "time-consuming work" sounds like irksome labor, perhaps like grounding panels with gesso or grinding pigment; in any case, it takes as its contrast, I suppose, a rather romantic conception of the artist as constantly and urgently expressing himself creatively, which hardly applies, I think, to even the most spontaneous thing artists in the Renaissance did—namely, drawing. In the third place, among scholars who I'll wager never handled a burin or made a print of any kind, there is little sense of how immensely absorbing the making of prints can be: the decisions that must

be made at every instant are as complex as any that arise in connection with painting, and while no doubt "time-consuming" work, print-making is art making as intense as any. Finally, the argument is made that "the early Italian engravers are artists of secondary importance, craftsmen who never had the same status which was held by the painters, sculptors, and architects, in the society of the time." What this overlooks is that while Mantegna did not precisely invent line engraving as an art form, as Vasari first proposed that he did, he is universally acknowledged to be the first Italian artist of genius to have practiced engraving as an art. And whatever may have become the case once engraving was widely practiced and institutionalized as an art form (in part because of its expressive possibilities and in part because of its economic advantages—Dürer, in the next century, complained when he took painting commissions, which were nowhere near as profitable as the sale of prints) need not have been so at the beginning, when the form was being invented. A nice thing about prints is that they can be done on spec, without having to negotiate the sorts of contracts frescoes or altarpieces required, or to get down payments for materials. (Andrea seems to have been concerned about money, since he sometimes painted major works with cheap materials, like distemper, in which glue or some other such sizing is used as binder: his celebrated *Triumph of Caesar*, because in distemper, has badly survived time and efforts at restoration, and was deemed far too fragile to travel from the London to the New York venue of this show.) The real dog work of the print studio is the inking and the wiping of plates, and the heavy work of pulling proofs. One can see how a master might leave that portion of the process to lesser hands. The authors of the careful taxonomy of states and stages of engravings may be right, but their arguments strike me as suspiciously a priori and sometimes downright anachronistic.

None of the sorts of issues that give rise to the notion of the "Premier Engraver" is likely to lift the hearts of viewers who came to see a show of Mantegna, unprepared to plunge into the precincts of fine discrimination; and though the prints are somewhat segregated in anticipation of this foreseeable lack of enthusiastic acceptance, without them the main body of the show is merely a somewhat scraped-together array of work that only in certain examples discloses the artist's power and the beauty of his images. Even more important, I think, is the fact that grouping so many prints together diminishes their power—they were never meant to be looked at from this sort of per-

spective. In truth, Mantegna is at his greatest in his engravings, which are something of a miracle. At the very least, had it been my show, I would have placed a blowup of one of the prints—*The Deposition*, say—at the entrance, in part because that would more truthfully advertise the main body of the show than the fragment from the *Camera*, but mainly because the enlargement of one of those extraordinary images would be even more compelling than the print itself. Let me attempt to explain why. Fifteenth-century engravings were not intended to be seen, framed and glazed, on a wall, and certainly not hung like specimens of something in regular rows. I surmise that they were placed on lecterns, as if to be read—a different, more intimate relationship with the image than that of looking at a virtual scene through a window in the wall, which was the standard way of thinking about tableaux. My thought is that an enlargement would compensate for the diminishing relationship in which museum exigencies require us to stand with regard to prints. In fact, the very idea of *The Deposition* enlarged, perhaps ten times, is simply thrilling, and would almost be too powerful to remain with for very long in the same room.

Engravings are said to have originated more or less simultaneously in Germany and in Italy sometime around 1420 (Mantegna's dates are 1431–1506). Thus, the first engravings were very nearly contemporaneous with the first letter press, and though there is a certain similarity of means between the two reproductive technologies, the way an image is transferred from an engraved plate to paper is very different from that through which it is transferred to paper from a block. The Chinese had block printing, but engraving, so far as I know, was an entirely Western invention. Most accounts locate the first engravers in goldsmith shops, and that makes a certain sense, since the ornamentation of metal surfaces through gravure has a long history, and would naturally fall within the goldsmith's practice. It is easy to speculate that there must have been some such device as rubbing color into the grooves and wiping off the surface of a piece of metal in order to get a clear perception of the pattern. The innovation came with the thought of transferring this color through printing to paper, where the metal surface becomes a means rather than the artistic end. It would not be obvious how this was to be achieved. With a relief print, such as woodblock, one can ink the surface and get a fair impression through light pressure. But with engraving (and, later, etching), the ink has to be drawn up out of the lines by very great pressure. The more ink a line holds, the darker and heavier the printing of it, which means that a

different mentality is required of the printmaker than of one who merely ornaments by means of engraved lines.

To "invent engraving" thus means having to create an entire system: plate, gravers, inker, ink, paper, press—what Heidegger calls a *Zeugganzes*, or "totality of tools." The tool, as Heidegger would say, refers to the plate and the plate to the paper and the press to the ink. It says something that the first engraved products were playing cards and virtually the first product of printing was the Bible. In any case, Mantegna's genius consisted in seeing, in what was at first a fairly trivial technology, the sublime medium of great art (the transformation of block printing to the point where a Bible could be envisioned was by contrast merely quantitative). Still, we must keep in mind the material understructure of what he achieved. One needed large copper plates (the fact that he used both sides tells a lot about the difficulty of getting these) and a suitably large press; and probably the scale of both was dictated by the maximum size of paper available. (Dürer, like the Japanese, made large prints by pasting small sheets together, but that requires special strategies of registration.)

The important consideration is that Mantegna was the first to see the medium of engraving as a process for art as great as was achievable through painting, or, to cite a medium highly esteemed in the Renaissance, intarsia. And indeed, he never did anything greater than his engravings. Let us consider, then, *The Deposition*. It is a large print, but it looks simply monumental. It is vertically marked by the stem of the cross, with two tall ladders leaning against the arm; and by a barren tree growing thinly out of the rocky shelf on which the Crucifixion transpired. It is horizontally marked by the arm of the cross, the plaque with INRI, the tiny platform for Christ's feet, and by the rocky shelf, populated by a fringe of spectators and mourners each about a third the height of the cross. Verticals and horizontals form a sort of scaffold within which the action of lowering Christ takes place. One man holds the corners of a sling that holds the inert body, which falls heavily onto the shoulders of a second man, while another, his arms upstretched, represents the third stage of the descent. Christ's arm hangs with the drama of dead weight, matched, in my memory, only in Michelangelo's *Palestrina Pietà*. Among the figures is Mary fainted, as the other Marys hold her head up, so that her body forms a curve; and it is almost as if the two bodies, flexed respectively by death and syncope, form arcs of the same tragic circumference. In the background, between abrupt crags that punctuate the desert floor, two figures stroll toward Jeru-

salem, a towered city on a distant hill. The sky is the white of paper, the far landscape drawn with single sharp lines.

The same platform of shale appears in the astonishing *Descent into Limbo*, where Christ is shown from behind, pressing toward the dark door of the underworld, toward figures who await him. Christ is clearly making an immense effort, walking against the moral grain of the universe, as if into a strong wind that whips his garment about him. Mantegna has invented fantastic demons to fly about the scene, two of whom, blowing horns, have shaken the portals of hell off their hinges for Christ to walk over. Against just the evidence of these two prints it is hard for me to see how critics can persist in speaking of Mantegna's humans "as if they were made of colored marble rather than flesh and blood," as Berenson writes, echoing Squarcione—proving that he has read Vasari, but not that he has looked at the art.

The same rocky shelf of the two engravings just described forms a natural podium for Mother and Child in the *Adoration*. It is approached, from the viewer's right, by two rather disreputable-looking shepherds, rough sorts altogether, barefoot and with torn clothing. The forward peasant somehow embodies Mantegna for me: his face is strong, lined and ugly, with bared teeth, and he could as easily be imagined slaughtering innocents as worshipping innocence. The Virgin rises like a flower above her sleeping infant, foreshortened as if in anticipation of the Brera's dead Christ, and she is shown in a posture of terrific complexity, adoring a being far greater than she who is yet utterly helpless and dependent upon her, unable even to turn over unaided. A river, in serpentine loops, flows past this marvelous scene, which figures approach across a plank bridge. The distant meadows are filled with sheep, the amazing sky with flocks of clouds. There is a miniaturist intensity in the clarity with which flowers are painted.

There is a lot to see, and more to write about than I have space for. The Met exhibition demonstrates that with a master like Mantegna—inventive, observant, powerful, fantastic—even a show made up of lesser works can be a revelation. You will have to work a little harder than usual to see it, but don't leave all the "time-consuming work" to the critic.

—*The Nation*, June 29, 1992

Eva Hesse

EVA HESSE was a pretty woman, a tragic figure, and a great artist; but the dark melodramas of her brief existence seem as little relevant as her diminutive beauty to the understanding of her art. She was a refugee from the Holocaust, the daughter of a broken marriage, and her mother committed suicide; her own marriage ended in abandonment and divorce. She died of cancer of the brain at the age of thirty-four. It is true that she came up in the art world at a time when the highest compliment a woman artist could be paid was that she painted (or sculpted) like a man, but she knew considerable triumph in the compressed few years between the time she found herself as an artist and her death—roughly from 1966 to 1970. She was saluted in *The New York Times* for being "at the outset of a brilliant career" when she had in fact already died. Hesse would make a natural subject for a novel if not an opera, with Sol Le Witt and Mel Bochner—her artistic mentors—together playing the role of Sarastro, no Tamino in sight, and a choral finale of enthusing critics, awed curators, and avid collectors. Instead, such are the critical sentimentalities of our age that she has been the steady victim of fictive interpretations that read her art as a transcript of her sex, her domestic unhappiness, and her various pathologies, all of which I count as yet a further dimension of her tragedy: she is the victim of those who insist on her victimhood. Her art is intelligent, surprising, vibrant, and funny; it is unlike nearly everything done before and like almost everything done since her bright appearance, for she was a total original and remains perhaps the most powerful influence on contemporary sculpture. Hesse would have found the disparity between her marvelous art and the martyrology

that occludes our perception of it absurd—a term she felt applied equally to her art and to her life. "I was always aware that I should take order versus chaos, stringy versus mass, large versus small," she told Cindy Nemser in a famous interview published in *Artforum* the month of her death, "and I would try to find the most absurd opposites." It was as though she wanted, desperately, to deliver the key to her work into our hands before the dusk of myth obscured its outlines. For those who love her art, the University Art Gallery at Yale must be a point of pilgrimage before "Eva Hesse: A Retrospective" comes down—although there is to be a second venue at the Hirschhorn Museum and Sculpture Garden in Washington.

There is a wonderful snapshot of Hesse, taken in May 1969, that tells the whole brave story. She is standing in front of her largest work, *Expanded Expansion*, which is about twice her admittedly small height. It must have been taken at the Whitney Museum of American Art, where the work was first shown in an exhibition called "Anti-Illusion," organized by Marcia Tucker and James Monte and considered the most important show of that season. The nearly child-sized artist is wearing a becoming polka-dot frock, but her face is swollen from the chemotherapy (she was still convalescing from her first operation). Hesse was as zealous about her looks as she was of her artistic reputation, and I was struck by the fact that in the video devoted to her in the Yale Gallery, she is almost always elegantly coiffed and wearing dresses, even in her studio, even when muddling around with gummy substances in vats. But she was concerned that her work not be perceived as pretty at all, and she went out of her way to achieve an uningratiating look. *Expanded Expansion* is made of a series of rather lumpy fiberglass and polyester poles, connected to one another with a curtain of latex-impregnated cheesecloth, and it has the look of a folding screen or room divider, though I am almost certain it would have been incapable of standing erect by itself, and it would be part of its helpless charm to collapse around itself the moment anyone tried to make it do so: it requires a wall to lean against, making it altogether incapable of discharging the screening function. Still, it might look like the imitation of a screen, and when asked whether this suggested an interest in decoration, she cried out, "I don't even want to use this term!"—linking it with its affines in aesthetic nomenclature: pretty, gracious, sweet, and the like. "It's so silly," she said, "and yet it's made fairly well," articulating exactly the kind of opposition she pursued, in this instance that between silliness and craft. "It can't be a whim, you

know. It's too considered." So there she is, a dying lady, still vain enough to want to look her best, ambitious enough to be present at a moment of triumph, standing before one of her most characteristic works—awkward, pointless, magnificent, "silly," unable to be anything but art. It is a very moving image.

Expanded Expansion, which must have begun to stiffen and discolor the moment it was made, is too fragile to have made the trip to Yale, though it was something of a miracle that so many works of comparable perishability have managed to keep the rendezvous. "She was very aware that it was temporary," her studio assistant Bill Barrette recently wrote. "She was not defensive about it," he quotes her colleague Doug Johns as saying. "She would say it was an attribute. Everything was for the process—a moment in time, not meant to last." You can take that as a metaphor for her life, but it is difficult to believe she meant it that way, for she wanted to live and believed she would live; her philosophy was that art is short and life is long, and she did whatever she could to ensure both. The fact that her flaking, cracking, stiffening works are among us while she is not is just a further footnote to her absurdism. It is quite wonderful now to be able to see so many works that have been available to us mainly in photographs, principally because they often look quite different than one would have anticipated. A case in point is *Hang Up* of 1966, which Hesse regarded as her first major piece—the "first time my idea of absurdity or extreme feeling came through." The title refers at once to the material circumstances of the display—it hangs on a wall—and to the sorts of neurotic difficulties a sculpture encounters when uncertain of its artistic identity. *Hang Up*, in any case, consists of two components—I suppose the concept of absurdity entails that there be at least two components whose concepts collide when one seeks to integrate them. One is a very large frame, bandaged with wrapped cloth painted gradations of gray, wound round and round as if by a somewhat inept mummifier. The other component is a long metal tube that comes out of the upper left corner and describes a large graceless loop in front of the frame, into which it disappears in the lower right corner. Neither of the components is up to much. The wrapping around the frame is lumpy, and the metal loop just seems on vacation. It looks as though it began with some serious project in mind, got only so far, and retreated to the security of the frame. I thought briefly of the two bums in *Godot*, wanting to make the best impression they are capable of, even though they are not capable of much. But that is probably too literary, so let the contrast

[268

be that between a rectangular component whose angularity is compromised by its awkward enwrapment, and a curvilinear component that achieves the maximum degree of gracelessness consistent with its geometry. Perhaps it is an allegory of male and female, or of the mechanical and the organic. In any case, there is a hang-up in their relationship and, one might say, in their ambition for themselves. At one time Saul Steinberg drew a series consisting of disheveled shapes fantasizing in thought balloons the Platonic perfection of figures like themselves. Thus a patched-together cube dreams of being a Euclidean solid with sharp edges and vertices one can be proud of. Hesse's components are like dreamers in Steinberg's world. They dream, respectively, of being a smartly wrapped rectangle with precise corners and a curve of polished chromium by José De Creeft, but they are never going to make it.

I think my favorite piece is *Metronomic Irregularity I*, composed of two pegboard-like shapes, carefully drilled by the artist and smothered in Sculpmetal and joined together by some sort of wrapped cord she has woven in and out of the holes and across the space between the panels. The cord is so comically disordered—so slack, loose, inept, and, to use her word, "silly"—that it looks as if the task were simply beyond whoever undertook it. The cord, in any case, is clearly not up to the mechanical expectations of the neatly drilled panels: it has done its best, and so it inspires in us a kind of compassion. But it is simply unable to realize its ambition of smart, patterned crisscrossing that the panels seem to demand. The puritanical panels are stuck with a hopeless companion in a relationship clearly not made in heaven. It is like an irregular metronome, utterly useless for the sole function metronomes are cast to discharge—namely, regularity. *Hang Up* and *Metronomic Irregularity I* are clearly kindred works, consisting of almost moral tensions between incompatible components forced to cohabit the same artistic space. In each of them there is a tendency to think of the frame or the pegboards as the base, and the loop or the tangle as the sculpture (and leave it to contemporary curators to formalize the tangle by comparing it to Pollock, as Robert Storr does in his catalogue essay!). But in fact there is no base: the work is the tension between what is forced into the roles of sculpture and base by those who think a sculpture has to rest on *something*. There is, so to speak, no figure-ground distinction between the components but instead a kind of dialogue. And this is true of a wide range of Hesse's work, once she found her direction. But even before she did, there is in the

earlier pieces, much less imposing than these paradigm works, the same signal irrepressible comic spirit. Much of it was done in Germany, where she went in 1964 with her husband, the sculptor Tom Doyle, both of them thinking of her as essentially a painter. They were given a factory space to work in, and it was not until Hesse began to fiddle with cord and discarded machine parts that she overcame the block she felt in trying to paint. She had returned to the country that would certainly have killed her had she not been spirited away to safety. She was undergoing the stresses and strains of a disintegrating marriage. She was stuck as an artist and trying to redefine what it meant to be a woman: "I cannot be so many things," she wrote in her diary. "Woman, beautiful, artist, wife, housekeeper, cook, saleslady, all these things. . . . I cannot even be myself, nor know what I am." There were so many dimensions of bleakness in her displaced life just then; her diaries are filled with apprehensions, doubt, resentment, and uncertainty. But the works from this period? *Ringaround Arosie; Oomamaboomba; Eighter from Decatur; C-Clamp Blues.* And they are as ludicrous as they sound, playful monuments to erotic comedy. *Ringaround Arosie* is painted and wrapped string, forming a kind of female emblem of breast and belly. *C-Clamp Blues* is a hermaphrodite composition, with a stiff metal bolt, painted pink, sticking out of a board, and a painted plastic ball, suspended from two wires, hanging down like a schematic uterus. *2 in 1*—a title that condenses the entire aesthetic of this genre of Hesse's expression—again uses a bolt (painted red this time) as some kind of penis analogue, coming through a pink aureola in (or on) what may be a breasted body but is again confected of wound string. Later on, Hesse makes sculpture out of beach balls or balloons covered with papier-mâché and painted black. Sometimes whole clusters of what had once been balloons are strung up like wurst, as in the case of *Several*, carrying whatever anatomic overtones you care to associate with them. Hesse used unprecedented materials in improbable ways to achieve results of an absolute originality, but the most we can infer about her as their creator was her sense of absurdity and her singular patience. One must count as among her masterworks the two *Accessions*, which are large metal cubes, densely but evenly perforated, through each hole of which the artist stuck short lengths of plastic or rubber tubing, yielding slightly nightmarish forms so far as their interiors are concerned, but which are smooth and regular on the outside. I suppose you could see them as psychological self-portraits, but if you do, you must accept the consequence that there is

no sure inference in either direction from bristling interior to regimented exterior. What cannot be claimed is that these works have any precedent.

Helen Cooper, the curator of this marvelous show, has drawn some criticism for devoting so much space to the early paintings, which Hesse did shortly after receiving her BFA from Yale. To be sure, the paintings are somewhat less novel than the sculpture, but they are wonderful and surprising works in their own right, which is reason enough to include them. And they are also good enough to explain why Hesse should have thought of herself as a greatly gifted artist, even when she was wandering in the dark, so to speak, lost in the space between a medium she could not develop and another that she did not yet know existed. Typically, the first paintings we see are of large heads, in which the head often seems simply an occasion for the paint it makes possible—the scrubbed hair, for example, in *Untitled* of 1960, where the mouth is slicked on as if with lip rouge and the eyes are bluntly stroked onto the surface. These are works that could hardly have been possible at any earlier moment in the history of painting, using paint the way they do, smoothly and physically, dribbled and scribbled, at once abstract and vestigially figurative, now and then cropped in surprising ways. But something in the large heads failed to sustain her creative drive, and though nothing she did lacks interest, many of the paintings and works on paper after 1960 appear to lack direction—though someone, knowing how things turned out, might be able to track her path through them from the heads to, say, *Ringaround Arosie*. Yet such an account would show nothing of the frustration, even the agony, of not knowing where to turn next, which we find as the urgent theme of the diaries. It was at her husband's suggestion that she began to work with string, and all at once painting struck her as anticlimactic: "I want to be surprised, to find something new. I don't want to know the answer before but want an answer that can surprise." This implies a sense of confidence that she now knows what she is as an artist. Until she began sculpture, she was not at all happy not to know how things were going to come out, and not certain that surprises awaited her. When she looked for surprise, the main one was over: her feet were on the ground.

It bears emphasis that it was her husband who helped her find her way, and who continued to intervene in showing her how to achieve certain things in her sculpture, since the marriage was unraveling and those who favor such interpretation may find in the careful knotting

and winding a metaphor for knitting life back together. Hesse was in the first wave of women who felt the impact of Simone de Beauvoir's *The Second Sex*, which all at once put into an intolerable perspective matters that they had taken for granted in their relationships with men, and that men took for granted as well. It was a difficult revelation, and more than one marriage crumpled under questions concerning feminine identity to which no one knew the answers. There was a lot of resentment, only part of it due to artistic competition: on their third anniversary she wrote, "Resentments enter most precisely if I need to be cooking, washing or doing dishes, while he sits King of the Roost reading." None of this, so far as I can see, finds expression in her work of that period, and while *Hang Up* can be read as a portrait of a marriage, that symbolism would be universal rather than confessional, wry rather than by way of aesthetic bitching, and joke far more than tragic lamentation.

The counterprettiness—I have no better term—of Hesse's work is in some measure a function of the aesthetically marginal materials she used, and in some measure a consequence of her eccentric forms, which have allowed commentators to see them as conveying surgical associations—abdominal corsets, elastic stockings, Ace bandages, wrappings of various sorts, and rubberized sheets. The argument is made that though Hesse was spectacularly sick in the last year or so of her life, she was never an altogether well woman, so the work stands as an extended metaphor of illness and, more abstractly, of womankind as physically suffering. One writer goes so far as to see *Tori*, a jumble of fiberglass-over-wire pieces, nine in all, as creating "the effect as of dismembered, squashed, and discarded female genitalia." Such interpretations psychoanalyze and ideologize at once; and while I would resist an altogether formalist interpretation of *Tori*, which sees it as about as antisculptural as sculpture can get (since the nine components can be arranged any way one likes, even be flung in the air and allowed to fall in a random array), the dismemberment of vaginas does not strike me as a Hessean concept. She is never morbid and, so far as I can tell, the will to live ran strongly in her to the end. And sexuality runs strongly in her as well, and is thematic throughout her work. The overall feeling of the show is one of exhilaration, intelligence, high-spiritedness, happiness—and a readiness to take artistic chances. Somebody could see *Untitled* of 1970, which is, as usual, fiberglass and polyester resin on armatures that are bent into crude L-shaped forms, as so many amputated limbs. But there is in fact

something indescribably comic in this little assemblage of One Foots, awkward and bumpy, which was designed to stand erect even if it requires wires from the ceiling to make this possible. It is, as a work, as "silly" as *Expanded Expansion*.

Occasionally the work transcends its material and something emerges of an unaccountable beauty. This is the case with *Right After*, a webwork of resin-saturated rope, suspended and luminous, an irregular filigree of monumental dimensions, with distant references to weaving or, more dangerously, in view of her intentions, to decoration. She completed the work right after her first operation for a brain tumor and was, Helen Cooper tells us, "unhappy with the way it turn[ed] out." I think I know why. It is after all perhaps too beautiful. It has all those aesthetic qualities that it was the resolution of her work to hold at bay, as if her fierce resolve not to be edifying had been weakened by illness. If that is the way it was, she was hardly the kind who would thematize weakness. On the other hand, the fact that *Right After* is the unquestioned high point of the show is evidence of how little ready we still are to receive her messages. Cry and the world cries with you. Laugh and you laugh alone.

—*The Nation*, August 3/10, 1992

Picasso's Still Lifes

WHEN THE FIRST VOLUME of John Richardson's magisterial life
of Pablo Picasso appeared not long ago to nearly universal praise, an
art historian known among other things for the wickedness of her
tongue announced that the book would set Picasso studies back by
twenty-five years. Richardson's work has many virtues, but if indeed
it can roll back the heavy style of interpretation the master has received,
it will have done immeasurable good. Increasingly, Picassology has
acquired the attributes that class it with divination, the artist serving
as the vehicle of the deepest reading the interpreter is capable of pro-
viding. This has nothing to do with the distortions induced on the
objects represented in the work, which sometimes disguise them to the
point that it requires a special and often collaborative process of de-
coding to determine that a certain shape is indeed a bottle, another
perhaps a bird. I refer instead to what I term "deep interpretations,"
in which it is taken as a given that in painting a bottle Picasso is saying
XYZ, and the task of the interpreter is to solve the equations that enable
the work to reveal an undermeaning of the greatest human magnitude.
In reading these exercises in pictorial hermeneutics, one feels oneself
in the company of censors from the old Eastern European regimes,
whose premise was that nothing written is innocent, that even "Having
a good time. Wish you were here" scribbled on a postcard from Odessa
hides subversive meanings dangerous to the state.

Picassology began much longer ago than a mere twenty-five years.
A Russian critic wrote of the 1908 *Carafe and Bowls*, which is, the
distortion of these objects notwithstanding, pretty clearly what the title
tells us it is, that "Picasso's earthenware bowls are the darkness of an

ultimate despair," when, to begin with, they are not especially dark at all. But the catalogue for the recent exhibition "Picasso & Things" at the Philadelphia Museum of Art observes that the front bowl repeats a bowl to be found in *Vase, Two Bowls, Compote, and Lemon*, of that same year, a still life painted over what had been a picture of a standing nude—and that *very bowl* "corresponds almost exactly to the womb of the woman that the X-ray reveals, her navel at the center." The desolation to which the Russian was responding "is probably repeating [the] symbol for an empty womb." The *four* empty bowls then multiply this emptiness and become "four empty wombs," which, the catalogue concludes, "represent a certain desolation."

This is an aggravated case of illicit intertextuality, with one painting deriving its meaning through reference to another, which derives its meaning from the painting it submerges. In any case, with what right do we claim that the painted-over woman's womb *was* empty? And indeed, if the overpainted bowl refers to her, to whose empty wombs do the sister bowls in the other painting refer? Or do they convey an emptiness too overflowing for a single womb/bowl to explain? And why, in any case, would Picasso be concerned with empty wombs in 1908? The catalogue goes on, in speaking of the four-bowl painting, to refer to "the mysterious red, fan-shaped shadow on the table." But shadows are mysterious only when cast by mysterious things, or when their shape fails to be explained by what casts them, or when nothing casts them but they exist anyway. No such mystery exists within this particular painting. The shadow is, within the vocabulary of the painting's objects, what we would expect, and where we would expect it. If, moreover, we imagined it absent, the painting would become badly off balance. And balance is almost the meaning of this work, as evidenced by the delicate way in which the smallest bowl is perched on the mouth of the carafe. This shadow echoes the shadow in the upper left of the painting—also fan-shaped—and there is a wonderful diagonal cascade of curves. Picasso was not always painting the *Demoiselles d'Avignon*. He was not always painting in the spirit of *Guernica*. Sometimes his paintings are what they appear to be. There must have been countless postcards from the Black Sea that meant just what they said: "Having a good time. Wish you were here."

Consider *Dog and Cock* of 1921. The ornamental rooster lies on its back, its feet in the air, its head hanging down. I would surmise that the inverted U at its throat means that its throat was cut, in the immemorial way of chickens for kitchens in France. The catalogue

finds merit in a Picassologist's suggestion that the painting represents a *sacrifice*, making this a religious painting. The interpretation gets worse: "The brilliant bird is . . . a cock, a word which in itself reinforces his masculinity." The English word might, but *coq*, so far as I know, is not a word for what the French call the *membre viril*. And what particular motive of self-emasculation is to have led Picasso to sacrifice his manhood on the kitchen table? And how does it connect with his earlier empty-womb syndrome? Next to the cock, in any case, are five roundish objects, somewhat schematic and mysterious only because not readily identifiable. Robert Rosenblum describes them as eggs. While there are arguments in favor of their being mushrooms or even apples, their identity as eggs gives license to interpret their proximity to the dead bird as an allegory of death and resurrection, though why the authors did not seize instead the masculinity of the cock and the femininity of the egg to propose an allegory of the triumph of womankind is left unclear. The implication is that something momentous is being transacted at the symbolic level. "The brown bottle, with a single golden eye and a black shadow, seems to withdraw to the edge of the table as an apprehensive spectator." Not so the dog, who "with bravado . . . confronts death." "He [whence this gender specificity?] does not withdraw from it like the bottle." What in fact is a fairly conventional still life—with bird, bottle, probably vegetables or fruit, and a lurking dog, an old friend from seventeenth-century still lifes— is treated as if an allegory for Iphigenia at Aulis or the Martyrdom of St. Denis. Why must there always be this overlay of meaning? Why must everything mean something sexual or sacramental or mythic, when food as *food* carries as powerful a meaning as anything in human life? Or are the still lifes insufficiently rewarding unless we treat them as caskets of secret meanings whose keys must be found?

"Picasso & Things" is one of three major exhibitions mounted by the Cleveland Museum of Art to celebrate its seventy-fifth birthday. Evidently, this is the first time the entire range of the artist's still lifes has been covered in such depth (which includes a number of his witty sculptures) and brought together as a great chronological sweep. Perhaps because the paintings deal with "things," they offer us a certain glimpse into the ordinary world of Picasso as defined by entities of these sorts. To be sure, Picasso did not think the objects he painted were in any way peculiar to him. He sought a kind of instant universality by painting objects everyone knew, or at least everyone who lived the commonplace lives of French men and women of his time. "The

objects that go into my paintings," he told Françoise Gilot, "they're common objects from anywhere, a pitcher, a mug of beer, a pipe, a package of tobacco, a bowl, a kitchen chair with a cane seat, a plain common table—the object at its most ordinary." And he elaborated: "I want to tell something by means of the most common object: for example a casserole, any old casserole, the one everybody knows. . . . I make reference to objects that belong to everybody; at least they belong to them in theory. In any case, they're what I wrap my thought in. They're my parables." He characterized his paintings thus in the sense that parables express abstract truths by means of homely incidents everyone can understand. From this it must follow, of course, that however abstract, the truth conveyed cannot be hidden or possessed of secret meanings accessible only to a few. In comparing the use of ordinary objects with Christ's use of ordinary incidents to convey truths at a level most people would understand, accessibility must be as broad as the object is common. Otherwise, the things become a code for initiates rather than the fulcrums by means of which a lay viewer might ascend to wider truths.

It is this imperative that tells against the butchered bird as sacrifice. Picasso's audience would not be readers of *The Golden Bough* or anthropologically knowledgeable regarding arcane ritual. They were plain men and women for whom, if they lived in France, chicken was probably not an item on the daily menu. It was a Sunday dish, and it certainly did not come in neatly arranged parts under plastic wrap. The splendidness of the bird is a metaphor for the celebratory occasion. It is charming to show the bird on the same table with a sheet of newspaper, but that just shows Picasso's unfailing realism. To have lived in France before the era of the *supermarché* is to remember getting one's purchases wrapped in old newspaper by frugal merchants. The paper bag, as I remember it, was all but unknown—except, I believe, for eggs, which were placed in fives and tens in flimsy sachets. That is why the objects on the newspaper strike me as more likely to be fruits or vegetables than eggs. So the still life here is a celebration of the Sunday meal, and derivatively, if you wish, of the sacramental character of food. The dog under the table shows the hopeful nature of its kind through its protruded tongue. But I am unsure a reading can be given of everything in this or in any of Picasso's paintings. In a fascinating passage, Picasso speaks of the real objects as the "few points of reference designed to bring one back to visual reality, recognizable to anyone. And they were put in, also, to hide the pure

painting behind them. I've never believed in doing painting for the 'happy few.' " This may be disingenuous, in that there cannot have been many in Picasso's art world who were open to the extreme rearrangement of forms we find in his Cubist portraits, such as that of Daniel-Henry Kahnweiler, his dealer. But these were pretty close to "pure painting"—"painting for its own sake," as he told Gilot—and had nothing to do with the kind of hidden meanings that are the currency of Picasso studies.

Fragments of now-yellowed newsprint figure in his classical still lifes of the years just before World War I, and it is incidentally disheartening to read about Serbia being on the attack then, as if the whole of twentieth-century agony were bracketed between episodes of Serbian warmaking. It is difficult to know to what degree Picasso was especially interested in the Balkan war, or if the contents of the newspaper clippings in any way contribute to the meaning of the works, which are what one might class as café still lifes, composed of a bottle or two, sometimes with precise but familiar labels, a pipe, a glass or more, and the rickety tabletop on which all this was deployed. Newspapers belong in that ambience, since reading the paper with a *coup de rouge* is a commonplace café occupation. But the question is whether, beyond that, any content is transferred from the clippings to the artwork. Robert Rosenblum has argued that certain of the headlines and fragments of headlines pasted or painted on do have a significance, largely through puns. Thus in a still life with guitar and wineglass, Picasso has pasted in the title of the newspaper *Le Jour*, but with the R cut off, leaving LE JOU. This has no meaning on its own, though *jouer* means "to play," which would go with guitars or with the whole work. Just beneath LE JOU is the headline "LA BATAILLE S'EST ENGAGÉ"—"The Battle Has Begun"—and it is interesting to ask what war it might be that Picasso has appropriated the words to designate —with the critic? the viewers? Or, since there is also a fragment of music beside the guitar, whether it is the battle of the sexes that is meant, begun with a drink and a serenade?

What is known is that Picasso was fond of puns, and it is consistent with the spirit of these marvelous works that there should be verbal jokes as well as visual ones: Picasso once painted a still life with apples and a bowler, which, since it is known in French as a *chapeau melon*, gives us a natural pun of melon with apples. The collages often have wallpaper pasted on, and wallpaper is still called *papier peint*. But painted is exactly what the wallpaper is not—it is printed—while the

wood grain of the guitar, which *is* painted by the artist, looks as if it were printed. There are all sorts of appearance-versus-reality jokes in these works, including the pasting of real labels onto painted bottles. Picasso was exploring the relationship between reality and art, was calling into question so many components in the definition of art, that the collages are often exercises in wry aesthetic analysis. And yet, at a level that everyone in that society must have grasped, they are café-tabletop still lifes. Maybe they embody the kinds of arguments about the nature of art Picasso must have participated in during the years to which these collages belong—a bit of metaphysics, a glass of *marc*. Sartre is reported to have turned pale when Raymond Aron told him that a phenomenologist could make philosophy out of a cocktail glass. Picasso was doing just that. How much of the high culture of France was enacted on the oval plane of the café table is beyond reckoning.

I recently revisited the Musée Picasso in Paris and was over-whelmed by the sense of happiness that ordinary life appeared to give Picasso. The work is consistently about affection and domestic plea-sure, with children playing and lovers clasping one another and figures running along the beach in comical striped costumes. I suppose our view of the artist was fixed by the somewhat sentimentalized suffering conveyed in the extremely popular Blue Period paintings (but senti-mentalized suffering is not without pleasure either) and of course by the indictments of *Guernica*. There is, for example, a painting of a nude woman the official catalogue for the Philadelphia show writes about as if she had been tortured, when in fact she is shown in the luxury of an after-bath snooze, her head thrown back, her mouth open. My sense is that we require of our cultural heroes that they have a tragic view of life, when it is far from plain that they do. Picasso was certainly sensitive to things like the loss of love and the decrepitude of age, and of course death. But these were the basic tragedies: the ordinary fabric of life is bright and calls for celebration and justifies amusement, as with the way dogs carry on, or children do. The still lifes from the years of World War II are cases in point. I was struck by the way the coffeepot had replaced the wine bottle. The coffeepot emblematizes the deprivations of those years, and its presence then emblematizes a certain scarce pleasure. With a candlestick, which speaks of another order of deprivation, the coffeepot allegorizes every-day life in a time and place when the French virtue of *débrouillage*— of extricating oneself from difficulties and going on to the next thing —was so highly valued. There is even a tomato plant from 1944, which

thematizes making do with flowerpots on sunny windowsills when that essential vegetable is in short supply. Perhaps the single ornamental coffeepot painted against what looks like a flag—red, white, blue, spangled—proclaims the human meaning of victory: plenty of coffee from now on! *Le Jou* continues to the very end, with an occasional skull thrown in as a symbol of the vanity of it all. But there were *vanitas* paintings at the very outset of the tremendous career, and in any case one does not argue that all is vanity when in fact the surface of life is bleakness and blood. It has to be a feast, rather, if the skeleton is to have the meaning that we must keep our mind on death.

So "Picasso & Things" was exactly the right way for a museum to mark an important anniversary, and one must wish the Cleveland many happy returns. There remains one last critical word to be said. A show all of still lifes really gives you the World According to Picasso. What it leaves out is the "pure painting," as he termed it, behind the objective references. The upheavals in style, which are after all the upheavals of twentieth-century art, are registered in the still lifes, but it is not always clear from the still lifes alone why these took place— why Picasso was Picasso, after all. Just consider the first painting in the show that has to have been unlike anything being painted by anyone else at the time, and utterly unlike what painting had been before. This is *Vase, Bowl, and Lemon* of 1907. What accounts for the fact that the round bowl and the almost certainly round bottle do not behave the way round objects in space are supposed to behave? The catalogue refers to the shape of their lips as ellipses, but that is wrong. They are pointed, the way a paper cup would be if someone squeezed it: the contrapuntal curves meet and form an angle at each end. They seem under some terrific pressure and yet they are made of hard, brittle matter unable to stand stresses of that sort. The paint is roughly applied, in crude strokes and rough patches. Everything seems imploding, bursting with an unnatural energy. This has nothing to do with *la douceur de vivre*. Vase, bowl, lemon seem clearly to be occasions for something taking place that interpretations of them cannot explain. This is nearly always true: the real story seems to come from without, at right angles to the plane of life. And a show only of still lifes cannot begin to explain that.

—*The Nation,* October 5, 1992

Henri Matisse

*It is very difficult now that everybody is accustomed to everything to give
some idea of the kind of uneasiness one felt when one first looked at all these
pictures. . . . I was confused and I looked and I looked and I was confused.*
— GERTRUDE STEIN, *The Autobiography of Alice B. Toklas*

THE ENTRY under "Post-Impressionism" in the fourteenth edition
of the Encyclopaedia Britannica characterized the art of Matisse as
having gone "farther even than Gauguin in reconciling Western art
with the Chinese," in that it "depends entirely on arabesque and is
not concerned with the third dimension." This sounds as if the author
had been especially impressed with a work like *Harmony in Red: La
Desserte* of 1908, which indeed is mainly in Chinese red and cinnabar,
and is united by a decorative arabesque running across the tablecloth
and up the wall, as if these were in the same plane, in violation of the
third dimension. Now, one way one might think of advanced French
painting in those early years of the century would be as the evacuation
of the third dimension, inasmuch as Cubism frequently was credited
with having moved into the *fourth* dimension. And since the glory of
traditional Western art lay in its conquest of the appearances of things
in three dimensions, for which our optical system had after all evolved,
enabling us to survive and prevail in real space—which pictorial space
more or less replicated—it was inevitable that two- or four-dimensional
representation would strike the eye as intolerably disconnected from
the world of routine visual appearances.

The standard compliment paid the traditional depiction of X was
that you could not tell it from X itself, leaving unresolved the question
as to how critics were to praise two- or four-dimensional representa-
tions of X, since illusion was patently out of the question. With Cubism,
the strategy quickly recommended itself that it had gone *beyond* ap-
pearance, to what the encyclopedia describes as "the essential realities
in pure abstract form." It was almost as if Cubist depictions were the

visual equivalent of mathematical representations of physical reality, and their enthusiasts did not hesitate to bracket them with the theory of relativity and non-Euclidean geometries. And the drab monochrome of early Cubist pictures—dull olive, dirt brown, clay tan, drab gray— made plain that the gratification of the senses was not on the menu: their pleasures were those of truth disclosed to the scientific centers of the mind. And the art of Picasso remained, long after Cubism waned or degenerated as a style, appreciated as if by priests and acolytes as the transcription in an arcane code of the deepest truths possible.

Cubist art connects with a philosophical tradition that goes back to Platonic times: the senses are at once the sources of cognitive illusion and of fleshly distraction. Hence the double message of the Cubist canvas: by appealing to intellect rather than eye, it slipped the danger of illusion; and by looking as if made of mud, it bypassed the senses as hedonic traps. So it was pure Platonic art.

Matisse's art was almost defined by these implications. Having scorned the third dimension, he fairly easily aborted the expectation of illusion. But in using black as a color rather than an additive for graying other colors down, and employing saturated hues in large flat areas—juxtaposed, typically, to intensify brightness—he must be read as appealing to the senses as centers of visual pleasure. Picasso's subjects are merely occasions for geometrization, gateways into the fourth and higher dimensions, and possess little interest in themselves: ordinary bottles, pots, pitchers, and the like. With Matisse, by contrast, the surfaces are all the reality one wants or needs, and motifs are selected for the connotations they carry of sensory pleasure: bare skin, especially female; flowers; dinner tables; sweet interiors; lush gardens; ornamental fabrics of a palpable luxury; the earth, *this* world, as a kind of paradise in which human beings dance, sing, play pipes and violins, feed one another as well as benign animals, bathe. And the surfaces of his paintings, with titles like *Luxe, Le Bonheur de Vivre, Pastoral, La Musique*, mark them as belonging to the same world they show. Matisse's paintings, at least of the period to which *Harmony in Red* belongs, are enhancements of a dimension of being that has in it room only for happy things and nice pleasures. In his famous *Notes of a Painter*, of 1908, he writes as much:

What I dream about is an art of balance, of purity and serenity, devoid of troubling or depressing subject matter, an art which could be for every mental worker, for the businessman as for the man of letters . . . a soothing, calming

influence on the mind, something like a good armchair which provides relaxation from physical fatigue.

Strikingly, Matisse connected this with seeking to discover "the essential character of things," which was supposed to have been the project of the Cubists. But that just shows that the two subscribed to different metaphysics. Picasso contrasted reality with appearance; Matisse defined reality *in terms of* appearances, in the manner, one might say, of Bishop Berkeley. The *essential* character of things would be that set of its appearances that most perspicuously presented the thing to the viewer, selected with particular reference to the feeling about the thing that Matisse meant to convey. It was not essential—and perhaps without a third dimension it was virtually impossible—that the appearances selected should give to normal vision what the thing looked like in real space. Because of the constraints this imposes on Matisse's system of representation, the appearances become at once a kind of ideogram or even a symbol, all the while having sensory content. But since the form of something within the picture will diverge from what it would be outside the picture, there is every reason to use colors ideogrammatically and enhancingly as well.

How important these divergences are may be grasped by considering a famous 1905 portrait of Madame Matisse, done when the artist was a member of the brief Fauve movement. It is often called *The Green Stripe* (*La Raie Verte*), from the fact that a green stripe runs down from Madame Matisse's hairline, along the bridge of the nose, stopping at the upper lip. It divides her face into a warm ocher and a cool flesh-tone zone, and it serves to intensify the hot and cool colors on either side of it. What one is not to infer is that Madame Matisse herself had a green nose, or that it was the style in cosmetics of the time for women to use green makeup to "take the shine off." Whatever Madame Matisse looked like outside the picture, this is what she looks like inside it, and Matisse always pressed this point. A companion portrait of a woman in an immense ornamental chapeau gives its subject brick-colored hair and a green nose, where the colors, in addition to obeying some principle of chromatic dynamism, transmit the truth that it is a real picture but not a real woman. "I am not painting a woman," he said to someone who raised the question. "I am painting a picture." Etta Cone, who with her sister Claribel went on to form one of the great collections of Matisse in America, was dumbfounded by the exhibition in which *Woman with the Hat* first showed: "Some

formless confusion of colors . . . ; some splotches of pigment crudely juxtaposed; the barbaric and naïve sport of a child who plays with the box of colors he just got as a Christmas present." Visitors jeered and howled, according to Gertrude Stein's brother, Leo, who nonetheless bought the painting, their first Matisse. It was among those that confused Alice B. Toklas in 1907. I am always amazed by the aesthetic courage of these early purchasers.

In 1911, Matisse executed a marvelous painting known as *The Red Studio*, which shows his workspace as well as several of his paintings on the wall (it is rare to see anyone else's paintings in Matisse's paintings, as if only his fit within the pictorial world he was creating). "You are looking for the red wall," he once said to a visitor, who must have looked puzzled, expecting the studio to look red. "That wall doesn't exist at all." The studio walls were in fact gray, and Matisse began by painting its contents against the true color of the room, but it did not convey at all the feeling he was concerned to project. So the color belongs to an imaginative transformation in which the appearances in the picture are disjoined from those of the real room. This makes it exceedingly difficult to make inferences from the paintings in the painting to those that must have hung in the room. Is the recognizable *Luxe*, for example, an early stage of the one we can see in the current exhibition of Matisse's work at the Museum of Modern Art in New York—or is it an alternative version? Or is it the same painting, transformed from pink to brown skin the way the studio walls were from gray to red? In the painting as we have it, the three women are in a flesh-ocher: perhaps this jarred with the red, or conflicted with the chair, in fact done in more or less that very color. A painting of a sailor has a pink background, both in and out of the picture. Perhaps it was left unchanged because it harmonized with the reds. Nobody can say.

Matisse once said to the writer Louis Aragon, "I do not paint things, only the difference between things." To our ears today it is difficult not to associate this wonderful if mysterious sentence with a parallel claim made by the linguist Ferdinand de Saussure that a language is a system of differences, that it is not the sound of a word as such, but the phonic differences between it and "all the others" that permit us to distinguish it. French thinkers like Derrida have made a great deal out of this idea of difference—even to the point that the world as we represent it linguistically is to be understood only as an interreferential whole, everything depending upon everything else.

Matisse certainly thought of his paintings that way, not as copies of the world but as integral wholes with their own reality, so that the picture of *Luxe*, in *The Red Studio*, is what it is through its differences from the chair, the table, the other pictures, even the nasturtiums in the thin-necked vase. "I must have a clear view of the whole right from the beginning," Matisse said, corroborating this view of his work. And we can confirm it by seeing what happens to the same painting when it appears in different works. Thus, the blue in *Dance II* is much bluer in the two versions of *Nasturtiums with Dance II*; and in the version on loan from the Pushkin Museum, the green of the original is completely blued out, so that the dancers wheel round in an undifferentiated blue space, rather than on a green hill as if at the top of the world, as in the original painting. In my view, the green has disappeared in order to intensify the coral of chair, vase, and stand; and the internal shapes of the dancers have changed as well, for whatever reasons of difference.

The Painter's Family of 1911 shows a checkerboard, with eleven squares along the front edge but running only seven squares deep. Though superficially the painting has a naïve, primitive quality, details like this show it is not: a primitive painter would have made sure of the number and painted it with deliberate exactitude. In traditional perspective paintings, tiles and ceiling coffers are typically countable, to underscore the illusion of depth—so Matisse's inexact checkerboard subverts perspective illusion, and the painting in general subverts depth, since the table on which the checkerboard rests is not in the same plane as the boys playing on it but rather almost flush with the picture plane itself: everything in the painting serves to flatten it forward and translate depth into mere pattern. What requires an explanation is Matisse's evident determination to diminish the authority of the third dimension and hence of solidity in the subjects shown. There is no modeling to speak of, for example, in the figures of the dancers in *Dance*, nor are there any shadows. In *The Red Studio* we see a corner, but the color of the walls, which meet at right angles, is uniform, as if they stood in the same plane. The floor in *Moroccan Café* is a single celadon green from front to back of the scene depicted—or from top to bottom of the depiction; and the six figures are as flat and boneless as cutouts. In fact, the painting, with its brown and figured border, looks as if it aspired to the condition of carpentry, and hangs on the wall as if displaced from the floor. The figures, lounging or squatting, indolently watching goldfish circle or flowers fade, are painted as if in

the same plane as the Moorish portico behind them—impossible in real space, only underscoring the autonomy of painting. Matisse gave no explanations. He once said, "Anyone who wants to dedicate himself to painting should start by cutting out his tongue." But my sense is that his conception of painting was essentially decorational and naturally implies collusion with architectural elements like floors, walls, or ceilings. Whereas the usual architectural reference for Western painting was the window, essentially separating the viewer from the scene visible through an opening into a different space, by bringing the subject onto a surface, Matisse in effect locates the viewer and the image in the same interior space. One's life is then enhanced by the surrounding decorations that, when chosen rightly, give us that sense of well-being he aimed for in his art. I think this goes some distance in explaining the large scale of his masterpieces: they are to fit naturally within the boundaries of real lived space. (*Dance*, for example, was intended to occupy the landing on a staircase in the mansion of his Russian collector, Sergei Shchukin.)

Critics almost uniformly most admire the work, experimental and at times almost abstract, that Matisse did in the years of World War I, but to me most of these paintings feel as if he had lost his way. Perhaps he was seeking to reconnect with a painting culture he had put in question, for who knows what personal or even patriotic reasons. Whatever the motive, there is a certain retreat from the surface, and hence from decorativity. There is a pair of paintings of Notre Dame, as seen from the balcony of his studio on the Quai St. Michel, from spring 1914. One is a cheerful Post-Impressionist tableau that, put alongside a painting of the same motif done in 1902, would show, to someone who did not know the rest of the work, almost no progress, or perhaps a regression to more secure means. The other could only have been done later in the century, for the building is ruthlessly compressed and simplified. The edge of the quai shoots back toward the cathedral, like a vector along the z-coordinate, pointing to a single brushy tree, which casts a heavy shadow. The cathedral itself casts a black shadow against the night sky. The Petit Pont is reduced to a single curve. The spatiality is altogether traditional. The portrait of Mlle. Yvonne Landsberg belongs to this dark, uneasy period: she sits caged by arbitrary lines that echo the contours of her body, like aftershocks or perturbations in space. Her face is a mask. The colors are the grays of steel and clay. Like many of the works of this and the next few years, it is an isolated effort, a stab at something, moody and

muddy, "experimental" because it tries to find some new way of connecting figure with real space by means that fail, because we don't know what their physical correlatives are, and can no longer be told that this is, after all, but a painting.

The tremendous exhibition at MoMA is on two floors, and so is divided into two sections, marking, one feels, a change in Matisse's life, internal and external. One exits from the period in which Matisse experimented unhappily, and ascends to the next floor, which corresponds to a move to Nice on the artist's part, and a *changement de vie*. To one's right is a luminous painting of Mlle. Matisse wearing an expensive plaid coat, glancing brightly up from her book, looking so like a passenger on an expensive ocean liner that one can almost smell the salt spray. Directly ahead is a painting of a violinist—Matisse himself, one supposes—playing to the outdoors through the French doors of his hotel room. The figure is abstracted, tiles and shutters are reduced and simplified, but the painting does not feel especially programmatic, and I like to think that music making here expresses a liberation from modernist dogma. The two paintings transmit release and happiness, which were to be Matisse's constant feeling, so far as the art reveals anything, in the long remainder of his life. The paintings now condense the very feeling one senses that Matisse has injected into his own life, alone save for the company of exceedingly decorative models, in rooms filled with pattern and with light.

Matisse was a very private person, but the paintings of the Nice years chatter eloquently of an opulent sensuality and a certain spirit of play. As a young artist, learning his craft, Matisse of course drew and painted the model, as painters always have. Now, however, his models have been taken into his art, and into the form of life he has chosen for himself. They are, so to speak, living still lifes, dressed and positioned in accordance with the artist's will, and almost objects therefore of fantasy in their absolute compliance and responsiveness. The paintings are objectifications of joy. Consider, only for example, *The Painter and His Model: Studio Interior*, of 1921. The model, nude save for what looks like a kerchief over her head, leans back in an armchair, supported by extra cushions to augment the feeling of softness and *volupté*. Matisse has rather daringly given her some pubic hairs, a naughty gesture, considering the conventions of his art. He is wearing the same striped pajamas he portrayed himself wearing in the 1912 *Conversation*, which many have interpreted as a scene of domestic tension, as fraught as Degas's portrait of the Bellelli family. Two bou-

quets of anemones, a striped tablecloth, the crisscross of floor tiles, floral decorations up the wall, and the tousled palm tree seen through the window join artist and model, and a Matisse on the wall, in a space of visual and erotic excitement. Abstraction has joined austerity on permanent furlough; Matisse has joined the dancers, the bathers, the singers of his early paganism. His art belongs to the world it depicts: he has, so to speak, entered his own paintings.

This is an exceptionally and deservedly popular show, but Fifty-third Street is a long way indeed from the Promenade des Anglais and the Baie des Anges in Nice. According to a *New York Times* editorial occasioned by the long lines for advance tickets, you must "arrive thoroughly convinced that Matisse is worth suffering for." I am not certain pleasure is worth suffering for, but if you take pleasure in painting, this must count among the experiences of a lifetime. Still, all that hedonism, all the *luxe, calme, et volupté*, may not cut much ice when you are jostled by throngs trying to peer around you. You are not alone in a room with ambient decoration, wearing your elaborate striped pajamas, leaning back in your armchair. I have one word of advice. The crowds thin as the pleasures thicken. So press past the first rooms where people cluster, looking at work that mainly has the external interest that it was painted by Matisse, but none of the interest of Matisse. Press along, past the Fauve work, noting that nobody is jeering this time or howling at the *Woman with the Hat*. Soon you will encounter a tiny portrait of Marguerite as a young girl that will stop you in your tracks. The rest is up to you.

—*The Nation*, November 9, 1992

Martin Puryear, or the Quandaries of Craftsmanship

AT A PRESS LUNCHEON held by the Philadelphia Museum of Art to celebrate the opening of an exhibition of Martin Puryear, widely esteemed as among our foremost sculptors, the young curator in charge of installing the eccentric and often unwieldy pieces told of an instructive interchange with the artist. Puryear had deflected an intended compliment, which spoke of his "consummate craftsmanship," by saying that his craft was merely adequate to the realization of the work at hand. This was not mere modesty on the artist's part, nor was it the protestation of someone whose knowledge of craft was such that he was aware of how far short he fell of the highest mastery. It was, rather, the demurral of a consummate craftsman who was conscious that the connotations of *craft* sit uneasily today with the connotations of *art* and who must have worried that the level of skill in his work is sufficiently high so that the works on which that skill has been lavished might be taken for exercises of (mere) craft instead of works of sculptural art.

It is certainly the case that virtually none of Puryear's peers—that small number of sculptors taken with the utmost seriousness by the critics, collectors, and curators whose opinion "matters"—can be accused of craftsmanship. Very few among them fit the stereotype of the sculptor who, mallet and chisel in hand, confronts the blank stone or the uncarved block of wood. It is almost as if the sculptors of today still smart from the Renaissance controversies as to which stands higher, sculpture or painting, when the implication was that poetry and philosophy perhaps stood highest in the scheme of human endeavors, as being the most contemplative. It was held that sculptors, their nostrils filled with dust, their workplace filled with din, stood so

far from the scholar's *studiolo* that they were little better than plain workmen. Donald Judd has his pieces fabricated for him, and it is part of his philosophy of sculpture that the artist's hand need never touch the work that embodies his or her concept. Richard Serra enjoys using the kind of gear—forklifts and bulldozers—that blue-collar workers maneuver on construction sites. There may be a component of skill involved in hefting plates of rusted steel and putting them in place, but certainly nothing one could call *craft*. Craftsmanship is shunned from two directions, then, giving way to conceptualization and sheer physical work. Small wonder, then, that even as a graduate student at Yale, Puryear noted that the "progressive artist must be suspicious of skills." Gene Santoro remarked recently on a comparable attitude among rock musicians: the thing is to sound like a bunch of guys playing together in a garage, shunning the stigma of virtuosity.

Craftspersons are often tormented by a boundary recognized between craft and art, and it must have been felt as vexatious and unjust that Serra be accorded great artistic merit for sculptures made by flinging molten lead into the natural mold created by the angle at which walls meet the floor and one another, forming rough ingots; or Eva Hesse celebrated for sculptures fabricated out of droopy lengths of rubber-impregnated cheesecloth, merely hung from rods, when *their* artisanry, perfect in its productions, beautiful even, and certainly ingratiating, was condemned to a lower category of creativity. Not long ago, the critic John Perreault, himself a "craftsworldperson," wrote that "most noncraftsworlders are negative about what they perceive of as the lowly craft. . . . They can see a chrome version of an inflated cartoon rabbit as art. They can see a pile of dirt on a gallery floor as art. But they can't see a clay pot or a glass vase as art. They can see a gigantic ball of rope as art, but they can't see a woven hanging as art. They can see an arrangement of rocks as art, but they can't see wrought-iron screens as art." At one point, the master craftsman Wendell Castle decided that it might be possible to penetrate the barrier by raising craft to some absolute level, making a work so achieved in its means that it would automatically self-transcend, bootstrapping itself into the domain of art. He produced a lady's desk with side chair so exquisite and luminous that it makes one catch one's breath. If he succeeded in creating a work of art, it would, however, not be through the cunning of his hands and his profound knowledge of joinery, wood, finish, and the like but perhaps because he had made craftsmanship its own subject and achieved a furniture piece that was self-reflexive, was about its

own processes. But he might have achieved this with considerably less expenditure of skill.

In a recent conference on the situation of the crafts today, Janet Kardon, the director of the American Craft Museum, complained that there is very little scholarship devoted to the crafts, and that by contrast with art history, *craft* history barely exists as a discipline. Yet Martin Puryear would have no interest in belonging to that history even if it did exist. He belongs to a history that includes the great sculptors of the Renaissance and Rodin and Brancusi, and his work demands enfranchisement within that narrow circle of contemporary sculptural expression that includes Serra and Judd, the late David Smith, Carl Andre and Mario Merz, and Robert Smithson. This notwithstanding, his work displays enough "consummate craft" to put it at risk in an art world in which deftness, elegance, mastery, and beauty are focuses of suspicion, and where the very implications of handiwork clash with the often proletarian pretensions of the Minimalist movement, which after all sought to erase the boundaries between fine and industrial art. There is a wonderful photograph taken of Puryear in his studio in Chicago in 1987. It shows him standing in front of a workbench with neatly arranged woodworking tools—hammers, mallets, chisels, drills, clamps, gouges, and saws. And it is possible to imagine these and other tools in connection with his works, as means to delicate ends. I cannot think of another contemporary sculptor who would use these sorts of implements: they could have no function in the production of Serra's *Tilted Arc*, say, or of one of Donald Judd's modular concatenations of metal boxes.

It might be said that Puryear's work internalizes the boundary it overcomes between craft and art, but it internalizes as well a number of other such boundaries, such as that between art and artifact, or between contemporary art and traditional folk forms of the sort that enter into the fabrication of shelters, traps, weapons, boats, and household goods. Puryear served for two years in the Peace Corps in Sierra Leone, after graduating college, and lived among the craftspeople in the village of Segbwema, where he taught subjects like biology and English, and where he learned the secrets of native carpenters. One often feels that he has turned into sculptures objects that serve some necessary function in the life-forms of people who live pretty close to nature and must make do with fairly rudimentary means—thongs, fibers, skimpy branches. Some years ago, Susan Vogel, the director of the Center for African Art, mounted a marvelous exhibition called

"ART/artifact," in which she displayed certain altogether utilitarian objects, such as a Zande hunting net, which resemble certain works of contemporary sculpture to the point that had we seen things exactly like them in a gallery, we would not hesitate to treat them as art. She demonstrated that whatever the difference between artifact and art, it cannot be determined on the basis of what meets the eye. Puryear is among those artists whose work raises the question in the vivid form in which Vogel posed it, by making objects that resemble things he encountered in his African experience and exhibiting them as art.

There are, for example, works in the Philadelphia show that would have made Vogel's point from the other direction. *Keeper* of 1984 is a work made of steel wire, formed into a kind of hanging net, about eight feet high and fastened at the top with an oblate plaque of smoothed pine. It looks like some anonymous and immemorial form devised to keep food out of the reach of animals; but there is a jaunty rhythm to the reticulation that contrasts with the austere regularity of the weave of wire in *Greed's Trophy* of that same year, a work that resembles a trap for medium-sized animals. These artifact-resembling works derive their status as art from the meanings they embody and the formal properties that these meanings make derivatively meaningful. There are allusions and references to primitive counterparts that are not artworks at all, as well as to the kinds of questions that the boundary between art and artifact projects. These exceedingly self-conscious works must be understood as the art of someone who has made the history of contemporary sculpture—and its complex relationship to other domains of skilled making—his own. It is this, in part, that makes his work so fascinating.

One of the first works on view, and among the earliest in the show, is not merely on display but makes display part of its subject. It looks like a gigantesque array of tools from an arcane but primitive technology. There is an immense sawlike form, mounted beneath what looks like a colossal forceps, fashioned from a bent sapling. There are four other components, skinny lengths of polished wood, bent and crooked, pointed or knobbed at their ends, like picks or probes. It is a collection of mysterious devices whose usefulness is implied but whose application is hidden. The work takes up about thirty feet of wall space. There are a number of wall pieces in the show, objects whose function looks as if forgotten but that survive their system of uses because of their beauty. I particularly admired *Untitled* of 1982, which is a maple sapling, peeled for perhaps half its length, with that part smoothed and

polished, and the whole then bent into a wide simple knot. What gives this piece its mystery is the attachment to it at either end of polished handles, of pearwood and yellow cedar, facilitating a function we cannot altogether fathom. Whatever its function, *Big and Little Same* of 1981 seems a ritualized version of it, for use, say, on ceremonial occasions. The "big" and "little" refer to the terminal similar knobs, and the shaft striated dark and light. The piece forms a large ring—roughly sixty-one inches in diameter—and it looks exactly like something that might have been lugged back by some expeditionary force to a now-forgotten African tribe at the turn of the century.

Puryear is himself African-American, and I wondered if, apart from his clear sympathy for African forms and values, there might not be some expression of racial identification in the show. There is, for instance, an imposing piece that looks like an abstract thumb and curves six feet up from the floor, very much in the manner of Rodin's *Balzac* or one of Brancusi's birds. It is made of joined cedar and mahogany, closely fitted, and painted black. The title of the work is *Self*, and of course one is constrained to read it as some sort of self-representation, in which the color is regarded as integral to the statue and hence to the subject. Or perhaps one should resist the temptation to think of it that way. The piece terminates in a circular sort of cap, and the whole thing could be read as a kind of majestic presence, like one of the Easter Island heads, solemn and numinous. The work is ambiguous in its evocations; it seems at once sacral and witty, contemporary and somehow ageless. It flaunts its craftsmanship and yet gives the air of something worn smooth by the touch of generations, a giant talisman rubbed for whatever power or magic it is supposed to bestow.

Yet my sense is that Puryear's attitude toward race is expressed in a particularly eccentric work, consisting of seven lengths of twisted and abraded rawhide, tautly stretched in parallel lines across a wall, looking like lines of script in some vanished notation to which the key is long since lost. It is called *Some Lines for Jim Beckwourth*, and I was told by John Ravanal—the curator to whom I referred in my opening paragraph—that Beckwourth is one of Puryear's heroes: the scion of a white father and a mulatto slave woman, he had a number of Native American wives and in fact became a Crow chief, though he was also a cowboy and a translator. Beckwourth was defined by the boundaries he transcended—black/white, free/slave, cowboy/Indian—and an artist who honors him is not likely himself to be a great respecter of boundaries. There is another piece called *For Beckwourth*, which is made

of oak slabs, forming a crude shape each side of which is a semicircle, the whole surmounted by a kind of dome on pendentives. It is covered with dirt, and feels like a miniature tumulus. (Both of the Beckwourth pieces are labeled "Collection of the Artist," from which I infer that they hold a special place in Puryear's oeuvre, since his work is so eagerly sought after and is found in so many major public collections.)

The material identity of the Beckwourth pieces, and the cluster of associations they evoke—of a burial mound, of an ancient script (which honors Beckwourth's gifts as a translator and mediator between cultures)—raise these works to a level of great symbolic power. But sometimes one fears that Puryear's references are too narrow and too greatly particularize works that otherwise have immense power and sensuousness. *Bower* is a case in point. It is made of ribs of thin spruce, fastened in a radial array to a curved frame. The wood is lightly stained and handsome in its grainedness, and the piece has the feeling of a ship before the keel has been covered over, given a skin, as it were. It is possible but somehow inadequate to think of it in the way the title recommends, as a piece of trelliswork, a sunbreak, a nook. The same must be said for *Thicket*, a crisscross of doweled timbers that looks like a hewn astrolabe. It would have been better not to title these pieces, to let the viewer's interpretive faculty range freely among associations, or simply to let the senses respond to the beauty of the wood and the workmanship.

It is odd to criticize such works for their titles, but these reservations disappear almost entirely with the wonderful *Old Mole*, which really does look like a mole, stylized and woven densely if irregularly, as if by a basket maker who has elected to form an animal by the only available means. *Old Mole* has the look of a tribal icon, an animal spirit venerated and perhaps even intended to be sacrificed by burning. The title is certainly allusive. One is reminded of Hamlet's cry when the Ghost disappears—"Well said, old mole! Canst work i' the earth so fast?" and of Marx's wonderful, sly use of the expression to refer to the underground revolutionary. With the association of ghosts, of being underground and yet alive, and of course of revolution, we are a long way from *The Wind in the Willows*. The title situates the work in Puryear's own culture, though I cannot help but feel that it evokes another culture entirely, in which craft, in this instance wood weaving, is subordinated to the production of spirit, shaping a being that transcends its means of production. Craft is rarely used this way in our culture, which may connect with the general uncertainty of whether

craft is art, and if not, why. Craft is perhaps too often an end in itself, its meaning what in *Old Mole* is merely a means. Yet when used to fashion presences like these, basketry and woodworking become something more than themselves, and are enlisted in the generation of art.

—*The Nation*, January 4/11, 1993

Fine Art and
Functional Objects

THE GREAT calyx krater, designed by the potter Euxitheos and dec-
orated by the master painter Euphronius, which the Metropolitan Mu-
seum of Art acquired twenty years ago for a flat $1 million, is, according
to Thomas Hoving, who negotiated the purchase, "the single most
perfect work of art I have ever encountered." It is the one work, of all
those the flamboyant director speaks of himself as having fallen in love
with, that is "an object of total adoration." In his recently published
volume of memoirs, Hoving tells us how important the first glimpse
of a work of art is. So it is disappointing to read that in his "first
penetrating examination of it," in the garden of a Swiss art dealer,
where the krater was on view for Hoving's private benefit, "the first
thought that came to mind was that I was gazing not at a vase, but at
a painting."

Hoving's first glance reveals the basic scheme of values that drives
the art world today: that it is the painting on the surface of the great
vase that is the object of adoration and the perfect work of art. The
fact that it *is* a vase, and hence an object that both possesses and refers
to a use or function, is filtered by that first glance out of the work's
"whole pedigree." It is almost as if, were one able to peel the painting
off that object of crass utility, frame it, and hang it in a gallery, rather
than allow it to remain humiliatingly attached to something that owes
its form to its ability to hold fluids, one would have left behind some-
thing that, however informative from the perspective of archaeology,
is irrelevant to the work's status as fine art. To be sure, Hoving might
have reflected that in fact the painting is there to decorate an object
of conspicuous utility—and, in the scheme of aesthetic value tacitly

invoked in Hoving's first aesthetic glance, decoration ranks nearly as low as utility itself.

It is fairly plain that neither decoration nor utility was regarded as an inferior artistic activity in the sixth century B.C., when Euphronius, himself a potter as well as a painter, flourished in the red-figure industry of Attica. The scene depicted is a particularly moving one: it shows the slain Sarpedon being lifted, in the presence of warriors and the god Hermes, by Sleep and by Death. One would not affix so profound a representation to a vessel unless the vessel itself was regarded as of sufficient stature that it would be difficult to decide if the painting dignifies the vessel or the vessel justifies a painting which touches upon so deep a theme. We know of Sarpedon from the same source as Euphronius did: the songs of Homer. And we read about the ancestors of the great krater in Homer as well: the heavy bowls in which Achilles mixed the wine at the funeral celebrations for Patrocles, Sarpedon's slayer, and which Achilles offered as trophies in the funeral games that followed. Those ancestral bowls were of course made of metal: pottery making underwent an evolution in technology which facilitated an immense progress in drawing, much as technical advances in photography were to enlarge the possibilities of the photographic image. Vase drawing, in fact, was a race against time much in the way fresco painting was; in order to get colors to sing, the painter was required to apply them before the plaster dried. An artist painting a vase had to work with a coat of thin wet clay, and get the drawing down before it dried, no mean task when the vase was as large as the Metropolitan krater. And, unlike the fresco painter, who could see the painting emerging beneath his brushes, the vase painter could only see the result of his work when the drawing became visible after the vase was fired. The whole technological complex had to be in place—shaping, drawing, firing, and the rest—in order for the work to emerge as art. The risks of failure increased enormously when the scale was that of our krater, or that of its tremendous counterpart in the Louvre, which shows the killing of the Niobidae. All this for mere pots? For mere mixing bowls? It is a perversion of aesthetic valuation to reduce these amazing fabrications to the images that appear on their flanks, as if the pottery stood to the image in the kind of relationship in which canvas or plaster does to a painting: as support, with no meaning of its own to contribute.

The Metropolitan's vase displays what experts call a "love name," as do so many of the masterpieces of its period. It says "Leandros is beautiful," and indeed Leandros was a famously beautiful man, whose

known dates help date the vase itself. I suppose the vase must have been dedicated to him, or perhaps conceived of as a lavish gift to heartbreaking Leandros. And the image itself may be a sly way of alluding to Leandros's overwhelming attractiveness, powerful enough to flatten brave men who take his beauty in the first glimpses that contain his whole pedigree. Or it may pay him some other compliment: perhaps he was himself brave, or a great spearman, as Sarpedon (who was killed by a spear) and certainly Patrocles were. All that is speculation.

What is not speculation is that the entire vase is an immense tribute to its intended recipient, as great a prize as any vase distributed at the funeral games. And the vases played a role in major festivities and celebrations that pictures by themselves hardly could: the wine could be mixed and handed round, enhancing and enlarging the significance of the occasion by the presence of so overwhelming a utensil.

The pot evokes associations with the great feasts in Homer. It might be from the pot's ancestor that the Libation-Bearers in the *Oresteia* wet the grave of the dead king Agamemnon. It points ahead to the *Symposium* of Plato, in which philosophers fall into drunken slumbers after disputing the nature of love. It is rare that a painting can evoke, and certainly never in the same way, meanings of such moment. The pot belongs to forms of life paintings can only show.

In one of the most fateful passages in literature—fateful certainly for the visual arts—Plato, defining the artist as an image maker, the framer of representations, contrasts him unfavorably with the carpenter. It is at the beginning of Book 10 of the *Republic* that Plato, speaking through the mouth of Socrates, embeds the distinction between art and craft, or between representation and functionality, in a system of metaphysics that serves, of course, to place art on the bottom rung of a ladder of cognitions. The carpenter knows how to fashion in real life what the painter can merely imitate; therefore, generalizing on this, artists have no real knowledge at all, trafficking only in the outward appearances of things. This severe demotion of artistic pretense affects Euphronius as a painter, but not as a potter; the potter shares with the carpenter the reality of cognition rather than cognition's appearance, and knows how to make things that will really hold wine or water or oil or honey. From the pot maker's perspective, pictures on the sides of things, adding nothing to their effectiveness, are mere ornament; and a picture detached from any useful surface is a decoration in search of something to which it can attach itself, like a stray shadow. There

is, in Plato's hierarchy, knowledge higher than that of the artisan—namely, that of the philosopher or scientist who understands the principles through which pots, for example, hold their contents without spill. Philosophers know in the true sense of the term, since they know about the forms on which are based the deep structures of the universe. Craftspersons are somewhere between artists and philosophers, but no one is lower than the artist. It was a very vengeful and punitive picture—what I have elsewhere termed a "philosophical disenfranchisement of art."

But even without benefit of the dense maze of Platonist metaphysics, one could make a comparison nearly as unfavorable. Think of Plato's own example, that of a bed, where the distinction is between what a carpenter makes and what a painter shows. In the *Odyssey* there is a scene in which Homer describes a bed Odysseus makes; Plato would say, scornfully, that Homer is able to use words, but you cannot sleep on *them*. There is a wonderful scene painted on an early-fifth-century Grecian drinking cup from the White-Levy collection of antiquities. It shows Achilles resting on his bed, with the body of poor dead Hector underneath, a sword hanging on the wall above him. Hector's father, Priam, approaches the bed with flexed knees, begging for his son's corpse so that it can be given a decent burial. Like the one Euphronius painted, this is a very moving image, but I am interested only in the marvelous system of meanings the image of the bed releases. Achilles rests on an elbow and does not rise, while the supplicant king remains standing, and together they define a choreography of power and weakness. The bed is an even greater embodiment of a position of superiority than a chair would be. Beds are, after all, where the basic dramas of life transpire: birth, death, sleep, recovery, and sex. But in Greece, the bed was also a visible emblem of power, which is always implied by true leisure. The guests at the Symposium converse from couch to couch as they drink and eat and fondle. The picture is moving only because of the meanings the bed makes possible. Plato could erect an argument on the basis of that alone.

Each of the major categories of furniture carries meanings of the sort the artist drew upon in the White-Levy calyx. In an essay I wrote on the chair, "The Seat of the Soul," I discussed three examples of chairs in art, and showed how the artists took over certain meanings and made metaphors of them, where the meanings themselves derive from the place and role of chairs in the structures of human life. I could have achieved the same point with beds, or tables, or with cup-

boards. There is, of course, a sense in which we can also think of pictures as a category of furniture, and hence of the role pictures play in human life—not in terms of representational power but in terms of the powers of representations. Think of the pictures we carry in wallets and show around, or the photographs on the mantelpiece, or the painting in *My Last Duchess*, or images of sacred personages where the holiness of the image has little to do with the skill of the artist and is often inversely powerful to the skill. Pictures, too, are articles of furniture, whatever magic they are supposed to possess in virtue of capturing reality (even if the reality captured is, in Plato's view, of a degraded order).

The point I finally wish to make, before passing on to a further elaboration, is that the three personages—the artist, the carpenter, and the philosopher—form, since Plato situated them in a structure of thought, an eternal triangle in conceptual politics, which has lasted from Plato's time to the present day, where partisans of any one of them will seek to diminish the difference between it and its higher rival, or insist that it is, in fact, the highest form knowledge takes. The way Hoving assimilates pot to painting in his allegedly authoritative first glimpse is an index of the degree to which he has internalized a scheme in which art, and most particularly the art of painting, has triumphed over craft and where Euphronius the image maker trumps Euxitheos the pot maker on the scales of prestige. The krater cost exactly one-fifth of what Velázquez's *Juan de Pareja* cost under Hoving's administration, but one wonders if that painting would have cost so much had Velázquez painted it on the back of a chair or the headboard of a bed. In fact, the painting *had* a use: Juan de Pareja was Velázquez's assistant, and he was required to carry the portrait from influential door to influential door, so that potential patrons could compare the real face with the painted one, and perhaps think of commissioning their own portraits. But today it comes across as pure art, and pure art has to cost more than "the most perfect work of art" if the latter is contaminated by use.

In the eighteenth century, the distinction between painting and decoration was all but nonexistent, and pictures were thought of as functional objects as well: Jean-Antoine Watteau's masterpiece, *The Shop Sign of Gersaint*, was actually used as a sign for Gersaint's art store, whose interior it represents; and François Boucher and Jean Fragonard were as willing to execute decorative panels like the latter's *The Progress of Love* as they were portraits or mythological subjects.

Critical Essays

In their capacity as functional objects, paintings ranked not especially higher than the opulent fabrications of inlay and porcelain. It would have been difficult to draw the line between furniture and art, and if it strikes us as unjust that artists were held in no higher esteem than chair makers, that shows the extent to which we share a scheme of prejudices with the former director of the Met: why not treat chair makers today with the respect accorded artists? In any case, the egalitarianism between art and craft ended with the French Revolution—ironically, given its commitment to equality and fraternity. Furniture was downplayed because of its association with the luxurious tastes of aristocrats and nobility, but the demotion of functional objects to minor arts was the achievement of a painter suddenly elevated to a position of political power: it was Jacques-Louis David who reversed the Platonic order when he was in charge of the artistic affairs of the Revolution. The *major* arts were painting (of course), sculpture, and architecture, whose functionality was conveniently denied in the interests of its symbolic powers.

David saw in art, narrowly restricted, an arm of revolutionary meaning, but in the course of the nineteenth century, art as art became something which ought to be made for its own sake. From a social ranking in which artists and pot makers were near-equals in the scheme of purveyors to the aristocracy, artists became transformed into inspired beings and near-gods in the Romantic afterwash of the Revolution. Even the philosopher was not in such immediate contact with the creative energies of the world. Théophile Gautier's preface to his 1835 novel, *Mademoiselle de Maupin*, asserted the primacy of beauty even over morality. His contempt for utility was absolute: "Only what serves no purpose is truly beautiful," he wrote, adding that "everything useful is ugly." His argument was that objects of utility exist only because we humans have physical needs, and hence are, as those needs themselves are, "ignoble and disgusting." It is degrading that we must eat, sleep, and pee: "The most useful rooms in the household are the latrines." It was surely in part some dialogue with Gautier that Marcel Duchamp was conducting when he put forward his celebrated and controversial urinal in 1917; and it is perhaps in response to Gautier's attitude that "latrines" have become more and more luxurious, rather than what I surmise were dark damp closets in Gautier's domestic architecture. Our response connects us in spirit to the Romans. Louis Kahn expresses the spirit magnificently: "It is ever a wonder when man aspires to go beyond the functional. Here was the will to build a vaulted structure

100 feet high in which men could bathe. Eight feet would have sufficed." But the baths acknowledged the human need for cleansing and the constant struggle with dirt: the Baths of Caracalla heroize this conflict!

The carpenter made a comeback in France in the later years of Gautier's century, perhaps in part because the advanced artists of the time began turning for inspiration, in life as in art, to other cultures in which pictures and statuary enjoyed no special prestige. Decoration even offered itself as an ideal to Paul Gauguin, and to the artists, like Pierre Bonnard and the Nabis, who were formed by his aesthetic example. Gauguin himself made objects of at least limited function, like tobacco jars. By century's end artists were making decorative and useful objects, while even the Salon was opened up to furniture makers. More or less concurrently, the Arts and Crafts movement in England projected the vision of an aestheticized society in which painting was treated as continuous with design and decoration, and the impulses of function were on a footing with those of art. In of course a vastly different way, the same vision, in which the artist was kicked upstairs and turned into the carpenter, characterized the Russian movement of "Art into life!" articulated by Aleksandr Rodchenko.

A special historical explanation is required if we are to understand how, once again, the painter reasserted primacy of the painterly art in the mid-twentieth century. Perhaps it is derivative from the preeminence of abstraction, and the thought that abstractness is at once as antifunctional as possible and perhaps comes close to philosophy. In any case, "decoration," "illustration," and "ornamentation" became in the 1950s, and especially in New York, critical pejoratives as crushing as "literary" or even "representational" as epithets. Willem De Kooning, to be sure, dribbled paint on a wooden toilet seat in the Hamptons, redeeming function as art, according to some, and carrying forward the conversation between Gautier and Duchamp. The Studio Furniture movement took its rise in the sixties just when Pop put an end to the exclusionary pretensions of Abstract Expressionism, and Roy Lichtenstein decorated some china, which we hardly can imagine Robert Motherwell deigning to do. And the theorists of Minimalism undertook to blur the boundary between art makers and a wider society. And in our own highly politicized time, painting is increasingly on the defensive as it becomes the favored target of those who speak of it scornfully as the tribalized emblem of the White European Male. It is not surprising that painters at the present moment should find making useful, functional objects an attractive moral option.

Critical Essays

The distinction between fine art and functionality is, I have sought in this brief sketch to suggest, historically contingent and constantly under negotiation. It is not a distinction inscribed in nature, like that between sulphur and potassium. There is no simple answer to the question of the relationship between them, but it is valuable to see this history as one of shifting alliances and treaties masquerading as philosophies of art. And like everything that has to do with art, how we think of function is a matter of who has the philosophical power to enforce a classification. We are, I should think, closer, at the end of *our* century, to the spirit of pluralism that characterized the relationships between fine art and functionality during the last *fin de siècle* than we are to our own mid-century's attitudes on the matter. The attitudes of our mid-century, of course, have a certain inertia in shaping attitudes and aesthetics today, but nothing in history changes overnight. Function is one thing, craftsmanship another, and the latter gets low marks today—but that is another story altogether.

—From *Art and Application*, exhibition catalogue,
Turbulence Gallery, New York City, 1993

Photographism in
Contemporary German Art

IT IS NOT altogether clear what it was in the Berlin art world of 1828
to which Hegel might have been referring when, on the last occasion
of his stupendous lectures on aesthetics, he announced that art no
longer "affords that satisfaction of spiritual needs which earlier ages
and nations sought in it, and found in it alone." But he did proclaim
that it was not to be expected art would ever again provide that kind
of satisfaction, and accordingly, "considered in its highest vocation,"
art was "a thing of the past." The best that art could do any longer
would be "to invite us to intellectual consideration . . . not for the
purpose of creating art again, but for knowing, philosophically, what
art is." No one possessed the vision required to undertake this philo-
sophical investigation after Hegel's death in 1831, and indeed nine-
teenth-century aesthetics never sought to rise to the occasion. But in
some way it was undertaken by art itself, and especially painting, almost
as an immense collective action by artists that has continued into our
own times, as they endeavor through their work to understand the
essence and identity of art.

Nothing contributed more as stimulus to this reflection than the
emergence of photography, which existed only as a vague idea and
aspiration in the minds of certain inventors while Hegel was alive. The
year after his Berlin lectures, almost as if history were bent on fulfilling
Hegel's agenda, Joseph Nicéphore Niepce and Louis-Jacques-Mandé
Daguerre decided to pool their knowledge. Ten years later, in 1839,
the invention of photography was made public by the French scientist
François Arago, acting on Daguerre's behalf, and by the British genius
Fox Talbot, acting on his own. Since the two processes were profoundly

different, there was no question of the theft of secrets. Rather, simultaneous independent inventions, as of the calculus or the theory of evolution, act as proof of the historical inevitability of the discovery. The same thing, parenthetically, is true of artistic discoveries as well: Cubism, Abstract Expressionism, Pop, were created as styles by artists often unaware of one another's existence.

The painter Paul Delaroche, whose work would have been described as "photographic" had photography existed, is said to have remarked of the discovery that it meant the death of painting. He might better have said that the painter was dead, for the daguerreotype demonstrated that the skills required to transfer appearances from the face of reality to a blank surface could be built into a mere mechanism. And in fact, neither Niepce nor Fox Talbot was an artist, a deficiency that in both cases served as incentive to find a way in which natural processes alone would be required for the generation of pictures. And a first step in knowing what, philosophically, art is was taken when it became evident that a theory of painting accepted since ancient times—that the mark of the true painter consisted in producing images that looked to the innocent eye exactly like what they were pictures of—now entailed that artists were not needed for art. At least, such a step was taken if photography was considered art—and to raise that question was to take the second step. It is one of the ironies in the double twist of the histories of painting and photography that photographers, aspiring to the status of artists, should seek to make their images look the way paintings do, with atmospheric effects of the sort more likely to be found in the smoky canvases of Turner than in the detailed clarity of the daguerreotype—or the "photographic" exactitude of Paul Delaroche.

The next time "Art Is Dead" became a slogan was in Berlin in 1920, at the First International Dada Exhibition, where again the photograph was a weapon in the anti-art art of the participants. The manifesto for the show took up the argument where it had been left in 1839: it asked what the point was of taking pains to paint a flower or the human body, say, when one need only take scissors and snip out pictures of one or the other as necessary. Now, in truth this would not have been meaningful had Daguerre's technology prevailed, for the daguerreotype is an image formed directly by photochemical means on polished metal, expensive to make and not easily duplicated: the daguerreotype replicated the forms of reality but had no ready way of duplicating the images with which it did so. Fox Talbot's invention did

both, because it was a two-stage procedure that used paper negatives from which as many prints could be made as needed, all meeting the same standards of resolution and clarity. It was essentially the insinuation of paper into the photographic process, with the capacity for unlimited repeatability, that the Dada manifesto took for granted. With the introduction of photogravure, photographic images became a common feature in modern societies. Dada was in its nature revolutionary, and the contrast between painting (the product of solitary artistic labor, resulting in a single work of presumed preciousness, essentially elitist in conception and in consumption) and photography (construed as mechanical, industrial, commonplace) provided almost an allegory for an opposition between the bourgeoisie and the masses. And of course the Dada contribution to art was the photomontage, assemblages of photographic fragments that more or less assume an unlimited supply of images no more valuable than the paper on which they are printed, and that are readily understood by everyone, since they form the vernacular visual vocabulary of the culture.

Photography thus posed two threats to painting, only one of which was evident in the first stage of the discussion, where it seemed as though the camera had replaced the hand-and-eye method of painstakingly representing the world through picturing it. It was at that stage that photographers sought to overcome the differences between painting and photography by appropriating certain strategies from painting, and making their own images look painterly. And with the fine-art photograph, certain qualities of surface—of the kind appreciated by connoisseurs—enhanced the value of prints as aesthetic objects. But this opened up room for a second threat, this one specifically aimed at just those aesthetic qualities cherished by enthusiasts, and at the kind of rarity induced by issuing editions of photographs, as if etchings, in limited numbers. These threats came from Dada initially, which seized on what one might call anti-aesthetic qualities of the kind that marked the "working photograph," which has only the surface of cheap newspaper and comes in "editions" is large as the press runs of mass-circulation periodicals. The first kind of prints is classed as "works on paper" by museum administrators; the second kind, clipped out and stored in archives because of the information they yield, would, until Dada, have been regarded as of no aesthetic or artistic value whatever. Nonetheless, it was the working photograph, or the rephotographed photomontage, that could become a potent vehicle for political propaganda (as in the stunning work of the German *monteur*

John Heartfield), which Walter Benjamin had in mind in his influential essay "The Work of Art in the Age of Mechanical Reproduction." But of course the connotations of cheapness, of mass circulation, of artisanship rather than the kind of artistry alleged to define easel painting, were only some of the qualities of working photographs seized upon by those who used the technology polemically against "fine art."

There is a distinction to be made, then, between photography *as* art and photography *in* art. Photography as art is aestheticized work of the kind urged, for example, by Alfred Stieglitz in his tireless effort to get photography accepted as fine art. Robert Mapplethorpe, who was a collector and connoisseur of fine prints, did photography *as* art, though he pressed against the moral boundaries of the licit subjects of art. The Dadaists, by contrast, used photographs *in* art for the working materials of their montages, bits and pieces that had no particular claim to art but whose "nonartistic" properties were extremely meaningful. When Andy Warhol used four-for-a-dollar snapshots from photomachine booths, he did so for just the qualities of harshness, uninflectedness, and automaticity that would ordinarily disqualify them as art, if we think of the criteria of photography as art. But those qualities by no means disqualify their use in art, where they contribute to the larger purpose of the work they facilitate. Robert Rauschenberg transferred advertising photographs for B.V.D. underwear into his magnificent illustrations for *The Divine Comedy*. I think it would be useful to have different words for those who make photographs as, and those who use photography in, art. I'll make the effort by calling the first group photographers, as is the practice, and introduce the term "photographist" for the latter. Warhol was perhaps both. A photographist can simply be an artist who uses photographs, or what one might term "the photographic," for artistic means. The German master Gerhard Richter, reversing Stieglitz's strategy, has at times sought to enlist the energy of photographs by making paintings that look as if they were enlarged photographs. His great series on the death of the Baader-Meinhof gang, for example, consists of paintings that resemble newspaper shots, with all their artifacts and accidentalities.

I think the distinction I am after is implicit in the nuanced title "Photography in Contemporary German Art," curated by Gary Garrels and presently on view at the Guggenheim Museum SoHo. It differs sharply from a show whose title might be "Contemporary German Photography," where we might expect to see works of state-of-the-art photographers. Some parts of the exhibition could appear in a show

of photography as art—for example, the images of mine heads by the husband-and-wife collaboration of Bernd and Hilla Becher. The Bechers are photographers as well as photographists, for they use their flat, cool, frontal images to make a point, through the qualities of photographs as photographs, about what they show—usually industrial structures like water towers or blast furnaces, and the quirky, nailed-together tipples of Pennsylvania coal mines—and through showing their works in series, which lends them a cumulative investigative quality. Human beings are present by their absence, one might say, and the photographs themselves belong to the same industrial reality they depict. But the Bechers are atypical in their photographic artistry. The typical artist here is a photographist who exploits the properties of photography to further Hegel's imperative and make art whose function is partly philosophical reflection on the nature of the kind of art it exemplifies.

Consider a pure photographist like Peter Roehr, who died in 1968 at the age of twenty-four. Mechanical reproduction is the theme and the substance of his work, rather than merely an external fact true of photographs as a class. Sometimes he used mechanically reproduced things like coins, arrayed in regular rows and columns, as his motif. There his works are *of* mechanically reproduced things mechanically arranged and photographed with as little drama or expression as possible. As such, the work belongs to the same impulse as the arrangements of metal washers Eva Hesse made under a kind of Minimalist agenda. But sometimes Roehr's work is more radical. In a 1965 piece, for example, repetition characterizes both the subject and the work itself, for Roehr formed a six-by-six grid out of the same photograph: we have thirty-six images of the same man and woman taking coffee, the woman looking up coquettishly, the man looking down possessively. It is clearly an advertising photograph seeking to associate coffee with a blandly eroticized intimacy (on the same principle as the Taster's Choice couple of TV); but repetition tends to negate the image. The viewer must concentrate on one of the pairs—which one does not matter—or the iterated coffee drinkers sink into a pattern, as of wallpaper. In another work, Roehr repeated jars of Maxwell House instant coffee, something like Warhol did with Campbell's Soup cans, but with an important difference. Warhol painted the cans, making a point of the fact that so banal an object should be done "in oils." And he represented them head-on in a painterly counterpart of the Bechers' photographic style. Roehr turned them at a slight angle, so that only

the first two letters of *Kaffee* are shown, hence iterated rows of KA KA
KA . . . But *Ka-ka* is German baby talk for shit—which somewhat
juvenilizes a work that otherwise is extremely compelling.

Repetition is not part of the content of any of the photographs of
Joseph Beuys, who more or less establishes the artistic spirit embodied
in the photographism of this exhibition, but it is certainly part of their
meaning, for the photographs shown come from one of Beuys's "mul-
tiples," and the assumption is that the multiples themselves do not
significantly differ from one another. This particular multiple is related
to one of the artist's performances (or "actions," as he termed them),
parts of which the photographs document. Beuys was attracted to the
idea of the multiple—a work that exists in a certain number of
examples—because it carries a connotation of anti-elitism. Of course,
bronze statuary also comes in editions, as do fine prints and of course
fine photographs; but there is something almost defiantly anti-artistic
in Beuys's multiples (one of his most famous multiples is a gray felt
suit, which looks like something one would wear in a penal colony or
an office imagined by Kafka). Beuys famously said that every person
is an artist, which clearly required that he widen the concept of art
sufficiently to make this true. The main multiple relevant to this show
is called *Celtic* +, and it has the look of a piece of emergency gear,
like a first-aid kit, with a canister of film strapped in it, together with
a vial sealed with beeswax. The photographs record moments of the
action Beuys performed on various occasions, and it is central to their
meaning that they not be perceived as photographs-as-art but merely
as serviceable images of the artist at work, wearing his signature felt
hat and hunter's vest and workman's shoes. Beuys's art projects a world
of almost total cheerlessness, pitched at degree zero of amenity. In
Celtic + he used real time in which to do a number of seemingly
pointless but somehow overwhelmingly symbolic things, and one wit-
ness to the action recalls that while "it sounds like nothing, in fact it
is electrifying. And I am not speaking for myself alone; everyone who
sat through the entire performance was converted, although everyone,
needless to say, had a different explanation." The photographs have
the grainy look of the sort of reality Beuys sought to project, which
made the landscape of *Waiting for Godot* look, by contrast, like Miami
Beach. He was a shaman of sorts, and a visionary, with magical beliefs
in art. I met a woman to whom he gave a poster, telling her that if she
hung it up, Nixon would be defeated. (Warhol actually made anti-
Nixon posters, which brought in enough money to make him the top

contributor to the McGovern campaign and a target for constant IRS auditing under the Nixon administration; the obsession with receipts apparent in his diaries is connected with that.)

In terms of photographism's revolutionary aspirations, Beuys was a pivotal figure, connected to the spirit of Dada through his participation in the Fluxus movement of the sixties (Fluxus was an outgrowth of Dada) and to the present through the fact that so many of the photographists were students of his at Düsseldorf. One supreme difference between the successful German artist and his counterpart in America is that teaching in a university is considered a fulfillment and a supreme accolade in Germany, whereas in America success is measured in terms of being able just to "do art." The consequence is that German artists are in their nature educators, and have a primary audience in students who are prepared to take art with a certain intellectual seriousness. Of course, in the sixties, the university was also a moral and political laboratory, and Beuys's social role as professor fused with his artistic role as shaman and performer and finally as someone who embodied the ravaged spirit of Germany defeated and Germany as morally resurgent. Someone who had internalized Clement Greenberg's vision of modernist art as that which was true to the internal nature of its medium must have found Beuys a pretty unsettling presence, for purity, certainly purity of medium, was marginal perhaps to purity of soul. He was at times a fairly scary type. (At the time of Beuys's great Guggenheim installation in 1979, he and I were scheduled to have a discussion in public, but we both backed out. I don't think he regarded me as savable any more than I regarded him as savior.)

Two of the major German artists—Gerhard Richter, as already observed, and Sigmar Polke—are in the Guggenheim show in their capacity as photographists. Polke exhibits a number of modified photographs of a famous cruel painting by Goya of aged women so caught up in their vanity that they are unmindful of the decrepitude visible to the world. Polke shows us an X-ray of the painting, which reveals it in a state of decomposition nearly as extreme as that which awaits his subjects, and it carries the aura of the geriatric ward over into the revealed anatomy of the work. In another photograph, he superimposes a network of dots over the ravaged women, very much as if embellishing the work with exactly the degree of futility their own effort at embellishment of themselves conveys: the dots feel more like an orderly rash than a flirtatious pattern. In yet another, there are circles of dots—like

petri dishes—distributed randomly across the image. The dots are exactly the familiar dots of the wire-service photograph, blown up and presented like mechanical Pointillist patterns occluding the image, I suppose subversively, since these are the kinds of dots that make mechanically reproduced images possible.

Richter shows framed assemblages of the kinds of photographs that will carry a certain meaning to the person who knows the subject but that underscore the anonymity of it for those who do not. They belong to that order of snapshot that belongs under the glass on a dresser top, or fixed with magnets to the refrigerator door until it curls up and is thrown away, or gets carried in someone's wallet. They are photographs of the kind one makes with point-and-shoot cameras, of people standing awkwardly in groups affecting smiles or shielding their eyes from the sun. It is demotic photography, photography of the kind that demands nothing by way of art but belongs to the same everyday life it shows, and becomes almost achingly poignant in its answers to human needs.

Demotic photography plays a certain larger role in contemporary German photographism, most particularly in the work of Hans-Peter Feldmann. I very much doubt Feldmann "takes" the picture he shows (or he takes them only in the sense of removing them from the most banal of books and manuals). He has them bound together into perfectly dumb little pamphlets with perfectly dumb titles like *Two Pictures* printed on the cover, together with his name. The two pictures might be uninspired and undistinguished views of mountains, of no visual interest whatever. But just because almost everything that makes for interest is withdrawn from these books (they hang from strings), they are somehow vested with a certain innocence that would be moving but for the fact that we feel ourselves manipulated. This little drama of the viewer is what the works are about. That drama intensifies with Feldmann's hand-colored postcards of the Eiffel Tower.

I have not yet touched upon the more viewer-friendly works you have in store once you make it past Beuys, Roehr, the Bechers, Polke, Richter, and Feldmann. But don't count on an aesthetic experience. This is a demanding and in fact a rewarding show. But you have to work hard to get the reward, which consists in what Hegel said we were in for—coming to know, philosophically, what art is.

—*The Nation*, March 29, 1993

The 1993 Whitney Biennial

THE INSTITUTIONAL Theory of Art was put forward some years ago as a philosophical account of how something gets to be a work of art. It was provoked by certain hard cases that seemed to test the borderlines of the concept of art, such as Duchamp's readymades or, later on, the Brillo boxes and soup cans of Andy Warhol. In its crudest form—and under critical pressure the theory underwent considerable refinement in the writings of its chief exponent, Professor George Dickie, of University of Illinois at Chicago Circle—something is a work of art when decreed to be such by a loose constellation of individuals who are defined by their institutional identities to be within something called "the art world": curators, art writers, collectors, dealers, and, of course, artists themselves who, for whatever reasons, put forward certain objects as candidates for assessment as works of art. In general, something receives that status when some segment of the art world prevails, and the objects in question become occasions for appreciation and interpretation of a kind that has no application to things that are not works of art. Exhibiting something in an art show is typical of an enfranchising maneuver, and the gallery or the museum serves as a powerful transformative agency for making into artworks objects that antecedently seemed as distant from that category as, say, an ordinary snow shovel, a pile of dirt, a heap of hemp, a hole in the floor, a bundle of newspapers, or, in the classic instance, a urinal.

By now it might seem that anything can be a work of art if there is sufficient institutional interest in making it so, and it might seem no less obvious that if any group possessed the power to achieve this in any instance, it would be the curatoriat of the Whitney Museum of

American Art. So it must come as something of a jolt to Institutionalists that the Whitney's effort to haul something out of the real world and across the line into the sanctum of art has failed to turn the trick. I refer to what must be the most widely known set of images in contemporary culture, those that show Rodney King being beaten by members of the Los Angeles police force in a record of visual agony and brutality that is so much a part of the consciousness of our times that anyone who could not identify them without having to think would thereby demonstrate a distance from the culture. It would be like not knowing who Madonna is, or what McDonald's sells, or what "Coca-Cola" possibly could stand for. Those images, as again is widely known, were made by someone with an ordinary camcorder who happened to see it happening and decided to get it down on tape. The rest, of course, is history, but as a pale footnote to that history, the Whitney curators have installed the King tape in the current Biennial exhibition without having managed to turn it into a work of art. So the 1993 Biennial gets credit for adding a footnote to the history of philosophical aesthetics by demonstrating that Institutionalism has its limits, and that the concept of art is not quite as plastic as recent turns in the history of art had led theorists to believe.

Now, the King tape certainly demonstrated the power of images and at the same time the limits of art, for no work of art in recent times (or perhaps any time) has had a fraction of the effect upon society that the King tape has had upon ours: the broken storefront, the burning city, the many dead—to paraphrase Yeats—all unleashed not so much by an act of police violence as by the fact that it was recorded and shown. The images had the effect in part because they were *not* art, because they were the flat and uninflected effect of reality mechanically registered on videotape: it was the zero degree of visual and moral truth the world beheld; were it to occur to someone that art might have had something to do with it, the effect of the tape would be diminished. I can understand an artist seeking to borrow the power of the King images for, let us suppose, creative purposes of his or her own, the way Spike Lee sought to do with his appropriation of them in the opening sequence of *Malcolm X*. Lee put them into a work of art without making the tape itself into a work of art; and indeed nothing can or should make a work of art out of that tape. That would put us in just the wrong relationship to it. In fact, any relationship in which we are put to the images other than the relationship in which they put us to the event they transcribe and record is a wrong relationship. About the

tape itself there is nothing to say. It may seem unjust that snow shovels, bottle racks, bicycle wheels, and Brillo boxes can cross the line into museum precincts while this tape languishes without. Still, it is instructive that there is *something* that evidently resists being turned into a work of art. In showing the limit and the limitations of art, the Biennial gets credit for a second achievement.

What I am giving credit for as a contribution to our understanding of art is almost certainly subversive of what the Whitney's curatoriat sought to achieve in this exhibition, which was to assemble a body of works potentially as transformative of consciousness, and thence of society, as the King tape proved to be. The viewers were to be made into better people and the world a better place. In this the show fails altogether. Art as art really has certain limitations, and these are made palpable when we reflect on what the King tape would lose to truth if it were art instead of document. But beyond that the order of work in the aggregate here is mawkish, frivolous, whining, foolish, feckless, awful, and thin. Its messages rarely rise to, let alone rise above, a level set by the bumper sticker, the T-shirt, the issue button. The average work here is a one-line zinger. A good example—it seems cruel to pick out an example when almost anything shown would do—is *Lineup*, by Gary Simmons. It consists of a set of parallel height lines against which possible suspects are placed in police lineups. On the floor is a row of pairs of athletic shoes—fancy hightops—of the kind favored by ghetto youths. (They are, irrelevantly, gilded.) The height lines together with the shoes form an enthymeme, a pair of premises from which the viewer is to draw a conclusion, which is that it is *ghetto* youths—the "usual suspects"—who are made to stand in police lineups. So the subject of Simmons's work belongs to the same reality as that of the King tape, with the difference that it is a cheap shot while the King tape is outside that kind of discussion altogether. Perhaps the Simmons work and the King tape form their own enthymeme, telling us that art, however well intentioned and in however good a cause, just isn't up to what the tape achieved and the curators wished for. I'll give the Biennial credit for that too, even if, like the exhibition's other merits, it is inadvertent.

Or consider Sue Williams, whose work is paradigmatic of what Lisa Phillips had in mind in the catalogue, where she writes:

One of the most powerful developments among artists in this emerging generation is a deliberate rejection of both an authorial voice and form—of all the emblems of successful art: originality, integrity of materials, coherence of

form. Much of the work is handmade, deliberately crude, tawdry, casual, and lacks finish. . . . Appropriation, much of it from the lowliest of sources, continues to inform much of this art, as does a heavy presence of words, printed or handwritten or scavenged.

Williams has scrawled, using the least refined lettering of which she must be capable (I take it this is a willed degradation of her drawing skills), graffiti-like proclamations of victimhood—though she has gone to some trouble to have fabricated (unless she bought it in a joke shop) a particularly convincing rubber-and-foam pool of vomit and laid it in front of her work on the floor. Her themes are eating disorders, pornography, and the abuse of women, and I suppose the coarse style she has appropriated, a kind of graphic raving, strikes her as the only one suitable to themes it would be wrong to represent with finesse. The work must be as raw as the feeling it expresses. It is aggressive toward viewers, and is almost transcendentally callow.

Now, the seemingly intractable subject of eating disorders can be treated with artistic intelligence, as in the three-part installation by Janine Antoni on the fourth floor. It consists of a very large block of chocolate, what once was a block of lard that looks somewhat the worse for wear but is readily enough replaced, and a stunning display case, in glass and polished metal, of the kind one might see in a swanky *parfumerie* in the Faubourg St.-Honoré. The piece is about bulimia, and this is emblematized by the fact that the artist has gnawed off and then spat out bits of chocolate (you can see the tooth marks) and of lard. These she has fabricated into the shape of chocolate hearts, and, mixed with beeswax, into shiny "lipslicks," both of which are displayed in the showcase, which bears the signature JANINE ANTONI, as if the name of a fashionable designer. My sense of the work is that it endeavors to show the mind of the bulimic symbolically, and from within. Antoni has found objects that emblematize the bulimic's fantasies of beauty and of love, for the sake of which she forces herself to throw up: the sweet heart, the lipslicks in their polished cases, embody her wishes in the form of symbolic fulfillment. The subtitle of the third component, the display case, is *Phenylethylamine*. This is an ammonium derivative that, I learned from a handout when I first saw this work at the Sandra Gehring Gallery, is present in both chocolate and the body's exudate in the act of love. The hearts and lipslicks, on one shelf wittily arranged in the shape of a heart and which suddenly can look like a rank of cartridges stood on end, embody the chemistry and

serve as symbols for the love the bulimic so pathetically seeks. It is a brilliant work—a piece of thought about a kind of thought—subtle, effective, reflective, and smart, and filled with a kind of gaiety so missing from the work in the show that Williams's shrill posters typify.

Sometimes the work looks interesting until you find out what its intentions are. Byron Kim, for example, shows a panel of monochrome browns, beiges, pinks, and ochers, arrayed as paint samples are in the charts one consults in paint stores. My first thought was that Kim had cagily used the format of the sample chart to deflate the extravagant claims monochrome artists—Malevich, Rodchenko, Reinhardt—have at times made in regard to their reductions of painting to a single color, what Kim describes as "something universal, spiritual, something too large for words." It was not at all this, but rather a kind of politicization of monochrome by using the colors of skin. "I believe that there is a gold mine of irony," Kim writes, "lying at the intersection of the formalist painting skin and human skin itself." Well, maybe. But there is a clear sense in which a painting is just its skin, whereas the color of our skin is, as we say, merely that deep. And Kim appears to make this point with his other, rather less interesting, work, called *Belly Paintings*, which shows a row of bellies, I gather pregnant, which bear the colors of the obvious races. Is the point not that beneath the skin we are all alike? Or are we like paintings, constituted by our skins, so that our surface colors penetrate us totally, to the point where someone not white might be able to assert, as do (in parts) the little flat admission buttons everyone must wear, "I can't imagine ever wanting to be white" (itself, by the way, a work of art by Daniel J. Martinez, who has used this artifact of today's art museum to the ends of mild propaganda). Well, Kim's work won't answer that question, and at its best it has made a slight contribution to the theory of monochromy as a painting gesture.

I have chosen four examples of the kind of issue-related art the show is made of in its entirety. A good many of the exhibits are strident in advancing their messages, and in form are noisy, disheveled, disordered, menacing, and arrogant, to the point that an injustice is done to many of the works whose originality, integrity, and coherence—all those attributes discredited by Lisa Phillips—are drowned out by the surrounding visual clatter. Cindy Sherman's astonishing arrangements of anatomical models into shriekingly erotic depictions (when in fact they are really medical still lifes) display that artist's mischievous taste for the grotesque. What her works tell us about the sexual imagination

requires a monograph-length analysis; but here their intelligence, wit, and inventiveness are flattened out by the context of plastic vomit and scribbled inscriptions. Nan Goldin's photographs of her friends, who appear to be paying terrible prices for living at the erotic fringes of existence, we can see must be poignant and felt deeply, but they have been recruited to make points rather than open vistas into her subjects' interior lives. Ida Applebroog's images, which here as always convey a saturnine misanthropy several shades darker than Goya's, are stifled by the presence of so much moral hoopla. None of the world's masterpieces could stand up to this much din and dizziness. None of these admirable artists especially need representation in the Biennial for the enhancement of their reputations; were I any of them, next time I would certainly get a clear picture of what my work was in for before I allowed it to be shown. This is a bean counter's dream show, with a number of artists selected, one feels, because they are representative of some group the curators felt it important to bring into the museum. By one criterion that is commendable, but at the price of putting such pressure on the concept of the museum that it is unclear what collateral harm has not been done.

I end by returning to the King tape, which if not a work of art is certainly the basis for some obvious metaphors. I and most of those with whom I have spoken felt as if we had been *bâtonné* by the art force, caught up in a moralizing rampage. I can't imagine ever wanting to have had anything to do with the 1993 Whitney Biennial exhibition.

—*The Nation*, April 19, 1993

AESTHETIC
MEDITATIONS

Art After
the End of Art

THERE IS a passage in the writings of Karl Marx which is as fateful as it is famous, and indeed its fatefulness is not unconnected with its fame: "Hegel remarks somewhere that all great, world historical facts and events occur, as it were, twice. He has forgotten to add: the first time as a tragedy, the second as farce." If this indeed is the second time this thought is expressed in the philosophy of history, it must by its own criterion be farce and its first occurrence in Hegel tragic. And something like this indeed is true: since every Marxist knew this line —it is the kind of slogan that gets printed on T-shirts—it made it necessary for them to dismiss repetitions as farcical, as the learned revolutionaries in the Columbia University uprising of 1968 did when the learned students of Harvard underwent *their* uprising. And this had the overall effect that there could be no cumulative revolutionary movement, veterans of first happenings being obliged to be contemptuous of the veterans of their repetitions. Hegel's statement is far less well-known, and indeed certain Marxist writers, such as my colleague at *The Nation* Alexander Cockburn, expressed doubt that Hegel ever said any such thing. But here is the passage, which occurs in the section on Rome in his *Lectures on the Philosophy of History*:

In all periods of the world a political revolution is sanctioned in men's opinions when it repeats itself. Thus Napoleon was twice defeated, and the Bourbons twice expelled. By repetition, that which at first appeared merely a matter of chance and contingency became a real and ratified existence.

Marx's jest appears in the tract *The Eighteenth Brumaire of Louis Bonaparte* of 1852, and it refers to the coup d'état of Louis Bonaparte,

the nephew of the great Napoleon, who executed a coup d'état on the Eighteenth Brumaire (November 9, 1799). Had Louis Bonaparte been a reader of Hegel he would have seen in the repetition a "real and ratified existence." Had the Columbia students been readers of Hegel, they would have seen in the Harvard uprising a ratification of their own. The moral, perhaps, is that if one wants one's writings to inspire revolutionaries, it would be prudent to resist wisecracks, for one's humorless readers will take them as literal.

Since my writings about the end of art, which started in 1984, repeat a thought expressed in Hegel's marvelous *Lectures on Fine Art*, delivered 156 years earlier, in Berlin in 1828, I would clearly rather see in the repetition a ratification of historical necessity than a farcical reenactment—not the only reason I prefer being a follower of Hegel rather than Marx. But in truth I am a follower of neither, for I don't especially believe in historical repetitions. If anything, I suppose, I am a follower of Wittgenstein on the matter of iterated utterances, for he held that the meaning of a sentence very often is a function of the role it plays in what he termed a language game, so the same sentence expresses a different sense on different occasions of its utterance. Or, better, I am here a follower of Paul Grice and his fascinating thesis concerning conversational implicature. Simply put, that means that to understand what someone means by an utterance, one must fill in the conversation in which it gets uttered and see what movement of thought the sentence advanced. I think, for example, of history as having something of the structure conversations have, so that one could speak of *historical* implicature. And that would mean that one would find, upon noticing that philosophers in different periods have said outwardly the same thing, that the sameness dissolves when one fills out the evolving discussion in which the sentence got uttered. But even within a context, the repetition is never simply that: Nabokov, an admirer of Robert Frost, points out how vividly the second "And miles to go before I sleep" differs in force and meaning from the first. As a critic I am never put off by the fact that what an artist does has been done before. That someone did it "first," it seems to me, is often the kind of observation which blinds you to what the artists did who did it "second." It need never entail a lack or absence of originality. Of course, you might say, I *would* say that, just to protect myself from being thought unoriginal when I have said something that has already been said by Hegel! But let's examine another case, especially since neither Marx nor Hegel talks about things happening more than twice.

Recently I have become absorbed in the topic of photomontage, which was the chief artistic invention of the Berlin Dada movement of the early 1920s. There are some wonderful photographs of the First International Dada Exhibition of 1920, showing some of the main contributors posed with a poster which proclaims the death of art. *"Die Kunst ist tot,"* the poster reads. "Long live the new Machine Art of Tatlin!" One photograph shows Hannah Höch and the "Dadasopher" Raoul Hausmann with the poster, another the great *monteur* John Heartfield and his colleague George Grosz. I think they thought that the photomontage exemplified machine art, as they understood it, inasmuch as it consisted of assemblages of cutout fragments of photographs printed in newspapers and periodicals of mass circulation, and both photography and printing were exemplary mechanical processes, conspicuously contrasted with the kinds of pictures the trained and expert hand might make by drawing or painting. It was what one might call "handmade" art that was dead, or fine art, or finally easel painting, which was what precisely radiated the celebrated aura Walter Benjamin made so much of. And I am certain that when he contrasted what we might call "auragenic" art with what Benjamin himself called "the work of art in the age of mechanical reproduction," he had specifically John Heartfield's photomontages in mind. Heartfield, in addition to using mechanically processed fragments, inserted his own montages into further mechanical processes, since he rephotographed his work, and then printed it on the covers of the Left-wing *Arbeiter-Illustrierte-Zeitung,* or *AIZ.* Benjamin was a great admirer of Heartfield, "whose technique turned the book cover into a political instrument."

Now, easel painting was villainized in the revolutionary artistic ferment of the Soviet Union in its early days. In 1921, a plenary session of the Institute of Artistic Culture (Inkhuk), charged with formulating a role for art in a Communist society, voted to condemn easel painting as "outmoded," and several of the leading members left Inkhuk to enter industry: this was specifically Rodchenko's "Art into life!" initiative. In 1943, Lincoln Kirstein published a report of his visit to the Siqueiros murals in Chillán, Chile, the year before: "Siqueiros is a fighter, and at the present moment he proclaims himself on a personal crusade to destroy easel painting. To hear him talk, the *caballete* [easel] is the fascism of art, this monstrous little square of besmirched canvas, pullulating under the skin of rotting varnish, fair prey for those canny usurers, the speculating picture dealers of the rue de la Boëtie and Fifty-seventh Street." So when, writing in *Partisan Review* in 1948,

Clement Greenberg warned of "The Crisis of the Easel Picture," he more or less adapted a critical matrix from radical thought and applied it to the art of his time, which he saw approaching the status of wallpaper as flat, allover patterning of interior space. And I think it fair to say that the villainization of the easel picture continues today, less as an assessment of the state of painting—less, that is, as a claim that painting has somehow run out of steam—than as an attack on social and political institutions and practices with which the easel painting has been associated: the private collection, the art museum, the art auction, the gallery, the "usurers" of whom Siqueiros spoke. And the art that is to replace easel painting—the photomontage, the book jacket, the mural, the dropcloth, or, today, the performance, the earthwork, the installation, the video—are promoted precisely because of the difficulties they raise for the institutional embedding of the easel painting. And needless to say, such art as this opposes itself to the popular mentality which treats painting as somehow having a spirituality and a mystique, which brings thousands and thousands to trudge past Monet's serial paintings of the 1890s, or, more recently, Matisse's stupendous oeuvre.

It should be clear that the "Death of Art," construed as the Death of Fine Art, is a political declaration. It is a revolutionary cry, like Death to the Ruling Class! The Communists, subscribing as they did to a doctrine of historical materialism, ought, if their theory were historically sound, merely to have had to await the withering away of painting as a practice. But revolutionaries are not famous for patience or, for that matter, for consistency.

Now my thesis of the end of art was not in the least an ideological one. It was almost, in fact, counter-ideological, in that it entailed the end of all mandated ideologies, which believed themselves grounded either in the history of art or in the philosophy of art. It in any case was not a thesis about the *death* of art, though my essay first appeared in a volume of pieces devoted to my thesis, and the book carried the dramatic but false title *The Death of Art*. I used "end" in a narrative sense, and meant to declare the end of a certain story. It was, as I pointed out at the time, consistent with the story coming to an end that everyone should live happily ever after, where happiness almost meant that there were no more stories to tell. My thought was that art came to an end when it achieved a philosophical sense of its own identity, and that meant that an epic quest, beginning some time in the latter part of the nineteenth century, had achieved closure. Painting played

a particular role in the epic because it was painting whose identity had been put in question by two factors, one of them technological and the other cultural. The technological *mise-en-question* was the invention of moving pictures, which meant that one could attain the great representational aims, always ascribed to painting, by a different means altogether. It was moving-picture technology rather than the invention of photography as such, for photography simply was another means of doing what painting had always done: it was, so to speak, a tie. But *moving* pictures quite left painting behind. The cultural challenge came with the challenge to the ideal of veridical representation itself, and the prize of other artistic ideals altogether, as practiced in alien cultures, Japanese, Chinese, Egyptian, African. Abstraction, which emerged in 1912, was one response to this latter challenge, but so was a good bit of post-Impressionist art. There was no question in artistic practice but that a certain idea of painting, in place since about 1300, had come to an end. The issue was what was painting now to be, and this in the end could only be answered with a philosophical theory which I saw the painting movements of the twentieth century as a massive effort to furnish. And I thought in fact it had found what it sought by the 1960s, and that art now had to be understood as one with its own philosophy.

I offered, in brief, a kind of master narrative which must be considered alongside the reigning master narrative of modernist painting which, as that very expression should suggest, was due to Clement Greenberg: "Modernist Painting" is the title of one of his most important essays. Greenberg is typically regarded as a formalist critic, but his formalism is grounded in a philosophy of history of great originality, and in truth I have often wondered whether one can be a serious critic without at least a tacit adherence to a philosophy of art history. In any case, Greenberg's philosophy of art history was in place at the very beginning of his critical career—for example, in his tremendous piece of 1939, "Avant-Garde and Kitsch," in which he sees a certain kind of abstract painting as the inevitable absolute for which the avant-garde had been seeking: "Content is to be dissolved so completely into form that the work of art or literature cannot be reduced in whole or in part to anything not itself." This is the "genesis of the abstract," and I draw attention to the historicist term. Greenberg goes on to say, "In turning his attention away from subject matter of common experience, the poet or artist turns it upon the medium of his own craft." And he then invokes the great deities of Modernism—"Picasso, Braque, Mondrian, Miró, Kandinsky, Brancusi, even Klee, Matisse,

and Cézanne"—who "derive their chief inspiration from the medium they work in." The historical dimension becomes explicit in "Towards a Newer Laocoön" of the same year: "Guiding themselves . . . by a notion of purity derived from the example of music, the avant-garde arts have in the last fifty years achieved a purity and a radical delimitation of their fields of activity, for which there is no previous example in the history of culture." He characterizes purity this way: It "consists in the acceptance, the willing acceptance, of the limitations of the medium of the specific art." And the philosophy of art history is this: "The progressive surrender of the resistance of the medium." Finally, "so inexorable was the logic of this development"—and I draw attention to the double connotation of necessity carried by "inexorable" and "logical"—that artists who wished to be part of history had little choice save to enter it under Greenbergian criteria. Recently, Greenberg told me that he was only describing things, not making any prescriptions. He cited the difference between "is" and "ought" which he was pleased to learn derived from David Hume. But in these influential early papers it certainly reads like a prescription: as he says, "The imperative comes from history." And "Modernist Painting" of 1960 puts it in this nutshell.

The unique and proper area of competence of each art coincided with all that was unique in the nature of its medium. The task of self-criticism became to eliminate from the specific effects of each art any and every effect that might conceivably be borrowed from or by the medium of any other art. Thus would each art be rendered "pure" and in its "purity" find the guarantee of its standards of quality as well as of its independence. "Purity" meant self-definition, and the enterprise of self-criticism in the arts became one of self-definition with a vengeance.

It is fairly striking that Greenberg and I see self-definition as the central historical truth of modernist art. But his narrative differs in every other respect from mine. He sees self-definition in terms of purity, and hence the history of Modernism as the pursuit of painting in its purest possible state: a kind of genre cleansing, as one might put it, a program easily politicized as aesthetic Serbianism. But my view is altogether antipurist. My thought is that art ends in philosophical self-consciousness of its own identity—but that entails no imperative to produce philosophically pure works of art. Far from it: a philosophy of art must be consistent with all the art there is and ever has been,

all of it art in virtue of embodying whatever essence it is that can be expressed in a real definition, with necessary and sufficient conditions. In fact, it seems to me, an adequate philosophy of art straightaway entails pluralism, for it would be wholly adventitious that there should be one and only one kind of art—only, say, five-foot squares, matte and black, partitioned into three-by-three matrices, of the sort that Reinhardt, speaking in the spirit of purism, declared to be the only kind of painting there should be. The Greenbergian position entails a critical practice in which one can say of what is not pure that it is not art. Mine by contrast is altogether accepting. In ancient times, philosophers sought to define what it was to be a human being. "Rational animal" was a good try. But there is a great deal more in human reality than is captured by such definitions, and to try to breed for humans who were purified of all these accidentalities would merely create misery.

The difference between the two positions can be further marked by thinking of abstraction. By Greenberg's philosophy, abstract painting is a historical inevitability. Figuration is an excrescence to be discarded by "self-criticism." Moreover, it has to be abstraction of a certain kind: Kandinsky deployed abstract forms in an unmistakable pictorial space. That too has to be purged. It belongs to what, in "Modernist Painting," Greenberg calls "sculptural illusion," for it implies a three-dimensionality inconsistent with painterly purity, which mandates absolute flatness. Greenberg concedes that "the flatness towards which modernist painting orients itself can never be an utter flatness." So, if you want to be a painter, you have a choice. You can endeavor to drive the limits further by whatever increment in the direction of utter flatness. Or you can become a sculptor, and seek whatever purity defines that medium. In any case, the flat painting is the destiny of abstraction on the Greenbergian model, and his own critical practice reflects this, first with color-field abstraction, then with the painting of such favorites of his as Jules Olitski, whom he continues to regard as the best painter around.

In my view, abstraction is a possibility rather than a necessity, and it is something permitted rather than obliged. In fact, the art world as I see it—as I think it sees itself, having lived through a certain history—is a field of possibilities and permissibilities in which nothing is necessary and nothing is obliged. Heinrich Wölfflin famously ended the preface to the later editions of *The Principles of Art History* by saying not everything is possible at every time. It is the mark of what I have

termed the posthistorical period of art that everything is possible at this time, or that anything is. A year or so ago, the advanced art periodical *Tema Celeste* asked a number of critics and artists why a painter today would make a painting without any recognizable images in it. The responses were presented in three entire issues of the magazine. The 1990 season, in fact, had at least five major exhibitions of abstract art, and every American art magazine had to respond to the phenomenon, asking what it meant. All this activity scarcely a year after a critic in *The New York Times* had said that abstraction was burnt out. Whatever the historical explanation of this complex event, it did not seem to me that as a historical repetition, it could be assimilated to either a Marxist or a Hegelian characterization. The second moment of abstraction was neither a farcical reenactment of an earlier one nor a ratification of it. And it seems to me that the kind of answers Greenberg would have given to the first moment of abstraction—that it was a historical inevitability, an imperative of history, a purification only to have been expected in the light of the observed dynamisms of modernist painting—hardly would recommend themselves the second time abstraction flourished. The clear truth was that abstraction was possible; the question was what made it so vehemently actual all at once. And the answer would have to be, it seems to me, causally local rather than global. It is the kind of thing one might expect after the end of art in its philosophical self-definition.

I think of posthistorical art as art created under conditions of what I want to term "objective pluralism," by which I mean that there are no historically mandated directions for art to go in, at least so far as the history of art, considered internally—as Greenberg certainly considered it—is concerned. For him, the arts entered their terminal phase when each ascended, as it were, to its own metalanguage, and where the materials of the art became the subject of that art. Under the auspices of that theory, for example, furniture making, as an art, would have as its subject wood, joinery, and finish. And the subject of sculpture would be stone and carving, or clay and the act of modeling. And painting, of course, would be about paint, and the act of putting it onto surfaces, and then the truth of surfaces. Painting about the way the world looks would be retrograde, historically speaking, since nonreflective. Strictly, it was not necessary, save for purposes of emphasis, that painting be abstract: it could be representational so long as it was not about whatever it represented, and I think De Kooning with his typical conceptual brilliance caught this point when he said, in 1963

in regard to his famous paintings of women, exhibited a decade earlier at the Janis Gallery, that it was of course absurd to paint the figure—but then it was no less absurd not to. But in 1953, when those works were exhibited, they were widely criticized as betrayals. And I think it impossible to convey to an audience of today the atmosphere of dogma which defined discourse in the art world of those years. The censoriousness of critical discourse would be captured in such phrases as "You can't do that!" or in the phrase which continues to play a role in conservative critical writing: "That is not art!"—said of something which could not in any obvious sense be anything but art. In painting, in the 1950s there was thought to be only one true historical possibility, and that was what one must call "materialist abstraction" because it was about the materials of painting and nothing else. And objective pluralism as I understand it means that in the sense in which materialist abstraction was the only true historical possibility, there are no historical possibilities truer than any other. It is, if you like, a period of artistic entropy, or historical disorder.

The philosophy of history was said by one of its greatest practitioners, the Swiss historian Jakob Burckhardt, to be a centaur, a monstrosity of thought in the sense that it demands the necessity of metaphysical truth and at the same time must be empirically true. My point is that Greenberg was seeking what in his own terms was a "historical justification for abstraction," which in fact was a historical justification of materialist abstraction in 1939. And I am seeking a historical justification for an account of posthistorical abstraction as but one of a number of other posthistorical possibilities in 1990, a quarter-century after a better philosophical answer to the question of art than materialist abstraction became available, and one, moreover, which liberated artists to do anything or everything. Here is a vivid recollection by a German artist, Hermann Albert, of a moment when what I would term the truth of posthistory dawned on him:

In the summer of 1972 I was in Florence for a while, and one weekend I went on a trip to the mountains with some colleagues. We got out of the car and there we were standing in the Tuscan countryside with cypress trees, the olive groves, and the old houses—it was harmony. The sun was setting and soon it was out of sight, but the rays of sunlight were still illuminating the countryside obliquely. The shadows were getting longer and longer, and you could sense the approach of nightfall although it was still daytime. We stood, with our own consciousness, looking at this dramatic spectacle, and suddenly one of us said,

"It's a pity you can't paint that anymore these days." That had been a key word I'd heard ever since I started trying to be a painter. And I said to him, out of sheer impudence: "Why can't you? You can do everything." It was only after I'd said that that I realized what had initially been a piece of provocation was really true. Why should anyone tell me I can't paint a sunset?

I want to underscore the date—1972. And I want to underscore the marvelous defiance in Hermann Albert's "You can do everything." As a German artist, the rejection of abstraction was particularly charged, for Germans had taken up abstraction as a way of reentering the community of Western culture. The postwar Germans took up abstraction, after all an American export, as a way of endorsing the values of the victors. So when Albert said, "You can do everything," he in effect was saying that it was now possible to be a figurative artist in Germany without being a Nazi. But "You can do everything" almost defines the decade of the seventies. The art schools were filled with unsuccessful Abstract Expressionists, painters who sought to transmit the teaching of Greenberg and of Hans Hofmann, who insisted that a painting is not a window, and that it was a crime against painting to "poke holes" in canvas. Eva Hesse and Robert Mapplethorpe both reported having been exposed to that kind of dogmatic instruction when students at Pratt. And in different ways they all enacted in their work the belief that you can do everything.

The seventies are a fascinating period whose art history is as yet uncharted, but it is certainly, as I see it, the first full decade of post-historical art. It was marked by the fact that there was no single movement, like Abstract Expressionism in the fifties or Pop Art in the sixties—or, delusionally, Neo-Expressionism in the eighties. And so it is easy to write it off as a decade in which nothing happened when in fact it was a decade in which what happened was everything. It was a golden age which seemed to those who lived through it to be anything but a golden age. And my sense is that what gave it that character was the objective pluralist structure of posthistory: it was no longer necessary to pursue the material truth of art. Or rather, a lot of artists continued to accept the materialist ideal as that in which art essentially consisted, but felt that it no longer responded to anything they were interested in, and they pursued what they were interested in whether it was really art or not. That gave artists an immense amount of freedom, and since the gallery structure, with some marginal exceptions in the newly settled SoHo, had no place for anything except what *was*

"really" art, artists had no special expectation anyway of fame or fortune. In 1973, New York was just staggering back from the edge of bankruptcy. One could live fairly cheaply, and do what one did for a very small circle of like-minded persons. And a lot of the cultural politics of the time in any case turned artists away from the institutions of the art world toward other, less commercial venues.

There was another kind of politics which began to ascend in that period, whose best example is a certain kind of feminism—namely, one which calls into question the kind of painting which was the vehicle of art history and which culminated, in Greenberg's theory, in materialist abstraction. The question began to be raised as to whether art of this sort was at all the appropriate vehicle for a feminine sensibility and creativity at all, whether, in fact, it was not itself a form of false artistic consciousness for women to seek to excel in something which was after all possibly just a form of expression natural to males. And analogous arguments sprang up along different lines through which various excluded minorities sought to express, in terms appropriate to their essence, the artistic forms of their being. I don't say this was altogether explicit in the seventies, but the tendencies culminated in the Decade Show at the end of the eighties, which had the consequence of marginalizing—guess what—easel painting. The reasons, certainly, were different from those which prevailed in Berlin in 1920 or in Moscow in 1921 or in Mexico in 1941. But it has been the mark of a certain form of politicized art in this century to villainize easel painting, and the charge that it is a white Eurocentric male expression is only the latest form the politics has taken.

So the slogan "You can do everything" is in many cases politically qualified in practice. In my own contribution to the *Tema Celeste* colloquium, I talked about abstract painting as a possibility in the accommodating framework of objective pluralism, and a correspondent scolded me for not realizing the kinds of pressure there are on someone who wants to be an abstract painter to produce work more feministically acceptable (the writer was a woman). There is beyond question a great deal of such pressure in the art world today, a lot of it, of course, internal, but unquestionably a great deal of it external, especially when one factors in wanting to make art acceptable to critics and institutions and programs with a clear political agenda. To this I have no response. Causes are causes. The only respect in which "You can do everything" is true is that of a philosophy of art history of the kind I have tried to develop here. But it is consistent with that that there should be all sorts

of causes, political and otherwise, which enter into the explanation of art.

I want to conclude on two notes. The first concerns abstract painting today. Since it is, to begin with, no longer the bearer in anyone's mind of historical destiny, abstract painting is but one of the things an artist can do. It is, as logicians say, compossible with representational art, and a great many abstract artists I know see no conflict, and certainly none of the ostracizing kinds of conflicts representational artists felt in the 1950s. Moreover, since the feeling of marginalization from within the art world is felt by painters whether they are abstractionists or representationalists, the two camps, bitterly divided in the era of Greenberg, find the differences between them today negligible by comparison with the differences between either of them and performance, say, or installation. But finally, there is a difference between abstraction and formalism. Some of the best abstractionists I know feel one does not leave meaning behind when one becomes an abstract painter, and that often meanings of a kind unavailable to figurative art can be carried by abstract art. In an interview with Carter Ratcliff, Sean Scully says about his severe abstractions of the late 1970s that he *needed* to paint "severe, invulnerable canvases, so I could be in this environment [New York] and not feel exposed. I spent five years making my paintings fortress-like." That kind of statement connects the formal properties with personal feelings, and confessionalizes the work in an extraordinary way. And when he says, "Recently I've been more interested in having my painting be more vulnerable," a great deal more is involved in the shift from the relentlessly thin stripes of the seventies and the almost organic dilating and brushy stripes of Scully's later work than a shift in style. It marks rather a shift in *life.*

My second point is that "doing everything" is distributed across the whole face of the art world, as if by a division of labor. But the most interesting artists in this respect, I think, and artists who, moreover, have no easily identified predecessors, are in fact those who do everything themselves, and in whose oeuvre there is in consequence a certain magnificent openness, whatever one thinks of the component works. These artists tend mainly to be German—I may be wrong but I can think of none in America. I have in mind Sigmar Polke, Gerhardt Richter, and perhaps Rosemarie Trockel. Richter's abstractions are in shows of contemporary abstraction. Polke does large cloudy abstractions almost as if exemplars of the materialist abstraction of an earlier time. But we have to ask in both cases what abstraction means, given

that one of the artists did the breathtaking images of the death of the Baader-Meinhof leaders, and the other produces montages using photographs, but also engravings from other times, paintings from other cultures, and what look like stylizations of fifteenth-century calligraphy. A show of Richter or, for that matter, of Trockel, looks like a group show, and in their resolute distancing of a marked visual style, their readiness to use whatever they require for whatever purpose, their blank disregard for purity, these artists embody, in all that as well as in their spirit of absolute free play, the posthistorical mentality in its most spectacular form. We are about as far from materialist abstraction as can readily be imagined!

Quality and Inequality

All things excellent are as difficult as they are rare.

— S P I N O Z A

N O T L O N G A F T E R the publication of Michael Brenson's article "Is Quality an Idea Whose Time Has Gone?" on the front page of the Arts and Leisure section of *The New York Times* for July 22, 1990, I participated in a panel during which one of my fellow symposiasts said, with a certain acidic jocularity, "I see the *Times* has taken a stand against quality." The speaker was an extremely well-known connoisseur, collector, and dealer, who had put together an important catalogue raisonné on the work of a major painter of modern times, and though he of course knew that Brenson was reporting more than editorializing, he meant to say something painful, because the news itself, if true, struck at the very foundation of his various competences: if quality was something over with and done, so was he. A month after the appearance of Brenson's piece, there was a critical response to it by Hilton Kramer in *The New York Observer*, in which again the intention was to inflict hurt, but which made the unexceptionable point that the denial of quality in art was inconsistent with "the nature of [Brenson's] own experience of art. It is in the nature of that experience to respond more favorably to some works of art than to others, and it is the critic's task to make sense of such differences." If quality is an idea whose time has gone, criticism is a practice whose time has gone as well—and with what right is Brenson to carry on as art critic if the very feature which calls for criticism has vanished from the critic's subject?

I think we may go further than Mr. Kramer did: it is the nature of experience itself, critical or otherwise, animal or human, to respond more favorably to some things than to others. We are built as discrim-

inating mechanisms, and were we not so, dear old evolution would crash to a halt. That leaves the question as to whether what we are responding favorably to is *quality*—or whether quality is simply a term which describes that to which we respond favorably—with the cynic saying that quality is all in the mind of the beholder, with no objective purchase on the world. But that overlooks the fact that beholders themselves are part of the world, and the explanation of their behavior requires at the least some understanding of how they (we) respond differentially to things. Not to respond differentially is not to respond at all, and our experience with the fine arts is simply a further transcription of something that takes place in our animal being and throughout the animate world. In an address Brenson delivered before the Visual Arts Program in Washington, D.C., on February 1, 1992, he said that he had been talking about the *word* "quality," not the *idea* which it expresses, and indeed he had said as much in his original article: "Should the word quality be used? Probably not. If it is used negatively, to criticize an artist or a body of work, it should be with extreme care." But what will have changed when the word is dropped or its use hedged if the idea itself remains intact, as well as the practices associated with it? No doubt the word "quality" has a tradition of invidious usage, as when the white folks in the manor house were designated as "the quality" in slave idiolect. And in the eighteenth century the aristocrats might have been designated as persons of quality in contrast with plebeians. But in the libretto to Beaumarchais's comedy about the barber, Figaro, which is an attack on the corrupt behavior of the aristocrats as emblematized by Count Almaviva, the hero refers to himself as "uno barbiere di qualità"—which could, of course, mean the barber who shaves the quality but in fact means that in the line of barbering, Figaro stands high. We may object to human society being divided between people of quality and people who lack quality—but in skilled exercises like barbering, there are masters and choppers, and if you want a shave of quality—as who does not?—one would be well advised to patronize Figaro. In an interview in *Sculpture* magazine, Kramer said in effect that when we go to doctors, we want to go to the best, and we reward science which is better than other science—so why should we all at once change our schedule when it comes to art and refuse to admit that some is better than the rest? It is possible that the word "quality" in all its uses has become generally so offensive that in an age where we have been taught that words can hurt, deference to sensibility enjoins restraint in employing it at all. But even the

arbiters of political correctness recommend alternative acceptable terminology. It is a far cry from saying that "quality" is a term that has become offensive to saying that quality is an idea whose time has gone! It is profoundly misleading to present as a revolution in thought what amounts to a mere recommendation in civil usage. The real question is whether, whatever terminology we used, we can or even ought to give up the procedure of ranking and grading which is bound to be invidious to whatever is assigned a lower rank or grade in the scales of preferability.

Now, it is certainly true that there are circumstances under which our propensity to grade can have no application. I would be genuinely puzzled, for example, were someone to deliberate in front of the Campbell tomato soup shelf, uncertain as to which can to take. There is a famous philosophical example, due to the medieval thinker Jean Buridan, which concerns an ass situated equidistant between two bales of hay. Buridan's ass seeks a good reason for going to bale A rather than bale B but cannot find one, and starves to death, a victim of thwarted rationality—which proves, Buridan is said to have said, that he is an ass. There is no basis for choice between cans of tomato soup, which Campbell manufactures to make choice unnecessary. "A Coke is a Coke," Warhol said, "and no amount of money can get you a better Coke than the bum on the corner is drinking. All the Cokes are the same and all the Cokes are good. Liz Taylor knows it. The President knows it, the bum knows it, and you know it." Ad Reinhardt's program in painting would have just that effect: all paintings would be black and square and matte. "Just one painting every time." Then choosing a painting would be like deliberating over which Coke to drink. All the paintings would be the same and all the paintings would be good. Nobody can be thought a good judge of Cokes, or a Coke critic. And if art were altogether Reinhardtian, neither would there be good judges of art, or art critics. There have been radical philosophies of egalitarianism in which the effort was made to minimize the differences between human beings as if they were like Cokes or black paintings. In Maoist China, for example, the uniform everyone was required to wear was a metaphor as to how everyone was required to be—namely, just like everyone else. If there is no ground for differentiation, there is no place for quality, and no rational basis for choice. Anything is as good as anything else.

Now, if one can find a perspective from which things which initially seemed differentiable turned out to be all alike, one could stun the

propensity to rank those things. Here is an extreme example of that. The Hindu theory of karmic causation tells us that we migrate from life to life to life, where the quality of the life we move into next turns out to be determined by our behavior in the preceding life or lives. From this perspective, we endeavor to conduct ourselves so that we get to live a qualitatively better life the next time around. We can get reborn as gods, or as human beings, or as animals, inasmuch as the entire universe is caught up in the great karmic order. According to this view, the *universe* is constructed along preferential lines, in a system of moral mechanics where everyone gets what she or he merits. But then, if we think of lives stretching on and on infinitely, the differences begin to seem negligible. There is the same monotonous round of birth, achievement, and death. And after a while the twist is not so much to get a better deal next time around but to get out of the cycle: not to be born into a better life but to stop being born altogether. The Warhol of Eastern wisdom would say that all the lives are the same, and all the lives are neither good nor bad, and that it is finally as irrational to rank lives as it is to rank Cokes.

That is a stupefying vision, and a vision, moreover, which seems to stultify a natural perspective from which it seems almost insane, and certainly hardly human, to say that lives are all of a piece. Someone who tells us that it is all one whether we are rich and healthy or if we are poor and sick may mean to say that anyway we all die in the end, but while we are alive it would be insane to say that there is no difference between lives, that the idea of the quality of lives is one whose time has gone. No: some lives are in their nature preferable to other lives, and at the very least those who recommend the abolition of the notion of quality are in fact urging that we replace our present form of life in which invidious distinctions are made in the name of quality with another form of life in which they are not. And indeed, the question of which form of life is best for human beings is at the very heart of the controversy Michael Brenson's essay refers to. At the end of Plato's *Republic* there is a very moving scene in which souls choose from among the lives arrayed before them. It comes at the end of a discussion of an ideal community in which differences in quality are built into the structure of the state to such a degree that injustice is defined in terms of individuals of an inferior quality being put in positions of social superiority. And yet at the end the crafty Odysseus chooses what Plato describes as that of the most ordinary of persons, a life of "quiet obscurity," and counts it the best life of all. And it

becomes plain that what Plato is telling us is that if we have not understood the *Republic* as a text which strengthens our ability to choose the best life, we have not understood it at all. The phrase from Spinoza at the beginning of this essay belongs to a discussion of a certain form of life which is best, and which nevertheless is "as difficult as it is rare."

Still, it is one thing to rank lives in order of quality and another to be able to live them. There is a famous discussion in John Stuart Mill's *Utilitarianism* in which he says, in effect, better a human being dissatisfied than a pig satisfied; better a Socrates dissatisfied than a fool satisfied. He said this in an effort to rescue a moral philosophy in which good was defined in terms of pleasure, from the accusation that it was a philosophy for pigs, by saying that there are different qualities of pleasure, and hence of lives. But now someone might say: There is really no way in which an animal can choose to be a human being or a fool to be a philosopher. And for that matter, it is not that easy for a human being to lead a merely animal existence, or for a philosopher to lead a life the fool would be perfectly happy in leading. These lives are really incommensurable, and that being the case, why hold one life up as preferable to another? Why not say that there are orders and orders of happiness, and what would make a philosopher unhappy might have no meaning for an animal at all? Each lives its own way, and in fact there is a formula for unhappiness in trying to get them to live lives other than those natural to them. Why discriminate between them? I recently read in *Newsday* a story about Jane Fonda, who has gone from practicing aerobics five hours a day to doing it five hours a week. "The point isn't to look like someone else, to get fixated on appearances. I'll never be as skinny as Cher. I'll never look like Cindy Crawford, but I'm the best I can be." And here, I think, the wisdom is to abandon the idea that all women should look like Cher, so that one might say "All women are alike and all are good" or that the life of the philosopher is to define the good life for animals and humans alike. There is, Fonda is saying, a plurality of good ways of being, and as between them the idea of quality might be, indeed ought to be, dropped.

Now, it is not difficult to move from forms of life, between which there is no basis for discrimination, to forms of art, which is clearly what those Brenson is representing in his essay have in mind. If there are, within the practice of art, differences parallel to those which divide lives into different kinds, suitable to different orders of being, then to judge one such kind as qualitatively superior or inferior to another is

as wrong as setting up a single model for physical excellence and demanding that we all look like that, and regarding ourselves as defective and remiss if we do not.

Up to a point, I think, we can accept this. The point beyond which we cannot concerns where and how we draw the lines between kinds of lives. We don't want every life to define a kind such that it has its own excellence, and values appropriate to another kind of life are inappropriate to it. That takes away the challenge to think of which are the best lives for us to lead, where the assumption is that we can in principle choose among them, and that the principles of partition are not like those Mill chose. There would be something fundamentally wrong in saying that as between the life of a crackhead who screws for quarters and that of someone who works for the end of AIDS, there is no real choice, though philosophers have said as much: Sartre, for example, emphasizes the extreme freedom which moral choice involved by saying that there is no objective basis for choosing between the drunk in the gutter and the leader of mankind. But if it were objective there would be no choice: the difference between drunks and leaders is not like that between animals and Socrates, which is objective. So it is clear in principle that not every difference between lives is like that which divides animals from humans or the Jane Fondas from the Chers. And in principle therefore there are at least two kinds of kinds, one within which criticism makes sense and one where it is inapplicable. After all, it would be a legitimate criticism of Jane Fonda that she is *not* the "best she can be," even if it would be wrong to insist that she be like Cher or like Cindy Crawford. And if the issues in art parallel these differences, there are similarly kinds within which criticism makes sense and kinds between which it does not. One could drop the term "quality" in the latter cases, leaving intact the use of the term in the former case. My fellow symposiast's form of life should not have been affected if "quality" were dropped as a word for discriminating *between* artistic kinds when he only needed it for differences *within* a kind. Let us say that criticism is valid within but not between artistic kinds, and it was a failure to sort these differences out that so muddled the discussion to which Brenson's article gave rise that one can sympathize with his desire to purge our language of a word which, within its sphere of application, is probably indispensable.

This would be a good point to discuss the issue of quality within its proper sphere, where there is an accepted and perhaps indispensable practice of grading and ranking, and where there is a clear place for

criticism. But the issues raised by the controversy discussed in Brenson's piece, and which tend to preoccupy the art world today, have more urgently to do with exploration of the boundaries past which these practices are not intended to extend, and where some injustice is done by applying the same yardstick of critical assessment in social and artistic spaces where another metric altogether is called for, even if, within these spaces, there is also a practice of grading and ranking, and an internal critical practice as well. Let me quickly run through some cases.

1. Vasari distinguishes three phases of Renaissance art, or three ages: that of Giotto, of Masaccio, and of Michelangelo. Each of these, Vasari appears to have believed, was defined by a different notion of beauty, relative to which Giotto and Masaccio would be incommensurable. This notion of incommensurability I have borrowed from the philosophy of science as framed by Thomas Kuhn. We might, for example, in parallel with Vasari, speak of three ages of mechanics: the age of Newton, of Maxwell, and of Einstein, or classical mechanics, statistical mechanics, and relativistic mechanics. It is sometimes said, by followers of Kuhn, that the terms in which the theories of these three periods are expressed have different meanings, so that the theories are not really intertranslatable, even if they share certain words, like "mass" or "force." And one might say something similar about the term "space" in each of our three periods, as well as the term "light," and the rest. And yet they do not seem altogether alien from one another, and just as it would have been natural to speak of a single progress from Newton through Maxwell to Einstein, Vasari certainly thought of a single progress from Giotto through Masaccio to Michelangelo, after which there could be no further progress. There is an important sense in which each of the three painters was trying to do much the same thing, and such that if it were imaginable that Giotto could have been shown a work by Michelangelo, he would immediately have seen that Michelangelo had discovered solutions to many of his problems. To be sure, Giotto could not take any of these solutions over without taking them all over—without becoming, as it were, Michelangelized—but it is reasonable to suppose he would have taken that course if he knew how. Mill says that the criterion of which life is best is whether someone who knows both would choose one in preference to the other. And by this criterion, no one contemporary with Michelangelo, who of course also knew the work of Giotto, would choose to paint like the latter. Hence the superiority of the former.

In any case, you can see in this example how one can say that each of the Vasarian periods should be judged in its own terms and how there can also be said to be enough commensurability to allow a kind of ranking. The nice part of this example is that nobody's tribal toes are being stepped on. The test comes in crossing tribal lines.

2. When the Jesuit artist Giuseppe Castiglione, known in China as Lang Shining, showed Chinese artists how to work in linear perspective, they were suitably impressed. They straightaway saw that that was the right way to represent things in space if optical fidelity was your criterion, and they admitted that had the ancients known about it, the history of painting in China would have been different. But, knowing both, they rejected Castiglione's tradition in favor of their own. They wanted things other than optical fidelity, and in fact from that point on, since perspective had entered their consciousness, the fact that they rejected it became a decision on their part to underscore that optical fidelity was not an issue for them. In fact, so far as I can tell, they did not, though Castiglione did, make a qualitative judgment. I think they were wise enough to see that Western representational strategies, relativized to Western ends, were as good as Chinese representational strategies were, relativized to Chinese ends. Both retained a notion of quality for internal criticism. And in the nineteenth and certainly in the twentieth century, the Chinese vacillated as to the superiority of their own as against foreign traditions. So, by the way, did the West, for with Van Gogh and Gauguin, Chinese strategies began to be regarded as superior to those of their own tradition. They really both wanted to be Orientals.

3. Their view was very much like Picasso's when he first saw Oceanic and African art in the Palais de Trocadéro in 1907, and began to appropriate those strategies for easel painting. Still, easel painting itself was an artistic form alien to those traditions, by comparison with sculpture, which was not. In 1920, in response to an exhibition of "Negro sculpture" at the Chelsea Book Club in London, the critic Roger Fry was able to say that in terms of "the power to create expressive plastic form"—which he regards as one of the "greatest human achievements"—"certain nameless savages have possessed this power not only in a higher degree than we at this moment, but than we as a nation have ever possessed it." Here Fry is applying a yardstick of internal criticism to an alien tradition and finding that tradition far stronger than our own! The serious question is whether one is doing justice to these works by thinking of them as "expressive plastic form."

Is that the way one African would judge the work of another? Are we doing them justice in treating them as if they were in our artistic tradition but just better at it than we? Are we even responding to the right kinds of things when we enter, say, the Rockefeller Wing of the Metropolitan Museum of Art and admire what we see there under an aesthetic we have learned from Roger Fry, Albert Barnes (who collected African art), and Clement Greenberg? Or is this in fact a misapplication of the concept of quality, even if the culture it is applied to comes out ahead? But if we don't apply that notion of quality, what are we to do? We are after all not Africans; we cannot take their notions of quality over without taking over a great deal of the form of life to which it belongs—without in effect *becoming them*.

And this raises the question of quality in the most acute form. How can we do justice to another tradition on terms other than our own? And if that is true is the alternative not to judge at all? In which case how are we to show the necessary respect exponents of non-Western traditions currently are demanding when they also demand that we stop using the notion of quality to grade their products? Are we honoring their tradition in treating it the way we treat our own—e.g., displaying its products in glass cases in a place of honor in our museums? Are we honoring their tradition in reading their books in the same way that we read ours, or getting them included in Great Books courses in our universities? Is the Koran a book intended to be discussed, compared with *Moby Dick*, and to have term papers written on it? After all, the institutions through which tribute is paid are themselves Western, and products of Western history: the museum, the library, the university. What are the alternatives? And if we do bring them within these institutions, how can they be exempt from criteria of quality and the application of critical standards?

I think the answer, so far as there is one, lies in the fact that, as our examples of Castiglione and Picasso demonstrate, cultures have been penetrating one another for a long time and with increasing complexity. This is what the anthropologist James Clifford has called the Predicament of Culture, and it may be exemplified by the fact that Coke is Coke the world round—the Zimbabwean knows it, the Chinese knows it, Boris Yeltsin knows it, and you know it. And pretty much all cultures have become exhibiting cultures, at a distance from the traditions they seek to display in the museums which are instruments of national pride and foci for tourism.

Given the function museums are to have in advancing an image

of a culture, it would stand to reason that the culture in question would wish to present what is the very best in its tradition, and that there would in consequence be a tacit appeal to whatever criterion of quality belongs to that tradition. Visitors to the museum would be required, in principle, to master that internal criterion of quality in order to appreciate the objects on view. But in fact something different has happened: in taking over the museum as after all a largely Western institution, other cultures have at the same time adopted Western criteria of quality, virtually as if these were universal. And this has meant taking over as conditions for admission into their museums criteria of what Michael Baxendall speaks of as "visual interest." But this in turn has meant taking over those criteria of formal excellence which have defined what it means for art to be good in modernist times, and hence adopting a concept of quality by no means necessarily internal to the culture which proposes to display itself. Clement Greenberg has pointed out that "there has been a broadening of taste in our time, in the West, and it is owed in a certain large part to the effect of modernist art." What he neglects to notice is that the broadening has been achieved by treating all art *as if* modernist, so that while it is true that "we appreciate all sorts of art that we didn't a hundred years ago," this has happened by obliterating as unessential whatever distinguishes exotic from modernist art. Greenberg's assumption is that all art is unchangingly the same—"art remains unchangeable," he stated in another interview. It will "never be able to take effect *as art* except through quality." But that means it will work as art just to the degree that it strikes the eye as visually interesting or excellent in whatever way modernist art does so. This, then, entails a kind of aesthetic imperialism, an expression which may be taken in either or both of two ways: as the imposition of Western aesthetics on world art or, more damaging, as imposing aesthetics itself on art in connection with which quite different values may apply than those which belong to aesthetics as such. So even if aesthetics were as universal as Greenberg believes—and as Kant hoped—art may have other aims than aesthetic ones. And hence have criteria of quality other than those defined by aesthetic quality.

This explains, I think, why quality, so identified, has come under attack by those who ask of art something other than the gratification of the eye, and hence of the museum that it present works to be appreciated solely or primarily in terms of visual interest. And it helps explain as well the marginalization of painting in recent years, just

because painting, under Modernism, was so narrowly understood in terms of visual gratification. This has put the art museum under the most intensely transformative pressures, as artists bent upon changing society, and museum professionals sympathetic to their aspirations, have sought to attack the aesthetic basis of museum culture. And, however subtle his formulations in fact have been, this "anti-aesthetic" movement—or even "anti-art" movement if art is narrowly identified with the aesthetic—has tended to villainize Greenberg as an enemy of change. Thus the term "quality" has been impugned, to the most muddled effect, in art-world polemic. It has struck those outside the art world, and indeed a good many inside the art world as well, as almost suicidal to art that it should declare itself opposed to quality. But in an age of indignation such as ours, and one moreover in which so much is expected of art, it is hardly matter for wonder that words lose their innocence and acquire strange edges and contours in the fray of passionate advocacy. And of course, once the word "quality" comes under attack, room is opened for the inflow into art-world argumentation of the most radical positions, advocating the abolution of grading practices of any sort, and insisting upon a total egalitarianism: all art is the same and all art is good. Everyone is an artist, as Beuys said, and everything is art.

I want to do something more, however, than merely to clarify usage. The term quality has beyond question a certain close connection with practices of art collecting, and I am anxious to weaken this connection somewhat. For it has sometimes seemed to me that the presuppositions of collecting have penetrated the way critics think of art, and the way critics implicitly enjoin others to think of art—as if, in drawing attention to "quality," they were in effect speaking of art from the perspective of its acquisition for a collection. Thomas Hoving, in his confessional autobiography, *Making the Mummies Dance*, expresses over and over again the thought that the collections of the Metropolitan Museum have in them only the very finest—a thought which underlay his much-criticized practice of de-acquisition, getting rid of works deemed of lesser quality in favor of works of higher quality. "Collecting still is what it is all about," Hoving writes. "Collecting is why people come in the doors. . . . You have to have the guts to reach out and grab for the very best." And he could hardly have been more explicit than this: "The business of a great art museum is quality." It was by appeal to quality that he got rid of Henri Rousseau's painting *Tropics* and *The Olive Pickers* by Van Gogh.

How is one to tell whether something has quality in the required sense? There are two passages in Hoving's book where he talks about works which possess it to the highest degree.

The first impression of a work of art is the whole pedigree, the rush that comes to the experienced art watcher in the first thousandth of a second. The fleeter the better. The speed wipes away false hopes and inflated dreams, the insidious way one's mind can cheat one into thinking the work more profound, more authentic, more desirable than what is really there.

He writes this in describing his first glimpse of Velázquez's *Juan de Pareja*. He refused to look until the light was on the work, whereupon he said, "Hit me!" And he writes, "The split-second impression was vivid." Hoving then elaborates in language that goes back to the Renaissance: "I thought I had seen a human being, alive and about to open his mouth to say something, coyly yet proudly gazing back at me. I believed I had seen a film of sweat on his brow." In brief, he had an illusion, a false belief. When he first encountered the great krater of Euphronius he refused to look at it until it was brought outside into natural daylight. "I felt as if I had been punched in the stomach. The first thought that came to mind was that I was gazing not at a vase, but at a painting."

Now, there is no question but that experiences of this sort occur in some of our encounters with art, but how far will they take us in understanding what is valuable or important in the works that elicit it, and if such experiences are the index of quality, then how important can quality be? Let me juxtapose Hoving's almost ecstatic transports with a quite opposed way of being an "experienced art watcher" due to the philosopher Richard Wollheim, from his book *Painting as an Art*:

Going back to look at works I already knew, or, in a few cases, as with the great *Drunkenness of Noah* [by Giovanni Bellini] . . . seeing a work for the first time, I evolved a way of looking at paintings which was massively time-consuming and deeply rewarding. For I came to recognize that it often took the first hour or so in front of a painting for stray associations or motivated misperceptions to settle down, and it was only then, with the same amount of time or more to spend looking at it, that the picture could be relied upon to disclose itself as it was. I spent long hours in the church of San Salvatore in Venice, in the Louvre, in the Guggenheim Museum, coaxing a picture into life.

(Wollheim wryly records that "I noticed that I became an object of suspicion to passers-by, and so did the picture that I was looking at.")

I want to cite what Wollheim finds in the Bellini: "What Bellini is showing us is, in effect, the dignity of a very old body: a dignity nurtured by asceticism, and now enhanced by frailty. He is still a patriarch, though his wits have decayed and he is drunk." He then makes some formalist observations, and goes on to speak of how the devices dwelt upon as formalist transform the painting "into the content of a reverie, a reverie that goes on in the head of the right-hand son, the good son, who, without looking either pruriently at or angrily away from his father's genitals, draws the wine-colored shroud across them." And his point is that the image we see is referred to the eyes of a spectator in the painting—we see the father the way he sees him. And the painting becomes a sustained meditation on piety, dignity, age, duty, and love. We are very far from the virtuoso "film of sweat." And whether or not this is the structure of the painting, what we finally understand is that the looking discloses a meaning we appreciate through analysis and which is embodied in the painting. Its beauty is not of the kind that "knocks your eyes out" as with Mr. Hoving, but which answers instead to the formulation of Hegel that Beauty is the idea given sensuous embodiment.

In a recent collection of his essays, *The Mind and Its Depths*, Wollheim observes, I believe correctly, that "we aren't interested— aesthetically interested, that is—only in good paintings. Indeed, if someone expressed indifference to all paintings except the best, we should doubt whether his interest in *any* painting was really aesthetic." And this returns us to Hilton Kramer's criticism of Michael Brenson's thought. We may want the best science, the best medical treatment, the best of everything. But painting, and art in general, is of a different character. Here is an observation by the philosopher J. O. Urmson in an essay titled "On Grading":

If you have an apple tree you know very well that all the apples will not be worth eating and that in a normal season there will be more apples on the tree which are fit for eating than you can eat immediately on ripening. There- fore, when you gather your crop, you will probably divide it into three lots— the really good apples, the not-so-good but edible, and the throw-outs. The good ones you will store (or perhaps sell at some high price), the not-so-good you will use at once (or perhaps sell some at a lower price), the throw-outs

you will throw out, or give to your pigs, or sell at a very low price for someone else's pigs.

This is called "grading," and Urmson reproduces some documents from the British Ministry of Agriculture on Definitions of Quality, which specify the criteria of "Super Grade" as against "Extra Fancy" apples, which you can learn to follow if you are an apple grader, or perhaps, to adapt Hoving's term, an "apple watcher." I think I can identify, though not on this occasion, the biological considerations that affect our preference for apples of quality. But we are not, I think, being what one might define as true to our biological nature in esteeming a painting, as we are in esteeming an apple of quality. We are rather being true to human nature, in that the painting addresses us in our humanity, and teaches us the way a great philosophy might. Perhaps the right kind of description of one's first impression of the painting would be analogous to that given by Proust in the famous episode of the madeleine, when he is conscious that there is a meaning to the experience, but he is as yet unable to get it to disclose itself. Hoving's "split second" seems irrelevant to this, for it takes time, analysis, and explanation to locate what different people may see more quickly than others, and of course one may finally disagree with Wollheim about the reading he gives.

My point is that with art, quality is of a lesser dimension than cognition, and that the appreciation of a work is not like one's appreciation of a fine apple, or a piece of horseflesh, or a rare claret. The latter are the kinds of things that go with connoisseurship, in which "quality" is a relevant predicate. And they go with the practice of ranking and grading, perhaps because these are structures of the same sort as those in which the connoisseur ranks himself in society, where connoisseurship is a measure of holding high rank, being conversant with wines, brandies, horses, clothes, guns, jewels. To look on art in that way is badly to misrepresent it. That is why it would be, in the end, a good idea to stop using the term "quality" in connection with art, simply because it expresses a concept that locates art within the kinds of systems of grading that occlude its true value for human life. I don't think mine are even close to the reasons Michael Brenson would give, though I daresay he could be brought around to accepting my reasons, which are based on a philosophical theory of works of art. And I do not believe for a minute that these have anything to do with the issues of ethnicity, the politics of gender, or the aesthetics of race.

On the other hand, I would not want to publicize my views too widely, for fear that some sarcastic symposiast somewhere will say, "I see the Johnsonian Professor of Philosophy at Columbia University and the art critic for *The Nation* has come out against quality." The symposiast I cited comes from the world of the dealer, the collector, the cataloguer, where quality is important because it goes with grading and with pricing. This shows, if anything, that the lifelong company of works of art is no guarantee against vulgarity.

Museum and Merengue

NOT LONG AGO I taxied from the Upper West Side of Manhattan, where I live, to the East Side. It was a beautiful morning, and I asked to be let off a few blocks from my destination in order to walk in it for a few moments before entering the dark auditorium of the Whitney Museum of American Art, where I had promised to participate in a panel on museum audiences today. My driver was from the Dominican Republic, and something of a philosopher, commenting on the beauty of our city, and speculating that it is the people who are responsible for life here not always being what the city itself projects. His people, he complained, really just lived here the same life they live in Santo Domingo—hanging out, talking on corners, drinking, and interested only in merengue, the intricate and passionate dance on which Dominicans pride themselves when they excel at it. They plan, he said, to return when they have some money—but there is never enough money to do that, and yet they never seek to break out of their form of life. It would never occur to a parent, he said, to take a child to a museum. I did not ask him whether he had been to a museum, or what it had meant to him if he had been, but that in any case was of less interest to me than the fact that for him the museum was like a gate into the containing culture, a way out of the transplanted Santo Domingo of upper Broadway, as much so, in its way, as Columbia University is, which defines a southern boundary of the neighborhood the Dominicans have made their own.

The audience on this morning was small and selective, consisting of well-placed friends of the museum, as well as members of the curatorial staff, and at one point I mentioned my little conversation as

evidence for the aura with which this genre of institution is surrounded in the larger society, as a place mere entry into which might, for a certain group of people, mark a boundary crossed, a decision made to change one's life. Most of the people there that morning see the museum from the top down, so to speak. In accepting his commission to design the Kimball Museum of Art, the great American architect Louis Kahn said the model he aspired to was that of "a friendly home." Kahn scholars cite as an influence on him recent visits to the Phillips Collection in Washington, in fact a private house and collection made public, but where a great sense of intimacy remains, so that for people for whom at least the idea of a house and collection of that magnitude is not intimidating, the sense of being in someone's home as a guest is vivid. Certainly the Kimball is not intimidating in the way museums can be, with their colonnades and grand staircases and phalanxes of uniformed guards, but the point is that the museum is, to the people I was speaking with that morning, a "friendly home," even if everything architectural in the Whitney—its moat, its feeling of a blockhouse, its parapets from which in a cruder time inhabitants could pour boiling oil on besiegers—cries out against that feeling, and encourages rather a feeling of embattlement: the window of the director looks out on a blank concrete wall, though if one cranes one's neck, one can see towers and sky. Entering the Whitney would be a very daunting experience for someone who wanted to bring an impressionable child from the Dominican or any other community: one crosses what in effect is a drawbridge under the overhanging parapet of a windowless façade the color of dried blood, and just at that moment, if one looked through the window, one saw a large photograph by Pat Ward Williams of five glowering ghetto youths, grafitti'd over with the challenge in Black English and red lettering: "WHAT YOU LOOKN AT." But for the people in my audience that morning in early May, the Whitney was a friendly home, a place where they knew one another and knew the rules and had some say in how things went. And the question someone raised was: how do we get that child into the museum?

In truth, if my informant was right, some social transformation is going to be required which I should not suppose museum people with the best will in the world were going to know enough, let alone have the means, to bring about. Probably the child will be brought there as part of a group from a school, and at the very least it will be the child's teachers who will have to be reached, and some reason given to bring their charges into museum precincts. I think one cannot overestimate

the degree to which high culture in some form penetrates ghetto con-
sciousness, simply because the emblems of high culture get transmitted
in magazines and over television, so that children know a lot about it
at some level, even if they have not visited a museum. Some years ago,
I was the academic adviser for a film on what is now a vanished
phenomenon, or nearly so—the "writers," as they called themselves,
who embellished New York's subway cars. There was a lot of Lich-
tenstein and Warhol on those cars—it certainly would not have spon-
taneously occurred to a writer to paint a Campbell's Soup can. And
there was some Picasso, and some Matisse. The writers themselves
were literate to some degree in the language of visual expression, and
beyond that they understood a great deal about the institutional char-
acter of art, so that when their work was brought into gallery space,
they understood how they were to behave, what rhetoric to flavor their
discourse with, what was expected of them: somewhere, without nec-
essarily having entered the museums, they had internalized a great
deal. They knew about Paris. They had heard about Surrealism. They
were, one might say, slightly conflicted: they were not painting for the
world they were brought into, but for their own, for that audience of
writers and would-be writers who could see their immense and elab-
orate "tags" being moved over viaducts or past crowded platforms, and
who would know who did them and admire what had been done, and
at what cost to the writer, and at what risk. They had a strong tradition
of art criticism, and were as severe on one another as the most biting
critics of New York. But at the same time they appreciated that entrance
might, perhaps, given the myths of discovery and success, open up,
and they would be celebrated by a wider world, and become as rich
and famous as, well, Picasso or Warhol: stars, as their peers in rap
were already at that time getting to be. Or as someone whose forms
they appropriated shamelessly was on the threshold of being—namely,
Keith Haring. Haring somehow entered their space, and deposited
forms in it which became part of the culture he aspired to. He was a
good example of how art could enter the extra-museum life of our
culture without those who appropriated and metabolized it for their
own energies themselves having entered the museum. I mean our
culture is far more of a piece, at one level, than one would suppose:
Somehow those poor black dancers got hold of the glossy magazine
Vogue, introducing mannerisms into their dances which were then
appropriated by Madonna, who, operating in the opposite direction
from Keith Haring, gave them new life, from which before long they

will enter ballet. But my point is that, from one perspective, one can know a certain amount about art in our culture without going into museums at all. One can know enough, in fact, to pass at least a certain kind of art-history exam consisting of image recognition.

I am afraid I had nothing very helpful to say to the audience about recruiting Dominican children that morning, but I did say that we have some responsibility to see that they will, having crossed the drawbridge, encounter something that will make the transit worthwhile. I made the point that you want to make sure that they will not, upon entering the museum, find something that strikes them as just like what they saw on Broadway and 145th Street, for then they will ask what the point of going to the museum was. That, given the mentality of museum people today, might not have been a worthless piece of wit. The Biennial this year, still installed that day, went as far as it could in making the inside of the museum as reflective of the outside as possible, as if, unless the exhibits were about the life the children already knew, they would have no interest in it whatever. I think this may be the premise of a good many installations today, and it contravenes the thought at least of my taxi driver that in entering the museum one is going to encounter something very different from what one will have left behind and to which one will return. How to prepare for the child's first visit seems to me something we might all want to think about. And that means one must ask what art is to be, for someone who encounters it for the first time, so that it may make that person, however inchoately, feel that what is in the museum is somehow different enough from what is outside to justify the enormous moral energy required to cross a threshold as momentous as the museum must appear in ghetto consciousness if my driver is typical: different enough and yet answering to needs that are connected with our essential humanity, even if we might not have had occasion to acknowledge those needs in the ordinary course of our lives.

The Whitney's architecture, as I said, is more than somewhat forbidding. If a child is sensitive to architecture at all, he or she must look down warily, expecting crocodiles or dragons, and must feel that what is contained within must be priceless, must be tresorial in some way for all those smooth, unscalable, windowless walls to be required for its protection. It must be disillusioning, but it may also be a relief, that the first thing one encounters is what the critic Joseph Masheck has referred to as "Calder's No-Fault Circus," for which ten or so years ago the Whitney paid a million dollars, to keep it for "the children."

In any case, the Whitney is in a tradition of tresorial architectures which seek to project through their design something that Kahn said in another of his statements: "A museum seems like a secondary thing, unless it is a great treasury." It is that spirit, it seems to me, the Calder somewhat defeats, even if it cost what we call a small fortune: it does not look like something one would pay a million dollars for. But I want at this point to talk about the rhetoric of museum architecture, just because it implies, for all its recent diversity, what attitude it is toward the objects it contains that those who enter it are encouraged to take.

It seems to me that there have been two forms of such rhetoric, one of them evolving rather recently, and as part of a large moral transformation in society. The first is exactly the tresorial rhetoric, where the approaching visitor is virtually transformed, metaphorically, into someone about to be in the presence of things of value which transcend the merely monetary, transformed, I like to think, into a pilgrim. The entry is momentous, or should be, and in its best examples is architecturally marked as such. Here is Thomas Hoving, who did more than anyone to inspire the second sort of rhetoric it was impossible for him to employ himself with the Metropolitan Museum of Art: "The Great Hall was magnificent, I had to admit. Hunt and his son had created a soaring space, with three domes hanging some sixty-five feet in the air, and three grand entrances into the galleries with staunch, impressive columns and a broad mezzanine above . . . an observer at the unveiling had called the hall 'a bride garbed in white.' " Hoving does not mention the great staircase in this passage, perhaps because he was anxious to see it removed at a later point and replaced with escalators. But the Great Stair is the perfect emblem of metaphorical ascent, and as such was used by David Hockney in the scene in *The Magic Flute* when Tamino and Pamina are undergoing initiation. It, moreover, the work of Calvert Vaux (Olmsted's partner), was a treasure in its own right.

The other form has as its best exemplar the Centre Pompidou in Paris, where the image projected is that art is fun, and where the audience itself is viewed as a throng of pleasure seekers, riding the escalators (*nota bene*), snacking, buying things, watching from above the sword swallowers and strongmen entertaining crowds on the plaza below. The way the building extrudes its working parts, its vents and cables, declares that it has nothing to hide, and the spirit of the es- calators transmits the message that it is effortless to visit. There are, of course, treasures there, but they are not hidden, which is part of

what being a treasure ordinarily implies, and one is not penetrating into sacral spaces when one stands face-to-face with them, which erases some of their power. It is not an easy business growing an aura in the Centre Pompidou! And critics have complained that it is, in the words of a recent writer, "a pleasure palace masquerading as a center of culture." On the other hand, those who criticize the center owe us an analysis of art as something more than fun for the eyes, like the Calder *Circus* is. My driver would expect more: there is no point in crossing the threshold if all that is involved is exchanging one sort of fun for another. The philosopher Jeremy Bentham said that quantities of pleasure being equal, pushpin is as good as poetry. But by that criterion pushpin is better than poetry if the quantities are right: and who is to tell us that Matisse outweighs merengue in the balance of pleasure? Bentham's disciple Mill spoke of qualities of pleasure, and thought them ranked in orders of higher and lower. But even if we accept this thought of higher and lower pleasures, the question remains as to what makes them higher—and architecturally we seem to lack something intermediate between designs fit for the Calder *Circus* and designs fit for numinous objects like altarpieces and Greek gods.

Museums have expanded along the hedonic dimension, adding restaurants and shops, so that it is possible to complain, as some have, that one can visit the museum in the sense of dining and shopping there, without seeing much by way of art, and perhaps, in the Pompidou case, without seeing any except what is unavoidable, because stuck in public space like obstacles. And yet people are divided. The new wing of the Boston Museum of Fine Arts, which, as Carol Duncan has observed, is now the main entrance to the museum, its ornamental classical portal closed except for ceremonial purposes, is packed with amenities, and probably it is the main entranceway as the result of a conscious decision to make money (one uses the traditional entry when the restaurants are closed, or at least the book-and-gift shop). And yet on one occasion when I visited it, I was impressed by the people massed as pilgrims to see the tremendous exhibition of Monet's serial paintings from the 1890s. They had undergone, were undergoing, an ordeal not untypical of museum visits today, to be in the presence of works they antecedently felt were repositories of great value, and they could not, despite the architecture, have been having a lot of fun. Nobody, I think, can have a lot of fun studying Monet's half dozen or so views of the valley of the Creuse. So they acted as if they were visitants to the tresorial museum, though in the site of fun. Hoving, whose mentality

was a division between the two values, tried to achieve in the Metropolitan a museum which was a pleasure house of treasures. He felt that quality, the highest quality, was all that mattered, and that people would throng to see it in the spirit of fun. And his ambition to remove the staircase indicates that his effort was, with one hand, to remove the distancing metaphors in architecture which go with tresoriousness, while, with the other, he bought up all the treasures he could, thinking that people would enjoy them as much as he did, and that part of the enjoyment would consist in knowing they were looking at the very best.

Neither treasure nor pleasure strikes me as compelling enough to remove a child from what it is possible of course to sentimentalize, and to start it on the stairway to what we will continue to think of as high culture, and yet the fact that we do not have any alternative architectural rhetoric is evidence that we do not as yet have a good answer to the question of why bring the child there. But neither, I think, can we look to curatorial personnel for answers, for they are divided as well between those who feel the art must somehow be about the child's own world if it is to be relevant to the child and those who think in more formal terms of the kind they learned in their graduate school days. The division, in brief, reflects the division between what is nowadays called the New and the Old Art History, and I would like to say a few words about this. For the moment, let us leave the child suspended between two worlds, between merengue and museum. The world of merengue, we might reflect before pressing on, must be an especially fulfilling world, in which one is fully there, in body and spirit, where all the senses are open and awake, and one's history and culture are fully present in the beat, the step, the slide, the excitement, the sexual enfleshment. In the world of the museum one is a *viewer*.

The few words I promised have to do with the emphasis upon the visual in the visual arts, in terms of the great enfranchising narratives that have governed the production of art from about 1300 to about 1965, and which includes the two main episodes, the second being Modernism. Consider first the pictorial tradition in which something like linear perspective emerged as a possibility and a triumph. What that entailed was an abrupt reduction of the audience to viewer, and a disembodied one at that, inasmuch as one had no *place* in the illusion perspective made possible: the episode viewed occurred in a space homologous to the space one stood in, but into which one could merely see from outside, as a kind of witness as if through glass. This was the Florentine exclusion, and it contrasts with what one might call the

Sienese inclusion, where a very different relationship between art and its user was intended, as witnessed by the fact that the dominant form of Siena was the altarpiece rather than the easel picture, and the altarpiece mediates between two worlds, that of the saint and that of the seeker. One does not *view* the altarpiece, one prays before it, and the space it implies reaches out to encompass the seeker. In the altarpiece it is not necessary that the eye be deceived; it is only necessary that what it sees be legible, that one can identify the saint by means of episodes that define the saint's life and stand as evidence for the kind of intervention one seeks. When one puts the altarpiece in the museum, out of the chapel, onto the wall, it compares unfavorably with the easel picture concerned only to present the eye with an array of stimuli equivalent to what the eye would receive from the face of nature. When the altarpiece is enmuseumed, it loses the encompassing space and seems inevitably primitive alongside the Florentine optical virtuosities, with chiaroscuro, foreshortening, and the rest. An effort to recapture that space was made in the baroque period, of course, when the concern was to use art to heighten faith—but again, to take baroque painting out of the chapel into the museum makes it look merely exaggerated and overdramatic. Vasari did not live into the baroque, but the epic he recounts has no room for it: it is an epic of the conquest of visual appearances by artists for the optical benefit of persons reduced to viewers. It is a world of pure vision.

Or not so pure. The lesson of Modernism, as advanced by Clement Greenberg, is, as we have seen, that the illusory space usurps the prerogatives of sculpture in an age where the imperatives of history demand that each art seek its identity in that which defines it essentially, and that painting must differentiate itself from sculpture by spatial means which carry no possible homologies with physical space and hence must be a space of pure opticality. Modernist painting can be representational, but it cannot be illusory, and those who appreciate it must be even more uncompromisingly visual, capable of responding to the forms arrayed in the thin space between background and surface, which all but touch: nudes as flat as paper dolls, still lifes which appear as if cut out and pasted to tabletops tipped up to fit between the membranes bounding pictorial space. In an interview in 1968, Greenberg wrote, "There has been a broadening of taste in our time, in the West, and it's owed in a certain large part to the effect of modernist art. Now we appreciate all sorts of exotic art we didn't 100 years ago, whether ancient Egyptian, Persian, Far Eastern, barbaric, or primitive." There

is no question that in terms of the Florentine tradition, these exotic forms appeared retrograde because they were optically unconvincing. Now they are optically convincing, but only because they often employ spaces parallel with those of modernist painting. But what we have done is to enfranchise them, but mainly by reducing them to their formal dimension, treating them in terms of plasticity and composition. As a critic, Greenberg took anything on, because the reductions of Modernism dehistoricized the contents of the museum and allowed the same criteria to be applied to cave paintings and Japanese screens and African carvings and Morris Louis. It aestheticized the museum's contents so totally that art was itself reduced to treats for the eye, which in turn led to the model of art as fun, architecturally projected by the Centre Pompidou. The 1985 exhibition "Primitivism and Modern Art" was conceived of in the Greenbergian spirit, but by the time it was mounted a change had taken place in the art world, of a kind which made it one of the most severely criticized of MoMA's exhibitions until the "High & Low" show of 1990. What it was was an exercise in demonstrating how modern art enfranchised primitive art, as if it were a cultural promotion for the latter to have influenced, say, Victor Brauner. But in reducing it to the optical, all the powerful relationships through which it was connected to its "users"—I flounder for a word—the way the Sienese altarpiece was a meeting place for saints and seekers—are severed.

Now, I think that what we may as well continue calling Post-Modernism, even if it involves not just the succession of styles but the collapse of a whole world of art, is in many ways an effort to reinstate these connections. But since the museum is defined visually, since it is an art museum and art itself has been defined through painting and something like 650 years of optical research, it is inevitable that this movement or countermovement is going to first be a reaction against the museum and second is going to involve a marginalization of painting. It is a good thing we left our Dominican child outside: she was in danger of being knocked over by curators seeking to escape the visual, and to reconnect art with life in such a way as to engage us more fully than we had been as disembodied eyes, with our bodies external to the visual experience, like dollies moving us from exhibit to exhibit the way a camera is moved about the sound stage. And perhaps the merengue is a possible model?

I do not think what is called site-specific work greatly changes things. In this work, art moves outside the museum spatially, but what

in fact it does is carry the optical premises of the museum to an extra-museum locus, which it colonizes in the name of museum aesthetics. A lot of so-called public art is of this sort, and consists of placing objects whose natural locus is the museum, having been conceived of in museum terms, in public places. The paradigm of this is Richard Serra's *Tilted Arc*, which treated the space it was put into in strictly visual or, let us say, strictly aesthetic terms, disregarding what I am thinking of as the kinds of reconnections the flight from the museum seeks to reestablish. And, of course, *Tilted Arc* set up a vigorous controversy with museum people on one side and those who were convinced that something more than visuality alone justifies moving outside the museum, on the other.

A second move tries to enrich the visual with extra-aesthetic references to the site, defined in terms of the content of the work. I think the impressive Spoleto exhibition of 1991, curated by Mary Jane Jacob, was a case in point. It sought to establish a connection between the visible and the invisible by means of historical references and allusions. It cleverly turned the museum itself into a "site," and I think the "exhibition" proclaimed its opposition to museum criteria and the test-of-time criteria often implied by that through its resolute ephemerality: it was to remain "up" only for a prescribed period, after which the museum reverted to itself. That resolution ran counter to the fact that some of the work was so successful that one wanted it to be kept in some way more experienceable than on videotape, with the result, I think, that the pieces so kept would turn into site-specific works more friendly perhaps than *Tilted Arc*, but still essentially involving colonizing extra-museum spaces in the name of the museum: the works would become installations *extra muros*. The museum continues to define artistic success.

The most successful site-specific work I know is Peter Eisenman's Wexner Art Center in Columbus, Ohio, mainly because it anchors local history and local geography in a complex system of references to its site: its brick tower refers to the armory it replaced, its various grids to the surveyors' plans for the city of Columbus, the state of Ohio, and the campus of Ohio State University. I have never encountered another work which so captured the souls of those who live with it, who are anxious to relate its architectural code to strangers and in so doing relive their own history and internalize their own geography. The Wexner Center totally penetrates the community it now defines, and transforms the flow of life into a kind of, well, let's try this: merengue of

artistic meaning. It transforms the site, in any case, and does not deem it irrelevant, as site-dominating work like *Tilted Arc* characteristically does. Still, it is an option available only to architects. Moreover, while it is possible that the same referential complex could have been achieved by a building with some other function, it must be emphasized that the Wexner is a museum which happens to have become its own best exhibit, though in ways which teach a lesson on aesthetics by fusing meaning with design in such a way that the art itself is lived. And the thought of art as something to be lived perhaps echoes Kahn's great insight that a museum should be based on "a friendly home."

But there is a more radical position available in what Robert Irwin designates—and practices!—as "site-conditioned/determined" art in which the art itself becomes invisible through the enhancement of the site. One of his greatest concepts was for a work called *Tilted Planes*, which, interestingly, was designed for the same campus that now has the Wexner Center as its pride. It would have been absolutely invisible, in that there would have been no way of seeing it and not seeing the campus itself, for it consisted of subtle displacements of the planes articulated by the system of campus crosswalks which produced the pattern of *Tilted Planes*. It was never built, for though the Dean asked a good question—"Where's the sculpture?"—he was not prepared to accept as a good answer that the whole site was the sculpture. Irwin's masterpiece, had it been realized, would have been the Miami International Airport, at which he worked for four years, only to have the entire thing shot down with a change in administration.

Irwin's approach to the airport was characteristically novel, but it was in fact more deeply novel than could be inferred on the basis of his previous response-oriented art, although the Miami project carries over into the new schematism a great many of the values and strategies inherent in its predecessors. It has become commonplace for airports, like any number of public agencies, to commission a piece of art, but usually this will be by way of adjunction: an artwork is adjoined to an existing complex, and serves as an ornament which does not penetrate the larger meaning of the site. To be sure, artists may make an effort to represent the function of the place in one or another way—to project some reference to flight, for example—though this is by no means always the case. The Columbus, Ohio, airport, for example, commissioned Roy Lichtenstein to construct one of his "brushstroke" sculptures for one of its plazas. Now, there is no semiotic connection between brushstrokes and airports, but there is a tenuous connection between

Brush Stroke and Columbus, since Lichtenstein was at one time con-
nected with the art department of Ohio State, and as the work of one
of its most famous cultural figures, the sculpture somewhat reflected
on Columbus as a culture center. The Miami airport at one point had
a mural by James Rosenquist, which included an oblique reference to
flight in its iconography. But for the most part, airport public art is
typically of the bauble category, a spot of aesthetic afterthought cal-
culated to grace a site whose essential business of moving people off
the ground into the air and vice versa goes on perfectly adequately
without benefit of the art. Needless to say, this would never have been
Irwin's way if he could help it, and he basically reinvented the rela-
tionship in which art and the airport experience were to stand to one
another. It is a tribute to his considerable powers of persuasion that
he actually convinced the airport administration of the viability, indeed
the necessity of this radical arrangement.

The idea was that the artist should participate fully in the planning
of the airport, that at every stage there should be decisions in which
the input of the artist would materially enhance the final result. Of
course, one could not begin from scratch: Miami's was a preexisting
structure. Even so, Irwin thought through what the relationship be-
tween art and design engineering was to be at crucial points in the
passenger's utilization of the facility. His project assumes that the air-
port, the first and last part of the city a traveler experiences, should in
some way emblematize the city, rather than serve some impersonal
outskirt function, architecturally everywhere and nowhere. This in-
volved him in the design of approach roads, parking, rental car return
sites, and the roads back to the metropolitan center. What is emblem-
atic of Miami is water (as water is emblematic of Pasadena by its
scarcity). The road from airport to city and back again should traverse
typical Dade County waterscape, planted with palmettos and reeds.
But there should be no scenic distraction at the point of approach where
drivers must find their way to departure, arrival, and parking sites.
Irwin designed a cool corridor through which one headed to these
various destinations, and the pattern of the driver's experience was an
alternation of shade and light. And he designed a marvelous "central
park," filled with plant and even bird life, an amenity for spiritual
restoration as needed by travelers, leave-takers, greeters. Artists would
enhance the way windows worked, and would collaborate on the place-
ment of Florida-like installations in the various approaches to the gates.
In the end, the entire airport would be art, and, of course, it would at

the same time be nothing but what it is, a busy international gateway, the users of which need hardly be mindful of the marvelous way art has been used to ease their passage. One of the goals of art in such projects, Irwin states in a sort of flowchart, is to "heighten awareness." Not to heighten awareness of art as art, but of the dimensions and features of life that art raises to the highest powers of enhancement while remaining invisible, directing the viewer's sensibilities with a kind of aesthetic Hidden Hand.

The great Constructivist visionary Aleksandr Rodchenko coined the slogan "Art into life!" He meant that artists were not to make the traditional sorts of things—paintings and sculptures—that hang in frames or stand on pedestals in prosperous salons. Characteristically, he and his followers transformed objects of use with fine bold designs: clothing, book covers, stage sets, posters. Irwin has, as with *Tilted Planes*, added a third dimension to this formulation. Anything can be art without having to look like art at all. The task he has set himself, as he says explicitly in the epilogue of his text, *Being and Circumstance*, is "to enable us to experience beauty in everything." Art is the means to that rather than its object.

"Rather than its object" means that were an Irwin-like program to become general, artists would cease making art, at least in the sense of making objects intended as objects of artistic focus, and instead turn themselves to the aesthetic transformation of the world. This could call for as much or as little community involvement as required by the proposal for the specific site. Art would be a means rather than an end, and I suppose that the museum would wither away as the central institution of artistic interchange, because the Irwin-like program would have brought its era to an end. After all, the museum has a fairly short history in the form we know it, and it would not be, by contrast with schools and hospitals, something that as an active force would have to outlive its moment. The museums would, so to speak, themselves become museums, relics of a certain moment of art history. People would stop building them, as the aesthetic needs of society would be fulfilled through different avenues. Art historians might refer to "the age of the museum" as a period of artistic practice dating from 1800 and the Musée Napoléon to some time in the twenty-first century. I think I might in fact love museums that had become exhibits in their own right, belonging to an increasingly distant epoch. They would resemble in a way the museums of my youth, which were encapsulated in life, but so far as I could tell made no special effort to be more than

what they were. It is an irony, meanwhile, that at this very moment, the Museum of Contemporary Art in Los Angeles is mounting an exhibition of the work of Robert Irwin. And since he has done more than anyone else I can think of to take art beyond the world of the museum, the thought seems unavoidable that the museum is not likely to go away soon. What Irwin and countless others may have done was to take off some of the pressure on museums which they sustained when they were the sole or the main agencies of artistic experience, so that they became scenes of embattlement, certainly not the loci of contemplation and culture my taxi driver must have envisioned.

My first museum was the Detroit Institute of Arts, where my mother took me to see Diego Rivera painting the murals there when I was the age I shall imagine our Dominican child as being when I take her *in loco parentis* to the museum. I have what I think are memories of Rivera painting, but they may be of photographs later seen which my mind has used to enhance very faded images indeed. Mostly I remember the immense paintings in the main gallery, of agonized saints under stormy skies, ornamental horsemen in feathered hats on rearing steeds, women in silk and men in steel, plates of oysters, moody banks of dark rivers, dancing peasants. None of these had anything to do with the life I led or the world to which I belonged, but I was drawn to them for their mystery and their presence. They seemed polished, dark, and abstractly meaningful without my having been able to say what they meant or even why they were there. They represented a kind of absolute otherness, of a kind which remains a criterion for me of art, even today.

I would like the Dominican child to have that kind of experience, it probably not mattering into what wing of what museum I were to take her. I would want to let her wander about, and try not to jabber at her, keeping the mystery intact, and when she was tired we could go. I would say the experience was what it should have been if she were to tell me she would like to go back.

Beauty and Morality

ROBERT MOTHERWELL'S *Elegies to the Spanish Republic*, of which he painted *Number 172 (with Blood)* in 1990, is a good place to begin discussing whether there is a conflict between aesthetic excellence and what Richard Schiff designates as "socio-political discourse." The *Elegies*, Motherwell said, "reflect the internationalist in me, interested in the historical forces of the twentieth century, with strong feelings about the conflicting forces in it." I once drew a sustained comparison between the *Elegies* and the other great series of paintings by a modern American artist, Richard Diebenkorn's *Ocean Park* series. It is reasonably clear, though both these men are abstract painters, that Diebenkorn's inspiration is landscape and his paintings achieve their beauty by way of an internalization of the beauties of the natural world—of sea and sky and beach—but raised to a certain power, as is always true of an art which, in Hegel's thundering phrase, is "born of the spirit and born again." But it might be false to say that Motherwell's *Elegies* owe their beauty to some transfigured natural beauty: they may in fact transfigure terrible suffering instead, which it would be a mistake to view as beautiful at all. "How beautiful those mourning women are beside the shattered posts of their houses, against the morning sky" is not a morally permissible vision. But Motherwell's forms feel like the shawled shapelessness of bent women, alternating with, or set amidst, the verticals of shattered architectures. It is a stark, black-and-white setting, touched perhaps with ocher or crimson, and the reality must in some way be shattering. But the works are unquestionably beautiful, as befits the mood announced by their titles as *elegies*, which are part music and part poetry, whose language and cadence are constrained

by the subject of death and loss and which express grief, whether the artist shares it or not. The *Elegies* express, in the most haunting forms and colors, rhythms and proportions, the death of a political reality, of a form of life, of hope institutionalized. Elegy fits one of the great human moods; it is a way of responding artistically to what cannot be endured or what can only be endured. Motherwell was medaled by the Spanish government, after the fall of Franco, for having sustained the only mood morally acceptable through the years of dictatorship, a kind of moral mission unmatched, I think, in twentieth-century art.

Elegies are artistic responses to events the natural emotional response to which is *sorrow*, which Webster's defines as "deep distress and regret (as over the loss of something loved)." I feel we understand too little about the psychology of loss to understand why the creation of beauty is so fitting as a way of marking it—why we bring flowers to the graveside, or to the funeral, or why music of a certain sort defines the mood of mourners. It is as though beauty were a kind of catalyst, transforming raw grief into tranquil sadness, almost, one might say, by putting the loss into a certain philosophical perspective. Kant famously and systematically connects the ascription of beauty to things that in fact please, but if and only if the pleasure can be universalized in a certain way: "The beautiful," he writes "is that which apart from concepts is represented as the object of a universal satisfaction." Kant does not especially speak of pain in his *Critique of Aesthetic Judgment*, but it strikes me that symmetry almost demands that there be a concept of beauty ascribed to objects which cause pain when the pain, too, can be universalized or philosophized, and so, though the death causes grief, causes as acute a pain in the survivor as the human being knows, since love is abruptly and irrevocably bereft of its object, the conjunction of pain with its universalization as mediated by beauty somehow is felt to be consoling through the consideration that death is universal, that, as the paradigm syllogism puts it, dryly and abstractly, all men are mortal. So the conjunction of beauty with the occasion of pain transforms the pain into a kind of muted pleasure. Everyone knows how pain distracts from pain—how we dig our fingernails into our palms to mute the agony of the toothache; here it is pleasure that mutes it, as caused by the music or the words or the cadences of forms which make the occasion bearable because of the common lot. And the recognition of this may—must, given the ubiquity of the phenomenon—give the bereaved a certain strength in the recognition of his or her participation in the very meaning of what it is to be human. So the

form of the elegy is philosophical and artistic at once: it gives a kind of meaning which is at once universal.

I will admit that it is not easy to extend this analysis to the *Elegies to the Spanish Republic*. Because these are elegies, they universalize through philosophization; but it is difficult to assimilate a political defeat to the mood of "queens have died young and fair." It makes it seem inevitable, the way death is, and this is not, I think, a perspective appropriate to political loss in, so to speak, zero-sum conflicts where after all somebody wins. And if this is unavailable, so is beauty. It is one thing when distant empires have collapsed, and all that remain are the ruins, the trunkless legs of Ozymandias, King of Kings, and the boastful legend is rendered instantly pathetic by the surrounding wastes and the thin desert winds. We do sentimentalize ruins, which is why they were so stirring to the temperament of the Romantics, who could stand below them and reflect on the transitoriness of glory. But we hardly can do this before raw wreckage, where the blackness is not so much the patination of age and nature, but the charred effect of fire and dried blood. Is the elegiac mood ever appropriate to so near a political catastrophe? Doesn't beauty distance it too abruptly? Have we a moral right to wax elegiac over something that was not all that inevitable or universal or necessary? Think, to bring it back to the individual death, to which beauty itself *is* the human response, when one feels that death was not inevitable (though death abstractly considered is): suppose one's lover has died of AIDS, and one feels that something should or could have been done, one feels anger that it has not been done, one blames and accuses: then beauty to which one is spontaneously moved also seems wrong, wrong because one is called upon to act (to "act up") and not to philosophize. Then that may translate back into the appropriate mood for the fall of the Spanish Republic, where elegy conflicts with the impulse to counteraction. (Of course, we then have to look at the dates: the first *Elegy* was done in 1948 whereas the Second Spanish Republic fell to Franco in 1939. Does this matter?)

This might be a criticism to which Motherwell's paintings are subject but to which Jenny Holzer's "Laments" would not be, as that work treats of death abstractly and almost disinterestedly. Kant's thesis is that the judgment of beauty is always disinterested: an object may be deemed beautiful only when it pleases "apart from all interest." If this is so much as a possible analysis, then the question remains as to whether it is ever right to respond to an event so close by creating

beauty, and hence whether beauty is appropriate when interest is morally prescribed. I shall return to this issue, so central in discussions of whether beauty is licit in art which is "engaged," as so much art today is; but my immediate concern is to stress that the beauty of Motherwell's *Elegies* is *internal* to the work. The paintings are not to be admired because they are beautiful, but because their being so is internally connected with the reference and the mood. The beauty is ingredient in the content of the work, just as it is, in my view, with the cadences of sung or declaimed elegies.

I want to expand a bit on this idea of internal beauty, which has an incidental consequence of showing how the line is to be drawn between natural and artistic beauty. Hegel asserts straight off in his stupendous lectures on aesthetics that the beauty of art is higher than the beauty of nature: "The beauty of art," he writes, "is beauty born of the spirit and born again." People have queried the meaning of this "twice-born" characterization of artistic beauty. I think it must merely have to do with the fact that the beauty in the first instance is internal to the concept of the work in the artist's mind, and then enacted in the work itself, so born twice—first in the idea and then in the embodiment of the idea. Whatever the case, it will be valuable to consider some examples, of which I will cite two, each of which internalizes the phenomenon of beauty in a different way, both times differently from the way Motherwell's *Elegies* internalize it.

First, I want to describe the beauty in (not the beauty of!) a Tibetan *tangka* of the late nineteenth century, which shows the death of the historical Buddha. The event takes place in an achingly beautiful garden, with green lawns under blue skies, rainbows fluttering like pennants, ornamental birds and plantings, amidst which the Buddha says his last farewells to grieving monks. The beauty of the day and of the place transfer their beauty to the work itself, which is beautiful in ways not typical of *tangkas*, which can be scary and menacing and repellent. But my sense is that this beauty *of* is subservient to the beauty *in* the work. The Buddha, of course, is calm, but the monks are not, which shows that they have as yet not internalized the message of disinterest, or detachment, which is the Buddha's central teaching. They still suffer because, on that theory, they are attached to *him*. So they have a very long path to tread indeed. They must learn to discipline the propensity to cathect. The Buddha, in this work, demonstrates his enlightenment by the equanimity with which he faces death, taking leave of the world at its best and most beautiful—taking leave of *this*, which the artist

arrays before the eyes of the viewer. Anyone, perhaps, can accept with equanimity the loss of a world gone bad and dark and hopeless: in those cases death is an escape, a way out. I once read, in a memoir of the French mystic Marie Bashkirtsev, the young woman's dying words to her mother: *"Maman, Maman, c'était pourtant si beau la vie."* That *pourtant* is a *cri de coeur* of one who had accepted intellectually the thought that the world is a poor place which in fact her feelings contradicted. But this *tangka* shows us the world made beautiful by the fact of leaving it, which transcends the natural beauty, just as Hegel says. *This*, which we see before us, is what we must learn to distance if we wish to be free: so the work is an aesthetic apparatus for the strengthening of the muscles of detachment. "Detach yourself from this, and you are on your way to Buddhahood!" Here, in any case, beauty and death relate in a very different way from that in which they do in elegies, mainly, I suppose, because it is the doctrine of Buddhism that death is something that can be conquered, that it lies within our power to overcome it, and that the common philosophical lot of suffering need not be finally accepted.

A second example is at the antipodes of this. I want to consider certain of Robert Mapplethorpe's images which present the phallus to the viewer as if it were a very pricey product advertised in a magazine like *Vogue*. The images are of a kind to arouse envy and desire in the right sort of audience, and hence the internal beauty of the photography has a rhetorical function, the way the advertising photograph does. Nonetheless, such is the presumed mentality of the targeted audience and such the size of the phallus displayed in each that the object by itself, one might suppose, carries its own rhetoric of magnitude and its own erotic promises, even were the photographs to have been flat and descriptive and documentary. Indeed, we can imagine three photographs of the same phallused male body, one of which is merely documentary, one which uses the artifact of the documentary photograph to make a point about visual honesty, and then one of Mapplethorpe's images in which the whole vocabulary of the glamour shot is marshaled in order to confer on the subject merely shown in the first photograph an aura one would hardly have supposed required, but which, when present, contributes a meaning of its own. Mapplethorpe uses in particular backlighting and shadow as we find it in the standard Hollywood black-and-white star-enhancing photograph, a language which is almost cosmetic in making the star seem beyond and outside the ordinary human range. Stars already are that, being beautiful peo-

ple in their own right, but with cosmetics in reality and light-and-shadow in photography they become transformed into works of art almost, or at least what was suitably named "Matinee Idols." It is quite striking, when one reflects on it, that an artist as certain of the language of visual stardom as Warhol should have altered the mode in which glamour is conferred upon a face: to be glamorous is to be presented in the mode of a Warhol portrait, regarding the beauty of which one must not be dogmatic one way or another, but in which the idiom of the silk-screened photograph overpainted and in some way blurred with a palette of greens and lavenders and lipstick red that is instantly identifiable as Warhol. Mapplethorpe was a far more conservative artist, appropriating the conventions of the fashion-and-Hollywood black-and-white to glamorize the phallus and, by indirection and synecdoche, the phallus-bearing body, almost always posed so as to render that feature of itself salient and enlarged, the way the well-endowed female star presses her shoulders forward to accentuate the visual definition of her breasts. Perhaps these pictures demonstrate, if I may use uncritically for a moment the feminist theory of the male gaze, what transpires when the male gaze takes the male rather than the female as its object. That they imply a male audience may just possibly be supported by the reflection that, according to an entry in a recent Harper's Index, the length of an erect penis according to males is ten inches and according to females *four* inches. In any case, the paradigm of the celebratory and glamorizing phallus shot is Mapplethorpe's *Mark Stevens (Mr. 10½), 1976*, where the subject is arrayed, as if upon an altar, on the upper surface of a kind of podium, and the owner of the subject bends over it in his leather leggings. A vertical triangle at the left and a horizontal one at the right point to Mr. 10½, and the podium itself is haloed with the most intensely white light in the image. The figure itself is severely cropped—at the shoulder, at the back of the legs, at the knee, and at the elbow—as if Mark Stevens's identity *was* that of his penis. It is a frightening and a dehumanizing image, but I offer it as a further example of internal beauty, where the beauty is yoked to the truth of the proposition visually projected in the image, as much so as with the *tangka* of the Buddha's death or Motherwell's *Elegies.*

Once we think of beauty as something "born of the spirit and born again," hence as something intended and then embodied in the work of art if the intention is fulfilled, hence, again, as something that has to be explained through whatever interpretation we give of the work

of art, so that we are dealing with something cognitive rather than merely aesthetic, then a painting—a work of art in general—can have an internal beauty and be a failure if, in fact, the beauty is inappropriate or unfitting. But that means there are works which are better off for not being beautiful, since they might be artistic failures if they were, so to speak, aesthetic successes—that is to say, inappropriately beautiful. With these, I suppose, nonbeauty too is "born of the spirit and born again." Serendipitously, I have come across an appreciation of a painting by the marginal Pre-Raphaelite Ford Madox Brown entitled *Work*. It depicts the laying of a sewer, and Dinah Birch, a Ruskin specialist, declares: "It is not beautiful. But that is part of Brown's point, for he was after qualities that counted for more than beauty. Its subject was carefully chosen. Brown knew that sewers mattered." They mattered because cholera mattered, and because adequate sanitation was a means of removing the threat of it. This was in mid-Victorian England, and Brown was particularly moved when he saw sewers being dug in Hampstead in 1852, and he realized that here was a subject suited to "the powers of an English painter." He worked on it for thirteen years. There will certainly have been aesthetes who reckoned sewage as an unfit subject for art, and one might have thought that the moony and dreamful Pre-Raphaelites would have been among them, given their general repudiation of the industrial landscape of the time and their thematization of the Middle Ages. The Pre-Raphaelite hero and heroine cannot easily be thought of as having to answer the calls of nature. To be sure, these artists did ideologize what they termed "visual truth," but there are in fact too many thematic decisions in *Work* not to suppose it to have been *composed*, and hence it is as dense with artifice as any of the academic works impugned by the Brotherhood. It is that which encourages us to accept Birch's thought that it was a decision on Brown's part not to make the work beautiful, that he would have fought beauty, and hence would have fought the implicit position that something is a fit subject for "the powers of an English painter" only when internal beauty is entailed by the rules of taste appropriate to art. And if she is right, the tacit theory is: this is not a beautiful painting because it treats of a subject more important than what is conventionally accepted as the subject of art, which entails the suitability of beauty. Were he really to have avoided artifice, Brown might have said: the truth is beautiful enough.

One cannot, when construing Brown's central work, refrain from thinking of *Fountain*, Duchamp's celebrated readymade of 1917, which

so many of those in the circle around the Arenbergs—his patrons—insisted on aestheticizing, as if this were his motive in selecting it and then displaying it—as an industrial form which bore certain strong affinities to the admired sculpture of Brancusi. Perhaps he did, perhaps it did, but if so it suggests, then, something about plumbing fixtures as such, where their formal beauty, if we may assume as much, was in the mode of celebration. The urinal proclaimed rather than disguised its function (it is not, for example, like a television set concealed in an antique armoire) at a time when plumbing itself was not something taken for granted, as it is today. In my building in New York, erected in 1912 by the Bernini of the Upper West Side, Gaetano Ajello, everything was meant to dramatize the difference between modern living and that still-nineteenth-century style of life of the brownstones only then being vacated, as people moved into multiple-unit dwellings such as mine. (The West Side was developed well before Park Avenue.) The architectural historian Christopher Gray pointed out to me that all the pipes and heating fixtures were exposed. There was no central heating—there may not have been much by way of plumbing in the brownstones—so the new tenants were proclaiming their change of lifestyle with features which, a generation later, would be buried in the walls. So pipes and porcelain would not be merely functional: they would exhibit their function as emblems. Duchamp himself said at one point that plumbing was the art of America, the urinal being then a literalization of this. But in any case, its beauty, as I suppose it must have been, did not arise by way of an effort to deny or to repress excremental function, but to transfigure it in some way: the urinal is the point at which the human being interacts with the system which transports waste back into the natural world. Its whiteness is a metaphor for cleanliness. But this is something of a digression.

I want now to return to the consideration that, if beauty is internally connected to the content of a work, it can be a criticism of a work that it is beautiful when it is inappropriate for it to be so. A good case of this kind of criticism is in a review by Richard Dorment of John Richardson's life of Picasso. "It now seems odd," Dorment writes,

that for one moment Picasso thought that Puvis de Chavannes's decorative classicism might be an adequate conduit for the tragic emotions he sought to express in the series of paintings inspired by the syphilitic prostitutes in the Saint-Lazare prison, but he did. Many of his gorgeously maudlin paintings of these lonely figures shuffling across empty landscapes or huddled in the white

moonlight are fundamentally phoney because their seductive beauty is at odds with the genuine misery on which they are based.

I am uncertain of this assessment, simply because I am uncertain of its implications for Motherwell's *Elegies*. What artistic address *is* appropriate to the depiction of jailed prostitutes? A clear documentary style conveys one message, a depiction embodying rhetorical anger another. Picasso need not have painted the whores at all, but it seemed a natural subject for someone who shared the late nineteenth century's sentimentalizing attitude toward such women, a kind of Baudelairean legacy. There can be little question that the sentimentalization of suffering gave a kind of market to such works—think of how moved audiences still are by cold, hunger, poverty, sickness, and death in *La Bohème*. Richardson writes, on the other hand, that "there is a hint of eroticism, even of sadism, to their portrayal." In a way, Picasso beautified the women because he relished the idea of a beautiful woman being caused to suffer. An ugly woman, or a woman rendered ugly by the harshness of her circumstances, blocks off the possibility of this perverted pleasure. Think, after all, of the history of depicting female victims, naked and chained to rocks, awaiting their rescuers. No one, presumably, would be interested in rescuing a hag, or a woman shown starved and emaciated. But this means that by and large beauty in the depiction of such victims comes in for a moral criticism connected not so much with "the gaze" as with the fact that the gazer takes pleasure in the agonies of a beautiful female. So Picasso's works from this period are not altogether phony: they belong to a certain tradition, in which the use of beauty is perverse. Perhaps the right way to depict such victims, from a moral point of view, is to exclude any such pleasure and hence to exclude beauty in favor of documentation or indignation. In any case, it is important to recognize that, if this is true, then it is incorrect, on Dorment's part, to speak of Picasso learning "to do without the consolation of visual beauty." Beauty in such cases is not a consolation but a relish, a device for enhancing the appetite, for taking pleasure in the spectacle of suffering. Indeed, Richardson says that "Picasso would describe women with some relish as 'suffering machines.' " But that then raises the question of whether Picasso's subjects were not always victims of his style, of his imposing his will by rearranging their bodies to suit his appetite.

Against these considerations it is somewhat difficult to accept Dorment's assessment that Picasso's eschewal of beauty "is what makes

him an infinitely greater artist than Matisse," as if Matisse could not live without the "consolation." In truth, it would be very difficult to accept the claim that Matisse's "Blue Nude" is at all beautiful: she is fierce and powerful and sufficiently ugly so that voyeurism seems ruled out, let alone arousal—almost as if the ugliness were a sort of veil of modesty with which Matisse covered her nakedness. Still, there is justification in general for Dorment's claim, in that the world Matisse's works depict is a world of beauty, and the works themselves belong to the world they show. Matisse is absolutely coherent in this way, and a hedonist and voluptuary rather than a sadist: he has sought to create a world which excludes suffering and hence the pleasure that might be taken in it. His characteristic corpus has the aesthetic quality of a medieval garden—a garden of love—from whose precincts everything inconsistent with the atmosphere of beauty has been excluded. And to be in the presence of a Matisse is to look into that garden and to be in the presence of—an embodiment of—the spirit of the garden: a fragment of the earthly paradise. I am extremely hesitant, on the basis of this comparison, to see him as inferior to Picasso, let alone "infinitely" inferior, but Dorment's claim that he is so seems clearly based on some disapproval of beauty as an aesthetic quality to be at all sought after or used. As I see it, in his view beauty is a consolation, and consolation means mitigating the bitter truth, which it is morally more admirable to admit and to face than to deny. And to the degree that this represents the current attitude, it is not difficult to see what has happened to beauty in contemporary art. It is not art's business to console. If beauty is perceived as consolatory, then it is morally inconsistent with the indignation appropriate to an accusatory art.

Let us return to a work in the elegiac mode, and one, moreover, as with Motherwell's paintings, where the beauty seems internally linked to the attitude the artist undertakes to arouse toward the subject of the work, in this case the American dead in Vietnam memorialized in Maya Lin's astonishing work. The color, the way the work seems to reach out its wings to embrace the viewer, as if dead and living were folded together in an angelic embrace, almost unfailingly bring tears to the eyes of visitors to the site, and it will be interesting for future generations to see whether this does not continue to be the case, long after there are any of those left who call the fallen by the names that denote them on the surface of the work, or who remember the raw agony raised in the American breast by the Vietnam conflict. At least it does this now, and what is astonishing is that this agony, which

expressed itself in demonstrations, in flag burnings, in shouts and trashings, should have so suddenly been replaced with elegiac feeling. The interesting question is the degree to which the memorial itself was a catalyst in this change. The narrative of the memorial by the man who brought it about, Jan Scruggs, is called "To Heal a Nation," and I know of few cases other than the Vietnam Memorial where it is possible to suppose that a work of art in fact achieved such a consolatory and healing effect. Some may feel the wound should never have healed, that we should persist in a posture of rage, rage against a polity that did what we did in Vietnam. The memorial belongs to a perspective much broader, much more philosophical, a perspective which, as I said in connection with Motherwell, puts us above and outside the battle, seeing it from the perspective of eternity, as Spinoza phrases it. And there may be an essential conflict as to whether it is morally right to be philosophical about it in such a way. Is it morally right to be philo-sophical about the things that seem instead to call for action and change? To say, in connection with sexual aggression against women, that men will be men, as if that were an eternal truth? Or, to take another case, to use Christ's saying the poor we shall always have with us as an excuse for doing nothing about the homeless? *If* beauty in such cases is linked with being philosophical, there are clear arguments against the moral appropriateness of beauty.

But then there is a question of the appropriateness of art as well, for even if the art is not beautiful, art itself is already internally enough connected to philosophy so that simply making art at all rather than acting directly where it is possible to act directly raises questions of moral priority. Consider in this light the work by Chris Burden called *The Other Vietnam Memorial*, discussed in an earlier essay, this one bearing the names of the Vietnamese fallen. Now, it would be won-derful if we as a nation could feel toward the enemy dead what we feel toward our own, but that requires a stance perhaps too philo-sophical to expect human beings who fight wars in the first place to take. The difficulty, nevertheless, with Chris Burden's piece is that it merely reminds us the enemy died as well without in any interesting way acting upon our hearts. His work is not beautiful, and in fact it is difficult to say what aesthetic qualities it has. It in any case does not touch the heart. It consists of several wings attached, like those of a bulletin board, to a central pole. Each one holds a sheet of metal on which are etched, in letters too tiny to read without glasses, the names of Vietnamese. These names as names mean nothing to us, as the

individuals are generic and stereotyped, though doubtless there are those, unfortunately also generic and stereotypical for us, who loved and cared for and mourned the individual denoted by the name that is abstract for us. If Burden's piece were a model for a work to be built, on a large scale, then it is possible that that work would induce feelings the model barely enables us to foresee. But we could not stand in front of the names and read them if it were any larger, and my sense is that this is the work, rather than the model for the work. And my sense further is that the work is not a success: it does not activate any feeling to speak of toward its subject which we might not have had before, so that we walk away with a shrug, an "Oh yeah." It does not help the dead and it does not move the living, and in the end it seems merely a clever idea, almost a gimmick, a kind of moralizing toy. Everything about it as art is wrong, given its subject and its intentions. And because it fails as art, it fails morally, extenuated only by the presumed good intentions of the artist. It should not, if one is seriously interested in causing certain attitudes in viewers, stifle the very possibility of those attitudes.

That is always a danger in activist art, I am afraid. I can understand how the activist should wish to avoid beauty, simply because beauty induces the wrong perspective on whatever it is the activist wants something done about. A work meant to arouse concern about AIDS in the 1991 Whitney Biennial—*AIDS Timeline*—is a case in point. It was, one felt, deliberately scruffy, as if its message was: There is nothing beautiful about AIDS. It had the look of a junior high school project, sincere, jejune, callow. One felt almost more compassion for the artists than for the victims of the disease. They were moving in their earnestness, their fecklessness, their impotence. But they failed artistically if their aim was to enlist art as an ally in their campaign. I don't say it cannot be done, but trying and failing may be just measurably worse than not trying at all.

Ours, however, is an age of indignation, and the lesson just mentioned will take a while to learn if it is true. The lesson is that art has its limits as a moral arm. There are things it can do and things it cannot. It can do, one might say, what philosophy can do, and what beauty can do. But that may mean that philosophy too has its limits as a moral arm. There is something terribly deep in Hegel's thought about the bird of wisdom taking flight only with the falling of the dusk. What another philosopher called the Great Noontide, the time of day appropriate to action and change, may not be appropriate either for

philosophy or for art. It is the moment of interest, and Kant may just be right that interest and beauty are incompatible. Interest and art may be incompatible, but it is not easy to see that this is something the Age of Indignation can accept—it is, rather, something else to be indignant about. So beauty may be in for rather a long exile.

Aesthetics
and Art Criticism

This flea is you and I . . .
— JOHN DONNE

I HAVE LATELY been admiring the engravings executed for Hooke's
Micrographia of 1665, especially plates 34 and 35, of the flea and the
louse, respectively; and I have wondered how, as an art critic, I could
account in words for the uncanny power and strange beauty of creatures
which, in Hooke's day, must have been regarded as pests, much as
they are today. They are no less fiercely constructed than the man-
dragoras and griffins of mythic imagination, but they at the same time
show the limits of the imagination able to do little better in confecting
its creatures than the mandragora or the griffin. The latter bear out a
thesis of Locke's, in that they are composed of parts which belong to
the gross anatomy of more or less commonplace creatures, with wings,
darting tongues, talons, fangs, fins, and stingers—a bit from here, a
bit from there, exemplifications of compound ideas fabricated of sim-
pler elements, themselves derived from experience. Leonardo is re-
corded to have played in this way with *membra animalium* to fashion
cobbled monsters—recombinant amalgams of found pieces. But who
could have imagined *these* bodies, enormous in proportion to their
skimpy haired legs, inadequate, one might suppose a priori, to carry
those plated abdomens and heavy, shelled heads? Hooke's flea is a
creature as ornamental and intimidating as a warhorse in Nuremberg
armor: the hairs stick stiffly out of its body like spikes, giving it an air
of armed menace. And the louse, clutching a hair as if a spear, looks
like a knight with a blazoned shield and the kind of horned headpiece
worn by the Teutonic Order. There is little doubt that these minute
creatures have been drawn just as the microscope revealed them to be;
but more than visual accuracy is conveyed by the images. They convey

a feeling which connects with a whole body of metaphysical propositions the insects illustrate; and it is this expressive supplement that I am somewhat at a loss to explain.

Perhaps it has to do with the way the flea and the louse fill the space of the plates. The flea's helmet-like forehead all but touches the right edge of the space defined by the plate, and its battery of tail hairs in fact touches the left-hand edge. There is no room in that space for anything else, so the insects look *monumental*. Yet they are not monstrosities, the way gigantesque insects in science-fiction movies are, large in proportion to the cowering humans who strive to evade their dangerous mandibles and slimy exudates. Hooke's plates instead imply that these tiny creatures are, notwithstanding their size, monumental and imposing in the intricacy and the proportion of their astonishing bodies. The great microscopists of the seventeenth century were possessed by a miniaturist aesthetics. It was not merely that, as Swammerdam proposed, we could, with the aid of the microscope, "find wonder upon wonder, and God's wisdom clearly exposed in one minute particle." It was, rather, that God's skillfulness and artisanry were even more manifest in the universe's invisible detail. Leeuwenhoek felt that greater craft was required to execute tiny mechanisms than large ones which performed the same functions, so that it takes a better watchmaker to execute miniature timepieces than great clocks. So a flea betrays the hand of the Maker more conspicuously than, say, a horse. Indeed, had Leeuwenhoek written the Book of Job, he would have had God challenge our puny limits not with the Leviathan but with the flea, to which he devoted no fewer than fifteen letters to the Royal Society.

Leeuwenhoek's aesthetics led him to some major discoveries—for example, that fleas are not spontaneously generated from excrement, as Aristotle had claimed, but that they have apparatuses of generation not all that different from animals greatly larger: he was even able to find the spermatozoa of the flea (Aristotle, wrong as usual, thought such small creatures had no insides whatever, but were organic atoms). One might as well expect to see a horse spring spontaneously from a pile of manure, the great Dutchman said in his earthy way, as to see a flea materialize from a dab of shit. The microscope's familiar name was *pulicarium*, or "flea glass," and *Ecce pulex!* is the rhetorical gesture of Hooke's engravings. They condense the miniaturist aesthetics that defined the world of the classic microscopists, and which those pioneers felt should define their own: the world grows more wonderful as we

cross the limits of unaided vision. They demonstrate as well the penetration by aesthetics of scientific observation. As much as anything, I suppose I admire the way the authors assume that the tremendous skill of the engraver's hand should be turned to something as vanishingly small and finally annoying as lice and fleas are, as readily as to the depiction of apocalyptic events: floods, fires, annunciations, crucifixions, final judgments. I admire even more the way these figures insist that nothing could be more wonderful than these minor beings, associated in the common mind with dirt and dogs. When Leeuwenhoek discovered that the tartar between his teeth housed whole populations of animalcules, he felt at once humble and triumphant.

I am also struck, if I may say so, by the readiness with which, as aesthetician and art critic, I am prepared to think of works as distant from the masterpieces of high art as the flea is distant from the horse in the common schema of value. The distinguished historian of Dutch art David Freedberg has recently devoted a fascinating essay to the "great book on the insects of Surinam"—*Metamorphosis Insectorum Surinamensium* of Maria Sibylla Merian, published in 1705, and which, in Freedberg's assessment, "raises the portrayal of insects to great art." Freedberg cites a passage from Johannes Godaert that could apply immediately to Hooke's formidable flea: Insects are "miracles of nature, the irrefragable testimony of infinite wisdom and power. From the outside, they seem to be disgusting and abject, but when you look at them closely, you soon discover they are very different." And perhaps this sentiment is distilled in Merian's certainly brilliant illuminations, in a book which, according to Freedberg, "stands at the apex of a tradition of scientific examination that had been growing for over a century." What Freedberg is endeavoring to do is to take toward these pictures of insects something of the same view that Maria Sibylla Merian took toward insects themselves: they overcome the distinction between high and low. He argues that if we identify art with painting, then the Golden Age of Dutch art ended in 1669, with the death of Rembrandt. "But if one considers art in its better and larger sense, the Golden Age is still at its height at the turn of the century. . . . Artistic energy may be seen to have drained from painting, only to pass into book production and the illustration of natural history." Our vision of art history, but most especially of Dutch art history, has been limited by what he somewhat fashionably calls the "patriarchal view." And the ascription of artistic greatness to Merian is further limited—"bedeviled," Freedberg puts it—by the low view of illustration in general

and the dismissal of natural history drawing as a predominantly female activity. Even today, "illustration" and "illustrational" are terms of critical demerit by those who cannot have pondered the engravings in *Micrographia* or Merian's luminous beetles. The phases of their metamorphoses are no less epic than the stages of Christ's redemptive ascent through filth and blood to transfigurative radiance.

But aesthetics itself, let us face it, is about as low on the scale of philosophical undertakings as bugs are in the chain of being or mere illustrations are in the hierarchy of art. A philosopher whose name is synonymous with the production of books as technical as they are numerous once boasted to me, when I delivered a talk on the ontology of art at his high-stepping department, that he had written not one single word of aesthetics in his entire career. There can be little doubt that some contrast was implied between what he did and what aestheticians did which paralleled perhaps the patriarchal privileging of painting by contrast with illustration, considered an inherently feminine because perhaps dependent activity, since there is no illustration without text. Aesthetics was not something the philosophically real man did. But quite apart from the invidiousness of logical machismo, there was in this prolific philosopher's view the conviction that aesthetics has, by contrast with science, nothing to report regarding the real structures of the world. *His* work was in the philosophy of science, austerely construed, and as he had little doubt that science was the vehicle of truth, so had he little doubt that the science of science, as practiced by himself, was the truth about the truth. But one great advantage of thinking about scientific illustration of the seventeenth century is the way it communicates to us the thought that scientific and aesthetic considerations were as intermingled as were the blood of the poet and that of the lady Donne addresses in his poem about the metaphysical flea which had bitten them both: "One blood made of two." Not just art and science, but cognition and aesthetics might concur that "This flea is you and I, and this / Our mariage bed and mariage temple is." Try to subtract expression from truth in Hooke's plate 34!

Can aesthetics and cognition be any less commingled today? Or was their marriage an artifact of the era of the early microscope—of the Age of the Marvelous, to cite the title of an exhibition, itself marvelous, itself a lens through which we could see the mind of the seicento, filled with the likes of fleas and ornamental microscopes? I think the future of aesthetics had better consist in finding out, and possibly

the place to begin is with scientific illustration as practiced today (photography has not made it obsolete but more necessary than ever). But alongside this difficult investigation—it is not easy to know to what degree we are able to raise styles of representation to that level of consciousness where they reveal the structure of consciousness itself—there is the task of clearing away the rather powerfully disenabling ideas of aesthetics that have tended to define the field, and which make it rather easy for my tough-minded colleague to feel there would be no great point in thinking about aesthetics in his endeavor to reconstruct the spiffy language of science. *His* ideal is to expunge from language everything Frege had in mind by *Färbung*, leaving its analysis only a matter of unqualified *Sinn* and *Bedeutung*. My sense is that Hooke's flea exemplifies a symbol in which *Färbung* is so inextricably bound up with *Sinn* that we can almost infer from it the vision of the world held by the author of *Micrographia* and his primary audience, providing we can do the right sort of art criticism on this image. Its aesthetics implied the way he and they lived in the universe, and the question surely is whether it is any different with us. Beauty and truth may not be quite one, but they appear to have been sufficiently wed in the Age of the Marvelous so that a sufficiently advanced aesthetics had a fair chance of being queen of the sciences: show me what men and women held to be beautiful and I will show what they held to be true. And the rhetorical question above implies my view that a thesis is entertainable that aesthetics stains so deeply the way we represent the world that no simulation of mental processes which seeks to filter it out could approximate to the way the cognitive mind actually works.

Hume famously wrote that "beauty is no quality in things themselves: It exists merely in the mind which contemplates them." Like the eye of the beholder, alternatively allocated as beauty's residence, "the mind" is meant as a sort of philosophical attic in which the madwoman of aesthetic coloration is kept out of ontology's way. But there is an awful lot which has been taken seriously by tough-minded philosophers that other philosophers have supposed to exist merely in the mind: time, space, and causality, just for starters. And while these may be forms for the organization and rationalization of experience, it would be a neat trick to try to describe "things themselves" without using them. Kant had no way of doing that, and the things *in* themselves are described only privatively, as that to which the forms of the mind do not apply, leaving "things themselves," as Hume uses the term, so commingled with these forms that we can hardly disassociate them.

Hume did like to speak of causality as something the mind projects onto the neutral fabric of the world, leaving it unclear how we are to represent to ourselves the pre-projected world. In any case, if beauty holds parity of philosophical nature with causality, aesthetics can hardly be discriminated from science in terms of objective authority.

So far as the eye is concerned, it is after all an extruded portion of the brain, and the brain itself, that entire computational system, is mobilized by what the eye finds fair: if beauty is in the eye of the beholder, the brain at the very least keeps the object of beauty in focus, the eyes open and upon it, the rest of the body's impulses put on hold. In consigning beauty to the eye, the cynic believes it subtracted from objects, overlooking the whole dense network of neural wiring that connects the eye to the rest of us, and us to the world through it. So in subtracting beauty from the world's objective order, it is we who are subtracted from that order, and the philosophical disenfranchisement of aesthetic qualities (in the mind, in the eye) is in effect the self-disenfranchisement of us, driven as we are by the colorations of meaning in choosing mates and metaphysical systems.

I literally cannot imagine what objects are really like abstracted from what might ingratiate the eye or satisfy the mind. Simply as a matter of genetics, and without bringing in issues of history and culture, there is probably enough complexity in the architecture of cognition to underwrite the truth of Hume's observation that "each mind perceives a different beauty," which does not mean that there is no accounting for taste, only that we know too little about the genetics of cognition to be able to do so. On the other hand—and this would have been the other component in Hume's account—there is enough genetic overlap from individual to individual so that it would be strange if there were not a few things humans as humans agreed were beautiful. Hume wrote that "it is fruitless to dispute concerning taste," and if he is right it is because the genetic understructure of aesthetics determines us to the reception of experience so seasoned with aesthetics that there is no opening for the intervention of rational dispute. But it is no less fruitless when tastes concur, when, to use his well-known example, "whoever would assert an equality of genius and elegance between Ogilby and Milton, or Bunyan and Addison, would be thought to defend no less an extravagance, than if he had maintained a mole-hill to be as high as Teneriffe, or a pond as extensive as the ocean." The two sides of Hume's thesis on taste are underwritten by the same physiology or psychology. The difference is that with the Ogilby-Milton

case, the Ogilby freak can at least be shown why his taste is perverse, why he *ought* to admire Milton, on the basis at least of the kinds of considerations which enter into the criticism of poetry. Still, no one can be talked into liking Milton by such reasoning when it is Ogilby who has that certain something that excites the soul. There are very few who know anything about painting who do not reckon Mantegna as among the greatest painters in history. But of those there is a considerably reduced number who actually like Mantegna, and perhaps an even greater number who actively dislike him.

When we ponder such examples, of course, we have already gone well past genetics, and are dealing with culture and history, bracketed a moment ago. I forbear, even so, from commenting on the crippled state of a cognitive science which treats us in abstraction from our historical and cultural locations. It is the mind and the eye that locate us in culture and history, but my thought here, from which the engaging tangle of Hume and Ogilby, Milton and Mantegna have distracted me, is that even the prehistoric, precultural eye and mind, if ever there were such, would have found beauty in things. On the other hand, the eye that makes the scientific observations and the mind that frames the scientific theories are so interwoven with the history and culture of their owners that the neat enucleation of aesthetics is, as the Germans say, *vorbei.*

The conjoint title of the journal in which this essay first appeared—*The Journal of Aesthetics and Art Criticism*—has increasingly been a matter of puzzlement to readers who in fact find very little actual art criticism in it. Either, to be consistent with its content, the title should simply be *The Journal of Aesthetics* or its range of articles should be expanded to contain more of the sort of article which naturally finds a place in such publications as *Artforum* and *October.* But in fact, as David Carrier once observed in a session at one of its annual meetings, members of the American Society for Aesthetics hardly follow contemporary art criticism and this recommends dropping the second conjunct. I have a different view of the matter. I feel, for example, that the wise founders of the Society felt that aesthetics has a reach far wider than the preoccupation with art as such—a position one might say is already in place in Kant, who has negligible things to say about art—and they would be dismayed to see how more and more of the contents of the journal have been given over to aesthetic questions which more narrowly deal with art, so that aesthetics and the philosophical concern with art have increasingly been seen as sy-

nonymous. No: they saw aesthetics as virtually as wide in scope as experience, whether it be experience of art or of insects. *Then*, when it is art itself that is to be dealt with, it should be very largely in the form of art criticism.

There is, then, the aesthetics which addresses itself to the encoloration of meanings, to speak in the formal mode; or which penetrates our experience of the world to such a degree—to move into the material mode—that we cannot seriously address cognition without reference to it. It would be on the whole an immense contribution to our understanding of ourselves as cognitive beings if we were to study, from that perspective, the extent to which we are aesthetic beings, whose minds, as the in-the-mind-of-the-beholder sort of theory allows, are filled with colorations and preferences, no better account of which can be given than that they are aesthetic. In brief, we allow the disenabling theory of aesthetics and use it as pivot to argue for a disenabling theory of cognitive science which fails to factor in what is "in the mind of the beholder." That means, in my view, that the progress of cognitive science is in hostage to aesthetics, and bound to be *retardataire* so long as the best work in aesthetics continues to restrict itself to conceptual questions about art. The future of aesthetics is then very much to be understood as the aesthetics of the future, construed as a discipline which borders on philosophical psychology in one direction and the theory of knowledge on the other.

So much for the in-the-mind part of the disenabling formula. The other part—"of the beholder"—is disenabling in a different way: it assumes, as has been the practice since Kant, that aesthetics concerns primarily what transpires in the eye of *beholders*, treating aesthetics as essentially a contemplative address to objects, divorced from practical considerations of every sort. We aestheticize only when the world is, so to speak, on hold. Whereas it is my view that if aesthetic considerations are commingled with cognition, and cognition itself harnessed to practice, contemplation is not the defining aesthetic posture at all. As if we left aesthetics behind when we snap out of our contemplative stance and begin to duke it out with reality! We may no doubt pause to admire the starry heavens above and the moral law within, but those parentheses of contemplation in no way exhaust all the ways we relate aesthetically to the world. So perhaps what we might call the aestheticization of aesthetics is by far the most disenabling strategy of all. Just think about Hooke's flea once more: it instructs us in how the flea looks, but it does more than that in instructing us how to think and

feel about the flea and about a world which has such creatures in it. I am content to follow the lead of David Freedberg in campaigning to have illustrations accepted as art. But that does not mean that henceforward plate 34 of *Micrographia* becomes just a focus for contemplation, to be viewed in the recommended disinterested way. It is no use promoting something to the status of art if that means putting it forever on cognitive sabbatical. But this brings me now to the topic of art criticism.

My book *The Transfiguration of the Commonplace* took a fairly hostile position on aesthetics, but the target of the hostility was that detached and disinterested aesthetics which is so salient in the philosophical tradition, and, beyond that, the tacit view, implicit in our practice, of linking art and aesthetics so closely together that they are somehow inseparable. My view was different. I felt that aesthetics does not really belong to the essence of art, and my argument was as follows. Two objects, one a work of art and the other not, but which happen to resemble one another as closely as may be required for purposes of the argument, will have very different aesthetic properties. But since the difference depended on the ontological difference between art and non-art, it could not account for the *former* difference. The aesthetic difference presupposed the ontological difference. Hence aesthetic qualities could not be part of the definition of art. True, the work of art has a set of aesthetic qualities. But so does that which resembles it without being a work. It may further be true that these are aesthetic qualities of different kinds. But I am not quite sure there are two kinds of aesthetic qualities, and in any case one would need the concept of art to say in what the difference must consist. So I was able pretty much to put aesthetics on ice in working out so much or little as I was able to work out of the defining character of works of art.

Let me now illustrate my claim by considering the example which carried me so great a distance in that book and elsewhere: Warhol's *Brillo Box* of 1964. Now, *Brillo Box* served a purpose in making vivid the deep question in ontology of how something could be a work of art while other things which resembled it to the point where at least their photographs were indiscernible, were not. The mere Brillo boxes which are not works of art nevertheless were not mere things, like fleas: they were among the kinds of things Joseph Margolis has called cultural "emergents," which, like artworks, embody meanings. The interesting thing is to show how the meanings of these two cultural emergents differ, and hence how their aesthetics differ. Or better: to show the difference in the art criticism of these two objects.

The "real" Brillo box, which actually houses Brillo pads, was designed by an artist, Steve Harvey, who was a second-generation Abstract Expressionist more or less forced to take up commercial art. It has a very marked style, which situates it perfectly in its own time and in fact there are some very marked connections between it and some of the high art styles of that time. Its style, however, differs sharply from that of Warhol's *Brillo Box*, which has almost no connection to those very high art styles at all. Where Warhol's is cool, it is hot, even urgent, in proclaiming the newness of the product it contains, the speed with which it shines aluminum, and the fact that its twenty-four packages are GIANT SIZE. Speed, gigantism, newness, are attributes of the advertising world's message—they pertain as certainly to that discourse as moon, blood, love, and death pertain to the discourse of poets. Warhol's work was very new indeed in 1964, but were we to read the NEW! as proclaiming that fact, the work would have a subtlety and cleverness we would not attribute to the box's design as such. The design uses sans-serif lettering—the lettering of newspaper headlines—to underscore the urgencies of its message; and my hunch is that Harvey was influenced, in his motif, by certain themes in hardedge abstraction. But none of this pertains to Warhol, who felt no such influence and had no such message. The wavy white band connotes water, the BRILLO exemplifies spotlessness in a blaze of chromatic clarity against the white (a few years later the paint might have been Day-Glo). Warhol just took all this over without participating in the meaning at all. For him, at best, it would be the sheer banality of the box that was meaningful, and this, internal to his box, would be an external assessment of the commercial container. But to Harvey the box was not banal at all. In any case, in point of meaning the two could not be more different.

Though *Brillo Box* and the Brillo boxes belong more or less to the same moment in history, so far as external chronology is concerned, nothing about the Brillo boxes would enable you to know that there was an artwork like Warhol's. You might infer from Steve Harvey's boxes the existence of an art of the kind from which he derives his motifs and his reductions: almost invariably, advertising art draws on high art paradigms. But there is scant connection between *Brillo Box* and those paradigms. The nearest affinities to *Brillo Box* would have been what Claes Oldenburg and Roy Lichtenstein were doing: but there are no interesting stylistic affinities between the various Pop artists, and certainly no affinity at all between Steve Harvey's box and any of Warhol's affinities—say, a plastic hamburger by Oldenburg. The

real Brillo box could not have been done in, say, 1910, but for reasons altogether different from those which explain why Warhol's *Brillo Box* could not have been done in 1910. For all that they resemble one another, they belong to different histories, and though Steve Harvey's work would be unthinkable without a certain kind of abstraction, and Warhol, of course, unthinkable without Steve Harvey's boxes, Warhol's was itself in no way dependent upon those kinds of abstractions, coming from a different space entirely than Steve Harvey's.

These differences could be protracted, but I have written enough to underscore, I hope, the aesthetic differences between the two works and the way in which these aesthetic differences are simply the differences between the art criticism appropriate to the two objects. I have no difficulty in accepting the commercial art as art for the same reason that I have none in accepting the scientific illustrations of the seventeenth century as art. But in this particular instance the differences are, if not of kind, then perhaps of quality. Steve Harvey's boxes are about Brillo and about the values of speed, cleanliness, and the relentless advantages of the new and the gigantical. Warhol's iconography is more complex and has little to do with those values at all. In a way it is philosophical, being about art or, if you like, about the differences between high art and commercial art. So Hegel may be right that there is a special kind of aesthetic quality peculiar to art. He impressively says it is, unlike natural aesthetic qualities (he uses the term "beauty," but that was the way aestheticians in his era thought), the kind of aesthetic quality which is *aus dem Geiste geboren und wiedergeboren.* But that is no less true of the aesthetic qualities of Brillo boxes than of those of *Brillo Box.* We would expect nothing else, given that both are dense with meaning and, in a sense, *aus der Kultur geboren.* It may be less important to distinguish high art from low than either from mere natural aesthetics of the kind we derive from our genetic endowment.

So my concluding proposal is this: we understand the aesthetics of art as art criticism, just as I am supposing the founders of the American Society for Aesthetics did, enshrining the difference between aesthetics and aesthetics of art—between what Hegel calls *Schönheit* and what he calls in contrast *Kunstschönheit*—in the joint title of the journal they established. Hegel, by the way, showed us how to do the kind of art criticism I fumbled toward in discussing the great engravings of the flea, in his marvelous—I would say unparalleled—passages on

Dutch painting and on the differences between it and the work of those whom he terms modern painters who attempt the same things. Just as a matter of interest, Hegel does not once use there the word "beauty" or any of the standard predicates of aesthetic vocabulary. As art critic as well as aesthetician, Hegel shows us both dimensions of our future.

Index

Index

Index

Index

Index